An American Saga

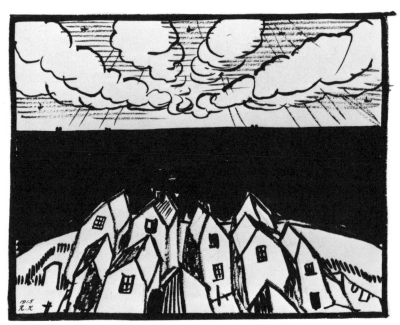

NEWFOUNDLAND (INDIA INK)

HARPER & ROW, PUBLISHERS
NEW YORK
Cambridge London
Hagerstown Mexico City
Philadelphia São Paulo
San Francisco 1817 Sydney

AN AMERICAN SAGA

The Life and Times of Rockwell Kent

David Traxel

This book is dedicated to my mother
and to the memory of my father.

Quotations from Rockwell Kent's letters are copyrighted by the Rockwell Kent Legacies.

PHOTO CREDITS

Carl Zigrosser Collection, 110; Collection of Carola Kavanaugh, 98; Collection of Mr. and Mrs. Dan Burne Jones, 28; Collection of Mr. and Mrs. Kneeland McNulty, 9; Collection of the Whitney Museum of American Art, New York, 11, 104; Columbus Museum of Art: 63; Philadelphia Museum of Art, gift of Carl Zigrosser, 119; Philadelphia Museum of Art, purchased: Lola Downin Peck Fund, 32, 73, 83, 85, 90, 145, 155, 167, 172, 207; Phillips Collection: 162; Rockwell Kent Legacies: 110, 134, 152, 158, 167 (shared with R. R. Donnelly & Sons), 179, 186, 194; Smith College of Art: frontispiece; Spectrum Gallery, 93; The New Britain Museum of American Art: 42; Worcester Art Museum, 24, 153.

FIRST EDITION

Designer: Patricia Parcell
Copy editors: Bill Reynolds and Bernard B. Skydell

Library of Congress Cataloging in Publication Data

Traxel, David.
 An American saga.
 "A Joan Kahn book."
 1. Kent, Rockwell, 1882–1971. 2. Artists—United States—Biography.
I. Title.
N6537.K44T7 1980 741'.092'4 [B] 78–20193
ISBN 0–06–014372–X

80 81 82 83 84 10 9 8 7 6 5 4 3 2 1

CONTENTS

	Prologue	1
ONE	The Early Years	5
TWO	Apprenticeship	17
THREE	Monhegan and Freedom	30
FOUR	Rebellion	53
FIVE	Winona	66
SIX	Frustration and Escape	80
SEVEN	Alaskan Wilderness	100
EIGHT	Success	117
NINE	Voyaging Toward Cape Horn	130
TEN	The Gold Camp	143
ELEVEN	Eskimos and Railroads	157
TWELVE	Fighting for the Cause	175
THIRTEEN	Hard Years	192
	Coda	212
	Acknowledgments	215
	Notes	217
	Selected Bibliography	237
	Index	244

ILLUSTRATIONS

Newfoundland / FRONTISPIECE
Madonna and Child / 9
The Seven Ages of Man—The Infant / 11
Man Seated / 24
Self-Portrait / 28
Monhegan Headland / 32
Toilers of the Sea / 42
Men and Mountains / 63
The Faller / 73
Ice Floes, Newfoundland / 83
Rescue in Newfoundland / 85
Man on Mast / 90
Hogarth, Jr., Tennis Player / 93
Portrait of Carl Zigrosser / 98
Man and Boy Sawing Wood / 104
North Wind / 110

Man Picking Apples / 119
Life Is So Rich / 134
Our Hope / 145
Rolls-Royce Advertisement / 152
Cottage in Landscape / 153
Couple / 155
Close Hauled / 158
The Voyagers / 162
Title Page for Moby-Dick / 167
Portrait of Josef / 172
Workers of the World Unite! / 179
Panel of Post Office Mural / 181
Nash Automobile Advertisement / 186
Album Cover / 194
Transportation Mural / 202
Self-Portrait / 207

COLOR PLATES

Following page 56
Interior of Cottage, Monhegan Island
Road Roller
Monhegan, Maine
Pastoral

Following page 152
Angel
Resurrection Bay
Clover Fields, Asgaard
Holsteinborg, Greenland

Do you want my life in a nutshell?
It's this: that I have only one life,
and I'm going to live it as nearly possible
as I want to live it.

—ROCKWELL KENT

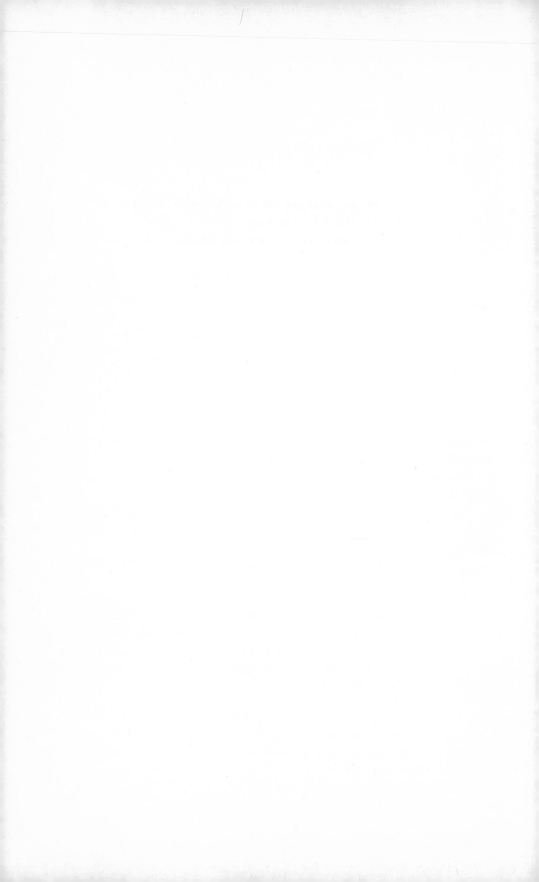

PROLOGUE

Rock, and sea, and a rising onshore wind.

The small cutter lifts and falls with the growing swell, tugging at its anchor line like a colt at a lead.

Mountains rise, blue and white, five thousand feet or more around the fjord, funneling wind through the narrow entrance, booming it from peak to peak, sending it down on the water in howling gusts.

As the wind mounts, the boat's motion becomes wilder. Gray dawn finds her winning the struggle with her anchor. Slowly, she begins to drag.

Two men suddenly appear on deck, rain and spray glistening on their yellow slickers. Moving as quickly as possible in the mounting gale, they try to set a second anchor. Still the boat drags toward the granite shore.

Wind whistles down from the mountains. Flung from sheer cliff to glacier to cliff again, its sharp edge seems to come from all directions. At times it forces the sea flat, truncating the wave tops, cutting the seas to mist. Moments later it shifts, hits the water aslant, like an ax blade, shooting spray into the air, cascading it over the struggling boat.

Still she drags, jerking her two anchors through the sand. She cannot keep her head to weather, but yaws, first one side, then the other, battered. With each buffet she heels farther, until one tremendous blast knocks her flat. Green water pours down the hatch.

A third man pushes his wet way to the deck. He is older and smaller than the other two. With an experienced eye he measures the scene; he exults. Quickly he returns below to get the third anchor.

But there is no time. Faster the cutter drags; the men try to protect their faces from the flying scud, the stinging rain. The surrounding mountains rise higher; they block the sky.

Suddenly, the anchors catch, the boat heads into the wind. She holds a moment, then breaks away. Now only feet from an angled granite ledge, the three men clutch at handholds and stare, all struggle forgotten, spellbound.

The sea lifts the boat and bears it with a rush to the rock. The men grip tighter, against a crash that doesn't come. Instead, graceful as a ballerina, she slips away.

Again the boat rushes, and this time, gently, her stern touches the ledge. A brief tremor, nothing more.

But the play is over. A great surge and the boat charges at the angled granite. Her iron keel strikes, then, shrieking, her wooden hull. With each following wave she lifts and pounds, lifts and pounds, held there by sea and wind.

With the first full blow the men are released from their spell. The Captain, whose air of phlegmatic calm has survived the disaster intact, gets ashore and tries to secure the masthead line to a boulder; the Mate, bulky with strength, scrambles after him with bags of salvage; Rockwell Kent, quick and lithe, returns below deck to save what he can.

Chaos. Books, beans, shelves and drawers, pots, pans, shoes and boots jumbled on the cabin sole, shaken, churned and hurled every few seconds as the boat pounds against the ledge. Kent calms himself, tries to curb his imagination. He methodically sets to work: matches, dry place to keep them, food, kerosene for the stove, alcohol to prime, then the stove itself; all shoved in a sack. He carefully takes the chronometers, wraps them in clothes and blankets, places them in the sack. His sextant follows, then his most precious possession: his father's silver flute, then the movie camera and more blankets.

The Mate stands at the hatch and shouts for him to come out. Kent hands up the sack, then scurries forward over the shuddering debris to the fo'c'sle, where his wife's picture looks out over the havoc. As he places the photograph under his clothes, over his heart, he thinks of the scene his romantic gesture will prompt from her. Grabbing what else he can of his personal belongings, he makes his way back through the ruined cabin and climbs to the deck.

There are only moments left before the cutter will sink. Avoiding the main boom, which thrashes back and forth across the deck, Kent follows the

Mate over the side. Swimming and wading, then climbing, they get ashore. Kent helps the Captain secure the masthead line around a boulder; no sooner done than the surging boat breaks the three-inch manila like twine. She is sinking now. Kent jumps to a bag, pulls out his movie camera and films her slide beneath the waves.

The storm rages on. Under the press of wind, rain strikes rather than falls, mountain cascades are lifted and blown to mist, waves are vaporized. The world seems in the process of creation: air to water to earth which smokes with liquid fires. The three men stagger through the maelstrom until they find an overhanging cliff that offers protection. They rig their boat's spinnaker as a lean-to, then return to the wreck to gather its wood; there are no trees in this misnamed Greenland. Flotsam fills the pounding surf. Though the hull of their boat lays beneath the seething water, its mast and rigging rise proudly above the waves. Using poles they fish for bits of gear. Kent finds, of the long, detailed diary he has kept on their voyage, only the last page, written twenty-four hours before. "And tomorrow," it reads, "I paint!"

In the primitive shelter, Kent prepares a meal of soup, wet hard-bread and chocolate. A chart has been saved of this rugged and broken coast; there is a settlement five or ten miles away, but they cannot tell if it is accessible by land. Kent, at forty-seven, is a voyager and adventurer of long experience. The Captain and the Mate, both twenty-two, are not yet out of adolescence. Kent is to go.

He sits in a trance for an hour before the snapping fire as his shipmates pass to and fro bringing salvage. His exultation has worn off; the disaster lacks the purifying totality he craves, and each new piece of soaking wreckage further mars its completeness. He curses the inelegance of fate.

At 1 A.M. he stands ready; his pack is heavy with rations, stove, clothes, and a clumsy ship's compass. The wind has moderated. He adjusts the tumpline to his forehead, and starts off with springy steps into the cold rain.

At the first dip he turns and waves at the two figures by the fire. Already a second gray Arctic dawn is breaking. He pushes into the wilderness of Greenland; soon, as he walks, he begins to pick the bright flowers that pattern the storm-matted grass.

THE EARLY YEARS

The Little Boy Lost

"Father! father! where are you going?
O do not walk so fast.
Speak, father, speak to your little boy.
Or else I shall be lost."

The night was dark, no father was there;
The child was wet with dew;
The mire was deep, & the child did weep,
And away the vapour flew.
 —WILLIAM BLAKE

I am not a very good boy but I try to be.
 —ROCKWELL KENT TO SANTA CLAUS, ca. 1887

Stormy petrel that he was, Rockwell Kent's life was filled with tumult, struggle and controversy. One public argument that raged for seventy years was over the quality of his "American-ness." From the early years of the century, when he first gained recognition, until his death in 1971, people saw in him either a genius whose art and character were of a uniquely American blend or a dangerous subversive who should "go back" where he came from.

It is ironic, then, that the roots of the Kent and Rockwell families can be traced to the beginnings of the white experience in America. Thomas Kent brought his family to Gloucester in the colony of Massachusetts sometime before 1643. His descendants spread throughout New England, and then, in 1812, to the Ohio River Valley.

In that year Zenas Kent, carpenter, joiner and Revolutionary War veteran, moved his family to Mantua, Ohio. There his grown son and namesake, also a carpenter and joiner, found opportunities to test his ambitions. Starting as a contractor and builder, the younger Zenas became a successful merchant, mill owner, bank president and railroad tycoon. Though wealth was not his only concern (he was a partner and abolitionist supporter of the de-

cidedly unbusinesslike John Brown), he was so successful that the seat of his financial empire, Franklin Mills, was renamed in his honor, Kent. One of his nine children, George Lewis Kent, was our Rockwell Kent's grandfather.

George Kent married Matilda Rockwell, whose ancestors came to America on the *Mary and John* in 1630. The couple moved to New York where George became a wholesale merchant and hotel owner. It was in Brooklyn and into a prosperous household that the first Rockwell Kent was born. The education he received reflected his favored circumstances: he attended Exeter, Yale and Harvard before deciding to study mining engineering at Columbia and in Freiburg, Germany. Restless and eager for success, he spent a year plying his trade in California, then returned to the East to enter law school at Columbia. After graduation he set up a law partnership in New York.

Sara Ann Holgate, who soon became his bride, was of more recent American vintage. Her father had emigrated from England in 1847, met and married her mother soon after and set up housekeeping in New York, where Sara Ann was born. The father was involved in several business ventures, and Sara Ann's early years were spent moving from one factory location to another. At the age of eleven, however, she was sent to live with her mother's sister and brother-in-law, Josie and James Banker, on their estate in Irvington, New York, near Tarrytown. James Banker was a wealthy capitalist, one of New York's first millionaires, who was closely allied with Commodore Vanderbilt. The couple had lost their own child a few years before. Looking to Sara Ann as a substitute, they were overprotective and confining, so, although the house was large and the grounds spacious, it was an unhappy life that Sara lived. She grew up lonely, and quietly rebellious.

In the late summer of 1880, she accompanied her uncle to a demonstration of the incandescent light given by the young scientist Thomas Edison. Also at the presentation was a handsome junior lawyer, Rockwell Kent, who fell under the spell of the twenty-year-old, golden-haired girl. So domineering and so jealous of Sara was Banker that he had already chased off one potential suitor. Mornings after young men had called he would rage at her, "Why did you sit out there and talk to that damn fool all night?" Sara was sure he would not allow her to leave the house if he suspected that she was interested in someone, so the relationship with Kent began, through the help of friends and loyal servants, without his knowledge.

The couple would meet when and where they could. Banker insisted that Sara accompany him to the railroad station every morning where he caught the train to his office in New York. She would wear a city dress under her station dress. Once her uncle was safely off she would rush to the carriage, close the blinds, remove the station dress, then ride into New York on

the train with Kent. Under these forced conditions their romance developed quickly, and that winter they became secretly engaged. Such was the fear, however, of James Banker's wrath that it was not until July that Kent wrote to him asking for Sara's hand. The fear had been justified; Banker erupted into a rage that terrified the household. "Never!" he shouted, then took to his bed, sick from anger. A few days later, aided by the same friends who had supported the courtship, Sara stole away to New York City, where she married Rockwell Kent.

The young man was enjoying considerable financial success. He had just become a full partner in the prestigious law firm of Lowry, Stone and Auerbach, and, possessing the boundless energy nineteenth-century Americans seemed to enjoy as a birthright, he also pursued a fortune through investments in foreign mining ventures. He often journeyed to Europe or South America to survey companies, investigate potential ore deposits or oversee the preliminary stages of mining operations.

A man of average height, he had thinning blond hair and wore long, wispy, muttonchop whiskers. Almost seventy years after his death, his son, who never really knew him, had his handwriting analyzed. The graphologist determined that the lawyer had been an easygoing, tolerant man of high, though slow-working, intelligence whose approach to life was basically intuitive. A man with "a warm and rich heart."

It was into a happy and comfortable setting that Rockwell Kent was born on June 21, 1882. Another boy, Douglas, was born two years later. The family, spending the winter months in New York City, the summer at a cottage at Shinnecock in Baytown, Long Island, and the spring and fall in Tarrytown, enjoyed all the secure material comfort of the late Victorian middle class, a security that could be seen stretching into a stable and ever more prosperous future. It was also a home of genteel culture and refinement. The father relaxed through playing the flute and woodworking; both parents appreciated art and filled the house with paintings and engravings. There were servants, horses, dogs and dancing lessons for the boys. The family's Austrian maid, Rosa, bore responsibility for the day-to-day care of the children. She developed a special relationship with little Rockwell as she taught him German, which he spoke before English, instilled in him the social graces and spent hours with him and Douglas in the fields and woods around Tarrytown.

But this peace and security did not last. In September 1887, Rockwell Kent, Sr., returned from a business trip to Honduras, was immediately struck with typhoid fever and died, leaving behind his two sons and a pregnant wife.

Sara Kent was an unusually strong and able person. While her husband

had been a warm, open spirit, she burned with a steadier, if smaller, flame. Not given to emotional display, she hid her grief from the children as she tried to resolve her fear and uncertainty about the future.

All her strength and ingenuity were needed, for upon her husband's death she and her children were left in near-poverty. Her father-in-law had died, survived by the widow of a second marriage, so there was no aid from that quarter. James Banker had immediately cut her out of his will when she had eloped and, though there had been a subsequent thawing, he had died leaving his estate to his wife, Sara's eccentric Aunt Josie, who was stingy though sympathetic. The financial difficulties were soon compounded by the addition of a daughter, Dorothy, to the family.

A period of very real distress began that was to last, off and on, for many years. The New York town house was given up, the servants let go, the horses and dogs sold. The family moved into a gloomy little row house in Tarrytown where they were joined by Sara's mother, who came to help raise the children.

Though Aunt Josie Banker was too tightfisted to give direct financial aid, she did offer some help. No doubt motivated as much by loneliness as by generosity, she would occasionally allow the Kents to move in with her at the Irvington estate while they rented out their row house. Rockwell Kent grew up knowing periods of luxury alternating with real, though genteel, poverty. He grew up with the sense of being a "poor relation," a sense of having fallen from high position—perceptions that often bring as their shadows resentment and driving ambition.

The estate's spacious grounds and large mansion made a lasting impression on the small towheaded boy. There were vast lawns to run and roll on, dark woods and overgrown meadows to explore and hide in, a stream arched by a bridge, ponds and fountains with fish and toads to be watched and wondered at. Even as a child Kent had tremendous energy. Loving the out-of-doors, he would spend hours roaming the grounds—but increasingly his intense loneliness drove him to his favorite room in the house, the library.

It had been thought best to keep the reality of the father's death from the children. The nature of his illness had been disguised and his absence explained as just another trip on which he had embarked, and from which he would return. But Rockwell began to understand that his father was gone forever. His mother, cold and controlled, did not offer much emotional support. He began to sleepwalk and to suffer nightmares—ambulatory dreams of death and dissolution. He felt abandoned, his loneliness intensified by the family's snobbery. As a member of the gentry, though from an impoverished branch, he was forbidden to play with the village children.

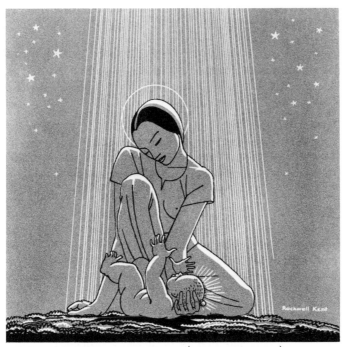

MADONNA AND CHILD (ZINC ENGRAVING)

Rockwell was a difficult child: willful, rebellious, intractable. His high level of animation made him even harder to control. He teased his young sister unmercifully, making fun of her posture, her speech patterns and the size of her teeth. "Why, when Dorothy goes for a walk," he would say, "she has to stop and take her teeth out to rest." His mother could not discipline him. As his sister remembers it, "There was something about Rockwell that intimidated people. He would get a look in his eyes that scared people off." Sara's sister, Jo (named after Aunt Josie), came to live with the family, and it was she who assumed the role of disciplinarian. The frequent clashes between the two were sometimes resolved through the application of a gold-handled horsewhip to Rockwell's legs and buttocks. One day, during such a confrontation, he grabbed the whip and fled to the woodlot where he buried it under an oak tree. Though the family searched fruitlessly for hours, Kent would not tell where it was hidden. Decades later he would claim he could still find it if he ever wanted to.

The family placed great importance on education. From an early age Rockwell was sent to local private schools. First to Miss Bennett's School for Girls, where, because he was too embarrassed to ask the location of the toilets, he distinguished himself by repeatedly wetting his pants. His next edu-

cational experience was with a Professor Richardson, who ran a small school in his house in Tarrytown and who taught not only the basics of reading and writing, but also the elaborate Spencerian calligraphy. As evidence of Kent's early artistic talent it can be noted that he won the school prize, a gold medal, for excellence in penmanship.

Even with the help of Aunt Jo, Mrs. Kent had not been able to keep Rockwell under control, so, at the age of ten, he was sent to a local boarding school to be taught how to behave. That experience, though distasteful to him, did not have the desired results, so the next year, 1893, he and his brother, Douglas, were sent to the Episcopal Academy at Cheshire, Connecticut.

The academy, subscribing to the Victorian dogma that character is built through discipline, was run on a military model, complete with uniforms, drills and old muskets. The headmaster was an erect, white-bearded veteran of the Civil War, Colonel Eri D. Woodbury, whose battle-maimed right hand fascinated the boys. His firm but fair discipline and warmth of heart seem to have won their respect and love.

The two boys were enrolled on scholarships through the help of their uncle, James Stoddard, principal of the academy, who knew that the widow Kent would have no other means of providing for their education. Unfortunately, their close connection with the school's power structure was known to the other boys. This, coupled with the fact that Rockwell and Douglas had first appeared at school dressed in matching sailor suits, led to a period of harassment that ended only after Rockwell thrashed a much larger boy in a fistfight.

Kent was an undersized youth, wiry and bursting with vigor. He was graceful and quick, and this, combined with a fierce competitiveness and an already strong will, allowed him to contend successfully with older, larger schoolmates in the sports he loved: football, hockey and, especially, baseball. These same traits led him into those schoolyard battles which, win or lose, increase one's standing among the boys.

Rockwell's stubbornness also led to conflicts with teachers. Though an adequate student, he did not see any value in learning Latin, and therefore decided that he would not. The teacher, having another opinion, forced Kent to spend every evening in his presence with the Latin book open to the day's lesson. Night after night went by with the teacher and student locked in a test of wills. "It got to be like a sporting event, a kind of marathon. Who'd last the longest." The teacher, finally deciding that the victory would not be worth the cost of his evenings, gave up the struggle.

Aunt Jo was a talented artist who had studied in New York and Paris.

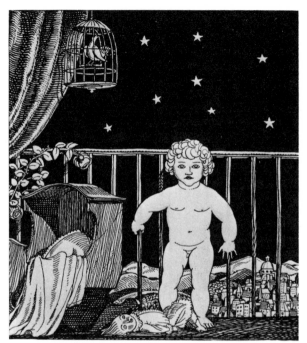

THE SEVEN AGES OF MAN—THE INFANT
(PEN AND INDIA INK ON RAG BOARD)

She decided to return to Europe during the summer of 1895 to pursue her studies. In spite of their clashes, she and Rockwell had developed an affectionate relationship, and, perhaps recognizing some early signs of his own talent, she decided to take the thirteen-year-old boy with her.

After a stop in England to visit relatives, they went directly to Dresden where Aunt Jo was to study the painting of Watteau scenes and figures on china. Rockwell, still remembering the German his nurse had taught him, was left free to roam the lovely old city's streets. While he was charmed by the contrasts between this center of European culture and the rawer civilization he came from, his most vivid experience took place when, rushing unexpectedly into the courtyard of his *pension*, he surprised three little streetgirls "one of whom had at that instant pulled her dress far above her waist. The impact of her lovely nakedness . . . sent me rushing past them in a state of wild confusion and furious desire. Upstairs and all alone, I realized for the first time one thing at least, that life was all about. If for no other memory, Dresden will be forever dear to me." It was his introduction to the differences between the sexes, differences kept hidden by a Victorian upbringing.

From Dresden, Aunt Jo and her charge traveled to Holland, where she studied flower painting with the watercolorist Margareta Roosenbloom.

Then, after another stop in England, they returned home, and Rockwell, reluctantly, went off to his second year at Cheshire.

Though Kent admired and respected Colonel Woodbury, and no doubt found in him some traces of a father figure, he did not enjoy these years away from home. His time at the Episcopal Academy was filled with rough-and-tumble, games, drill and some learning, but the lack of personal affection and close contact between the faculty and students caused him to regard this experience as "tantamount to seasonal orphanage." In 1896, to Rockwell's great relief, the family decided he had been in military school long enough. He was allowed to live at home while he commuted to New York City where, with financial help from Aunt Josie, he attended Horace Mann School.

Coming from the strict and completely masculine environment of military school, Kent had some difficulty adapting to the modern principles and coeducational realities of Horace Mann. He became marked as a discipline problem, and leader of the school's rowdies. The target of his pranks were quite often his female classmates. "I became a woman hater." Though his natural talent, supplemented by his charm, allowed him to make scholastic progress, his relations with the school principal were not of the best, a situation that was to have uncomfortable repercussions for Kent.

The school, following the teachings of Horace Mann, believed that the manual arts were necessary to learning. It was this part of his formal education that held the most appeal for Kent, and it had the most lasting effect. Metal casting and woodworking were exercises that "enlarged the horizon of my life, opening channels of activity that were subsequently to lead me . . . into the ranks of labor, and . . . to that *respect* for craftsmanship which . . . I hold to be fundamental to the practice of all art." He also found great value in the mechanical-drawing classes, which trained both his hand and his eye in the realistic rendering of everyday objects.

His art training had really begun long before. "From as early as I can remember, I drew pictures." Encouraged in his work by his artist aunt, he was also given strong support by his mother. At military school he had made bookmarks, letterheads and fancy designs for other students, but his first "professional" work was the drawing of coats of arms for the more pretentious citizens of Tarrytown. As the financial strains on the family grew tighter, every possible source of income had to be tried. Mrs. Kent gave cooking lessons to the town's bachelors, took in sewing, and sold baked goods and crocheted items through the Tarrytown Woman's Exchange. Aunt Jo designed placemats and menus, and occasionally sold a painting. After her return from Europe she bought a charcoal kiln, and began to produce Dres-

den-style china. Rockwell assisted her, but he avoided the Watteau scenes; instead, he produced china with paintings of Dutch windmills and little English cottages done in delft blue. The work, of professional quality, proved popular.

The household seems to have been happy, though cramped. In addition to Sara's mother and her sister, the three children and the church organist, who had been taken in as a boarder, Sara's father had joined them in his frail, old age. The family played music, sang together and in the evenings Sara would read the Victorian favorites, Scott and Dickens, aloud to them. She had a good reading voice, clear, modulated, and with precise enunciation. She drilled the children constantly to ensure that they spoke with the same clipped precision. It was a lesson that Rockwell learned well.

Sara Kent had great expectations for her children, and seems to have had particularly rigorous standards for Rockwell. She supported his attempts to master new skills, she bolstered his sense of self-confidence and she pushed him to try his hardest, to do his best.

Punctuality was another Victorian virtue practiced in the Kent family. "Neither before time, nor after time, but *on* time" was the byword. Every morning the children had to meet various schedules. If they weren't out of bed with the first call, Mrs. Kent would grab them by an ear and pull them onto the floor. This became known as the "Death of William the Conquerer," after a well-known painting of the time. The technique worked. The children were never late for anything, a habit Kent followed all his life.

Though not a devoutly religious woman, Sara had the family attend Episcopal services at Christ Church every Sunday. The children went to Sunday School, then joined the adults for the full service. Young Rockwell took religion far more seriously than the other members of his family, and at one of the morning services he was overwhelmed by a feeling of religious ecstasy. "The organ and the voices of the boy and girl choir, the hymns they sang, the beauty of the stained-glass windows . . . and the heavenly beauty of one girl singer" combined with his deep faith to sweep him up in a wave of emotion that left him weeping uncontrollably.

Loneliness had not disappeared as the boy grew into the man. He was still small, weighing only 101 pounds at fourteen, but his health and energy continued, as did his love of sports. But close comradeship with boys his own age eluded him. The village boys were to be associated with as little as possible. "My mother shared in the prevailing views of her associates and of her class: that working people—those whose lot it was to do the hardest or most menial work—were of a different and lower order of mankind." Aunt Jo, sharing these aristocratic pretensions, turned away one suitor because he was

a dentist, and therefore a social inferior. These views, common in Victorian America, became ever more important to the family in their economic decline. If nothing else, they had their social position. Raised with these values from infancy, Kent shared in this snobbery. He could not recall, in all his school years, having ever had a playmate to his house or having gone to anyone else's.

It was natural that a young gentleman in such a situation should continue to find in books the companionship he needed. He read both German and English adventure stories, stories in which "the heroes were invariably youths or men of incorruptible virtue and dauntless courage." The Victorian ideals urged on him by his elders now took on fleshly form. Good and Evil were easily defined, and a good youth followed the line of virtue as simply and straightforwardly as a hero in a novel by George Alfred Henty or Horatio Alger.

As the time for his high-school graduation approached, the family discussed what professional career Rockwell should pursue. Since both Mrs. Kent and Aunt Jo recognized the young man's talent, they felt that his life's work should be in a field offering his skills free play; but the family's financial situation required that he enter a profession that would provide the means for a gentleman's way of life. Architecture, it was decided, offered the perfect blend of art and income. He would study at Columbia, which meant he could still live at home.

In June of 1900 Kent's class graduated from Horace Mann. He did not; the blow was due to his failure to pass French. Since graduates of the school were eligible to enter Columbia without examination, this was a setback to his plans. The inconvenience grew into a real barrier when the principal, no doubt because of Kent's rambunctiousness, refused even to recommend him for the exams. Kent was forced to attend a special tutoring school which then made the recommendation. When he did take the exams he passed easily, and in the fall of 1900 he began the study of architecture at Columbia.

Kent had never been a scholar. Restless, energetic, and without direction, he had usually gotten by because of his high intelligence and "Peck's bad boy" charm. At Columbia, for the first time, he saw purpose in his studies. Mathematics, archaeology, history of architecture, English—all were classes he enjoyed and at which he excelled. Architectural drafting was a particular favorite. Kent's naturally sharp competitive drive was honed by financial need; at the end of his first year he had won a Benefactor Scholarship, and in 1902 he was appointed a Vanderbilt Scholar. Both awards were given for achievement, which he had to maintain if they were to be renewed.

While his level of work was high, so were his spirits. This offended a

certain Professor Hamlin. "May I also add . . . the wish that in your work next term you will strive to repress your somewhat exuberant . . . tendency to vivacity and frolic . . . I am sure not a little success of our graduates, and of the school's reputation, is due to the constant cultivation of dignified and gentlemanly manners and the recognition that its courses are a preparation for the serious battle of life."

This battle was taken very seriously indeed at the school of architecture. The students, housed at the top of the Havemeyer Building, were kept at their work from nine in the morning until late afternoon. In spite of this rigorous schedule, the irrepressible Kent did find time for social activities: joining the Hackley Dramatic Club; serving on the staff of both the class annual and a humor magazine, *The Jester*; and becoming a member of a fraternity, Phi Delta Gamma. During the fraternity initiation one of the brothers extinguished a cigar on Kent's shoulder, leaving him with a scar he carried all his life. Through these activities he met students from disciplines other than architecture, some of whom became lifelong friends.

Kent had spent the summers of his sixteenth and seventeenth years working, for three dollars a week, as a messenger in a Tarrytown bank. The family's cottage at Shinnecock was usually rented out due to their lack of money, but in 1900 Mrs. Kent decided that they could afford a summer at the shore. To further his painting skills, Rockwell was enrolled in the summer art program established there by the painter and teacher William Merritt Chase.

Chase had studied in Munich in his youth, then returned home to take part in the revolt against the stodginess and conservatism of the National Academy of Design. He had helped found the Society of American Artists, which in its early years provided a forum for the display of younger artists' work. A Realist, he believed that the "truth" of art was found by honestly and skillfully painting what one saw. The *aim* of art was to raise the artist to levels of income and recognition that would otherwise be denied to him.

"Look at me," he would tell his classes. "Beginning as a shoe clerk trying on ladies' shoes, I have come to be the guest of kings." Pompous and eccentric of dress (batwing collar, spats, gold-edged pince-nez, and a fresh white gardenia always in his lapel), he was also a concerned and able teacher who attempted to get his students to look closely at the world around them. "Your foreground is weak and nonexistent; it isn't solid earth and grass that you could walk upon." As a Realist he was impatient with those students who tried to paint in a nonrepresentational manner. Once, when presented with a series of canvases lacking discernible subject matter, he asked the student why she had done them. "Oh, but I felt that way, Mr. Chase." "Madam," said Chase, "the next time you feel that way, DON'T PAINT." His tutelage

was of great assistance to Kent. "And his criticisms, rarely if ever in terms of art but, rather, of nature itself, were of direct help toward my achieving in my pictures the actuality at which I aimed."

While at Shinnecock, Kent was also given an object lesson in Victorian social mores. One of the students enrolled in the art school was a vivacious young grass widow whose high spirits enlivened the hours the students spent outside of class. She was extremely popular, until she made sexual advances toward one of them. The members of the class, with the exception of Kent, cut her out of their activities, refusing to have anything more to do with her. It is unclear why Kent, trained in these same mores, and at the time rigidly following them, was more tolerant, but his strong independence of mind must have contributed to his stand. He was never one to fear the crowd's condemnation.

As Kent's awareness of the world grew, so did his appreciation of its beauty. "The Hudson River and the hills and Palisades beyond, all bathed in early morning light; the city as its ships, towers, domes, theaters and temples lay all bright and glistening in the smokeless air. . . . Truly, I loved this world of ours. I wanted to arrest its transient moods, to hold them, capture them. And to that end, and that alone, I painted." He studied for three summers at Shinnecock, concentrating on landscapes. Chase recognized his student's great talent; Rockwell was awarded the class prize in his second summer, 1901, for a painting of a Long Island graveyard, and during the third summer he won a scholarship to study that fall at the New York School of Art, popularly known as the Chase School.

Architecture had become an increasingly stale compromise. As his talent developed, and attracted the favorable attention of his teacher and fellow students, he began to believe that a career as an artist might be possible. It was during his junior year, while attending the annual exhibition of the Pennsylvania Academy of the Fine Arts, that he made his decision. As he toured the hall he closely examined the paintings, comparing his work and talent with that on display. "Hell," he thought, "I can paint better pictures than these. If these people are artists then so am I." The next day he went to Professor Ware, head of the school of architecture, and asked to be allowed to drop most of his course work so that he could take advantage of the scholarship to the New York School of Art. Professor Ware was understanding, gave his approval, and recommended Kent use whatever the architecture school had to offer that would be of assistance in his painting. Kent immediately put his art scholarship into effect, and enrolled in the night class taught by the charismatic and talented Robert Henri.

APPRENTICESHIP

Art is draughtmanship.
—WILLIAM MERRITT CHASE

It is not the subject but what you feel about it that counts.
—ROBERT HENRI

No man may be termed "intelligent" who is not a revolutionist.
—RUFUS WEEKS

Art in turn-of-the-century America was dominated by the National Academy of Design. Founded in 1826 as both a school and a sponsor of exhibitions, by the late nineteenth century it had come to represent that which was old and safe in American art. The "Academic" attitude was, as William Innes Homer and Violet Organ point out, "more of an approach than a style," but through its control of exhibitions the Academy had the means to deny exposure to younger painters who disagreed with that approach.

Kenyon Cox, a dedicated Academician, gave a clear statement of what the Academy felt it stood for: "The Classic Spirit is the disinterested search for perfection; it is, above all, the love of permanence and of continuity. It asks of a work of art . . . that it shall be fine and noble. . . . It strives for the essential rather than the accidental, the eternal rather than the momentary— loves impersonality more than personality, and feels more power in the orderly succession of the hours and seasons than in the violence of earthquake or of storm. It loves to steep itself in tradition."

Because Academic art with its noble ideals, its imitation of English styles, its emphasis on technique and its "storytelling" canvases was commercially successful, a tightly closed structure had been erected in order to promulgate the philosophy, and to protect the market. The primary threat to this concentration of power came from a tall, lean painter and teacher named Robert Henri.

Born in 1865 to a professional gambler and an attractive, refined mother, Robert Henry Cozad spent most of his youth on the American frontier. John Cozad, his father, had founded a town in the Nebraska Territory on land that had previously been used for cattle ranching. Robert grew up sharing the rough, free life of cowboys, and riding with Indians as they traveled the wilderness of the Great Plains.

This wild and woolly life was brought to a sudden end through a classic frontier tragedy. Cattlemen resented the increasing numbers of settlers who were fencing off the range. John Cozad, leader of the newcomers, became a focus for their hostility. In 1882 he was attacked by a knife-wielding cowboy on the town's main street; reacting quickly, he drew his gun and shot the man. As a crowd formed, Cozad fled, later to be joined by his family. The man died, and though legal action was not taken against Cozad, it was decided that the family's name should be changed in order to be free of any trace of scandal that might follow them. John Cozad became Richard H. Lee; the older son, also named John, became Frank L. Southrn (sic); and Robert Henry Cozad became Robert Henri. The family moved to Atlantic City where Cozad/Lee became a successful real-estate speculator and hotel owner. Robert Henri stayed there for several years before deciding on a career in art.

The leading art school of the time was the Pennsylvania Academy of the Fine Arts, located in Philadelphia. In 1886 Robert Henri enrolled there as a student under Thomas Anshutz. Thomas Eakins had just been purged from the faculty for being too progressive a teacher, but his influence, felt in the school for several more years, had a strong effect on Henri. Eakins and Anshutz both stressed painting from live models and believed in studying anatomy in order to better understand the construction of the human body; both had rejected the Academic approach as sterile and too involved with surface technique; and, most importantly for Henri, they both believed in American art based not on European fashions but on the depiction of American scenes and American subjects.

While Anshutz and Eakins helped Henri recognize the need for an American art, the intellectual basis for his ideas came to him through the American transcendentalists, particularly Ralph Waldo Emerson, and Walt Whitman. Studying their lives and writings, he developed his conception of the American artist—one who discovers beauty in the American scene, interprets that beauty from an American point of view, then communicates that interpretation through a technique developed from American roots. No longer should native painters try to impose a European viewpoint on their work. Henri, like Emerson and Whitman, rejected the idea that since America was a younger land it necessarily lacked greatness. "It is a very interesting idea to

me that we are as old as any European people, that we are, in fact, the same people vastly strengthened by the fact that made us pioneers in successive generations."

Henri had a philosophy, he had a developed talent as a painter and in 1902 he gained a forum from which to promulgate his views. While at the New York School of Art, and later at his own school, Henri inspired a generation of American artists. George Bellows, Carl Sprinchorn, Glenn O. Coleman, Edward Hopper, Guy Pene du Bois, Julius Golz, Walter Pach, Randall Davey and many others studied with him and benefited from his influence. While in Philadelphia he had worked with George B. Luks, James Preston, William Glackens, Everett Shinn and John Sloan. This circle of friends followed him to New York.

Henri's classes reflected his personality: informal, lively and, at times, intense. He would stroll slowly around the room, stopping when struck by a student's problem. A pupil later recalled: "Sometimes he would just dribble along and then, suddenly, Henri would hit upon an idea and golden moments would follow." The subject of the talk could be a question of technique: "Work with great speed. Have your energies alert, up and active. Finish as quickly as you can; in one minute if you can. . . ." It could also be about philosophical questions with the well-read Henri making references to the best of American and European writers. "When Henri spoke of writers . . . what he did was to inspire . . . the listener to go out, to look up all this stuff and to get involved with it."

The classes also had their lighter moments. New students were subject to hazing and practical jokes. Henri's emphasis on masculine vigor ("Be a man first, be an artist later") was a reflection of Teddy Roosevelt's America and his own frontier background. His students organized a team and played brawling games of baseball with representatives of the much larger National Academy of Design and the Art Students League. Helped by the gifted athlete George Bellows, the Henri people were able to boast of having never lost a game.

Kent's decision to cut back on his architectural studies and enter Henri's night class was presented as a *fait accompli* to his mother and aunt. They protested vehemently that he was destined for a life of poverty, but were unable to sway him. Attending the night class during the spring of 1902, he also took humanities courses at Columbia. That fall he resumed his attempt to straddle two worlds, but within a few months he recognized that the university had nothing more to offer him. Giving up the formal study of architecture, he enrolled full-time as a day student, still on scholarship, at the New York School of Art.

If Kent's family had realized the full extent of his change of life they would have raised even stronger objections. Henri was not just a teacher of technique, he was to have a fundamental impact on the very manner in which the young gentleman viewed the world. Coming from, and still living in, an upper-middle-class home, Kent had been protected from the rougher edges of American society. Henri's emphasis on the reality of the slum and working-class sections of the city opened up to Rockwell new worlds of experience. As one of Henri's biographers wrote: "Henri's point of view, which advocated all life as subject matter for art, brought in its wake the belief that the poor were nearer the realities of life and so more appropriate subjects for art. Life seemed to the Henri student to flow stronger and fuller in Bowery bars and riverfront alleys than in the Knickerbocker Hotel or in the fashionable streets of the Upper East Side. . . . "

Kent's fellow students in class "were men and women who, almost without exception, either worked and earned their livings elsewhere or . . . pursued other studies during the day." Both in the classroom and in the street, Kent was being exposed to a reality he had not known. He found the experience deeply disturbing, but he did not find it artistically inspiring.

The portraits and figure paintings of Robert Henri are generally accepted as being his most representative work, but during the first years of this century he painted a large number of landscapes and cityscapes that "exerted a strong influence on the course of American art." They certainly exerted an influence on Kent, for Henri, with the help of William Merritt Chase and the great naturalist-painter Abbott Thayer, led Kent to the appreciation of nature and the land that underlies all of his early work.

Henri had been introduced to the American landscape through the frontier. "At an early age he was thrust into contact with vast expanses of raw, unspoiled nature; to escape it on the frontier was impossible. This experience undoubtedly helped him to conceive of nature as an insistent vital force which man should seek to embrace for his own betterment." As Henri himself put it: "I find nature 'as is' a very wonderful romance, and no man-made concoctions have ever beaten it either in romance or sweetness." Henri helped Kent, and numerous others, turn their attention to the dramatic beauty of their native land, and to see in that beauty the material for great art.

Though Kent later denied it, his painting was also influenced by Henri's "simple palette," an attempt to eliminate all bright colors from the canvas. "Bright red, bright yellows, all the blues were, if not outlawed, strongly in disfavor." As Kent remembered it, "some of us—holding pigment at its brightest to offer but a poor approach to light—opposed it." If one looks, however, at his early paintings like *Dublin Pond* or *Winter (Berkshire)* it can

be seen that they show the same somber, dark hues used by Henri and other contemporary Realists.

Another important influence was introduced to Kent in 1903. Aunt Jo had studied with Abbott H. Thayer, and through her help Kent was accepted that summer as an apprentice by this eccentric and domineering master.

Abbott Thayer is today best known for his theories of animal coloration and his paintings of beautiful, serene female angels bearing such titles as *The Virgin* and *Caritas*. Friend of William James and other New England intellectuals, he and his family combined a love of learning with a deep interest in the out-of-doors. They had, when Kent first met them, recently moved to Dublin, New Hampshire, near Mount Monadnock, where they lived year-round in a ramshackle cabin that had once served as their summer place.

Kent was taken on to assist in a peculiar technique that Thayer occasionally used. When one of the painter's canvases had reached a satisfactory level, he would stop and have it copied so as not to lose, through an inadvertent brushstroke, anything worthwhile. He would then work on the copy until it had been advanced to a higher stage, have it copied onto the original, then return to that. A laborious method, but Thayer was a cautious man who demanded precision in his work. As he explained to Kent: "It was like keeping one foot always planted firmly as one climbs a dangerous cliff."

Since Thayer did not always use this method, it happened that Kent was not immediately needed after his arrival in Dublin. Instead Thayer told the young artist to go off, paint, and show what he could do. Kent set up his easel in a nearby pasture offering a clear view of Mount Monadnock. "In painting it I tried . . . by all the means that mere pigment afforded . . . to re-create the mountain in its majesty, the forest in its penetrable depths, the foreground as a portion of solid earth, the sky in its infinitude; and, above all, the sunlight of that day." Remembering an artistic dictum—distance softens edges—he carefully blurred the skyline of the mountain.

Thayer praised the picture. "But," he asked, "what have you done to the skyline?"

Kent told him that he had blurred it. "You know; to make it stay back there."

"Look at that mountain edge," Thayer replied. "Don't you see those tiny spruces up against the sky? . . . So small that on your picture their height wouldn't equal the thickness of a pin? So sharp? Well, then, why don't you paint them that way?"

The effect of this lesson on Kent was immediate and long-lasting. "And at those words, dogma, all dogma as to what one should or should not do in art, fell as a veil from before my eyes. From henceforth [I would] see as a

human being . . . and as a human being . . . not an artist, paint."

Thayer decided that the young man was too good a painter to waste his time copying, and encouraged him instead to do his own work. The artist-naturalist did have Kent help on the plates for *Concealing Coloration in the Animal Kingdom,* the classic work on natural camouflage that he and his son Gerald were compiling. Mrs. Thayer wrote to Rockwell's mother:

"Mr. Thayer says that Rockwell has a big gift and will surely be a prominent artist. He is most valuable help too. I don't know how many times Mr. Thayer has showed me Rockwell's painting of a snake's head, saying 'Isn't that a *most marvelous* piece of painting!' or 'Isn't that a most *beautiful* work!' "

Kent became very close to Gerald Thayer. Together, Rockwell lugging paints and canvas, they tramped the woods and climbed the slopes of Mount Monadnock. Poet as well as artist and mountain climber, Gerald described in his poems the outdoor life led by the two young men. They appreciated most

> all the particulars and loved details
> of savage fitness and simplicity

In a companion piece he describes how,

> Leaving easy life behind,
> We turned the winter kind
> To us who faced its cruelty like men . . .
> Let the swift years come and go,
> For we who've trod the snow
> On old Monadnock, know the best of life!

Men in early twentieth-century America were obsessed with the need to display Vigor and Manliness. Teddy Roosevelt's idea of the Strenuous Life serves as an example, as does the success of Jack London's *The Call of the Wild,* published in 1903 and an immediate and long-lasting best seller. This enthusiasm for physical action and Nature-in-the-Raw was both a product of the frontier and a result of its closing and, in part, a reaction to the Genteel Tradition which, it was feared, had sapped Anglo-Saxon vitality.

The wilds and sports provided the most convenient arenas for display of this vigor, and, of course, war was also a splendid theater. Kent, as an active and healthy Anglo-Saxon youth, had breathed this exciting air from childhood. Military school had reinforced it, as had reading the adventure novels of George Alfred Henty and H. Rider Haggard. He was to keep throughout his life an interest in nature as a proving ground, but it is through Thayer, as well as Henri, that a deeper element was added, for Abbott Thayer's love of nature came not out of a need to conquer, but from the promptings of the

New England transcendentalists, particularly Emerson and Thoreau. Thayer helped draw Kent into a sensitive reading of their works, and he also introduced him to other writers, like Prince Kropotkin, the Russian naturalist and philosopher. It was here at Dublin that Kent first heard German lieder sung, and he fell particularly in love with those of Robert Franz. It was also through the Thayers that Kent first read the Icelandic sagas, one of which, the masterpiece *Burnt Nyal,* turned his interest to the far north, an interest which was to lead him to Newfoundland, Alaska and ultimately, Greenland. So, though living conditions at Dublin were Spartan, the intellectual climate was Athenian. Kent would visit and be influenced by this odd, drafty household for years.

It is likely that Kent had done more than his share in the harassing of students new to Henri's class, but it was at Dublin, and with the aid of Gerald Thayer, that he pulled off the first of the elaborate practical jokes with which he was to plague friend, foe and innocent bystander alike for the next sixty-five years. One summer night, while the two youths were camping, Gerald boasted that he had perfected a bloodcurdling scream that sounded like all the goblins of hell were on the hunt. Kent insisted on hearing it. "That cry was everything that he said it was: the scream of human agony, the shriek of fear, the werewolf's howl, a monstrous feline's passion cry, it rose, subsided, rose again, filling the darkness, echoing from the mountainside . . . hardly had the echoes died than cottage doors flew open, voices shouted, brave men gathered for the hunt." Kent and young Thayer hid in the upper branches of a spruce tree while the men, firing random shotgun blasts into the bushes, searched the woods for the source of the mysterious scream.

The summer residents were sure there was a wildcat in the area, a threat to life and property. Traps were set in the woods and search parties crisscrossed the region. The two young men spent the next few weeks roaming the forest, springing the traps, giving the "monstrous feline's passion cry" and howling with laughter at the antics of the hunters.

On this first visit to New Hampshire, Kent turned his energy to more than just tramping the woods and bedeviling the citizenry. Working long and hard on several canvases, he produced two which seemed particularly worthy to him, worthy enough to be submitted for consideration to that winter's show at the National Academy. To his surprise they were accepted and, even more of an honor, were hung "on the line" at the exhibition. Within a few days, *Dublin Pond* had been sold to Smith College and *Monadnock* to Charles Ewing, brother of one of Rockwell's friends. The young painter was now a professional.

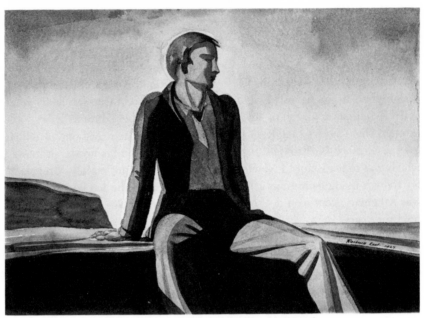

MAN SEATED (WATERCOLOR ON PAPER)

When Kent enrolled full-time at the New York School of Art, in addition to Henri's morning class he attended Kenneth Hayes Miller's afternoon class. Miller, born in 1876, had studied under Kenyon Cox and William Merritt Chase. Though not as academic as his two mentors, Miller did place an emphasis on technique that Kent found a needed corrective to the more intuitive approach of Henri. A man of learning, Miller combined mysticism with intellect in a manner that both fascinated and amused Kent. "As Chase had taught us to use our eyes and Henri to enlist our hearts, now Miller called on us to use our heads." Through their common love of baseball, and Kent's personal respect for the serious-minded Miller, they became good friends.

Aunt Josie Banker died in February of 1903. After a long, bitter court battle with other heirs, a portion of the estate went to Mrs. Kent. One of the first decisions she made after receiving the money was to build a new and more pleasant house. Charles Ewing, who had purchased *Monadnock*, was an architect working for a large New York firm. On the basis of Mrs. Kent's commission, he and another young architect, George Chappell, set up their own office. This firm, Ewing and Chappell, was to provide intermittent employment to Rockwell during the next ten years. All of his previous knowledge of architecture had been completely theoretical; now, working as a

draftsman, he began to learn some of the practical aspects of design.

Mrs. Kent also used her new wealth to buy luxuries for the family. For her sons she bought what Rockwell had long wanted, a horse. Kitty was a well-trained but spirited saddle horse that had been raised in the rural quiet of upstate New York. Their first ride was along the Albany Post road, where they had a stimulating encounter with a beast rare at the time: a stinking, chugging horseless carriage. Kitty, in a panic, bolted and almost threw Rockwell. Even after the Maxwell-Biscoe Automobile Company established a factory in Tarrytown and used the local roads for testing, the sight of one of the snuffling monsters was enough to send Kitty into a frenzy. The blond, wiry youth loved this dramatic display and used it both to impress the neighborhood girls and, elaborating on the dangers, to scare his younger brother off. The horse became Rockwell's alone.

Finally, during these years, close friendships developed. Not just at the Thayers or through art school, but also nearer home, in Tarrytown. It was through playing sports that Kent met Blaine Ewing. They quickly became friends, working on art projects together, and sharing each other's family life. Other friendships blossomed so fully that Rockwell became part of a social set that sang and rode together, and put on amateur theatricals. Kent had a natural talent for acting which he developed through these productions. He would often put his skills to use outside the theater, dressing in costume, changing his voice, using a putty nose and makeup, then appearing at a friend's house as a tramp or an arrogant servant. The fact that he was able to fool so completely these people who knew him bode ill for those strangers he would later desire to hoodwink.

He should have been content. He had close companions now, and a horse he loved; he was not only painting but, most unusual for an American artist of the time, actually selling his works. Still, he was not satisfied. In early 1904, Kent entered into a severe crisis of conscience and identity that would not be fully resolved for years.

Henri had shown him a different and far grittier world than he had known before. True poverty, the lot of the working class, the degraded living conditions of the urban poor, contrasted sharply with the luxury he had intermittently viewed at his great-aunt's estate or the reduced circumstances of his own home. He began to examine all facets of the beliefs by which he had been raised.

As a boy Kent had read widely in the works of the English Romantics. Now, with his increased sensitivity, he began to find new depths in their words; not just beauty, but philosophy, hints of a new code of conduct. They echoed his concerns, the love he was feeling for all living things. Words-

worth's dictum that one should never take pleasure in the sorrow of small or dumb creatures struck deep, and moved him to take a further step away from his family: in spite of their hostility he decided to become a vegetarian.

Even more hostile was their reaction to his acceptance of the controversial theories of Charles Darwin. Kent had passed through his formal education without having heard of Darwin or the theory of evolution, but when he did discover and read *On the Origin of Species* it profoundly shook his faith. His new views offended the religious respectability of his family; at Christmas a stuffed monkey was placed on the tree and labeled "Rockwell's Cousin."

Robert Henri was known for his grasp of Western literature and his use of it during his classes. Though Kent at first felt out of his depth, he listened carefully. One day Tolstoy's *What Is Art?* was mentioned. Kent obtained the book, casually glanced through it and laid it aside. Time passed and Kent looked at it again. "And suddenly it was as though my whole being had achieved the power of utterance, as though a God within me spoke, resolving the chaos that was me—my mind, my heart, my conscience—into an integrated man, aware and 'purposeful." It had never been his practice to mark books, but he did mark a passage of Tolstoy's:

"The destiny of art in our times consists of this: To translate from the region of reason to the region of feeling the truth that the well-being of people consists of their union, and to substitute for the kingdom of force, the kingdom of heaven, that is, love, which presents itself to us all as the highest aim of life."

At this crucial point in his life Kent had the good fortune to renew his acquaintanceship with an old family friend and fellow resident of Tarrytown who would resolve many of the questions that were tormenting him.

Rufus Weeks, born in 1846, was an actuary and vice-president of the New York Life Insurance Company. He was also a Socialist who, along with many other members of that party, believed that socialism was the logical working out of Christian precepts and ethics. Kent had first met him through the "sociables" Weeks hosted. These parties were open to everyone, for it was Weeks's hope that all the different economic classes would mingle in good fellowship. Weeks later abandoned these get-togethers because, as he explained to Kent, "they served only to lend a false and misleading facade to the ugly reality of the class struggle, a struggle that was only to be resolved by the action of the working class itself."

Weeks was a "millionaire socialist" who used his money not only to fund social evenings but also to support radical magazines like the *Masses*. He also contributed articles to such journals, but as the radical cartoonist Art

Young recalled, they "were inclined to be too leisurely philosophical to be appropriate in a periodical designed to appeal to the working class." The philosophy reflected in those articles, and no doubt passed on to young Kent, can be seen in an address Weeks gave to the meeting that celebrated the twenty-fifth anniversary of the Actuarial Society of America.

Titled "A Backward Glance over a Stage of the Zeitgeist's Journey," the speech brimmed with optimism and confidence in human progress. It began by claiming that one era in the history of the human spirit had closed. "I hear the tolling of funeral bells . . . for Authority is dead . . . Authority is no more." A new king was now enthroned, "and his name is 'The Intrinsic.' We of today do not accept what the fathers said, nor any deliverance coming from this or that high place; we accept only that of which we can be shown the intrinsic merit." The human spirit "has come forth into the open air. . . . The Gothic period is over." Instead, the human spirit had reached the state where it valued "equally real Science and sincere Poetry."

Mankind had also changed in terms of where it placed its loyalties. "But now all the fences seem breaking down: the sense of a common humanity is coming in like a flood and is submerging all the old dykes. . . . The normal partisan takes himself less seriously than formerly. . . . The world is turning latitudinarian." This broadening of view could be seen in the growth of religious tolerance and also in the growing political awareness of the common man. Part of the reason for this change was the "vast growth of the reading habit" which might cause the working class to come to life politically, "and if that happens, the present active political body may have to undergo some sharp growing pains."

Weeks believed that these changes should be viewed positively, in light of the fluidity of society, as explained by Darwin. "In these days, we no longer expect permanence. . . . Evolution has gone deep into the human consciousness. . . . Nothing we have is so good but that we look to see it supplanted by better; progress is the very breath of our thought." Weeks rejoiced at the sight of the new generation assuming control. "The world they are entering upon is a place where none can order them how they shall feel or think, where the totality is sympathetically felt in larger and ever larger units, and . . . it is a world felt not as a rigid framework, but as a flowing stream."

Naïve and hopeful, trusting in the power of education and goodwill, this speech can serve as more than just a statement by Rufus W. Weeks; many of the early Socialists subscribed to similar views. It was delivered in 1914, just a few months before the start of a war that would make such optimistic rhetoric, such trusting belief in human progress, impossible to maintain.

However, in 1904, he was an invaluable friend to a questioning young

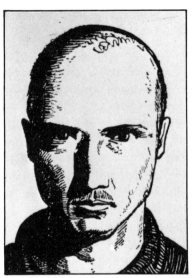

SELF-PORTRAIT
(PEN AND INDIA INK ON PAPER)

man. Kent could ask him why there was poverty, why there was so much suffering in the world, why there were so many undeservedly wealthy people. And Weeks, an honored neighbor and businessman, served as a strong ally against the Republicanism and bourgeois respectability of Kent's family. The frail old gentleman's influence on Kent was to last for years. In 1908 Rockwell wrote to his fiancée, "I love to talk with him . . . we went over lots of things . . . in fact everything of great worth that the human mind has to occupy itself with. . . . I love to talk where I do not need to argue and do not want to. One does not dispute what Mr. Weeks says. I at least just listen very humbly."

In the early fall of 1904, Weeks took Kent to the local Socialist party meeting. After the political discussion was over, Kent officially joined the party as a dues-paying member. That November, when the Republican party sent a carriage to his house to take him to the polls, he refused. "Tell them I'm walking down," he instructed the driver. "I'm voting Socialist." His first ballot was cast for the militant labor organizer Eugene V. Debs.

Henri had introduced Kent to the underside of America, the side that had been carefully hidden from the young gentleman's view. Tolstoy, the English Romantics, and Rufus Weeks showed him that action—individual and collective—could be taken to improve society. Though it would be several years before Kent became directly involved in political action, the groundwork for it was laid in New York and Tarrytown.

No matter how concerned Kent had become with social problems he still took intense pleasure in painting and in playing sports. In the fall of 1904 he returned to art school, where, through his energy, talent and strong personality, he had become a leader. When social life seemed to be lagging, Kent proposed that a student government be formed to spark activity. Soon three parties were in the field: the Simple Palette and Full Life, the Temperance and Prohibition, and Kent's own Free Graft and Strenuous Life. Their platforms were based on questions of equal rights for new students, the frequency of dances and proposals designed to continue the "base-ball nine" on its victorious course. Though the campaign had been started in fun, it soon gained an unpleasant personal edge when the factions began lining up behind their favorite instructors, turning it into a popularity contest. Harsh remarks were exchanged, and Kent was seen by some as bearing partial responsibility for the unpleasant atmosphere that had developed. After the election, which found Kent's people victorious, Henri approached him and expressed his displeasure at the outcome.

In spite of whatever brief irritation Henri felt with Kent, he did, a few months later, do him a great favor. After returning from a painting trip to an island off the coast of Maine, he told the young man "of such cliffs and pounding seas as made me long to go there." In June of 1905 Kent packed and was on his way.

MONHEGAN
AND FREEDOM

He is a hard-liver is Kent in the sense that one says "hard-drinker ..." but he is more to be envied than the latter, and yet I could not possibly do his way. A fine young heart.
—JOHN SLOAN

I discovered sex late, and spent the rest of my life making up for lost time.
—ROCKWELL KENT

Monhegan Island lies ten miles off the Maine coast and twenty miles from Boothbay Harbor, in 1905 its point of communication with the mainland. During the summer months the native population of fishermen and their families were swollen by an influx of painters drawn by the spectacular clash of rock and sea, and by tourists enjoying the fresh air. The village consisted of only twenty-five or thirty houses scattered randomly around the small harbor, and two large, ugly hotels that catered to the summer visitors.

Kent was almost twenty-three when he arrived that June, his first venture on his own. In spite of the premature thinning of his blond hair, a mien of naïveté combined with his size made him seem even younger than his age. Of moderate height, five feet nine inches, and slender, weighing only 145 pounds, he was of average appearance, with a rather large mouth and a niggardly chin; it was his eyes, brown and intense, that commanded attention.

With his usual verve he quickly set about exploring the island. Everywhere he turned he found stimulation. The battle of the rockbound coast with the long rolling Atlantic seized his imagination as nothing previously had; every day, whether the island was bathed in sunshine or draped in fog, he explored and painted. The still wild forest, the meadows, the stern headlands, the fish shacks, the village—all added to his rising fever. For weeks, sleepless with excitement, he lived at full pitch, all nerves extended. For the first time he realized what it meant to be completely alive and free.

Though the summer visitors and the fishermen saw each other as distinct groups, they did intermingle through that great American social catalyst—sports. Every afternoon, at four, all the male inhabitants of the island—fishermen, painters, tourists and loafers—would gather in an empty field to play baseball. As Kent got to know the locals a respect for them grew. Henri had introduced him to the working-class sections of New York; Rufus Weeks had provided theory to explain the conditions that class endured: on Monhegan the young gentleman began to feel not a sense of pity or concern, but envy.

"I envied their strength, their knowledge of their work, their skill in it; I envied them their knowledge of boats and their familiarity with that awesome portion of the infinite, the sea. I envied them their worker's human dignity." He had been trained for intellectual labor, labor that denied him the full use of his body. "God, how I envied them their power to row! To pull their heavy traps! I'd see my own thin wrists, my artist's hands. As though for the first time I saw my work in true perspective and felt its triviality." At the end of the summer, when the seasonal visitors left, Kent found a job and set to work.

Since most of the island men worked the sea, finding land jobs was easy—pick and shovel work, house painting, cottage repairs; he would occasionally substitute for the lighthouse keeper, and he would clean privies for ten dollars apiece. Fairly steady work was found as assistant to an epileptic well digger. That, on a mound of rock like Monhegan, was labor at its heaviest. Hour after hour, he and Hiram Cazallis would take turns holding the drill while the other swung the eight-pound sledge. Kent's body protested at first, blisters and sore muscles, but soon his hands became calloused and his wrists, arms and shoulders thickened.

The team of Cazallis and Kent was called on not only to dig wells, but also to blast graves. That winter they were required to provide a last resting place for an elderly island woman. The two men quickly drove their drill several feet into the frozen hillside, primed a stick of dynamite, shoved it in, lit it, then retired to a respectful distance.

Nothing happened.

After waiting a prudent length of time they tried again.

Still nothing.

A passerby ventured an opinion. "Your dynamite is froze."

The men trooped to a nearby house, put the charge in the oven to thaw, then sat and waited.

Kent, having had no firsthand experience with the powerful explosive, nervously eyed the stove. He knew that he was undergoing just as close a

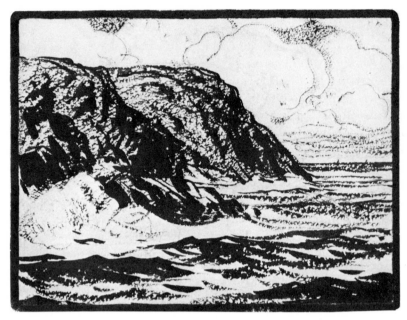

MONHEGAN HEADLAND (INDIA INK ON PAPER)

scrutiny from his companions. "Every move I made and word I spoke was studied for effect of calm."

He passed the test; the dynamite was thawed and safely exploded.

The toughening of his body was not the only benefit from his work: for the first time he was paying his own way in the world. The dollar a day he was earning provided room and board with a small bit left over. Independence from family help led in turn to a feeling of interdependence with the world. "I now felt myself to be no longer a mere spectator, but an integral part . . . like beasts and birds and fishes . . . and working men and women . . . an indigenous inhabitant by natural right. I *earned* my living. I belonged." Six months after first setting foot on Monhegan, he returned to Tarrytown with a hardened body and new self-confidence.

The young workman was enthusiastic about going home. It was a chance to show off his muscles, his hard-earned skills, his self-sufficiency and competence. The reality of the homecoming was disappointing; while he had worked and traveled, becoming a more worldly man, his family seemed to have stood still. He felt he had flown back into a cage. Nothing ever seemed to change, no one ever seemed to grow. The same books in the bookcases, the same old thoughts expressed in the same tired clichés used since he was a child. He felt an alien.

Many years later, a friend of Rockwell's visited Sara Ann's household:

I spent the weekend with Kent's family in Tarrytown. They must have money, for they have a very spacious house in a rather exclusive park up on the heights. There is a superb view of the Hudson. Rockwell's mother and sister live in this great big house.... Everything is handsomely appointed and they have everything that money can buy. They have no servants at present except a handyman, but at one time must have maintained a big ménage. Mrs. Kent is a nice quiet practical sensible old lady and an excellent cook; she has no intellectual interests whatever; for her life has been lived on the physical plane with an observance of the conventions.... It is this environment with its perfection of physical comfort; its preoccupation with the petty details of life, and its unswerving devotion to custom that Rockwell revolted against and broke away from long ago.

As Rockwell put it: "Altogether . . . what with a banker brother and a churchly little sister and a mother who approved of both . . . it was a static household to return to from my flights." The family was no less critical of the course his life was taking: college dropout, physical laborer, vegetarian and, as a Socialist, a hopeless dreamer.

Tensions were undoubtedly heightened by Kent's aggressive personality. It was not enough that he felt he held the correct views—whatever the subject—they had to be expressed, and not diplomatically. "Would you like more corpse?" the vegetarian would ask solicitously at the dinner table. "Pass the carrion to Dorothy," he would request. It was, perhaps, at one of these family dinners that Kent's mother, referring to his stingy-chinned profile, made the cruel observation that he looked like a duck about to quack.

Kent returned to work at Ewing and Chappell as an architectural draftsman, catching the 8:10 to New York and returning on the 5:05. Free time was spent visiting with friends, attending Socialist party meetings with Rufus Weeks or riding Kitty along country roads. He also volunteered his talents as "scenic artist" for an amateur play, *Picklock Holmes*, which was put on as a fund-raising event by the Amackassin Club. He was biding time, saving money, waiting to make the break.

In April 1906, Kent returned to Monhegan, but not just as a laborer. He became a man of property, buying a lot on Horn's Hill overlooking the village. For a while he resumed swinging an eight-pound sledge for Hiram Cazallis, but soon took the inevitable step for an able-bodied male on Monhegan; he became a lobsterman. Hiram's brother, George, took him on as a helper. The lobster fishing was done from a dory, and Kent, who picked up physical skills with uncanny quickness, soon became adept at the handling of small boats.

Meanwhile, he gathered construction materials. The former student of architecture knew what he wanted: a simple, small house with clean, traditional New England lines. He drew up his plans, contracted a local "wood butcher" to build it, then waited impatiently for the work to begin.

Impatience turned to anger as delays mounted. Finally, when the lobster season ended that summer, and the man had still not started, Kent called the deal off. He would build the house himself.

After the initial burst of anger he hesitated, unsure whether he had the necessary skills, but his strong sense of self-confidence quickly asserted itself. He was familiar with tools, having grown up using his father's woodworking equipment; building a house would just be a matter of using common sense. Kent hired an islander to help, and set to work. Since his funds were limited, wooden posts were used instead of a masonary foundation. From the ground up he learned the art of building. "The rough floor laid, up went the corner posts, the plates, the studs. Next came the sheathing; then the attic floor; the rafters and the roof boards. Then the chimney." Kent quickly shingled the roof, and, mail-ordering a four-lid kitchen range, soon had a home.

The building of his own house served not only as an apprenticeship, but also as advertising. People began to come to him with more carpentry and construction jobs, so many that he was required to hire help. He called on a black man he knew from Tarrytown to assist in the building of a small house that had to be finished quickly. The arrival of William Moody, the first black ever on Monhegan, caused a sensation, and his deep-voiced, cadenced prayers in church led to such warmth and acceptance that his visit was talked of for decades.

Again, when the summer visitors left, Kent stayed on. He had his own house now, skills by which to make a living and a warm circle of island friends. He also had his books, plus that most pleasant of companions, a cat. Contentment still eluded him, however. What he lacked was a fully developed code by which to live, a code to replace the one he had discarded in Tarrytown.

That fall of 1906 he set himself the task of formulating one. The books helped, of course. Works by Turgenev, Ernst Haeckel, Schopenhauer, Ruskin and Herbert Spencer were read, argued with and digested. He felt particularly close to Henry Thoreau, finding parallels in the simple, frugal ways of life they had both chosen, lives stripped to the essentials so as to have the freedom to create.

But it was mainly on Tolstoy and the Christian socialism of Rufus Weeks that Kent based his philosophy that year. Sitting close by his warm, coal-burning stove, he filled page after page with his tight architect's hand,

crossing out, rewriting, then crossing out again, trying for the right words, the clear phrases, that would express the simple and obvious path of virtue: Christ's teachings.

Most people tried to evade the real message He had left, tried to believe that His words and deeds were metaphors; Kent felt they should be taken literally. To follow those teachings one had to turn from the materialistic, class-bound life in which one had been raised "and instead one must lead a life of toil and poverty." Wealth led to cities, which were centers of immorality, and to class distinctions, which were sinful. It was no excuse to say one would use one's wealth to help the less fortunate. "Realize that every penny is the product of some man's labor and that this same man or class of men that does the work that brings you money is the class of men whose sufferings you are attempting to brighten."

Everyone should do his own hard or distasteful labor and then, with what strength was left, one should help others. "Helping them either by working for them, or by science or by art, as you may direct. . . . So Christianity calls for a life of toil with an aim not of riches but of happiness to others." A life of toil to provide for the necessities of life and also to be "made strong and well by toil in the earth and under the blue heavens, sleeping soundly and rising each day with the sun, and with this health and strength, pure sound minds and time for quiet thought as shall bear fruit in our acts and in every act showing the kindness of heart and love of God that must come to thoughtful men in the face of nature."

Kent worked hard that winter to live up to his code. Lobstering again, he would rise long before dawn, fix his spartan breakfast—sometimes having to break a sheet of ice on the water bucket—climb into his heavy oilskins and walk down to the dock, where he would load the dory with traps, lines and bait. As the sun rose, he and his partner would be rowing past Manana, the small island of rock that formed the harbor, setting traps. The rest of the day would be spent making circuits to collect the catch; then, in the evening, he would return to his small house and eat a simple dinner of oatmeal, rice or beans.

Even while working such a grueling schedule, Kent found time to paint, to "help" others through his talent. "The fact is that there on Monhegan Island, between and after days of work with maul and drill, with hammer and nails or at the oars, on days it blew too hard at sea, on Sundays, I was painting; painting with a fervor born . . . of my close contact with the sea and soil. . . ." Kent's superb energy, the energy that earned him the island nickname of "Jumpspark," enabled him to paint some magnificent canvases while laboring at tasks that would have exhausted most men.

The evenings he did not write or read or draw would be spent visiting friends. He would join a group gathered around the kitchen stove; men working on fishing equipment as their wives and daughters canned or cooked. They sang and laughed, talked and flirted. At one of these social evenings he met Janet, a girl whose vivacity and forthright spirit charmed him; a strong mutual attraction developed and they were soon thought of as a couple.

In the spring of 1907, Kent was offered a chance to exhibit his growing body of work. Aunt Jo had persuaded a leading New York art dealer to show the Monhegan pictures, so in March he returned to Tarrytown, bringing fourteen paintings with him. The show opened in the Clausen Galleries, on April 1, to critical acclaim. James Huneker, one of the country's leading art critics, wrote in the *New York Sun:*

> If you long for a thrill, go . . . and look at the new pictures . . . of Rockwell Kent . . . *Donnerwetter!* But he knocks you off your pins before you can sit down with these broad, realistic, powerful representations of weltering seas, men laboring in boats, rude rocky headlands and snowbound landscapes. . . . The paint is laid on by an athlete of the brush. Dissonances are dared that make you pull up your coat collar. Mr. Kent lives with the fishermen of this desperate coast, and he has evidently endured the rough weather, the bleak scenery, for the sake of catching their reality. . . . Those fishermen in their cockleshell crafts on a sea that is running like a millrace and tumbling like tornado clouds, those fellows out there under the lee of that harsh pile of rocks are rendered with a fidelity that tells of a big grip on essentials. But rough paint, crude paint, very rough paint! Kent could be seen in a ten-acre field without a spyglass.

The *New York American* ran a large headline announcing the show and began the review "At last we have another American painter." The reviewer went on to say of the paintings, "They have economy, precision, dignity and force." The show was heavily attended and the catalogue was sold out "in less than no time." George Bellows attended; struck with envy at Kent's skill, he promised himself that he too would go to Monhegan and paint even finer works. Another visitor was John Sloan, who was captivated by Kent's talent. He recorded his reactions in his diary:

"These pictures are of immense Rocks and Seas in fair weather and in winter. Splendid big thoughts. Some like big prayers to God. I enjoyed them to the utmost and accept them as great. I'd like to buy some of them."

Unfortunately, in spite of the large crowds, the enthusiastic critical reception and the interest of John Sloan, no one did buy a painting. At the

close of the two-week showing, Kent found himself famous, but a hundred dollars poorer. "And now I have the satisfaction of seeing my name frequently (I belong to a press bureau . . .) I am led to believe that I am one of the prominent and flourishing painters of my time . . . until . . . I recollect the unbroken collection of my works piled high in my studio. . . . Moral—'Don't believe all you read!' But I am very buoyant . . . and still at it."

Even though his "unbroken collection" contained works such as *Winter*, now at the Metropolitan Museum in New York, and *Toilers of the Sea*, it was to be years before he sold a picture. After spending another month with his family in Tarrytown, he returned to Monhegan, to labor that at least allowed him to pay for his beans and rice.

Soon after his return he was offered a contract to build large twin houses, the first on the island to have running water. Kent brought a drive for perfection to any task he attempted, but there was extra incentive to do good work on the Jenney brothers' houses. Some of the locals were angry over a newcomer gaining such a profitable job; they checked the workmanship with a critical eye. Kent would spend the evening thinking back over the day's work, looking for mistakes. At least once he found one. "At daylight I was on the job. I fixed it."

As the summer progressed, so did the relationship between Rockwell and young Janet. She was a tall girl, rather plain, but with a sweet, sensitive nature, and a lovely singing voice. Janet had an impulsively adventurous side, and would run down the steepest hillsides, laughing if she slipped and fell; but she was disciplined enough to have taught herself to play the organ. Kent would read his favorite authors to her, providing comfort when the beauty of the words or the exalted sentiments caused her to cry. He taught her his favorite German lieder, the love songs of Schubert and Robert Franz. They would also walk the island's forests, taking care not to step on any living thing.

She visited his little house daily, cooking his meals and cleaning for him. It was obvious to them both that he could make love to her if he wished; he held back. Such a prig was young Kent that he would ask the tellers of risqué stories to either desist or leave his presence; so strong had been his sense of Christian virtue while at Columbia that he would stop prostitutes on the streets, give them money, then urge them to leave their sinful ways and go home. Somehow, there had been one fall from grace, remembered as "a night of alternating sin and tears," but with Janet that was unthinkable.

Rockwell had many visitors that summer. His mother came, bringing with her the rest of the family. They all fell in love with the island. Gerald Thayer visited for a while, and convinced Kent that the two of them should

spend the winter in the farmhouse of the painter George de Forest Brush, near Dublin, New Hampshire.

Kent worked through the fall on the twin houses, then left for Tarrytown, where he spent the Christmas holidays. In early January of 1908, he saddled Kitty and rode for several days through difficult weather to Dublin.

The Brush family used their drafty old farmhouse only as a summer residence. The young men relied on the open fireplace and their work to keep themselves warm. Gerald wrote poetry while Kent painted; it was the first time in two years that he could paint without the need to work for a living. One of the canvases he started that winter was the well-known *Road Roller,* now in the Duncan Phillips Collection. The two artists were soon joined by another young man, George Palmer Putnam, a member of the publishing family, whom Kent had met on Monhegan and befriended. When not working they would ride horses, ski cross-country or pull practical jokes on each other.

Kent and Putnam had foxed the Monhegan natives the previous summer when Kent, tired of being asked how soon he was going to get married, announced that he was going to the mainland to pick up his bride. Kent returned to find the locals gathered on the pier, cheering and holding a banner of welcome for the loving couple. It was a while before they discovered the "bride" was a disguised George Putnam. Now, at Dublin, Kent attempted a joke that had an unexpected outcome. A cow had dropped dung in the woodshed. Kent took the dropping and baked it in a pie with apples and spices, then served it to George. As soon as he began to cut it, Putnam realized that the contents were not what they should have been; he stayed his hand. The still-undamaged pie was sent, properly wrapped as a gift, to George's brother Robert, who was regarded by the Dubliners as a pompous ass. Robert Putnam, an executive at G. P. Putnam's Sons, Publishers, in New York, called in a number of the staff to witness the pie being sliced and to share in the bounty. When the joke was discovered, it was regarded as an affront to the corporate dignity, and the family recalled George from the haunts of the barbarians. As Kent put it in a contemporary letter, "The mighty bulwarks of society are closed forever."

A more important event occurred in late January, when Abbott Thayer's niece, Kathleen Whiting, visited Dublin. The tall, lovely seventeen-year-old immediately became the focus of local bachelors. Her quiet, shy charm, her talent at the piano and her clear singing voice strongly attracted Kent; for the duration of her visit he spent most of his time at the Thayers'. When Kathleen left to return to her family's farm in the Berkshires Kent

drove her to the station. They agreed to correspond, and Rockwell promised to visit her.

It is an indication of the depth of Kent's interest that less than a month later he and Gerald Thayer left Dublin for Crestalban. Having only Kent's horse for the two of them, they "rode and tied" their way across the mountains. Winter conditions were so severe that the young men lost their way, and almost lost their lives. When they finally did stagger onto the farm, Kent had frostbite; he was immediately put to bed.

The attraction they had felt at Dublin deepened and intensified as Kathleen nursed the invalid. His outgoing, virile charm; his energy, so disciplined yet applied to such wide-ranging activities; his love of music, and art, of good books and unusual adventures, matched well with her more quiet ways, her sheltered upbringing, her Berkshire isolation. The Whitings had no objection to the courtship, but, when Kent asked for Kathleen's hand, they insisted that, because of her youth, the marriage be postponed until New Year's Eve. Though Kent protested the delay, he knew he would have to put the intervening time to good use if he was to support a wife. After returning to Dublin for his things, he went to Tarrytown to tell his mother the news and to introduce her to Kathleen, who arrived a few days later. With the details of the wedding still to be settled, Kent left for Monhegan and Kathleen returned home.

On the island, the first order of business was to finish the twin houses started the year before. There was also a new project. When his mother had visited Monhegan she had been so taken with its beauty that she had bought land on the shore and contracted with her son to build a house there. The natives warned the young carpenter that the building site was too close to the ocean. "Often, that year and for some years to come, I'd wake from nightmares of disaster, of the house demolished and of myself struggling in timber-littered, breaking seas." The house still stands.

When not laboring or painting, Kent worked in his garden or wrote long letters to Kathleen; in those days of efficient mail service a letter could make the extensive distance in one day. Because of his temper and his, at times, contentious nature, he had more than the usual number of personal foes; they began to write to Kathleen's mother. "It's too bad the enemies are writing to mother now. Do keep her in good spirits."

Many members of the Whiting family were against early marriages and were unhappy about Kathleen marrying at the age of eighteen. She did find one ally. "I went over to see Mrs. Griffen yesterday and she told me again how wise I was to get married young. She says she thinks that if a woman

waits until she's nearly thirty, that by that time she has seen so many men she —doesn't know which one she wants."

Another problem came from his choice of diet. Kathleen wrote, "There is something I've had on my mind for three or four days. . . . What if I cannot be a vegetarian. [She'd been in bad health as a child, and had had bad teeth.] I would do it no matter what happened to my health if it weren't for our children." Kent's reaction was immediate; if she really had to eat meat then she could:

> Only this you must do. Please remember sometimes that lives are sacrificed to feed you and when you eat animals, do it sorrowfully . . . then it will do no harm to you.
>
> Anyhow, you can never be one of the millions that daily smack their lips and joke as they cut up and hand around some little lamb or good old mother sheep, or what was once a fine, loving beautiful cow. That's too nasty for words. . . . We pride ourselves nowadays on our advance from the time when we delighted in public hangings thinking that at last having reached the glorious 20th century we find ourselves at the very top notch of gentleness and spirituality. But . . . I *know* that the age will come when our spirituality and godliness will be mixed up in men's minds with the muck of the Dark Ages, and all this perhaps with the ethics and customs of the Zulus. So we can't make our viewpoint from which to regard ourselves too far ahead, for what today to most men is silly sentimental abstinence will some day be looked upon as but a trifling step in the vast scale, the infinite scale, of growth that lies before us.

Several trips were necessary to Boothbay Harbor, to pick up building supplies. One took place on Decoration Day, and the sight of the Civil War veterans marching in their old uniforms inflamed his patriotism. "We can say what we like against war and all that, but the feeling of patriotism comes from deep down in our souls. It is too overpowering and too ennobling to be wrong."

On another trip, to Portland, he climbed the rigging of a large barkentine that lay in the harbor. He went as high as the first crosstree, then started down until some men on the wharf called out, "Don't you dare go any higher!" Kent, never one to resist such a challenge, started up again "and climbed to the highest and farthest-out point."

He continued to work at his art whenever he found a spare moment. "Yesterday afternoon I painted a little while and got on pretty well. I wish I could get more time for it." Social evenings were still spent with friends, but his relationship with Janet was on delicate ground; the news of his engage-

ment had been a blow to her. Kent tried to handle the hurt by having Kathleen and Janet correspond, hoping that a friendship would develop. It softened her pain a bit, but Kent wrote to his fiancée, "She has been trying . . . to forgive me. . . . It is very sad." The real sadness, however, lay more than a year in the future.

In July, a schooner was discovered adrift at sea, its masts shattered by a storm, and was brought into the island harbor. The captain, aloft when the dismasting occurred, had fallen to the deck, breaking a leg and suffering internal injuries. Kent was impressed by the quiet courage of the sailor, who lay smoking a pipe while his leg was set. "A wreck is a mournful sight," he wrote Kathleen. "I should like to paint a picture of just such an old hulk with its crew aboard. It seemed like being a part of a book to be talking to the men who had just come out of such an experience."

Work on Mrs. Kent's house went smoothly, but Rockwell's constant drive for perfection made great demands on him, for he felt he had to keep an eye out even for mistakes made by others. After spending several hours repairing such a mistake, he wrote to Kathleen, "the work was well done in itself, but done without the use of any brains or foresight whatever. That's why the average carpenter stays the average carpenter."

The sharp edge of his anger was also directed at what he saw as more deadly errors. Since he was a vegetarian of conscience, he regarded the killing of animals for pleasure or recreation as little less than murder. He became so enraged at the wanton slaughter of small birds on the island that he had himself appointed game warden in order to legally harass those who were doing the shooting. He got into several altercations trying to stop them. "When I feel like this, it is no wonder that I am pretty generally disliked here," he wrote Kathleen.

In October, having finished his mother's house, Rockwell visited Kathleen in the Berkshires, then went to Tarrytown to pack his belongings and to spend some time with the family. True to his calling, Kent painted while at home; he tried his hand at watercolors, worked on a bookplate for his growing library, and also completely repainted a large oil, *Burial of a Young Man*, wishing he could get a new perspective on it. He also tackled again the moral questions which obsessed him, trying to put into words his feelings about life, his responses to what he saw in the world around him.

Rufus Weeks, while visiting Kent that summer, had urged him to take a more active role in the Socialist movement. "He wants me to go into a city and join a trade union and begin public speaking." Once back in Tarrytown, Kent immediately visited Weeks and volunteered his services to the cause. With some comrades from the local, he attended a mass rally in New York.

TOILERS OF THE SEA (OIL)

My darling, darling little Comrade,

I have just come . . . from . . . attending a Socialist meeting in Carnegie Hall. . . . Kathleen, it is the first time in my life that I have been in a public meeting and heard *Men* speak and looked at men who *were* men. . . . Well, I have heard a man speak who moved me and would have moved you. . . . I know that when I had to sniffle, you too would have needed my handkerchief. The speaker was named Wilson, he is an ex-Methodist minister, a Westerner, I think, who has lived lately in London; a deeply inspired Socialist not for political or theoretical reasons, but because he has seen and lived amidst suffering. . . . This is how he looked. He stepped out onto the stage . . . and stood for a moment or so before speaking. He was tall and broad shouldered, dressed in black . . . trousers bagged at the knees. He had a high forehead and a great mass of hair that kept flapping across his eyes. . . . He was homely and strong featured, eyes that seemed half closed. . . . He began speaking in a low tone of voice, slowly and distinctly, stooping over and looking on the ground at one side. Everyone listened attentively. His subject was "Capitalism, the anti-Christ of today." In a few moments his voice grew stronger and he began to speak and continued to speak as if a violent passion was in him.

I shouldn't call it inspiration but something more human than that. He said, "You think you are listening to a speech but this is not a 'speech,' it is but a feeble grunting striving to utter that great human cry that is behind me." Every sentence had the ring of such deep conviction that he seemed to create the truth as he spoke. There is no more describing such a thing than of describing a violin solo. I can only say that I was more profoundly moved than I can tell you. . . . He argued Socialism from the standpoint of its moral justice and, Kathleen, I tell you that anyone who really understands Socialism today and does not vote it, is utterly unworthy of the name of man. It is not politics, it is life or death of a million men, women and children. . . . There are two political parties. Those who *tolerate* the suffering and degradation that are unspeakable in these times (or refuse to see it). Or those who would give all that is theirs to save these people. . . .

Even before being inspired by Wilson, Kent had stumped for the Socialists, speaking at meetings and rallies. Because he had returned too late to register, he was unable to vote. "However, I am to be a Socialist 'Watcher' at one of the polls." The character of the party members greatly attracted him. "It is splendid to meet a crowd of young men so deeply interested utterly outside of themselves. They are all poor and workmen of a quite different sort from those I have come most in contact with and it is a real pleasure, and an inspiration, to be at their meetings."

Kent became particularly close with Sokol, a young Italian druggist, and ate many of his meals with the family (avoiding the bologna and corned beef). "I have met several Italians and they are grand fellows—and intelligent, understanding modern science, evolution, and very able to talk up such things intelligently and well, better than any, almost, of the people of our class."

Many of the unconventional ideas held by his Socialist comrades attracted him. The Sokols had married informally and without benefit of clergy, merely calling their friends together, then standing before them and stating what they felt to be their responsibilities to one another. "He did it as I really believe it should be done and not at all as we are going to do. . . . What a pity it is that we shouldn't be doing right this one time in our lives."

Still of major concern to Rockwell was his lack of money; except for a small amount of capital, the couple would have less than a hundred dollars with which to start married life. He reassured Kathleen, though, that "we in all our lamented poverty are *rich* compared to the many, many thousand poor who have this winter staring them in the face and nothing to meet it with." Perhaps less reassuring was his promise that "if it ever comes to the worst, Kathleen, I'll turn burglar." The crisis was resolved in December when his mother told him what her gift was to be. "It is $4,000 worth of bonds that will give us an income of almost $200 a year. Isn't that grand? I guess we're all right now."

The relationship between the Socialist painter and his future in-laws was becoming more strained as the Whitings became better acquainted with his views. Products of generations of New Englanders, they disapproved of his politics, his philosophy and his heroes. Kent had urged Kathleen to read Turgenev, but when she tried, her family laughed and called the work "slush." Kent responded angrily. "Cast not thy pearls before swine, lest they trample them underfoot." This sniping and counterattacking grew ever more fierce as anger rose on both sides. A few days before the wedding, Kent hit on using a New England hero as an ally.

I have just been reading a chapter of Emerson's called "Heroism"; it is a glorious essay and has set me quivering all over. It expresses the relation in which we have lately found ourselves to other people, particularly your parents, and so clearly tells the right and wrong . . . that your mother must read it. I have thought of writing to her myself, but I could not remain temperate and so am going to ask you to ask her to read it in order that she may realize now and forever the position that she has come to occupy to me as an opponent of all that our deepest convictions prompt us to do. . . . I can never forget her attitude in op-

posing the course that has lain before you and me . . . she stands as an opponent of the absolute sovereign right of conviction, of conscience [because she opposed their marrying earlier and was forcing them to have a minister marry them]. I almost despise Unitarians as Atheists who have not the moral courage to speak their minds.

Though not able to win a completely secular ceremony, Kent did effect a compromise; he wrote the wedding vow read by the Whitings' Unitarian minister before the gathered family and their friends in the Berkshires on the last day of 1908.

The Whitings required the couple to spend their first winter of wedded life near them so that Kathleen could be protected should the need arise. Kent took a job as a draftsman for an architect in nearby Pittsfield, riding his horse the eight miles to work and back in the cold New England winter. The couple spent their nights sitting by the stove, reading to each other from favorite authors; Dostoevski and Jane Austen provided the greatest pleasure that season.

The newlyweds also attended Socialist party meetings. "Pittsfield being an industrial city, the party membership included a large minority of factory workers; they constituted the local's more aggressive and outspokenly revolutionary element. It was with this left-wing group that I became associated and for whom I was the occasional spokesman." When the wealthy Socialist intellectual J. G. Phelps Stokes and his wife, Rose Pastor, came to Pittsfield to address the local, the Kents served as their hosts. After the speeches, the Stokes stayed the night with Rockwell and Kathleen. Talking into the morning hours, the couples became friends; later it was arranged that the following winter the Kents would stay at the Stokes mansion on Caritas Isle, in Stamford, Connecticut.

The Kents lived frugally in Pittsfield, saving so that they could spend the summer on Monhegan, where Rockwell would paint and Kathleen practice her music. They did own a piano, a large square grand given to Kent by a grateful woman after he had saved it from her burning house.

Before going to Monhegan, the couple spent a week in New York pursuing their mutual love of music. They attended an opera every night, sitting in the Family Circle, where seats were cheapest. They saw several Italian operas, but it was Wagner that most moved them, rekindling Kent's love of the German tongue, German music and German culture.

Kathleen loved the little Monhegan house Rockwell had built. The one room was big enough for her piano, on which she practiced every day. She cooked on the cast-iron stove and kept her dishes in the open shelves Rockwell had built into the wall. In the attic, under a westward-facing window,

was placed the feather bed given them by Mrs. Kent. A snug, secure and well-constructed home; Kathleen, who had become pregnant, was happy there.

Kent painted the whole summer of 1909. He hiked everywhere, lugging his canvases and oils, climbing the headlands, probing the forest or painting the view from the beach. Janet still lived on the small island, and on one of the isolated trails they met again. They talked; their attraction for each other flared once more; they made love, and began an affair that was to touch upon many people's lives.

Raised as a late Victorian gentleman, taught to repress emotion, stifle sexual desire, live up to the codes of the heroes of his adolescent reading, Kent had a highly developed conscience, a conscience that had prevented him from satisfying his earlier desire for Janet. Kent began married life having had only one night of sexual experience, a night of trauma as well as pleasure. This had occurred several years before his marriage and had been a source of torment to him, a reminder to his conscience that he was impure.

As he had orbited farther and farther away from Tarrytown, he had been introduced to new realities, new philosophies. The sexual mores of his class had been ingrained through prep school and reinforced by the adults closest to him. Sexual tensions were, perhaps, heightened by living in a household lacking a father, a household run by two strong women. But he had found, first through Henri, that the conventional was not the only way of living. Christian socialism had moved him to another position from which to appraise his class. The reading of unconventional writers moved him farther away, but it was his intense association with the radical, and mainly foreign, wing of the Socialist party that had most changed him. As he had written Kathleen during their engagement, "The type of mind that grasps the great social needs of our day, that is stirring for better, truer living also comes to hold unbiased & natural views upon life & love, & to despise the abnormal letter of convention that is smothering nature's ways." Though he had struggled to practice celibacy, the tensions built until they burst suddenly and surprisingly through the very institution that was designed to contain and channel them: marriage.

Marriage was his introduction to sexual pleasure: unfettered, nonremorseful enjoyment of the human body. He found it disappointing. He had expected too much, his imaginings had been too creative. The struggle to bring expectation into line with reality lasted for several months, but when he was finally freed from the tyranny of imagination, his desires rekindled in a new and healthier direction, Kathleen had become pregnant and increasingly unavailable to him. The always strong attraction for Janet flared. They

met in the island's wilds, the affair began; Kathleen did not know.

Though during their engagement Kent had written, "Oh, Kathleen darling, I pray above all things that we will have children," now, her pregnancy complicated an already confused situation. Financial worries, too, were increased by the news, for as his collection of paintings increased, his savings just as steadily decreased. In September the couple left Monhegan and moved in with J. G. and Rose Stokes on Caritas Isle.

The island covers two or three acres of land attached to Connecticut by a bridge. Besides that of the Stokes', there were two other houses hidden in the woods, one belonging to the radical sociologist William English Walling, the other to a writer, LeRoy Scott, who was also a Socialist. The Kents were accepted immediately into the close-knit community. Since the island was a center of Socialist activity, Kent met many of the movement's leaders, such as W. E. B. Du Bois and Mary "Mother" Jones; but most interesting to him were four people who were more private than public characters: Mrs. Walling's sister, Rose Strunsky; Leonard Abbott of the *Literary Digest*; Horace Traubel, friend and biographer of Walt Whitman and editor/publisher of *The Conservator*; and a mysterious, one-eyed stranger who was hiding from the police. Traubel and Rockwell became particularly fast friends, and the younger man later introduced the old companion of Walt Whitman to the Henri group, where he made a great hit.

For Kathleen, the community, with its vague, unstructured schedules, was less exciting. J. G. Stokes she found icily intellectual and unfeeling, Rose more human but constantly busy. Kathleen, alone much of the time, spent hours playing the piano, and waiting.

In early fall, a boy was born to the young couple, and named after his father. Rockwell was proud of and happy about the child, but there was already stirring in him a restlessness, an eagerness to roam the world and to be free. That December he wrote a particular hero of his for information about one of the remotest spots in the world: Pitcairn Island, last refuge of the *Bounty* mutineers.

Jack London answered the letter promptly, writing to "Dear Comrade Kent" that though he had never been ashore, he had cruised by the island, and had met some of the natives while in Tahiti. He offered to write Kent a letter of introduction if he decided to go, and closed, with a militant flourish, "Yours for the Revolution."

Kent could not go; so diminished were the couple's savings that he had to return to Ewing and Chappell as an architectural draftsman. Since the commute from Stamford to New York was a long one, he found himself away from Caritas twelve hours a day. Having no time to paint, he feared he

would lose all the skills he had labored so hard to learn; he decided to reenroll in Henri's night class.

Henri's relationship with the National Academy had come under increasing strain. He had tried to work within the Academic structure, tried to lead its conservative membership into a wider acceptance of younger painters like Bellows and Kent, but his frustration deepened as he failed again and again. By March 1908, it seemed obvious to him that his only recourse was to mount an alternative exhibition. Gathering his friends together, he led the launching of the famous and successful Eight Show of 1908. By December 1909, Henri and his good friend John Sloan were interested in mounting another show, but it wasn't until the following March that plans took definite form; it was to be a large exhibition having a short run. After several weeks of hectic activity, in which Kent was energetically involved, the Exhibition of Independent Artists opened on April 1, 1910.

The opening caused a near-riot, which John Sloan saw as a good sign:

"The three large floors were crowded to suffocation, absolutely jammed at 9 o'clock. The crowd packed the sidewalk outside waiting to get in. A small squad of police came on the run. It was terrible but wonderful to think that an art show could be so jammed. A great success seems assured."

The assured success did not take place. Though crowds jammed the exhibition hall, the sales amounted to only seventy-five dollars. Everyone was deeply disappointed.

Kent entered four paintings in the Independent show. None was sold, but Henri, in an article about the exhibition, gave Kent's reputation a tremendous boost. "He is interested in everything, in political economy, in farming, in every phase of industrial prosperity. He cannot do without this interest in his art. The very things that he portrays on his canvas are the things that he sees written in the great organization of life and his painting is a proclamation of the rights of man, of the dignity of man, of the dignity of creation. It is his belief in God. It is what art should mean."

During the planning and organizing of the show, Kent and John Sloan spent much time together; a friendship developed. "A fine energetic character is Kent and a big painter." Rockwell stayed overnight several times, and occasionally he brought Kathleen and the baby to visit the Sloans. "Mrs. Kent played the piano . . . plays very well though Yeats says not much expression. I liked her playing."

Still a constant worry to Kent was the family's financial situation. Architectural drafting provided immediate cash, but it allowed little time for working at his art. Though they lived simply, it was impossible to save enough to buy a period of free time. What was to become of his career as an

artist? In discussing this dilemma with another Henri student, Julius Golz, an idea took form. Even though there was little market for paintings, there was one way to put their art training to remunerative use: teach. They issued a prospectus, placed ads in the art magazines, then waited. To their surprise, they received responses from nearly twenty people. The Monhegan Summer School of Art was launched.

Rockwell's mother offered to pay for materials to build the school's studio if he did the work. He left for Monhegan in May, immediately set to work, and by mid-June, just as the first students arrived, he had finished.

Most of the students were women, but there were also men of working-class background. One, a man of thirty-five, was a friend of Jack London's who had come all the way from California to study on Monhegan. Kent as teacher seems to have followed the lead of Henri. He gave general talks, with some emphasis on technique, but mainly along philosophical lines. His written evaluation of one student, a Miss Barkley, noted that she used "True, fine color," but she needed "to go more directly to the point and to state it more forcibly." She had "a lack of direction in line, of majesty in line. . . . Her future depends upon her ability to connect her work more directly with her life. It still lacks the impress of a mind." After stating that she had the ability and talent of a good landscape painter, he asked, "What is she going to do with it?" He answered by paraphrasing Tolstoy on the duty of art to promote the brotherhood of man, and used the great writer as an example of a successful artist.

It was about this time that a reporter for the *Philadelphia Record* visited Monhegan and, recognizing the energetic young artist as good copy, held a long interview with him; it was printed with several photographs showing Kent working on houses, painting and posing dramatically by the sea:

> It seems like a far cry from Yasnaiya Poliana, Russia to Monhegan Island, Maine but the voice of great reformers is strong and knows no geographical barriers. [On Monhegan lives] an American of good Anglo-Saxon ancestry who paints fine pictures of the mighty Maine rocks, the boundless blue, and the golden sunlight and at the same time strives to make his life accord with the theories advocated by that grand old Russian, Tolstoy. Rockwell Kent, the Tolstoyian disciple in question, would undoubtedly prefer to have the latter phase of him mentioned first; he considers it vastly more important to be regarded as a man than as an artist, and art, at best, he deems only an incident in any man's life. Moreover, he thinks it absolutely essential that a man's art be thoroughly consistent with his life and not apart from it, as it often happens to be.

"Art," says Mr. Kent, should be a record of one's life and of one's experiences. . . .

"The fundamental thing in my life," said Mr. Kent to his visitor, "is an interest in life and in social conditions. There is too much respect for art itself; that's the least thing that we ought to respect. We must live as human beings live, love and hate, feel and think, act and enjoy; out of this comes art, but it is incidental. Character is formed out of life, and art is an expression of a live personality; that sort of art has a truer ring than any other art." It is not surprising, therefore, that Mr. Kent should consider Thoreau vastly finer than Emerson. The first, to him, "loves life and lives," while in Emerson he sees the "professional dreamer and thinker who thinks beautiful thoughts and does not live."

Kent was to be amazingly consistent in these views for the rest of his life. Art comes out of life's experiences; it has value because it serves as a tool to awaken mankind—not only to the social and political realities, but also to the beauty of the world.

Visiting the island that season was a young instructor from Columbia University, Bayard Boyesen. The son of Hjalmar Hjorth Boyesen, a well-known critic, translator and novelist, Bayard had grown up in an intensely literary environment. Though aristocratic in bearing, he was an anarchist in his politics and was later purged from Columbia for appearing at a meeting with Emma Goldman. The two young men were instant friends, spending hours discussing art, and arguing politics. Boyesen told Kent of his literary ambitions, describing the plot for a play and reading some of his poetry to the artist. Kent spoke of his own plans for adventure in such exciting terms that he was able to write to Kathleen, "He even offered to go to Tierra del Fuego with me." Boyesen, kibitzed by Kent, gave a lecture on "Anarchism and Literature" to the art students, and when he left the island, Kent promised to visit him in New York.

Kathleen was not with Rockwell for most of the summer of 1910. It is unclear how she found out about the relationship between Kent and Janet; perhaps he told her or some wisp of gossip may have reached her on the island. However the knowledge came, its effect was shattering. Stunned and forlorn, she took the child and retreated to her family in the Berkshires.

Janet was living in Boston, where Rockwell visited her in early June; glad that she was not to be a resident on the island that summer, he still felt a need to see her. The letters to Kathleen during June and July show his confusion. No details of his relationship with Janet were spared Kathleen, and at times there seems to be a deliberate attempt to hurt her through unsoftened honesty. On one occasion, when Janet visited him, he wrote Kathleen, de-

scribing how they were almost caught together, by his mother and several is-land friends, on the small boat serving Monhegan. "As I write this it doesn't seem tragic & it didn't then. It has been a very thrilling episode & very amusing—if only you could see it so." He did love them both, but he was un-sure of which path to take.

Finally, after much soul-searching, he decided to stay with his wife and child. An attempt was made to break with Janet. "Well, Kathleen, our plans are made, *two years grace!* No letters from Janet and no seeing of one an-other." Janet's resolve, however, failed, and within two weeks she was again writing Rockwell. He tried, as he had all along, to reassure Kathleen. "Oh, darling, with all my love for Janet if only you can know that I *do* love you dearly."

To the Whitings this extramarital adventure was proof of the suspicions they held toward their radical son-in-law. They made Kathleen's stay with them as uncomfortable as they could. "I can't bear to hear [Mother] call you and me the names she does." Needing an ally, she turned to her cousin, Ger-ald Thayer, who immediately came to her side. Later, he told his father of Rockwell's transgressions, and they both wrote to the sinner, whose immedi-ate reaction was anger over their interference. "I'm cross at the way you have set your bulldogs on me—namely Gerald and Mr. Thayer—so just call 'em off and use them for your own amusement and counsel."

Several days later he wrote again: "[Their letters were] brimming over with *self*-complaisancy and conceit. . . . I wrote them to give *you* all the ad-vice they wanted to, but not to bother me with any. The way your family derives all its lustre from what relation you have to the sage of Dublin is sickening. . . . You can choose between us; stay in the pure, holy and spotless sanctuary of Thayerdom, watched over by the immaculate flesh eater, the pure and lofty Abbott H. Thayer, or come to this stinking den of vice and degeneracy. But *don't* bring along any of that purity and virtue with you."

The break between the Victorian code and Kent was complete.

After several false starts, Kathleen finally returned to Rockwell in Sep-tember. Though he continued to be unsure about the life he wanted to live, he knew he loved her and the child. Janet, still living in Boston, was told of his decision; the relationship was considered over.

During their talks on Monhegan, Kent and Boyesen had discussed founding a communal art school; a school that would teach, as its fundamen-tal lesson, that art had validity only through its service to mankind. Since the two young men had only limited resources, they decided to search for a site in Newfoundland, where land costs were low.

In early October of 1910, Rockwell took his wife and child to New

York, where they were to stay with friends. While in the city, Kent, at the invitation of Boyesen, gave a rousing talk to an undergraduate group at Columbia. One student, Carl Zigrosser, sat spellbound as Kent enthused over his love of nature and reverence for all forms of life, and showed his anger at social injustice. "My response to his magnetic personality was immediate, and the rapport established that evening . . . led to the foundation of a lifelong friendship." As might be expected, not all the students were impressed; one wrote in a campus publication, "Mr. Kent sprayed the Society with a strong solution of Socialism, which evaporated with much spirited argument."

Kent, contacting fishermen in Gloucester, Massachusetts, learned that the herring fleet would sail for Newfoundland on October 15. Making arrangements to work his passage on one of the boats, he left for Boston. He was on his way to the frozen north.

REBELLION

It is important to record that, seeing my teachers as the embodiment
of arbitrary authority, I was in constant arms against them. . . .
 —ROCKWELL KENT

I will be good. . . .
 —ROCKWELL KENT TO KATHLEEN KENT

Newfoundland. The idea had not come casually or suddenly. Kent and Boye-
sen were encouraged by the success of the Monhegan Summer School of Art,
but believed the island too small for their more elaborate scheme; also, ru-
mors of Kent's troubled and complex love life had offended the local resi-
dents.

Since Boyesen's funds were limited, and Kent's even more so, there was
a need to economize. They hoped that cheap land would be available in
Newfoundland. Most important, however, was the call that cold, harsh, un-
forgiving environments made to Kent. Drawn to them as much by his need
to be tested and to conquer as by their strange beauty, he would respond to
that call all his life; this first trip to Newfoundland was a logical step along
the path that would eventually lead him to Alaska, Tierra del Fuego and
Greenland. "I had served what in a lifetime's schooling may be called my
kindergarten years in the mountains of New Hampshire; and having passed
from there to the grammar school of a North Atlantic island, I was now . . .
headed for higher latitudes."

Immediately upon arriving in Boston, Kent telephoned Gloucester and
discovered that the fleet would not sail for a day or two. He took a hotel
room, spent a boring evening with a friend of Horace Traubel's, and went to
sleep. The next morning he telephoned Gloucester again, and was told that
the sailing date was still uncertain, but that he would be notified as soon as it
was set.

Though he had decided that the affair with Janet was over, he was now

on the loose for several days in the city where she lived. He made a struggle to resist the irresistible, but it was brief and, since he still cared deeply for her, probably halfhearted. He called on the young woman, who was living with her sister. The three of them spent a pleasant afternoon sightseeing and watching a motion picture; but when he picked up his mail that day there was disturbing news: the herring fleet would not sail for Newfoundland until after November 1. Since he could not afford the delay, he quickly decided to go by train and boat.

The ticket agent told him that there was a train to North Sydney, Nova Scotia, leaving every morning, including the next day, Sunday, at eight. From North Sydney he could catch a boat to Port-aux-Basques, Newfoundland. Kent bought a ticket and said his good-byes to Janet, telling her not to come to the station to see him off, that this was the last farewell.

When he arrived the next morning at the ticket gate, he discovered that there had been a mistake—there was no Sunday train to North Sydney. Furious, he made his way out of the station to find Janet waiting at the exit. They crossed the street to a cheap hotel, where he registered and left his suitcase, and spent the afternoon walking the city. That evening she gave a singing recital at church, where Kent thrilled again at her lovely voice. After everyone else had left, they sat together at the organ, only a few candles for light, and sang the lieder Kent had taught her. His resolve washed away: they walked to his hotel, and she spent the night.

He was tired the next day as the train rattled northward and complained in a letter to Kathleen of having had a sleepless night due to the "grunting and thumping" of a pile driver outside his room. The New England forests were blazing with fall colors, but soon autumn gave way to winter as Massachusetts and lower Maine were left behind and silver birch replaced the oak and maple. Late in the afternoon he noticed, building in the distance, masses of dark clouds, which he found "dramatically ominous." The omen came too late to save Janet, Kathleen and Kent himself from even more unhappiness than had gone before.

On reaching North Sydney he discovered he had two full days to wait before he could proceed, so he registered at the town's only hotel and became acquainted with the citizenry. One of the friends he made was a man who worked in the local coal mine. Kent, always curious, induced the man to take him on a tour of the operations.

"That trip into the mine . . . was a glorious experience. Just think, 680 feet straight into the earth." Though it was glorious, it was also horrible, and reminded him forcibly of Zola's descriptions of such scenes in *Germinal*. "Once down there it was hard to believe the distance that was above . . . in

the remote parts of the mine at the ends of the long passages leading out from the central shaft, passages miles in length . . . the air is hot and bad."

Kent could not let a chance for political proselytizing go by. "You should have heard me planting discontent in the minds of the miners," he wrote to John Sloan. In spite of the danger and discomfort of the job, or perhaps because of these challenges, Kent was drawn to the work. "I have planned to come back here some day and get a job underground. It is an experience that I covet."

While waiting for his boat, he painted two small landscapes and a scene on a satin pillowcase for the landlord's daughter. He received $1.50 for the pillowcase—just enough to pay the hotel bill.

The boat trip to Port-aux-Basques was uneventful, but he was excited by the stark Newfoundland landscape. "Oh, you never dreamed of such hills and mountains, terribly stern and bleak—absolutely treeless except for spruces that grow in hollows [eighteen inches deep] and exactly fill them up to the ground level." He was fascinated by the deep spongy moss covering the ground and by the desolate moors. A train ran from Port-aux-Basques to St. John's, the capital, but Kent wanted to see the coast. Deciding to wait for the boat, he whiled away the time by taking a walking trip deep into the countryside.

There had been one unpleasant event to mar his introduction to Newfoundland. A customs inspector, suspicious of Kent's art equipment and learning that it was used to paint pictures, demanded that duty be paid on it at the same rate as that for a camera—forty percent of its original value. Kent, outraged, argued furiously with the fellow, but to no avail. Edward Morris, premier of Newfoundland, happened to be visiting Port-aux-Basques; Kent wasted no time in complaining to him of this bureaucratic harassment, nor did he hesitate to explain his grand scheme. The premier was impressed. Kent found him "to be a first-rate fellow . . . not only is . . . the custom officer to be rebuked, but all sorts of special customs privileges are to be extended to me for the art class and half rates on the railways and S.S. lines." Encouraged by Morris's enthusiasm for the art school, Kent boarded the boat for St. John's.

The trip was wildly exhilarating to the young adventurer. "[We] have been running before a southwest gale all day." Waves had battered the boat severely, but it was luckier than some. "During the night a larger steamer than ours was wrecked . . . all hands lost." Kent had spent hours outside on the upper deck watching "very carefully the angle that the vessel made with the horizon on some of her rolls." He also closely watched the coast slipping by. "And, oh Kathleen, what a wonderful coast in this weather. Mountains

right down to the sea—absolutely bare and bleak; no tree, no house, absolutely nothing but bare white rocks and clinging vegetation, rich red and green." He drew ink sketches of the scene. "Range after range of hills seen through the driving mist, golden toward evening—and the sea dark blue-green. Never have I seen such a sight."

Rockwell got off at Grand Bank, planning to take a schooner to the French-controlled islands of St.-Pierre and Miquelon, but the weather was still too wild. Spending several days waiting for it to clear, he grew increasingly impatient. Time was running out and still the site had not been found for what he had come to call the "Newfoundland University." Hearing of an old fishing port, Burin, that lay not too far away, he decided to forget about the French islands. Acquaintances had told him that the walking distance was less than thirty miles, so on the morning of October 29 he set out on foot.

The trip proved a rough one, for heavy rains had turned the path into an impassable bog, forcing him to make his way along the beach, alternately sinking into sand and scrambling over boulders. He made the hamlet of Garnish by nightfall and learned, to his astonishment, that although he had walked twenty-five miles, Burin lay twenty-two miles farther. Spending the night with a hospitable family, he got an early start the next morning and arrived in Burin by midafternoon.

The town's location on a deep fjord, with an island-punctuated harbor and a broad view of both land and sea, captivated him. More importantly, he found there what he had been searching for. The Jersey Room was an abandoned fish-processing plant consisting of six or seven rundown but still sturdy buildings on a level point of land near the harbor. Kent immediately wrote to Boyesen and Kathleen of his discovery. The location was ideal, and though the buildings needed work, their repair would be a valuable learning experience for students at a school designed to integrate art with life.

Kent went immediately to St. John's, met with the premier and offered a proposal. If he and Boyesen could have the Jersey Room rent-free for five years, they would restore it to top shape and maintain it. Morris, enthusiastic, felt that something could be arranged, and he set about contacting the abandoned plant's owners.

It was time to return to the States. Kent had planned to stop at Monhegan on his way to New York, but a letter from Kathleen forced him to reconsider. Lonely, sad and sick at heart over his visits to Janet, Kathleen wanted him to return to her at once: "if you really and truly love me and care for me, you will . . . give up Janet and Monhegan and return. . . ." Rockwell lost no time in replying, "I will be good . . . you and you alone are in my heart all the time. . . . Poor little girl, you shan't cry on my account ever again."

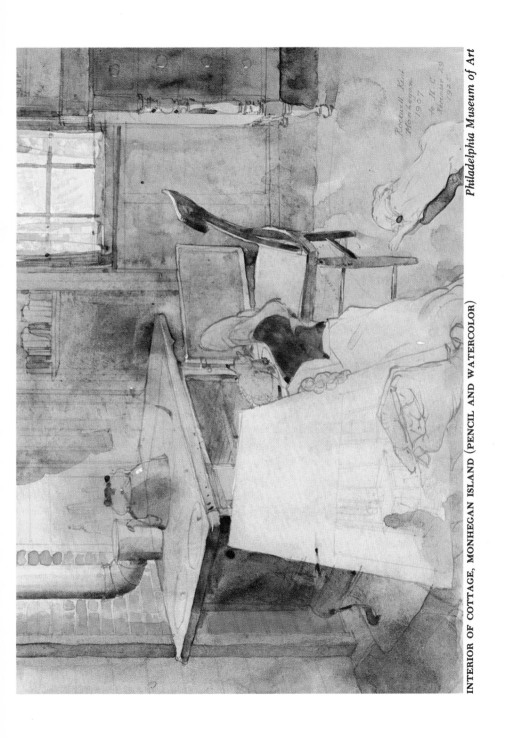

INTERIOR OF COTTAGE, MONHEGAN ISLAND (PENCIL AND WATERCOLOR)

Philadelphia Museum of Art

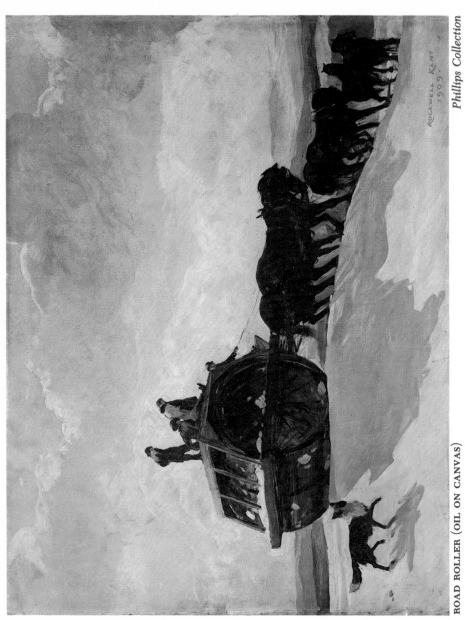

ROAD ROLLER (OIL ON CANVAS)

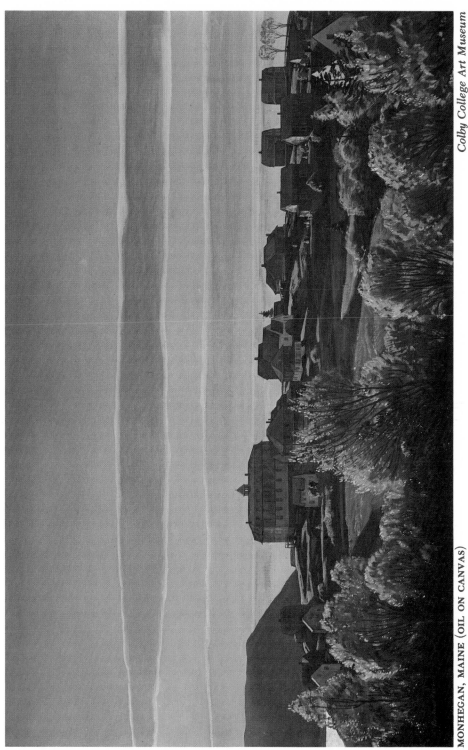

MONHEGAN, MAINE (OIL ON CANVAS)

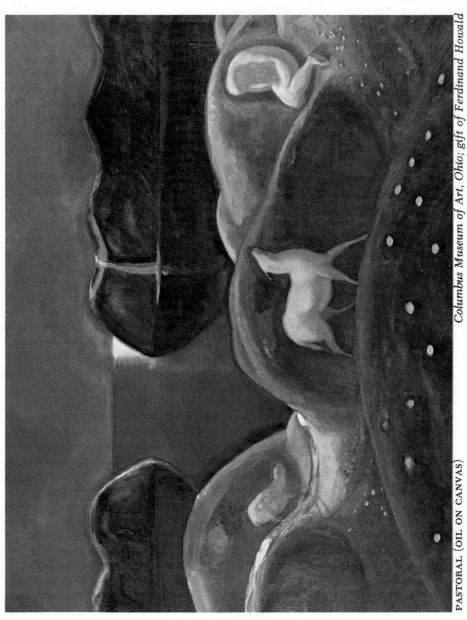

PASTORAL (OIL ON CANVAS)

Columbus Museum of Art, Ohio; gift of Ferdinand Howald

He quickly packed his bags, asked the premier to inform him immediately upon an agreement being struck with the Jersey Room's owners and left for New York.

The Kents were reunited on November 16. He worked to calm her fears, to convince her that though he still cared for Janet, that relationship was over. He would not be seeing her again. The couple spent some time looking for an apartment, finally finding one on the floor just below the Sloans. Kent, in his autobiography, remembers that it was John Sloan who found it for them, but that is doubtful since the Sloans were already becoming annoyed at what they considered Kent's cavalier attitude toward his wife and son. Kathleen and little Rockwell had stayed with them part of the time that Kent traveled in Newfoundland. Though Kathleen was a quiet woman and the baby well behaved, the Sloans had found the visit rather trying. Sloan recorded in his diary, "[Kent] is greatly joyed at the prospect of being our near neighbors. . . . Myself, I am more reserved."

The following weeks were spent by the Kents working on their new apartment, painting, doing some minor carpentry and putting in a new stove. Often they passed their evenings in the Sloans' apartment. "R. Kent is a good entertainer," Sloan noted. As soon as the family was settled in the apartment, Rockwell left for Monhegan. They had decided to sell their small house there and put the money in the Newfoundland adventure; while preparing the house, he would also work at his art. Sloan, a master etcher, gave him some instruction in the process, and advised him on what materials to take to the island.

On the steamer to Boothbay Harbor, Kent became involved in an argument between a young, unemployed laborer and a stout, white-haired, prosperous-looking gentleman. The argument began in the salon, immediately after dinner, and quickly drew the attention of the other passengers. Kent wrote Kathleen that the laborer "spoke clearly, not always wisely, but quietly and unaffectedly. And as the argument progressed the old man grew more eloquent, more confident, more boastful, more withering, carrying his crowd with him to a man—so that the poor workingman said less, through the futility of saying anything, and was almost becoming ridiculous in the eyes of the crowd." Kent ached to get into the argument as he heard the working class denounced as being not only depraved, dishonest, filthy, drunken and degenerate, but also the richest class in the country. "They had a thousand million dollars in the savings bank in Boston; ten thousand million in New York. . . ."

Finally, Kent could restrain himself no longer. Seeing that the workman was becoming the laughingstock of the crowd, he entered the fray.

"Why," Kent asked the portly gentleman, "if the workingman is such a

crook and so utterly worthless, do you persist in trying to hire men? [Without employees] your farm becomes worthless, because with your business in Boston you can't work it. This is so with every single investment you possess. Every one of them is absolutely *dependent* upon the man you so despise so that in truth *you* are the dependent of those same villainous workingmen . . . everything that you value and call wealth is merely the embodiment of so much of the labor of the class that you despise. Labor is the beginning, middle and end of everything that is called wealth."

The capitalist counterattacked with the charge that Kent was a Socialist "trying to turn the country upside down."

"Yes, that is what I am," Kent replied, "and if you'll consider the last election, or turn to any periodical, you'll find that there's just cause for you to fear that the time will come when, with a landslide, we actually will turn things upside down."

The man said they should all be "loaded into vessels and carried over the water and dumped." Kent answered that, on the contrary, a time might come when the capitalist and his kind would be "shipped out of this workingman's land."

When the workingman tried to rejoin the argument, Kent stopped him by putting a hand on his shoulder. "Here is the landslide that I promise you. You see this angry workingman? There are in this country hundreds of thousands of such angry men, and each day they grow angrier and stronger. You can hear their muttering all over the country. They want what you possess. Do you suppose that these big, furious men are going to stop before they get what they want?"

Cowed by Kent's righteous indignation and the verve with which the crowd had been turned against him, the "Scab Boss" slunk off. Kent lectured to the gathering for a time, then retired. He reported to Kathleen that the subject of socialism was still being discussed the next morning in the salon, and ends the letter: "I have made myself crow a great deal and be a grand hero. But you can reduce that, and understand the scene."

The event illustrates a contradiction in Kent's political beliefs that was shared by many other Socialists. Though they saw the working class as honest and diligent, with a legitimate right to the wealth it produced, it was, as well, unfocused and impotent without the leadership of educated, articulate sons of the middle class like himself. Arising partly out of the snobbery of his family and partly from the elite radicalism of Stokes and other party leaders, Kent's attitude was strengthened by his own need to feel in command of a situation.

Arriving in Monhegan, Kent found that his house had been taken over

by rats, and, making a distinction between these and other small animals, he energetically set about poisoning them. That accomplished, he turned to some unfinished canvases begun the previous summer; a "croquet" picture and one he called *Fisherman's Farewell*. "Do you remember? . . . The big one with the row of people extending across it. It looks pretty fine now." Less successful were his first attempts at etching. He had tried to get the ground of the plate as finely prepared as Sloan's, but "it flaked off the minute I put the acid on." The next try went better. To relax from his artistic efforts and handyman's chores, he practiced on the silver flute that had been his father's and which he had recently decided to learn to play.

Kathleen was less relaxed. She had not liked being on her own while he was in Newfoundland. "I am not happy, dear. It is terribly hard . . . being left alone in this big, sad city, with the entire responsibility of the boy on my shoulders." Now there was a new development; she had discovered she was pregnant again. Her own feelings, given the domestic upheavals of the past year, were probably mixed, but others were not hesitant to give her their opinions. "I feel that everyone that knows is displeased. I know Mrs. Sloan is, for she as much as told me so."

Kent, who had always wanted a large family, was probably happy. Life must have seemed good to him as he prepared the Monhegan house for sale: he had a loving, talented wife, a fine son, and a welcome child on the way. Though he had erred in Boston, he would steer clear of those shoals in the future. He had his health and fine energy, a little money, an earned reputation as an artist, and a dream that would, perhaps, enrich the world by producing artists who integrated art with life, politics with brotherly love, creative hard work with sharing. Satisfied with the present and hopeful of the future—his happiness was shattered by a letter from Boston. Janet, too, was pregnant.

Rockwell left immediately to see her. He told the young woman that there were two choices: have the child or terminate the pregnancy; he would support whatever decision she made. She hesitated, then followed friends' advice to have the child. Kent had probably wanted her to say that; he asked her, if it was a boy, to name him Rockwell. The crisis shook his resolve and reawakened his love for Janet. Reawakened it to the point where he considered, briefly, divorcing Kathleen. It was agony for him, and, of course even worse for Kathleen, who had hoped that the romance was over between the two. Now, not only were the old wounds reopened, but they were enlarged by the need to provide for Janet and her child. Both Rockwell and Kathleen felt there was only one course to take: the $4,000 in capital given them as a wedding present by Mrs. Kent, their savings, and the proceeds from the sale

of the Monhegan house were all given to Janet. "And so, Kathleen, we start all over again and this time really at scratch."

The plans for the communal art school were reluctantly abandoned; and Kent returned to work at his old job with Ewing and Chappell. On his salary of twenty-five dollars a week they were able to supply their needs and had enough left over to pay for Kathleen's music lessons. Painting again was fitted into the weekends.

Through all the turmoil of the year Kent had kept at his art. Now, having a large collection of new works, he felt that the time was right for another Independent show. George Chappell, good friend as well as employer, served as a director for the Society of Beaux Arts Architects. He was in sympathy with Kent's idea for a new exhibition and offered him the use, rent-free, of the large gallery at the society's headquarters. Kent eagerly accepted, then rushed to see Robert Henri, leader of the Independent movement.

One of the ways in which the National Academy exerted such powerful control over the domestic art scene was through its command of almost the only exhibition space in New York. Kent reasoned that since the Academy excluded the Independents from showing, the way to strike back would be for the Independents to refuse to exhibit the work of any artist who showed at the National Academy of Design. Kent, always assertive, told Henri of the free gallery, then added his condition.

Henri was, of course, enthusiastic about the idea of the show, but he refused to go along with Kent's demand. He argued strongly, but unsuccessfully, that talent should be the only criterion. The younger man left in anger, and went to see John Sloan, who at first supported the boycott of the Academy. Sloan was puzzled by Henri's noncooperation—"What the dickens does that mean?"—but didn't believe there would be any problem getting other artists to join them. They decided to ask Arthur B. Davies to help organize the show.

Enigmatic and mysterious in his personal life, Davies was a painter of strange, romantic canvases depicting such scenes as unicorns and long-haired maidens meeting in unearthly gardens. He responded to Kent's proposal by saying that it was time that Robert Henri was put in his place and that he, Davies, would be glad to help. At the end of their first meeting he thrust a wad of bills in Kent's hand and promised more when it was needed. The wad proved to be more than $200.

Robert Henri had been focus, leader and symbol of the Independent movement since its beginnings. He had been responsible for encouraging some members, like John Sloan, to try painting in a serious way, and he had argued, cajoled and fought with the Academy for years to get its members to

accept new talent. His strong personality had been necessary for the organization of the movement, but there were painters who, though respecting all Henri had done, felt his influence needed to be trimmed.

In March of 1910, Walt Kuhn and several other painters had been worried about going into the Exhibition of Independent Artists as "tail" to Henri's kite and asked Henri to shift responsibility for the show to Kuhn. Henri became angry and argued that if he was not spokesman there would be little attention given to the exhibition. Sloan, who attended these meetings, agreed with Henri. "The reporters are bound to come to him on account of his record as a Revolutionist. . . ." Sloan did have some sympathy with the dissidents. "[Henri] is perhaps over-advertised, but that cannot be stopped nor need it be, for his work stands on its merits." Now Kent with his free gallery, his terrific energy and his inability to stay in anyone's shadow for long was to combine with and be guided by the organizational skills of Arthur B. Davies to engineer a break from Robert Henri's fold.

Sloan's early enthusiasm for the Kent show did not stand up under Henri's arguments. "Henri is right in saying that we have never put the 'screws on' anyone in our exhibitions." This isn't quite accurate, for the previous April Sloan had noted in his diary, "Went to see Henri . . . and we talked over . . . next year's Exhibition. We decided to incorporate. To disqualify any artist who sent to the National Academy."

There can be little question that personal elements entered into the conflict. Kent's driving, aggressive personality could become abrasive when he was excited. According to Sloan, Henri was angered by Kent's language and the manner in which he laid down the conditions under which an artist could enter the exhibit. Kent talked of "forcing" those who showed at the Academy into line and he denigrated the achievements of the original "Eight Independents." Henri wrote to a friend explaining his stand: "I have no thought of sending to the N.A.D. but oppose anyone else dictating to me or to others about it."

Added to these irritants was the growing personal tension between Sloan and Kent. Sloan, quiet and mild-mannered, felt increasingly put upon by the outgoing young man. Asked to baby-sit several times, he and his wife had acquiesced but, as the requests continued, they finally refused, much to Kent's anger. When Kent approached Sloan about the show, the two men had not been talking for several weeks. Sloan, for both personal reasons and on principle, refused to enter the show. He and Henri were able to convince several other members of the original eight not to exhibit, but, in spite of this opposition, Davies and Kent had success in marshaling their forces. John Marin, Julius Golz, Guy Pene du Bois, Glenn O. Coleman, John McPherson, Maurice

Prendergast, Alfred Maurer, George B. Luks and Homer Boss all contributed works. Kent was represented by fifteen paintings and twenty-four drawings, while Davies submitted a somewhat lesser number.

Opening night of the exhibition, called by the press "Kent's Tent," was well attended, but Kent saw little of it. George Luks, always boisterous and frequently drunk, had begun his celebration early in the day; by the time Kent arrived Luks had gathered a circle of onlookers to regale with wit and obscene stories. The other painters were unhappy about this distraction from their art, so Kent and John McPherson carried him home to Mrs. Luks.

The show was an impressive display of contemporary art; attendance was large, if not overwhelming, and critical reception was favorable. *Vogue*, in a long article, went into the history of the exhibition and finished by describing the show as "an unusually uniform one, even in tone and quality, and most entertainingly divergent in theme. . . . These painters have things to say, ideas to express, despite style, and with bravery and with youth in art, if not in age, are determined that they shall be expressed." The only area in which the exhibition could not be considered a success was financial. Only two paintings were sold.

The products of the Academy still dominated the marketplace. Buyers of art were too conservative to purchase the type of work, realistic in technique and often depicting a prosaic or unpleasant scene, that Sloan, Bellows, Kent and their fellows produced. Illustrative of the problems faced by these men is a struggle that occurred over one of Kent's Berkshire pictures, *Men and Mountains*.

It was sent to Columbus, Ohio, in 1910 as part of a large show of contemporary art organized by Robert Henri. The scene was a grassy hilltop against a background of mountains, and an ominous cloud-filled sky. In the clearing were two naked, wrestling men. Even though only the back of one of them was exposed, the directors of the show were so offended by this nudity that they attempted to ban the painting. It was only when Henri threatened to withdraw the whole exhibition that they relented and allowed it to be hung in a separate room marked MEN ONLY. Also banned, for a time even from the "Men's Room," was George Bellows's *Prize Fight;* the peculiar argument was advanced that since prizefighting was illegal in Columbus, it would be breaking the law to show a painting of that criminal act. It is obvious that more was involved here than the statutes of the state of Ohio.

Though Kent's painting had a classical motif (the struggle of Hercules and Antaeus), the depiction of unclothed bodies was considered in "bad taste" and seen as a threat to morals. Bellows, dealing with a grubby, sweaty scene that lacked even the socially redeeming feature of classical allusion,

MEN AND MOUNTAINS (OIL)

was viewed in a worse light—degeneracy for the sake of degeneracy. It is no wonder that buyers were afraid to purchase such works; established critics often denounced their themes as being more concerned with trash cans than uplift and their technique as being slapdash, hurried or nonexistent.

These economic realities had been well learned by Kent over the years, but he had even more reason to brood on them as he labored at his drafting board through the winter and spring of 1911. Kathleen's pregnancy was a difficult one. Rockwell arranged to trade a painting to the doctor in exchange for the delivery, but when the baby, a girl named after Kathleen, was born a month early, the expensive struggle to keep her alive exhausted their meager resources. The doctor warned that a summer of quiet in the country was an absolute requirement for both mother and infant.

Desperate, the young painter sought advice from Davies, who referred him to William Macbeth, a New York art dealer. To Kent's intense relief, Macbeth offered to advance him $500. Overcome with gratitude, Rockwell told him to visit the warehouse where his canvases were stored and choose what he considered to equal the money in value. Macbeth, interpreting those instructions liberally, picked thirteen paintings, including *Burial of a Young Man,* now in the Duncan Phillips Collection, *Down to the Sea* and *Toilers of the Sea.* Since many of the works had already been expensively framed, Kent realized less than twenty dollars apiece from them.

Encouraged by the previous summer's success, Rockwell decided to combine another art school with Kathleen's need for country quiet. His partner, Julius Golz, was also enthusiastic, so Kent, avoiding the disturbing memories of Monhegan, followed a friend's advice and investigated an isolated area of southwestern New Hampshire called Richmond.

He found a farmer with a huge old house who would be willing to lodge and board students. Further searching located a nearby barn that could be used as a studio. The greatest find, though, was a tumbledown, abandoned house on an overgrown farm. Kent tracked down the owner and arranged a deal whereby Kent would rebuild the house, using the owner's materials, and live in it for free.

Returning to New York, Kent worked up a glowing brochure for the summer school and had it distributed. He wrote to Golz, urging him to hurry to Richmond to help rebuild the house, then left for New Hampshire. Since the house as it stood could not be lived in, the reconstruction had to be quick so Kathleen and the children could join him.

Plans began to go awry from the beginning. Though his work was done under the hot sun, Kent made rapid progress on the house. Golz, however, had not joined him. "Julius has not yet come. He seems to be quite unrelia-

ble." The results of the brochure were disappointing; only six students responded, and of those only three stayed. When it became obvious that the school was not going to be a success, Golz decided to drop out and take a job as director of the Columbus, Ohio, Museum of Art.

The summer of 1911 was an unhappy time for the Kents. Neither Rockwell nor Kathleen liked the tame New Hampshire landscape of fields and third-growth timber. Its bucolic charms were lost against Kent's memories of the smashing sea at Monhegan and the stark, dramatic beauty of Newfoundland. The lack of attractiveness for Kathleen was compounded by their isolation; the nearest town lay four miles away. She also did not appreciate the insects, birds and snakes that found their way into the uncompleted house.

But the most trying part of the summer for Kathleen was Rockwell's attempt to have Janet and her newborn son, named Karl, become part of their household. Mother and child visited the Kents at Richmond; Rockwell wanted them to stay, wanted them all to become one big family. The attempt failed. The women did not like the idea, really did not like one another. Kathleen's shy innocence was irritating to the more sophisticated Janet and, though Rockwell had insisted that she could, Kathleen complained, "I just can't love Janet." Kent felt he had done the right thing, later bragging to his sister, "I tried to do what Shelley would have done."

After Janet left, Kent sank into self-pity. He wrote her often. "A dozen times a day I have shaken my fist at these tree-covered hills. . . . That satisfaction that one feels standing at land's end is forbidden here . . . at the top of every hill there again spreads out the same endless panorama of green." And he mourned, "We poor banished children!"

Kent poured his unhappiness into his painting. He painted the sea, and, at a time in his life when he had met an unprecedented series of rebuffs— failed love, failed ambition, failed school and unsalable art—he turned his back on reality and Realism and produced a series of allegorical paintings that were never exhibited. He also lost himself in reading German literature, particularly the prose writings of Richard Wagner and Carlyle's translation of Goethe's *Wilhelm Meister*.

Unhappy as the Kents were in New Hampshire, they hated the idea of returning to the dirt and noise of New York. Rockwell, wanting to move west, wrote to an architect friend in Spokane about employment, but building there was at a standstill. The Kents reluctantly made ready to return to the city; Rockwell left first, to find an apartment.

CHAPTER FIVE

WINONA

I cannot live entirely outside myself—I have only myself for the
measure of things—I have only intelligence and a simple faith in
beauty wherever I find it—and I am as faithful as a dumb animal
when I know what I am faithful to. . . . Personally I hate life and
love living.
 —MARSDEN HARTLEY TO ROCKWELL KENT

. . . if I am killed off by the roughness of the life or by the attacks of
the police or as punishment for killing an oppressor, I'll die at all
events knowing that my cause was a good one.
 —ROBERT PEARMAIN TO ROCKWELL KENT

While searching out a suitable home for his family, Kent stayed in the studio
of the mural painter Barry Faulkner. He wanted a place in Greenwich Vil-
lage, which, because of low rents and a sense of isolation from the bustling
city, was entering its first full bloom as a haven for artists, radicals and bohe-
mians.

We have seen how Kent, when an undergraduate at Columbia, had
been filled with such Christian moral fervor that he would stop prostitutes on
their rounds, give them money and urge them to go home. So completely
had he changed that now he felt sexual virtue to be only a product of fear.
He decided to experiment, to test his new theory by visiting a prostitute.

As he strolled through the evening crowds, Kent began to reconsider. He
was repelled by the streetwalkers' overpainted looks, their loud voices and
rude manners. Just as he had given up the idea, he came across a fresh-faced
blond girl standing shyly on a street corner. While Kent watched, she refused
several men who talked to her. Challenged and attracted by her selective-
ness, he approached and started a conversation. She was Finnish, a recent
immigrant with small command of English. They talked for a while of Fin-
land, her delight with the cheap, gaudy jewelry in a nearby display window,
and her job; she worked during the day as a laundress, at such low wages

that Kent was shocked. He finally asked to go to her room; she asked what he would pay. "But that is too much," she naïvely burst out when he told her.

They had walked only a block when a man came up and put his hand on her shoulder. "You'll have to come with me."

"And who are you?" Kent asked. When the man showed a badge, Kent bluffed. "She is my wife."

The detective was unmoved. "Easy enough to prove in court."

"All right, she is not my wife. What will happen to her?"

The officer said she would probably be fined ten dollars. Kent, to the astonishment of the detective, gave her the money. As she was taken off, he reflected on the injustice. *He* had approached *her*. He had instigated the whole encounter, yet she had been arrested. Off to night court he rushed.

The case did not come up until long after midnight. As he watched, girl after girl was given a heavy fine or a jail sentence. When the Finn's case came up, the judge was unsympathetic to Kent's attempted explanation. "Are you her pimp?" he demanded. Fear had made the girl's English unintelligible. Ordering her held in jail, the judge postponed the trial until the next night, when an interpreter would be available.

Rockwell had made plans to visit a friend in the country, but he broke the engagement to return to night court—"It was the only manly thing to do"—where he found a different and more understanding judge. When the case was finally called Kent was allowed to speak—indeed, was invited to sit next to Judge Corrigan and quietly explain what had happened. On his recommendation the girl was given a suspended sentence and released. Though virtue might be a product of fear, there were still moral responsibilities a man had to meet.

In late October 1911. the Kent family moved into a large flat on Perry Street, in Greenwich Village. Kent had become well known for his architectural rendering, and was in demand not only at Ewing and Chappell, where he had received a raise to thirty-five dollars a week, but also with other architects, for whom he would work on his own time.

Architectural drafting and rendering are demanding arts. The drafting of an elevation or working drawing requires exactness of line, lucidity and attention to detail. Rendering calls on more subtle and persuasive skills; the architect's bare lines, his abstraction, must be seductively fleshed out and made real for the client. Kent defined a renderer as "one who by a bit of pretty watercolor work makes any kind of architectural design look like a million dollars." To excel at both tasks, one must combine a talent for precise, stringent clarity with a color-filled, sensuous imagination. Kent, as both perfectionist and world-loving romantic, excelled. But the only value he saw

to these accomplishments was economic; the amazing speed with which he worked meant that he could support his family, though not on a grand scale, yet still have time for what he saw as his true profession.

Though the income from his labors was adequate for the frugal vegetarians, they found it almost impossible to save much. Economical not only in food but also in entertainment, the Kents would spend their free evenings playing music and singing, or visiting with close friends like the talented artist Marsden Hartley and the younger painter Robert Pearmain, whom they had met in New Hampshire.

Kent, always needing to be physically active, played a great deal of sandlot baseball, often with former teacher Kenneth Hayes Miller. Enjoying the eclectic bohemian atmosphere of the Village, he put much of the rest of his bounding energy into the most fitting symbol of the time and place: the irreverent, irrepressible *Masses*.

The *Masses* had been started in 1911 by Piet Vlag, with money supplied by Rockwell's old mentor Rufus Weeks. Though a radical publication, it had no ties to any particular party or dogma. As John Reed and Max Eastman wrote in a statement of its philosophy: "[It is] a revolutionary and not a reform magazine; a magazine with a sense of humor and no respect for the respectable; frank, arrogant, impertinent, searching for the true causes; a magazine directed against rigidity and dogma wherever it is found...." It printed drawings, cartoons, poems, stories and essays by writers and artists such as Art Young, Floyd Dell, Cornelia Barns, Stuart Davis, George Bellows, Louis Untermeyer, John Sloan, Mary Heaton Vorse, Robert Henri and Glenn Coleman. Kent, too, submitted cartoons and drawings, and urged others to do the same.

As often as possible he sat in on Henri's classes to draw the model. Frequently he would walk home with a young student, Maurice Becker, who showed Kent some of his work. "A man who draws as well as you do," Kent said, "ought to be drawing for the *Masses*." Becker took his advice; before 1912 was over he had become one of the magazine's contributing art editors.

Though happy with his family, and enjoying his friends' companionship, Kent was increasingly disturbed by the way his life was slipping by as he worked at a job he didn't like, cramming his painting into spare moments. He was turning thirty and he needed a change.

The opportunity for at least a geographical change came that spring of 1912. The architectural firm of Lord, Hewlett and Tallent, aware that Kent had had both architectural training and practical building experience, asked him to move to Winona, Minnesota, to represent it during the construction of two large houses they had designed. Kent accepted immediately. They were going west.

Winona, in those days a small manufacturing town of fifteen thousand people, lies on the west bank of the Mississippi River in southeastern Minnesota. The construction job had been undertaken for a Mr. Prentiss, a banker, and a Mr. Bell, who headed the local lumber mill. Their wives were sisters, and the families were very close—so close that they were jointly settling on Briarcombe Farm, an estate of several hundred acres located in the bluffs four miles out of town. The houses were to be twin Georgian mansions joined by an arcade.

The Kents found an abandoned schoolhouse to rent, close to the building site, but so small that the family must have had difficulty living there. Live there they did, however, for the first five months they were in Winona.

Rockwell bought a half-wild, coal-black gelding to ride. The fiery-tempered beast, named John Brown after the great abolitionist, came close to killing his owner several times, but actually succeeded only in breaking Kent's arm and destroying the family carriage. For the young roughneck it was exhilarating; he loved the challenge of keeping J. B. under control, and the danger in riding him. The pair became well known through their merciless and never-ending struggles to dominate each other, and their local fame waxed even stronger when they ran away from the whole field of racers at the county fair.

Kent had been sent to Winona to ensure that the architectural plans were followed by the builder and that economic corners weren't cut. Since that did not take up much time, the firm had him open an office in town. Kent followed their directions, but after a few weeks, when no business came his way, he closed down the office and spent his free time painting, riding John Brown, and, much to the shock of Prentiss and Bell, vending fruits and vegetables from a wagon to earn extra money.

The summer of 1912 sped by. Though his time was not completely his own, he was in a new, interesting part of the country with more opportunity to paint than he'd had in New York. Through an intense correspondence with his two dissimilar friends, Marsden Hartley and Robert Pearmain, he kept informed of the political and artistic struggles being waged on more active fronts.

Pearmain, slender, dark-haired, handsome scion of a wealthy New England family, had become a friend the summer before. A painter, he had married Nancy Brush, daughter of George de Forest Brush. They had been staying at the Brush house in Dublin, New Hampshire, while Rockwell and Kathleen were in Richmond.

Kent was still held in great disfavor by Thayer and Brush because of his sexual adventures, but Pearmain defied their opinion and walked the long distance to meet Rockwell. Through their discussions of art, politics and sex-

ual mores the two men became close. Pearmain reported that the Brush and
Thayer clans were in an uproar over the first visit, but that "After having
more than a week in which to think matters over since last I saw you, my
personal attitude in your direction is precisely the same as when I was with
you." Other young friends like the poet Alan Seeger felt the same way: "Mr.
Seeger . . . the boy with the hair, seems to have taken quite a shine to you in
spite of the reports."

Pearmain, product of the upper class, was going through a crisis of be-
lief similar to the one Kent had suffered in Tarrytown. Now Kent, older and
more experienced, helped guide his young friend, just as Rufus Weeks had
supported his own conversion. The Pearmains had been frequent visitors to
the house in Greenwich Village, where Robert and Rockwell had debated
radical tactics. Pearmain at first thought he would dedicate himself to amass-
ing a huge fortune, to be used to ameliorate the suffering of the working
class, but Kent argued him out of the idea, explaining that one would con-
tribute a great deal to the misery through the very accumulation of a for-
tune. When Kent left for Minnesota, Pearmain was advocating a moderate
Socialist position.

Through letters, Pearmain kept Kent informed of his activities and his
changing politics. With the idea of later working in the logging camps, he
journeyed to the Adirondacks to enroll in Biltmore, a forestry school run by a
professed Socialist, but he discovered only hypocrisy. "I found that the old
fakir's whole principle in his school's teaching was to preach against . . . sci-
entific lumbering and that he believed that each timber owner should cut his
timber so as to realize the largest immediate profits without any regard for
the future yield or for the condition in which he left the land . . . even
though he left it in a state where a fire would invariably get a start within a
few years." Leaving in disgust, Pearmain toured the mountains, viewing the
scenery: "It was superb and the forests quite met my fancy." He visited the
logging camps, distributing radical literature and meeting the workmen. "I
came across an Albanian revolutionist, solitary and lonesome for the sympa-
thies of fellow troublemakers, and we had long talks. . . ." He also got drunk
for the first time in his young life. "I did it purposely and drank all I could,
but the trouble was I put in too much of a mixture. Don't ever do that. Stick
to one line of booze. . . . God, I was sick!"

As Pearmain traveled, listened and studied he discovered the extensive-
ness of the struggle. "Things are very interesting . . . all over the world. The
impending trial for their lives of Giovanetti & Ettor at Lawrence, & of
Haywood, Trautman, Hayes etc. for inciting to riot. . . , the San Diego, Aber-
deen & Spokane fights between bosses and labor men of all kinds, the coal-

strike troubles, Tom Mann's arrest in England, newspaper strikes, New York hotel strikes, etc., etc., are all absorbing my attention."

Class lines were clear and sharp in 1912. There were the capitalists like John D. Rockefeller, J. P. Morgan, and their minions, who controlled entire industries or sectors of the American economy. There was the middle class, which was composed of small-scale entrepreneurs or professionals, who feared both the strength of the economic giants and the potential power of the working class. And there were the workers themselves, harassed, poverty-stricken immigrants speaking a multitude of tongues, or native sons and daughters forced off the farms and into factories, mines and mills.

Their misery was both real and apparent. There were no social programs to provide relief, nowhere to go for help, no food stamps, no welfare, no unemployment insurance; even the right to organize unions was not recognized without a long, tough struggle.

The political movement that arose from these conditions was strong but diffuse. The Socialist party in 1912 had 118,000 members throughout the country; Eugene Debs, their perennial candidate for president, that year gained six percent of the vote. But the leftist coalition contained many disparate groups and competing organizations. Large but relatively unfocused, it tried to incorporate elements from the middle class, workers and children of privilege like Kent and Pearmain.

In New York Pearmain entered into the very heart of this movement. Margaret Sanger, Emma Goldman, William Trautman and Alexander Berkman, among others, became associates or admired friends. The respect was reciprocated. Berkman, recently released after spending years in prison for the attempted assassination of the steel baron Henry Clay Frick, called Pearmain "a most unusual product of American conditions & a most inspiring sign of the times . . . a real fighter & a noble soul." Margaret Sanger, to whom Pearmain was particularly drawn, was probably also thinking of him when she once complimented Kent: "I think it takes the blood of the aristocracy to bring about the biggest revolution. Everywhere, when they are once convinced of a thing—they act magnificent."

With a group of friends Pearmain attended the May Day parade of 1912. "There were about 30 or 40 thousand marchers . . . Socialists, IWW men & labor unions. There were many Anarchists among us too, and the speeches we heard from men of all kinds of social beliefs were great. The most powerful speakers were those who advocated unions on industrial lines, such as the IWW."

It was to this group he was most attracted. The Industrial Workers of the World were militant, rowdy, colorful and run by true workers. They

were very different from the relatively tame Socialists and the often elitist Anarchists. The IWW was organizing all over the country: farm workers, the lumber industry, textiles, steel. Believing that craft unions played into the capitalists' hands, they wanted all workers to belong to "The One Big Union."

As the son of a rich Boston banker, Pearmain had to take certain steps before he could really feel part of such a group.

> Nancy and I now plan to drop all advantages that we have by virtue of the money that we receive and by our social position, in order that we may put ourselves out among the wage-workers and be in the thick of a movement which we believe should come from the workers themselves. We don't care about becoming leaders, nor do we feel we are making any sacrifice, because we believe that the workers (the unskilled and skilled) are the most deserving of the people and the finest, and we think it best to throw in our lot with them, taking their trials, sufferings, and persecutions along with them, and joining them as mere individuals in the great fight for freedom.

The Pearmains were ready to turn their backs completely on their former lives, "damning to the goddamnedest hell & puke all our previous associations, aspirations, social society friends, etc.," in order to join this new movement. "I want to experience unemployment, prison life, strikes & all the forms of life which make up a worker's & a down-&-outer's existence. I'd like to run a whorehouse if I could." He was prophetically aware of the dangers: "& if I am killed off by the roughness of the life or by the attacks of the police or as punishment for killing an oppressor, I'll die at all events knowing that my cause was a good one."

So infectious was Pearmain's enthusiasm that he carried with him friends like fellow painter Barry Faulkner and family, including his staid New England father-in-law. "Mr. Brush, for 20 years an extreme conservative in the Socialist Movement, I have so convinced that yesterday he was discussing on his own initiative a new weapon for killing & throwing consternation into police or soldiers who molested strikers & for use in case of civil war."

Because Kent shared so many of his political views, Pearmain felt the need "to justify myself in your eyes for my premeditated act, because I thought you would understand." Kent did understand, but wrote him not to expect gratitude from those he hoped to help, and not to expect to find "intellect, glory and romance" in the poorer classes.

During the same months that Pearmain was writing these letters so full of revolutionary enthusiasm, Kent was receiving equally enthusiastic word

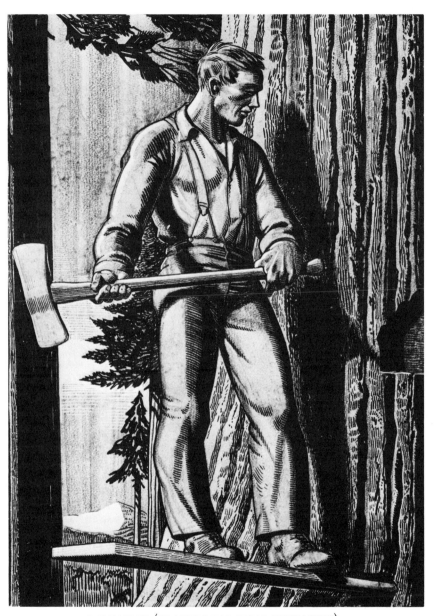

THE FALLER (DRAWING FOR WOOD ENGRAVING)

from another New England painter, Marsden Hartley.

Hartley was born in Lewiston, Maine, in 1877 and spent most of his youth there. His parents, English immigrants, were so poor that he was forced to quit school at the age of fifteen to work in a shoe factory. Later the family moved to Cleveland, where, while working in the office of a marble quarry, Hartley took art lessons. It was through diligence, talent and luck that he managed to become an artist; he came to the attention of a rich patron who provided funds that allowed him to study and live in New York City.

There he entered into the struggle against the conservative art promulgated by the National Academy of Design. Though he knew Robert Henri, John Sloan and other members of what came to be known as the Ashcan School, neither he nor they were strongly drawn to each other's work. Hartley was more interested in the avant-garde approach of Alfred Stieglitz and the group that gathered around him at 291 Fifth Avenue.

Kent had met the tall, hawk-nosed esthete while organizing his Independent exhibition in 1911. Hartley had become a constant visitor to his Greenwich Village apartment; indeed, so regularly were his meals taken there that he advised Kathleen on what dishes he preferred and how best to prepare them. He enjoyed being involved in what he perceived to be ideal domestic bliss, an ideal denied him because of his homosexuality. "Kathleen and the sweet babies; I have read no lovelier poem, I have heard no lovelier song, I have seen no lovelier picture than that which you have offered me so generously with open heart." He felt he knew and appreciated women. "[Kathleen] is purely an intuitional feminist who is doing exactly what any real woman should do—be a mother as often as she can. . . ." And he encouraged Kent: "You at least are not denied this particular beautiful aspect of life and you are very capable of appreciating it."

He wrote from Maine: "I shall make a big try for a season in Europe. . . . I want to see things and get in touch with modern art . . . to get an idea of the aesthetic movement over there. . . ." Stieglitz found another financial sponsor for the poverty-stricken artist and by the summer of 1912 Hartley was enjoying the benefits of the Continent. "What is fine in general is the nearness of art circles—owing to the nearness of countries. . . ."

He settled first in Paris. "I go to the Trocadero considerably, instead of to the Louvre, for it is among the gods one finds art. . . . In the Trocadero are the great collections of comparative sculpture which are splendid and it is from these wonders in stone and clay that I get most in the way of strength and simplicity." The reputation of Paris he found overstated. "Whatever Paris may have been as an art center it is nothing now—for there is an im-

mense tendency toward dissension which . . . does destroy the idea that Paris
is the place for art." Also disappointing were "the Frenchmen—alas for their
degeneracy are most pitiful to look upon."

Hartley's talent and reputation gained him entrance to the artistic com-
munity of Paris, and it was there that his enthusiasm was finally sparked.

> I was at Gertrude Stein's yesterday looking at her collection of Pi-
> cassos and Cézannes—and I assure you this man Picasso is a wonder.
> He is unique in the world at this time for his depth of understanding
> and insight into the inwardness of things. . . . He is . . . absolutely silent
> himself—teaches nothing—has no art theories whatsoever—and is a
> simple quiet Spaniard with a love for work. . . . Just now he is doing . . .
> things of a most abstract psychic nature—things which are in them-
> selves pure expression—without subject matter in the accepted sense
> yet full of subjective realism.

The American felt that his own style was due for a change. "I had in-
tended going to work after several days of doing nothing owing to certain
spiritual metamorphoses taking place. I have felt the need of stopping for a
time as I shall have a different sort of thing to say soon and I want to be
ready for it inwardly. . . ." Kent was wont to chide friends for being "unin-
volved" in social issues, and he may have so pricked Hartley. Whatever the
reason, Hartley felt a need to present and defend his beliefs. "I personally
can allow myself no other obligation than being true to myself. . . . My scope
is not great enough to be absorbed in other than inward issues. . . . A man
lives entirely for himself I have always believed. . . . Personally, I hate life—
and love living."

The change Hartley had felt due in his work was later met with approv-
al by his friends. "I am making a real success in my new field of expression
and am told by critics in Paris (as well as laymen of all sorts) that it is a new
development and that I am on the right road. . . . As for subject matter it is
entirely subjective from a mystical vein." Gertrude Stein was particularly ap-
preciative. She told him that he was "the first since Matisse in his early ca-
reer to give color its real significance and as a result [Hartley's paintings]
were the most refreshing that she had seen in Europe in a long time. . . ."

In spite of this encouragement he did not feel at home in Paris, nor was
he comfortable with the French love of rationality. Hartley took what he
wanted from the clear, cool, logical approaches of Fauvism and Cubism, but
what he felt he truly needed was to discover a style that allowed freer rein to
his strongly felt emotions and deep mysticism. He became good friends with
the circle of German painters who gathered at the Closerie des Lilas; through
them, Kandinsky and other members of the Blaue Reiter group learned of

his work. "I have an audience there at once among the modern Germans who understand mystical or subjective qualities . . . while the French are dense to it." He was tired of the "art game" in Paris and would go "gladly to Berlin to live where life is a lovely thing in itself, where mankind is healthy and beautiful and has more of a soul than I could ever discover in France in a lifetime." He knew that many would criticize such a move. "Of course the military system is accountable for many things—and to some this military element is objectionable—but it stimulates my child's love for the public spectacle—and such wonderful specimens of health their men are—thousands all so blonde and radiant with health. . . ."

Robert Pearmain had never been robust or healthy. He had joined the IWW planning to work as an organizer in the lumber industry, but "Big Bill" Haywood, the charismatic, one-eyed leader of the Wobblies, convinced him instead to head for Pittsburgh, where the union had recently received some severe setbacks. He left New York in midsummer of 1912 and, to save money, walked most of the way to the Iron City. Though he arrived pale and weak he immediately took a job in the Westinghouse Electric Plant hauling heavy loads of equipment and helping to organize his fellow workers at the same time. William Trautman, a leader in the Pittsburgh fight, was worried about Pearmain's poor physical condition and advised him to seek clerical work, but Pearmain insisted that if others had to do hard physical labor he would too. His strength seemed to return somewhat and Trautman was happy to see him looking hopeful and more fit at a large demonstration in Kennywood Park. Pearmain was actually operating solely on enthusiasm. As he wrote Kent, "The place is just seething with revolution. Every man I have met so far is a socialist." There still was no question as to his allegiance. "The IWW boys are the best of all. They're crude but they've got good hearts and they are really 'red'. . . . We are trying to pull off a general strike next month."

Young, idealistic and eager, Pearmain put his energy wholeheartedly into the struggle, but his body could not stand the strain. After several weeks he collapsed at the plant, but refused medical help. With the little money he had he bought a ticket that took him partway home to Boston. He tried to finish the trip on foot, but again collapsed. His family was finally called; he was rushed home and to bed, but it was too late. Unknown to anyone, he had been suffering from leukemia. He died on September 28, 1912.

Kent was heartbroken, and his grief was probably not assuaged by Hartley's reaction.

And you told me in your last letter of Robert Pearmain's death. I was shocked to hear it a few days before from Seeger the poet. . . . It is too sad all this—I often think illuminations are not good without ac-

companying logic to execute them rightly. Robert's idea was certainly permeating his youth and frail body. . . . Visions are so full of peril when not logically understood . . . but one must always have reverence for the pure idealist even if the ideal departs greatly from one's own. . . . It is a pity that a little larger insight might have saved him for the growing needs of his family. So my dears—I must stop now and go . . . and meet my good German friends. They have invited me to somebody's studio for a flowing bowl which is probably to be "toute la nuit"—for it is somewhere over in Montmarte.

Kent possessed both Pearmain's fierce sensitivity to society's flaws and Hartley's belief in the importance of art. He had extensive, deep contact with the working class; he knew the burdens under which it labored. At the same time he was critical of the ignorance and crudeness he found there, the lack of "intellect, glory, and romance." Though recognizing the moral claims of the struggle, he still reserved a part of himself. Kent understood the reasons behind Pearmain and Hartley's dissimilar approaches to life and art; both outlooks struck responsive chords in him, both affected his own actions.

Nancy Pearmain wrote to Kent about Robert's death, ending her letter, "He was your friend to the last." But Pearmain had really been more like a younger brother, and Kent had been partly responsible for his radicalization. Older, poorer and with a growing family, Kent could not follow exactly the same course, but he did join the IWW. Winona, like most small towns, did not have great reserves of tolerance. Physical threats were made, rocks were hurled through the Kents' windows, the water pipes in their house were sabotaged, but still Kent spoke his mind.

The Kent family was always near the financial edge, but in early 1913 their need for extra income became even more pressing. Kathleen was pregnant again. They had decided against settling permanently in Winona, so Kathleen took the children and returned to New York to have the baby. Rockwell stayed in Minnesota to supervise the final stages of the construction project and, in an unusual move, he also, being a skilled carpenter, joined the local union and became a member of the building crew. The additional money was sorely needed.

After Kathleen left in March of 1913, Kent began spending a great deal of time at the house of Alex Geckler, a fellow worker from the building project. Geckler and his two-hundred-pound wife were Germans and Socialists. It was a great opportunity for Kent to refresh his knowledge of the tongue he so loved. "Nothing but German is ever spoken. We sang student songs, talked, drank beer."

There were many Germans working in Winona, and Kent visited their homes, attended their parties. He was impressed with their depth of culture,

their knowledge of social and political issues. "They're so different from our working class." Hartley had written, "I always remembered your love of German and German songs—and I know you would be happy among them. . . ." This love of things German combined with his sorrow over Pearmain's death and moved him to a decision. "I am . . . determined that we shall go to Germany." It was not just a visit he had in mind. He was so disappointed with the social policies of his native land that he could consider a permanent break. "Why should we not emigrate for good?" He wrote Kathleen to start studying German.

While in Winona, though, he stayed busy. Ensuring that the architectural plans were followed, carpentry and partying took only part of his time. Finding a client that needed a house remodeled, Kent designed the addition and painted a decoration for it. "It's really good fun to do my own architecture." He also played for hours with the neighborhood children. So forceful was his personality that he would be remembered by them for decades. "He was the first guy who could bunt," recalled one old admirer in 1971. As he wrote Kathleen, "Just think—besides cooking for myself, I carpenter nine hours and superintend besides, play ball in the half-hour at noon, make drawings for Lord and Hewlett . . . and paint pictures."

In May of 1913 he was given an opportunity to display those pictures. Of his two patrons, Bell and Prentiss, it was Mr. Prentiss to whom he was closer. Bell, like most of Winona's establishment, was angry at Kent's political organizing, and viewed the balding young radical as impertinent, if not downright dangerous. Prentiss was more tolerant, feeling a great deal of affection for Kent, and it was under his sponsorship that the town library, with its beautifully proportioned rotunda, was made available for the exhibition.

PAINTER OF FAME WORKS AS CARPENTER, the local paper headlined a lengthy article. People came to view the show, but didn't know what to make of the unconventional canvases. One visitor did appreciate them. "You are a great painter," the small, intense man told Kent, shaking his hand. He turned out to be Carl Ruggles, conductor of the Winona symphony, who was to win fame as a composer.

This exhibition, though met with indifference, may have served as some small consolation for not being invited to exhibit in the Armory Show organized by Arthur B. Davies. Kenneth Hayes Miller wrote him, "I was astounded to hear you had not been invited to send to the International Exhibition and cannot conceive of the microscopic smallness of mind that left you out. . . . The newspapers gave your name . . . as one of the prominent exhibitors." Kent's anger was probably all the greater for hearing Miller's opinion of the show. "It was like setting off a blast of dynamite in a cramped place—it

blew everything wide open. I feel that art can really be free here now." This feeling of rejection added to his desire to leave the country.

For the time all he could leave was Winona. He and Geckler had been a great team, spreading Socialist ideas to the local workers. "During the day we talk much socialism on the job and most of the men are 'seeing the light.' Alec is grand at that business." When his fellow workers decided that they were not being paid enough Kent became their spokesman. Negotiations with the construction firm broke down, and a short strike ensued before the wage demands were met. Frances Lucas, the Prentisses' daughter, remembers that as being the first strike ever in Winona.

Now it was time for him to return to his family in New York. As a farewell he threw a huge picnic for all his friends, and designed a banner to hang over the table: GRAND INTERN. WORKINGMEN'S ANTI-BOSS CONVENTION. In June 1913, a few days after the farewell celebration, he returned east for what he hoped was a brief stop before journeying farther.

FRUSTRATION
AND ESCAPE

In all fields, hostilities are softening into antagonisms; antagonisms
into disagreements; disagreements into diversities. Creeds are melt-
ing down into poetic conceptions; prejudices are evaporating.
— RUFUS WEEKS

I assure you I want to be investigated and either shot or be left
alone to do my work in whatever privacy I choose.
— ROCKWELL KENT

In New York, Kent reluctantly returned to work at Ewing and Chappell. He
was, as always, dissatisfied there but more than ever he needed money; just
before he had left Winona, Kathleen had given birth to their third child,
Clara. Rockwell felt like an escaped prisoner, recaptured and brought back
in chains. He began to wonder if they could ever save enough money to
leave the United States.

Some office boredom was relieved through the usual pranks and practi-
cal jokes, and he did enjoy the major job of the season: the design of the re-
cently established Connecticut College for Women. Kent was not the sort of
man to sit quietly and draw the creations of others. When his own sense of
design was offended by a feature or even a complete approach, he would, of-
ten to his employers' irritation, make his feelings known. When he found his
ideas for the Connecticut College job being ignored by Ewing and Chappell,
he went directly to Dr. Seitz, founding president of the college, and argued
his case. Some of his contributions were accepted, and Seitz was so impressed
that he later wrote to ask him to organize and head the school's art depart-
ment.

It was around this time that his painting received an impetus; he ac-
quired a dealer, Charles Daniel, who had but recently established himself in
the business. Kent designed and oversaw the conversion of a rented loft on
West 47th Street into an attractive gallery for Daniel, who soon represented

some of the finest painters of the time: John Marin, Benn Benn, Abraham Walkowitz, William Glackens, Charles Demuth, among others, quickly joined him there. Daniel had a genuine interest in Kent's work and made an energetic effort to get it before the public.

While still a boy in Tarrytown, Rockwell, with another youth, had handwritten and illustrated several small books for the enjoyment of family and friends. Now, during the fall and early winter of 1913, Kent tried his hand only a bit more seriously at a field that would later bring him fame and moderate fortune.

Fred Squires, architect and classmate of Kent's at Columbia, wrote a series of amusing stories for an architectural magazine, and asked his friend to illustrate them. In early 1914 they were published as a book, *Architectonics: or Tales of Tom Thumbtack*. Kent had done the job as a favor, in haste, with no time to do truly good work, so he did not put his name on it, but he did enjoy putting the three-hundred-dollar commission into his savings.

Those savings grew all too slowly. That he was leaving New York there was no doubt, only when? And the longer he stayed in the city the more he wondered where would he go? He had originally decided Germany was the place he longed to be, but more and more often his thoughts returned to Newfoundland, the stark bare beauty, the cold, the simple lives of the fisherman. A final decision was made: Newfoundland.

In October 1913, he approached Charles Daniel with a proposition. If Daniel would pay Kent $200 a month while the artist and his family lived in Newfoundland, all works produced there would belong to the dealer. Daniel was hesitant but promised to consider it. Rockwell informed Kathleen, "While he is not yet ready to commit himself to any definite promises, he assured me that a part of my expenses he would definitely pay." Kent worked hard the next few months to save as much money as possible. He also worked on Daniel, trying to convince him that the Newfoundland proposition would benefit them both. But, whether Daniel cooperated or not, Rockwell had made up his mind to leave New York.

While waiting he, as usual, found time for painting, and for socializing. He designed the scenery for a musical, *Come to Bohemia*, that lasted only a night or two on Broadway, and he often took an active part in New York's own "Bohemia," Greenwich Village.

Kent's attitude toward the unconventional lifestyles flourishing in the Village was mixed. He certainly was no exemplar of most of the virtues termed "middle-class," but he no longer felt completely at home with the intellectuals, artists, radicals and poseurs that gathered at places like Mabel Dodge's salon.

"Last night for me wasn't very gay. The crowd was at Mrs. Dodge's but Mrs. Dodge was not there. And Emma Goldman wasn't either. The rest were for the most part 'intellectuals' of the worst type. Lincoln Steffens spoke and then a long discussion followed. It became perfectly driveling in its intellectuality. The right thing to say kept turning itself over in my mind 'till I had to say it. It cleared the atmosphere and gave everyone a good laugh. So I was very well satisfied."

What Kent said to "clear the atmosphere" was probably that the discussion bore no relationship to reality, that the group was thinking in abstractions not based on experience, and that instead of talking they should be "doing." Kent, though well read, was not interested in abstractions that were not firmly tied to application. The ideas he was interested in were ones that had an immediate use: Spencer on education, Tolstoy on the social responsibility of art, Kropotkin tying evolution to the need for social cooperation. Kent's experience as a workingman no doubt added an edge of arrogance to his pronouncements, and it could be that the "good laugh" that everyone had was in part directed at his posturings. He spent the rest of the night talking with Marsden Hartley, who was "pleasantly intoxicated . . . I was delighted with him. I drank but I couldn't have warmed to that crowd."

By February 1914 he was ready to leave all the irritations of New York behind. Daniel first pledged support, then withdrew the offer at the last minute. Kent's mother promised him fifty dollars a month, and he decided to go. With that amount plus income from whatever paintings Daniel sold, they would be able to survive. Kathleen and the children were left to follow as soon as he found a place for them to live.

The boat trip was exciting. For two days and nights they "ploughed through fields of ice . . . one to two feet thick." When St. John's was reached the "harbor was frozen across so thick that the steamer had to butt her way, coming to a stop, backing up and then ramming the ice again."

As soon as the boat was safely docked, Kent started asking about suitable towns. He was told that Brigus, an old sealing port about forty miles from St. John's, would have inexpensive housing, and that "the country there about is . . . beautiful and of just the rugged character that I'm looking for." Once a prosperous home port for ships sealing in the Arctic, Brigus had fallen on hard times when the introduction of steam-driven vessels had allowed the trade to be concentrated in the capital. Along with other east coast ports, Brigus suffered a decline in fortune and population.

Kent was happy with what he found there. Only a few hours by rail from St. John's, it was located on a small inlet at the head of Conception Bay, giving it unparalleled views of the sea and of steep cliffs. Since many of the

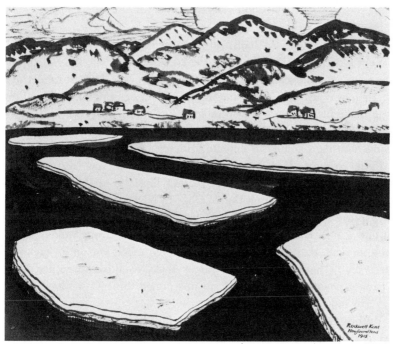

ICE FLOES, NEWFOUNDLAND (PEN AND INK)

residents had moved away, there were houses available at low rents. Kent found an abandoned mansion that he at first thought could be restored, but it turned out to be too far gone. "So instead of living as the aristocracy of this place, we descend to the plane of humble cottagers. Our house is tiny and I must build a wing to it . . . and it is in the farthest outpost of the town."

The house was not only tiny, it was dilapidated. Hiring a local carpenter to help, he quickly began the rebuilding job. The walls were stripped bare, rotten wood replaced, holes patched, then repainted. There were only four small rooms, so the artist built an attached studio that was just big enough to hold an easel, table and chair. He found, neglected in a yard, an old figure-head from a sailing ship. Receiving permission, he restored her faded beauty and set her above his cottage door, eyes gazing out over the sea toward the horizon.

Reconstruction of his house was delayed because his tools, which he had shipped separately, had sunk with the S.S. *Sydney* during a gale. Even more important to him than their practical value, he lamented to Kathleen, was the fact that many of them had belonged to his father. He sent telegram after telegram to the steamship company imploring that every effort be made to recover them. He was elated when divers finally brought up the

black walnut chest and the tools were returned to him.

Kent soon made friends among the Newfoundlanders. Most of the local young men were off sealing on the ice floes, but every day old-timers would make their way up to his cliff-clinging house, either bringing food and small gifts to make his life more comfortable or just wanting to bask in the unseasonably warm sun and talk. Rockwell would walk to the village to spend his evenings visiting, playing his flute and singing German lieder for his hosts.

Kathleen wrote him of terrible storms raging in New York and of her worries over how much worse the weather must be for him so far north. Ironically, for most of March the weather in Newfoundland was warm and sunny; spring seemed to have arrived early. But at the end of the month, as Kent and a new friend, Robert Percy, walked home from Sunday evening church services, they noticed the fresh crescent moon low on its back in the western sky. "That's a bad moon," said Percy. "We'll have weather, for you can hang a powder horn on it." Kent questioned this folk wisdom. "I never knew it to fail," Percy assured him.

Within twenty-four hours snow was falling; soon after the wind was blowing at hurricane force. It beat at Kent's exposed house so severely that he was forced to take shelter with the Percys. As the storm grew more ferocious everyone's thoughts turned to the sealing ships and their men. Word came that the Southern Cross was in exposed waters. "It's a hard chance she's got in this," said Robert Percy. The family sat around the stove and talked of past tragedies: ships lost, men injured or dead trying to wrest a living from one of the world's harshest environments. On Wednesday a rumor spread that the entire crew of the steamer Newfoundland, 160 men, had frozen to death on the ice. Kent's horror was not diminished by the later report that put the loss at 80 men. Nothing more was ever heard of the Southern Cross.

The storm lasted for several more days, then died. The sun returned, the eight or nine feet of snow melted, but Kent did not forget. Having shared the Newfoundlanders' sorrow and admired their courage, he felt he had found a place he could settle in permanently and happily.

At the end of April, Kathleen and the children joined him at the small cottage. Though they lived far from the center of town they had an active social life, visiting with friends and singing at church sociables. The Kents had developed a wide repertoire in their years together: Scottish and Irish songs, American folk songs and, of course, German songs. Rockwell also made himself useful around town, tuning the minister's piano and painting signs for stores and the local bank.

The American spoke on socialism to the poor but generous and proud

RESCUE IN NEWFOUNDLAND (INDIA INK)

Newfoundlanders. He was astounded by the prevalence of beriberi, caused by the lack of an adequate diet, and the need for weekly delousings of his own children's heads. He asked Rufus Weeks to send pamphlets and books on the Socialist movement for distribution in Brigus. Weeks immediately complied, and urged Rockwell to pay close attention to what his friends had to say. "Nothing is so vital as firsthand information about the working-class mind." Impressed by the detailed and evocative letters his young friend was writing, Weeks urged him to try his hand at magazine articles and short stories. "You could do that kind of work along with your painting—they are so different that each would be a relief from the other."

Kent had always written, on trains and streetcars, in free evenings at home, and during his youthful attempts to form a philosophy. Those jottings had been for his own needs. Now, encouraged by Weeks and other friends, he tried to present and interpret Newfoundland to the world. He wrote a political analysis, "In the Land of the Fisherman," and a story on the recent disastrous storm, "A Tragedy of Newfoundland." Both were sympathetic depictions of the harsh living conditions on the island. To match their subject they were written in a dramatically heroic prose that was, unfortunately, less readable than his letters.

Although the pieces were rejected by various magazines, Kent continued to write, and even tried poetry. Kenneth Hayes Miller liked his work, and for a while tried to place it; finally, however, he turned against the idea of Kent writing. "Your poem will find a place I am sure and I hope you will not cease sending it until it does. Nevertheless if I should bring my thought to the surface, 'but don't write more, do that thing on canvas.' The most splendid energy can do so little in a lifetime set to only one kind of effort."

The relationship between teacher and pupil had deepened over the years. While studying in New York, Kent had found Miller, with his emphasis on an exalted form of craftsmanship, a needed corrective to Robert Henri's disregard for technique. Miller shared with Kent a love of baseball and of books; their correspondence is filled with references to both. They also shared a common view toward art and life.

Miller, along with Kent and Henri, believed in the primacy of the latter. "I can't accomplish 'living for art'; I live for *living* and the art can only be a product of living . . . painting does not make a complete life for me. . . ." He also played a role in turning Kent's appreciation to seemingly barren environments. On a trip to the deserts of western America, Miller wrote, "And nature here is free from the silly charm of leafage. She is nobler being *naked* and not so simperingly benevolent." The elemental quality gave clarity. "In the East, the landscape confuses me by its lack of simplicity, but here there are two masses—the earth, embossed and powerful, and the sky. And I admire Nature for her want of complaisance toward men." Several times he urged Rockwell to explore the West, confessing "All that space out there haunts me, a kind of nostalgia, continually."

Miller was a Realist, but of a Romantic bent. He wrote Rockwell of his striving for "an extension of consciousness deeper into the mystery which is life, and which life is." Albert Pinkham Ryder, Miller's close friend, was his guide to the native American tradition of realistic fantasy. Though Miller wrote Kent that "Poor Ryder is himself an ancient ruined temple: the altar fire is out," the fire had really been passed on to him, and for a while from him to Kent. Many of Rockwell's paintings during these years show the influence of Miller's blending of symbolic fantasy with realistic technique.

Spring and early summer of 1914 passed peacefully for the Kents. There were money worries, but everyone they knew had those. Rockwell spent much of his time hiking the lonely coast, sketching and painting. He also competed in a sport popular in Brigus, tennis. Since the only court was a bit of uneven pasture, Kent and some friends organized a tennis club, leased land on which to build a proper court, then labored for days to level and smooth it.

When the court was ready for play they found they had been betrayed. The lease had been a verbal one. Personal animosity had broken out between Hearn, the owner of the land, and several members of the club, so Hearn decided to break the agreement. Like the others Kent was furious, and decided on a scheme that he thought would solve their problem: he would terrorize Hearn into granting them permission to use the court.

Once again his hot temper combined with self-righteousness to lead him into trouble. He gave no thought to the consequences, since he knew he was in the right. He and his friends had been made fools of, and that could not be tolerated. Hearn was unpopular. Pushed by Kent's sense of outrage, the other club members agreed to help.

One day in July they met Hearn at the railway station as the landowner was returning from a trip. In front of a crowd of witnesses—for everyone in town had heard what was to happen—Kent collared him, then dragged him to a carriage manned by an accomplice. The plan was to take the man to a local doctor's office and, before cases of scalpels and other slivers of cold steel, to frighten him into signing the lease. Unfortunately, the accomplice panicked and drove away, leaving his leader standing in the dusty road clutching the victim while club members scattered like quail. Kent quickly pulled Hearn into the railroad agent's office. There, in front of the jostling crowd that had followed, he told the terrified fellow that he, Kent, had killed many a man before and would not hesitate to continue his life of crime. This bullying went on until the railroad agent stopped it.

Kent went home apparently thinking that the "practical joke" was over and would be forgotten. Three days later he was served with a summons to appear in court to answer charges of assault. Since there were so many witnesses, there was not much to be done but admit his guilt and submit an explanation that it had been a joke. The judge may or may not have seen any humor in it. He did give Kent the choice of thirty days in jail or a fine of five dollars. Kent paid the fine.

While this episode did not win the painter any friends, even bigger troubles were on the horizon. That summer the assassination of Archduke Ferdinand, heir to the Austro-Hungarian throne, set in motion forces that had lain dormant in Europe for decades. By August 1914, Britain and her empire, of which Newfoundland was a small part, were at war with the German-speaking peoples.

Discretion had never been Kent's strong point and the bandwagon was not his favorite mode of transportation. He came across a quote that summer which seemed to him the definitive statement on modern warfare. It was from a speech given before the German general staff by the American Civil

War hero Philip Sheridan. "The proper strategy in war," the general said, "is to inflict as much suffering as possible upon the civil population of the enemy. They should be left with nothing but their eyes to weep with." His love of German culture added to his horror at the thought of what the conflict meant in terms of human misery; he spoke his mind. As patriotic feelings rose, so did voices. When challenged with the statement that British troops would soon be in Berlin, Kent sarcastically replied, "Oh, well, I'm not sure the English will reach Berlin in a fortnight. Perhaps it may be even a year or so."

Small provincial towns don't take easily to strangers at the best of times. Kent's personality, a combination of charm and abrasion, had made him friends in Brigus, but he had also alienated a good portion of the population. Now he was seen not only as a roughneck and a bully, but also as someone with decided sympathies for an enemy civilization.

Suddenly his activities were seen in a new light. Why, if he was an American, did he speak and read German so well, and why did he know so many German songs? Why did he spend so much time tramping the hills along the coast? What had been in that locked chest he had been so anxious to recover from the wreck of the S.S. *Sydney*? What went on in that little room he had added onto his isolated house? Why wasn't anyone allowed in there? Why had he laid in such an enormous amount of coal?

Rumors supplied all the answers. He was *not* an American; he was really a German spy making charts of the Newfoundland coast. The chest had contained a radio, now set up in his "studio," by which he kept in contact with U-boats, letting them know when to sneak in and take on supplies of coal.

Kent at first laughed at these suspicions, then, as the whispers grew louder, he became angry. Over the door to his studio he nailed a sign, decorated with the German imperial eagle, reading: BOMB SHOP, WIRELESS PLANT, CHART ROOM. He spoke out even more forcefully to the locals on the merits of Germany, and he wrote to friends in the United States expressing his views. Some of his letters, among them those written to his old drinking companion and fellow Socialist agitator Alex Geckler, were in German. In one of these he wrote, "What will the censor say to this?" The day after he mailed it a police officer appeared at the house, ordering Kent to appear before Inspector General of Police Sullivan in St. John's for examination.

The inspector general made his point briefly and clearly. Kent was to stop his German propaganda. Rockwell responded hotly that under British law he had a right to voice his opinions. The interview ended with the magnificently mustachioed Sullivan bellowing at him, "I'll show you that the po-

lice are stronger than the law." Kent was ordered to prove his American citizenship by providing birth records. Later, when he tried to ship the painting *Portrait of a Child* to Charles Daniel, officials refused to let it leave the country, alleging that charts of forts and coast defenses were cleverly concealed among the lines that formed the child's face and body, and in the mountain background. Only after an exhausting bureaucratic battle were the necessary permits given.

It is hard for us, after having fought two savage wars with Germany, to appreciate the important role that nation played in America's intellectual life. For generations of writers, artists and scholars, Germany served as both example and training ground. This was particularly true for those of the left, for it was in Germany that the Socialist movement was first successful. It is understandable, then, that many of Kent's friends were in agreement with his stand. Alfred Stieglitz, Kenneth Hayes Miller and others wrote him letters of support.

Rufus Weeks also wrote to Rockwell of the war, and the effect he hoped it would have on the class struggle. "The mental subservience of the working class is the most fundamental evil in the world today; it is the source of all wars. . . . It is just possible that the present awful war will prove the shock needed to shake the working class of Europe out of their stupid sleep."

Kent, however, found it difficult to see any good coming out of the conflict. His sense of depression is evident in his paintings throughout the fall of 1914 and the winter and spring of 1915. With the exception of *Portrait of a Child*, a picture of his daughter Clara lying asleep under a starry sky, his work in Newfoundland reflected extreme anxiety and despair. *Ruin and Eternity, Man the Abyss, Newfoundland Dirge*, and *The Voyager Beyond Life* are the titles of some of these canvases, but perhaps the best known is *The House of Dread*, showing a woman in an attitude of hopelessness before a house on a cliff above the sea; it is his own house in Brigus that is depicted. Suffering harassment for his views and suspected of being a German spy, he found his love of Newfoundland and his affection for its people turning to bitterness; but still he held on.

The artist did receive some support from his remaining friends in Brigus, and he also contacted James S. Benedict, American consul in St. John's. "I *do* claim the privilege of holding and expressing my views within the limits of the British Constitution." He assured the consul that he was not a spy, though a "strong admiration for the Germans, coupled with my wide knowledge of their language leads me to wish a limited victory to crown their struggle." He asked the consul for help, but there was not much Benedict could do.

MAN ON MAST (PEN AND INDIA INK)

Added to this worry were money problems. Daniel, slow in sending payment for items sold, explained that he was hard pressed himself, that no one was buying paintings. "Because of the depression in business there is no money for luxuries." Soon, though, Allied war orders caused an economic boom. In January 1915 the dealer wrote with some good news. "I believe the worst is passing. I have made some sales . . . *Portrait of a Child* and a Monhegan picture. The buyer is Mr. [A. J.] Eddy the Chicago collector." Also sold were some drawings, and chances looked good for more sales in the future.

News of the New York art world was passed on from time to time. "The Ass'n of American Painters and Sculptors of the Armory Show has split apart. Henri, Sloan, Luks, Jerome Myers, . . . du Bois . . . and a few others have resigned. What is at the bottom of it all I don't know, but it seems to be Radicals (Davies, Walt Kuhn, Walter Pach, etc.) and the Conservatives (Henri ·((irony of fate)) and the others) pulling in opposite directions." Daniel, for one, did see some good coming out of the war. "It would not surprise me if this war would kill off most of the important work in Europe for the next few years, giving the American artist a rare opportunity to take a commanding place in art."

At this time it was discovered that Kathleen was pregnant with their

fourth child. While the New York sales helped, the Kents' finances were as insecure as always. Connected to this economic need was an incident that took place in the summer of 1915.

Karl, Rockwell's illegitimate son by Janet, had been in poor health from birth; in early 1915 he died. When Kent learned of this he wrote Janet, who had married, a letter expressing his grief. A short while later he was contacted by a Boston lawyer named James Dennison. The man who acted as trustee for the money Kent had given to support Karl had proven unreliable. Dennison, called in to oversee the trustee's bankruptcy, knew the details of the case and thought that what was left of Kent's money should be returned to him. Rockwell wrote to Janet and asked her to agree to the transfer. She was willing, but her husband was not. In May, Kent was called to Boston, where a trial was held to determine the merits of his case. A compromise was eventually reached, and part of the money was returned to him.

After several weeks in Boston, and before the issue was resolved, Rockwell had to rush back to Newfoundland because of Kathleen's pregnancy. There were dangerous physical complications, exacerbated by tension arising from the government's harassment. After being delivered of a baby girl, Barbara, on June 7, 1915, the mother was required to stay in a St. John's hospital for several weeks while Rockwell looked after the children. He found it an arduous task and missed her sorely. "I'm without anchorage here when you're away." He was ecstatic when she returned.

But the happiness he felt in anything was blunted by his new dislike of Newfoundland. "I can't bear the *thought* of Newfoundlanders now." The suspicion and harassment had taken their toll: his work showed the strain; Kathleen certainly felt it; Rockwell's stomach began bothering him and he spent much of his time in bed. His reading concentrated on the lugubrious: *Wilhelm Meister* an uncounted number of times, and Andrew Lang's translations of the Greek tragedies. As the pressure mounted, his stubbornness increased to match it. He felt he had a right to express his opinions no matter how unpopular they were. Though he knew his mail was being read by the authorities, he continued to state his views in letters to friends.

In May of 1915, however, he had gone further than just writing to friends, with a letter published in *The New Republic* expressing strong hostility toward the British and toward the British colony in which he found himself. The letter ended with a wish that any reader of the magazine who found himself in a little, far-off German colony would write his story. "I wonder whether the provincialism there is of such a kind that he is driven by it to pray God for the enemy to come, capture, transform, and annihilate that sterile land."

This was probably the final blow to the government's restraint. Perhaps he was a spy as some claimed, perhaps not; he *was* an inconvenience. In July the American consul wrote Kent, "I have been advised by the Deputy Minister of Justice of Newfoundland that you are expected to depart from this Colony not later than . . . Saturday the 31st instant; and he has asked me to notify you accordingly."

Kent was furious; he vowed to continue the fight from the States. Kathleen was relieved; finally the harassment would be over, finally there would be peace and a quiet place to recover her health. After a one-week postponement, granted because the children were suffering from whooping cough, the family, escorted by a policeman, boarded a steamer for New York.

Back to the United States. The trip which had started so hopefully seventeen months before had proved a failure. Now penniless with four ill children—the youngest of whom was barely a month old—and a wife still weak from giving birth, Kent found himself once again on the streets of New York. Friends came to his rescue.

George Chappell gave Rockwell his old job back at the architectural office and secured a cottage in New London, Connecticut, where Kathleen and the children could recuperate. Charles Daniel found temporary lodging for him in the studio of the artist Maingault. Kent immediately began an elaborate, and ultimately fruitless, campaign against the British government, demanding recompense for the costs of his hasty departure, and an apology.

August and September of 1915 were spent working again at his drafting board and looking for a place to settle the family permanently. The search centered on Staten Island, for Kent knew the family wanted open space. "I have found one old house that belonged to Aaron Burr, but the rent is $60 a month and I have found another which is not so nice but cheaper." They took the cheaper place which had a cool arbor and several acres of land. Not until after they moved in did they discover that there was a terrible stench when the wind blew from the chemical works on the Jersey shore.

George Chappell, for his and others' amusement, wrote light verse about people and their foibles, and about architecture. Kent had provided illustrations for some of the poems early in 1915 while still in Newfoundland. Building in New York entered a slow period and Kent, temporarily laid off, decided to try to find work illustrating for magazines. He took the drawings he had done for Chappell's verses to Frank Crowninshield, the eccentric bon vivant editor of *Vanity Fair*, who liked them and took several.

This was the beginning of a new career, one that would later prove very profitable. At this time it proved very frustrating. Clutching his portfolio under his arm, Rockwell would make the circuit of editors' offices, summoning

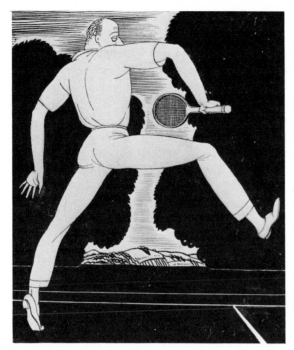

HOGARTH, JR., TENNIS PLAYER (PEN AND INK)

up all his charm and self-discipline to meet the irritations of a freelancer's life. In spite of rejections he persevered. Soon he was selling drawings to *Vanity Fair, Puck* and other humor magazines for ten, fifteen, or, very rarely, twenty dollars apiece. He also tried to sell his work to the more established and prestigious magazines, but was unsuccessful. Still thinking of himself as a painter rather than an illustrator, he refused to use his own name on what he saw as frivolous hackwork and took the pseudonym Hogarth, Jr. Between his magazine sales and occasional drafting and rendering jobs, he was able to support his family in their usual barebones style.

All of Kent's free time during 1916 was devoted to what he saw as his true purpose in life. He struggled at his painting, trying to finish the large number of canvases he had brought back from Newfoundland. Through a deliberate crudeness of technique and distortion of form, and by employing a rather heavy symbolism, they gave a vivid portrayal of the depression and anguish he had suffered in Brigus, conditions he began to see as the fate of man. He described these paintings as "a continuous wail of lamentation of man's tragic, solitary lot in the vast and soulless cosmos. . . ."

Rockwell, in spite of his travels, was never really out of touch with the art world. Miller, Daniel and Marsden Hartley had kept him informed of

new movements and entertained him with bits of gossip. When he returned to the city he renewed old friendships and made several very important new ones. Kent had attracted a great deal of attention through both his talent and his adventures; the expulsion from Newfoundland had been well covered by the New York papers, and it had made him something of a celebrity.

Gertrude Vanderbilt Whitney was, as her name indicates, an heiress of impressive lineage and fortune. She was also a dedicated sculptress. Turning her back on the glittering uptown milieu of her family, she moved to the bohemian world of Greenwich Village. In 1914, with the efficient help of her friend Juliana Force, she formed the Whitney Studio Club. Her large house at 8 West 8th Street provided exhibition space for non-Academic artists, and also served as an informal meeting place. Whitney used her great wealth generously, buying paintings and providing direct support for impoverished painters. Kent became an honored member of the Whitney circle.

It was during this period that Rockwell met Marie Sterner, who was in charge of contemporary art at the well-established firm of Knoedler and Company. She admired his work so much that she asked Charles Daniel to allow her to include a Kent painting in a show she was organizing. Daniel refused, so she borrowed *Winter*, a canvas Rockwell had given Robert Henri. The Metropolitan Museum of Art, an institution that usually ignored contemporary American artists, bought it. Henri, noble as ever, gave the money to Kent.

As a result of his reentry into the New York art world, Kent became involved with the huge Independent Exhibition of 1917, held in the Grand Central Palace. He served as the paid, full-time organizer/administrator for the eclectic show, a show that had as its rallying cry the motto "No jury, no prizes; exhibits hung in alphabetical order." This free and open attitude resulted in an exhibition of more than two thousand works of art, including one by six-year-old Rockwell, Jr. The line was drawn, however, when Marcel Duchamp, using the pseudonym R. Mutt, tried to enter a urinal as a piece of sculpture. There was a fierce argument over whether it should be accepted, whether it would be a betrayal of Independent principles to reject such a work out of hand. To Kent's relief it was finally rejected, but on technical grounds: the entry card had been improperly filled out.

Rockwell still was not reconciled to monogamy. There had been casual affairs since the break with Janet, and he was fond of shocking more conventional folk by stating, "Virtue is a sin!" To Kathleen he insisted over and over again that these affairs did not diminish his love for her, but that an artist "needed to experience all of life."

Inevitably he met a woman who was more to him than just an experi-

ence. Gretchen was German, a blond blue-eyed Follies dancer. Kent and she had passed on the street one day and, struck by her beauty, he used a line as old as desire to start a conversation. "You are so beautiful," he blurted, "I've got to speak to you." It worked; two weeks later the lovers were camping in the splendid isolation of Mount Monadnock.

The summer of 1917 brought a return of hard economic times to the Kent household. The United States entered the war, all its energy and treasure went into the effort, and domestic building suffered a decline. The part of Kent's income that derived from architecture was cut off, and he also ran into difficulty placing his illustrations. To save money it was decided that Kathleen would take the children to Monhegan to live in his mother's house while he rented a small utility apartment in New York and continued to freelance.

It seemed at first that things might work out. "I took work down to *Vanity Fair* and sold it today." Soon, however, it became obvious that bad times were not so easily overcome. "I'm earning not one cent although all my time is spent looking for work or doing things that I hope to sell. It is most discouraging." All the years training his hand and eye seemed to have been wasted. "Nothing important, financially, has developed yet. Will it ever?" Why continue the sacrifice? "I am seriously considering not painting any more or drawing for a long time—but getting a job somewhere at some other work."

Kent, like one drowning, clutched at every passing straw. He drew cartoons and submitted them to newspapers around the country. All that got him were insults. "An Oshkosh (Wis.) sheet wrote 'Oh Art, what crimes are committed in thy name!' " Finally a friend found him work drawing automobile ads. "I'm making money! $50 last night. $50 today and maybe $50 more tonight . . . Advertising!!!"

He was occasionally recalled to Ewing and Chappell to assist on architectural projects. Though the money was desperately needed the return to a dead-end job sharpened his despair. "Here I am again at the old office. How hot it is in New York—and how depressing. I do love the sea and the open sky and you and the dear children. It is pitiful to be drawn back here *away* from where I could best do the work of my life." Thirty-five years old and intensely ambitious, he could not tolerate the failure that seemed his fate. He began to question the point of it all, not just the pursuit of art, but life itself. The idea of suicide was toyed with; he sought solace and strength in the arms of Gretchen.

Kathleen, on Monhegan, was also sad and depressed. The children had no proper clothes, there was no money, she was alone. There was, of course,

another reason. "This last 'affair' has left a scar on my life that will not soon disappear." Rockwell was sorry he had hurt her. "It is, I promise you, only in spite of my best wishes that I'm untrue to you." But he made no promises about the future, except to write that as soon as possible he would visit her on the island.

Suddenly things began to open up. Through Marie Sterner, a painting was sold. The $600, paid in monthly installments, allowed him some piece of mind. George Chappell then brought him more good news. A friend and client named Tom Howell had seen some of Rockwell's work and decided he wanted the artist to "make him a decoration for his large room. I think it's settled . . . I should get $1,500 for it." In mid-September he wrote Kathleen, "In a few days I can start for Monhegan . . . I now only have to arrange with George about the decoration—its size and other details." By the end of the month he was with his family in Maine.

Kent was not a man satisfied by domestic routines and a steady job. Maine, Minnesota and Newfoundland had only whetted his hunger for travel and adventure. By early 1917 he was planning an extended trip to Iceland, home of the sagas that he loved, but America's entry into the world war cut off that possibility.

Kent then shifted his attention to the American Southwest, receiving a promise of free transportation from E. I. McCormick, a vice-president of the Southern Pacific Railroad who wished to encourage artists to paint the Apache Trail. The financial problems of the summer of 1917 required a delay, for he not only had to have enough money for his own living expenses, but it was also necessary to amass enough to care for Kathleen and the children. As his fortunes improved during the last months of 1917 he began to rethink his plans.

Painting the Southwest had probably only appealed to Kent as an escape from New York. His love was not for hot, dry climates, but for the even harsher and more dramatic challenge of cold and sea. With a letter of appreciation from Byson Burroughs, curator of paintings at the Metropolitan Museum, and aided by McCormick and John Cosgrove, editor of the Sunday edition of the *New York World*, Kent was able to promote free steamship passage to where he had decided he really wanted to go: Alaska.

Through late 1917 and the first half of 1918, Rockwell pursued every possible source of money. He labored, whenever he could, at architectural jobs; he churned out and tried to peddle his humorous drawings; he designed wallpaper; he worked at his oils; and he taught himself the almost forgotten art of painting on glass. Aided by Gretchen, he turned out glass panels and mirrors decorated with ships, stars and full-blown goddesses. Though beautifully executed only a few were sold.

Marie Sterner introduced Kent to Dr. and Mrs. Theodore Wagner of Brooklyn, a couple whose young daughter had just died. They commissioned Rockwell to make a handlettered, illustrated book as a memorial to her, and they later bought a painting. An even bigger sale took place in the early summer of 1918 when Mrs. Sterner sold *The Seiners*, a Monhegan painting, to Henry Clay Frick for $1,500.

These victories helped lighten the artist's despair, but his personal happiness was shadowed by the social madness he saw engulfing America. For one who had such a strong love of things German the anti-Teutonic hysteria that followed the entry of the United States into war was horrifying. German music could no longer be played, the language was dropped from university curriculums, sauerkraut was given a patriotic flavor by calling it "liberty cabbage," citizens of German descent or origin were spied on, harassed and intimidated into changing their names. Kent, in angry reaction, took up their defense, speaking out on the idiocy of a campaign of dehumanization directed against one of the richest cultures in Europe. For the duration of the war he fought it as best he could. "It's strange," he wrote Carl Zigrosser, knowing full well it was not, "my consistent singling out of men of German blood for friends."

A ready ally had been found in Zigrosser, the handsome young man he had met through Bayard Boyesen at Columbia. Sensitive and shy, Zigrosser was involved with the Ferrer Association, an anarchist group that had a particular interest in education. His extreme intellectuality complemented Rockwell's more fiery temperament, and they spent many evenings together lamenting the state of the world and arguing over the true purpose of art. Zigrosser, who edited the Ferrer Association's magazine, *The Modern School*, published his friend's drawings, and encouraged him to write essays.

Kent's last doubt about the possibility of his expedition ended as his savings grew. This assurance was reinforced through Ferdinand Howald, a collector and patron of the arts, who offered to advance Kent any funds needed to support the family. As the trip became a certainty Rockwell began considering the advantages of a traveling companion. Though he loved the free and the wild he did not relish the solitary. "I can't face the thought of the loneliness I'm going into." Kathleen was asked, "Can you come to Alaska with me? Will you come?" But, she pointed out, who then would look after the children? For a while he considered taking Gretchen, but finally rejected the idea. He then pleaded with his wife to be allowed to take their son, young Rockwell. Kathleen refused, but Kent pleaded even more strongly. "I know all the terrors of that impossibly lonely life. None of my past experiences have been forgotten." Even if he wanted he felt he could not back out; he needed this chance to fulfill his talent. "Never did I enter upon any

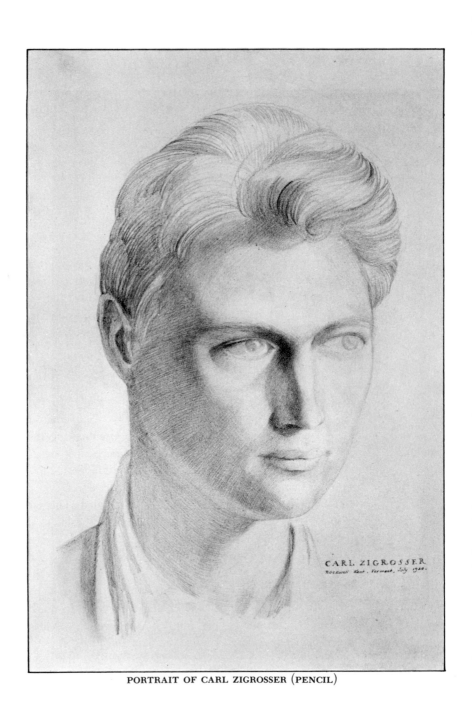

PORTRAIT OF CARL ZIGROSSER (PENCIL)

course with such a sense of necessity, of duty, as drives me into this Alaska trip." Finally, with great misgivings, she consented.

Kathleen, too, had been thinking of isolation. She wrote him from Monhegan, "I get terribly lonely for a man's protection and love, and when I feel too badly I cry out and I cry out to you, for there is no one else, but at other times I fully realize that you cannot give me the love I want—and—I cannot give you the love you want! *You have said so.*" She told him that the captain of the island mail boat was paying her court. "I'm sure you'd object to his attentions!" She put him on notice. "Please remember that it is not my fault. Please remember that I have been very patient & very devoted & faithful to you for many years."

If this ominous note of rebellion caused him unease it did not change his plans. The last job to be done was a mural for Tom Howell's house on Peconic Bay. It proved difficult, for the unseasonable cold and damp kept the painting from drying enough to be varnished and fastened to the wall. A further complication arose when it was discovered that Kent had misunderstood the desires of Howell and part of the work had to be redone. It wasn't until late July that he finished. Quickly packing, Rockwell had a farewell dinner with Gretchen and Carl Zigrosser. The next day he and his son set off for Alaska.

ALASKAN WILDERNESS

Great things are done when Men & Mountains meet
This is not done by Jostling in the Street
—**WILLIAM BLAKE**

"No! No! Thrice No!" he cried vigorously, and stroked his beard.
"I know better! There still are blissful islands!"
—**ZARATHUSTRA**

Rockwell and his nine-year-old son took a Canadian Pacific train across the northern Great Plains. The travelers were fascinated by the scenery, or rather by the lack of scenic features, and spent hours on the observation platform, returning to their car so covered with soot and dust that they looked "like stokers." "This prairie is impressive. Land so monotonously bare and flat that it suggests the infinite as the sea and sky do. . . . It's so marvelously elemental!" He found the other passengers less interesting, except for several officers returning from the front. Their stories both horrified and fascinated Kent, and he felt they more than justified his opposition to the war. When he and little Rockwell arrived in Vancouver they were accosted by a "tall, splendid-looking man in shining full-dress army regalia. . . . 'Why aren't you in the army?' " he demanded. Kent felt no shame as he lifted his hat and showed the warrior his prematurely bald pate. Pointing to his son, he said, "I have this one and three more like him."

From Vancouver the adventurers took a short boat ride to Seattle, where they boarded the S.S. *Admiral Schley* for their trip up the famed inland passage to Alaska. The spectacular beauty stunned him. "It's quite beyond anything I've ever heard about it. . . . There are inlets that seem to go straight to the foot of lofty ranges and islands in them or points of land that seem to have been made for poets or romantic painters to live upon." They spent the whole of every day on the upper deck "straight under the sky. I play my

flute there and look to my heart's content at the scenery and so pass the day to the vast improvement of my tired body and rather stupefied soul. Rockwell races his feet around the deck to see which one will reach the finish line first."

The beauty of Alaska made him sensitive to what he had left behind: family, friends and lover. He wrote Carl Zigrosser, "If I could have a very few wishes one would be for an island here and you and three or four others to come and make it paradise." It was obvious who one of the others would be. "How is Gretchen? I wish she was along. She'd love it and be the best sport in the world in tackling the hardships."

Kent's enthusiasm for Alaska did not extend to the settlements. When the *Schley* reached Petersburg, he went ashore for a quick exploration. "It is, I believe, typical of Alaska and it's the most utterly squalid and hideous collection of ramshackle wooden shacks that one can conceive of. . . . God, what a contrast! These noble mountains and primeval woods and what man has brought to them." He almost lost heart at the thought of what people were doing to the country, "but I've come to see that even this extreme of human wretchedness and commonplaceness can serve me."

Kent had been told that the wildest and most beautiful scenery along the Alaskan coast was to be found in the region of Yakutat Bay, so it was there that the two Rockwells left the steamer. For a few days the father worked in a salmon cannery to increase their small store of cash. He and his son slept in a narrow mattressless upper bunk in a cabin full of "huge and hairy Norsemen" who also worked in the cannery. The Norwegians, who seemed as fine a lot of men as Kent had ever met, gave him what information they could about the area.

For a while Kent thought he might stay at Yakutat; the mountains, forests, sea and rivers had the dramatic, wild air that most moved him. But— perhaps it was too wild; he had his young son to consider. Though he found a place that seemed right, he held back, then decided against it; since it was thirty miles up the river, provisioning would have been difficult, "And there are wolves and bears [it] would have cost me the expense of a gun."

Kent chose to travel on to Seward, where they arrived in the early morning of August 24. After registering in the Seward Hotel, Rockwell, his son and a traveling companion, Conrad Birkhofer, hiked four or five miles inland. Though the valley through which they passed was lovely, it was too tame. "I knew at once that we must choose the seacoast to settle upon." Back in Seward, he inquired about islands in Resurrection Bay, and was introduced to John E. Thwaites, the local photographer. The two men quickly became friends, and Thwaites told him about Fox Island, which had some cab-

ins, and about an old fishing camp on the bay. The photographer also advised Kent to get into the good graces of the town's tinsmith, a man named Graef, who planned a berry-picking party down the coast of Resurrection Bay on Sunday.

Kent tried to find some whiskey to take along as an icebreaker, but since Alaska was "dry," he had to settle on two large cigars. He found Graef at work in his shop; he also found him anything but affable. Kent talked and joked with the man, but was unable to break through his reserve. "In the midst of my most charmingly ingratiating attempts at conversation he turned his back and went about his business." Quickly, Kent produced the two cigars, lit his and made ready to light the tinsmith's. Graef, however, merely grunted, laid the cigar on a shelf and returned to work. The artist stood for a minute, sucking on his cigar in lonely discomfort, and considered telling the man to go to hell. Instead, he stuck it out, mentioning again and again his appreciation of Alaska's beauty, and how he had heard that Resurrection Bay held more scenic wonders than any comparable spot on earth. Either because of the charm of these effusions or through being worn down, Graef made the invitation: the Kents were to join his party.

Sunday morning dawned clear and sharp. The large group of berry pickers motored six miles down the bay to the camp of an Englishman named Hogg. While the rest of the party climbed the mountain in quest of blueberries, Rockwell borrowed an old dory from Hogg, and with his son set off to explore Resurrection Bay.

Mountains rose about the water in serried ranks, the nearest spruce-clad, others rising white and tall behind them; the Pacific gleamed blue to the southern horizon. Father and son rowed out onto the bay's calm waters, all around them a wilderness, open and free, untouched, there for the taking.

Setting as their goal a nearby shore, they started off, only to discover that they had been deceived by the clarity of the air and the immensity of scene; after an hour's rowing they seemed no closer to it. Just as they began to get disheartened, they sighted a motorboat bearing down on them. As it drew nearer, Kent could see its sole occupant, a thickset old man. They hailed each other, then sat, boats gently rocking in the blue-green solitude, as Kent described what he searched for. The old man pointed seaward to where a mountainous island loomed. "Come with me, come and I show you the place to live." He took them in tow.

As soon as the two boats rounded the island's northern headland, and Kent saw its harbor, he knew his search was over. Two high mountains flanked the entrance, their slopes falling gently to join and form a graceful ridge behind the crescent of a pebble beach. Forest ringed the little bay, and

climbed the mountains' sides. So monumental was the scale that at first Rockwell did not notice the two cabins tucked in the woods.

One of the cabins was the old man's, but the other stood vacant. It was filled with trash, odd bits of equipment and, since it had once housed goats, the floor was covered with their droppings. The old man, Olson, offered it to the Kents, and Rockwell immediately accepted. Though the cabin was small, and in need of much work to make it livable, the overall situation could not have been better. He later wrote Kathleen, "Our cabin is about 12' x 15'. The door is only 4'6" high and so is the small window. The end windows give the only light. It's rough logs inside and out, chinked with moss—only that has to be done again." Promising to return as soon as they could, the Kents excitedly bid farewell to Olson.

In Seward, Kent quickly set about purchasing what they would need for their island winter. An old, splintery dory was found for fifty dollars. Kent paid cash and the owner threw in an antique outboard, which tinsmith Graef and his assistant Otto Boehm were asked to make run. The list of stores seemed endless—beans, rice, cornmeal, farina, hominy, fifty pounds of flour, one hundred pounds of potatoes, a Yukon stove and pipe, nails, building paper—the drain on Kent's limited cash threatened his peace of mind. Still, he had to buy in large quantities in case weather kept them from making regular trips. For his work he bought turpentine and linseed oil; he had brought his paints with him, and canvas was on its way from the States.

Finally they were ready; the food, hardware, trunks, clothes, paints and books filled the dory to its gunwales. In a cool gray Alaskan fog the Kents pushed off for Fox Island. Their rackety, old outboard helped them along for several miles, but then, with a bang and a whir, it quit, leaving them drifting on the water. Through the mist Kent spotted a fisherman's shack on a nearby point. Sitting awkwardly on top of their household goods, father and son managed to oar there. They unloaded engine, gasoline and battery, then cleared a space from which to row. Row they did, nine-year-old Rockwell handling his oars like a man, for the next four and one half hours, until, exhausted, they heard the keel ground on their pebbly beach.

First they had to make the old log cabin habitable. Trash was carried to the beach and burned, the odiferous, goat-marked floor ripped out and replaced with rough-hewn boards and the roof was patched with building paper. Moss was gathered and left in potato bags near the stove to dry, to be used to fill the gaping spaces, some of them inches wide and two feet long, between the logs. Woolen sweaters, socks and scarves were stuffed in the cracks as an emergency measure.

A major need was firewood. Kent planned his tree felling carefully, in

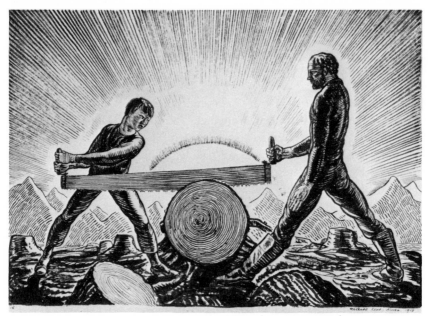

MAN AND BOY SAWING WOOD (INK ON PAPER)

order to allow more light into the small cabin windows, and also to open up
vistas to the mountains and bay. "I sharpen my axe and fell trees with such
ringing strokes that I think myself a thorough woodsman when—the axe has
slipped, my boot is ruined and my foot shows a gash that . . . lays open just so
prettily."

In spite of the dangers, Kent loved the work. "I wonder if you can
imagine what fun 'pioneering' is. To be in a country where the fairest spot is
yours for the wanting it. To cut and build your own home out of the land
you stand upon. To plan and create clearings, parks, vistas and make out of a
wilderness, an ordered place. . . . Ah, it's so fine and wholesome a life!"

Misplaced axes were not the only barrier to speedy work. "Well, it rains
and rains and rains . . . since we've been here on the island, seventeen days,
there has been only one rainless day." This led him to give thought to what
the winter would be like. "Just think, there'll be months this winter when
we'll not see the sun from our cove—only see it touching the peaks above us
or the distant mountains. It will be a strange life without the dear, warm
sun!" There was, though, a compensation. "Olson says the wind blows fierce-
ly from the north in the winter—for many days at a time. That ought any-
how to bring the clear cold weather that makes me feel so fit."

Olson worked with Kent to prepare the cabin. A Swede who had come

to America as a young man, he had lived a rough, freebooting life, mining and trapping from the Dakotas to Alaska. He had first visited the territory in the 1870s and was well known there. As he described himself, "i am noting bott an old brokendown Freunters Man. . . ." Olson's tales of his many adventures fascinated Kent, but it was for other qualities that the painter most admired him. "I have never known such a man. I'm no admirer of the picturesqueness of 'rustic' character. Seen close it's generally stupid and coarse. I have always taken all men seriously. . . . So I've seen the working class close at hand and without illusion. But Olson has such kindness and courtesy as to put him outside of all classes." Bald, short and solidly built, he was as much help to Kent as his seventy-one years allowed.

Rockwell was disturbed to learn that the old man did not plan on making very frequent trips to Seward. "He laughs at my plan of rowing in; they have an uncanny fear hereabouts of the salt water." Kent was impatient with the trapper's warnings, "continually talking of frightful currents and winds in a way that seems incredible to me." The painter felt he needed to visit the town to send and pick up the mail that was his only connection to the loved ones he had left behind. As for not being able to, "Well, I'll believe that when I try it and get stuck." Three weeks later, he and his young son were struggling for their lives as a rising gale slashed at their boat.

They had rowed the twelve miles to Seward for supplies and correspondence. When ready to return, their old acquaintance, Hogg, gave them a tow to his camp, then insisted they stay for tea. As they finally began their seven-mile row home, the weather did not seem too threatening, merely drizzle and a faint northeasterly wind. Shortly, however, squalls began marching in from the open sea to the south. For a while wind and swell were confused. Kent, recognizing the danger, made for shelter.

Heavy, dark clouds swept across the sky, turning to blue-black the green of the surrounding mountains; the sea became a bright yellow-green. Rain fell continuously; powerful squalls lashed at the water, raising a steep chop; white heads growled past. Both Kents rowed as hard as they could to windward, hoping to get far enough into the storm to turn and run downwind for either Fox Island or some protected cove, but there was little refuge available on that precipitous coast.

Young Rockwell, even though at first unaware of their danger, pulled at his oars as strongly as he could. As the wind mounted, whipping the rain at their unprotected faces, turning the steaming sea into a dangerous and nimble beast, the boy felt a touch of panic. Still he rowed, and he shouted at his father's wet back, "You know, I want to be a sailor so I'll learn not to be afraid."

Finally, Kent decided enough headway had been gained; they turned the heavy dory and made for their island, running now before the wind. Few experiences can compare with the cat-and-mouse game of handling a small boat chased by mounting seas. One moment of inattention can mean either broaching beam-on or catapulting end over end. Looking back, one watches the following sea rise high, then higher, a bit of curl foaming at its crest. This great gray mass fills the sky, rushing with feline grace and speed, seemingly intent on swallowing boat and crew alike. Instead, if properly handled, the boat lifts quickly, the wave roars under and past, the boat drops into a trough; the chase begins again.

Without rudder or proper keel, Kent had to rely on his oars to control the boat, and he was both terrified and exhilarated as the dory surged toward the island. Pushed by monstrous seas, they seemed to be within minutes of safety, but as they rounded the headlands of their cove the storm gave them a final blast of wind that careened their dory toward nearby rocks. Kent, responding quickly, just managed to straighten the boat in time. They rowed to the shore, where Olson waited with block and tackle to pull them through the surf. That night, as the gale continued to batter the island, father and son slept with their arms tightly wrapped around each other. For Kent it was the stuff of nightmares—and of art; at least one of his later works was based on that experience.

Little Rockwell proved a boon companion. The fair-haired boy not only faced up to the sea's challenges, he chopped and sawed wood, helped repair the cabin and kept in good spirits. "I never dreamed of so sweet a disposition as he has shown to have. He's touchingly sensitive and kind; loves every living thing to the very gnat that stings him."

Kent had been so busy the first few weeks providing the necessities for their winter life that he did not draw or paint, but on September 30 he recorded: "I cut more wood and at last, after one month here on the island, I PAINTED. It was a stupid sketch, but no matter, I've begun!" Later he wrote to Carl Zigrosser of his way of life and work on Fox Island. "Here I have stopped for a few minutes to note down a dramatic evening cloud effect. That's the way the day's work goes. If I'm out-of-doors at work with the saw or axe, I jump at once to my paints when an idea comes to me."

In order to provide a memento for his son, and to simplify the demands on his own time, Rockwell decided to keep a diary of their island experience. Sending the pages to Kathleen from time to time, he asked friends to stop by her place to read them. To these friends Kent also wrote personal letters, filled with more than just the details of daily life; he poured out his plans, fears, fantasies and philosophy.

Carl Zigrosser, quiet, mild-mannered admirer of Kent's spirited talent, provided a perfect sounding board for the painter's thoughts. Their shared unhappiness over the course of modern civilization had grown more intense as America enthusiastically joined the European slaughter. Kent felt "fury at a world that could mess things so. . . ." But their anger flamed to new heights over the treatment given a close friend, Roderick Seidenberg, who, as a conscientious objector, had refused induction.

The army, under whose jurisdiction he fell, treated him brutally. Seidenberg "has, after ever-increasing punishment, been confined to a dark cell, fed on bread and water and strapped upright to the door with his arms out even with his shoulders." Kent wrote Zigrosser, "But about Seidenberg! I raged! It is almost beyond belief. The cowardly scoundrels with that tender young idealist!" The artist immediately sat down and wrote the prisoner a letter of support:

"It is only by the slender thread of the endurance of such a man as you that any of us can now believe that the spirit of what man shall become is stronger than the best of what he has been. . . . Your sufferings have finally embittered my hatred of such a civilization as is in America today and of such a government and army as, in the name of Liberty, become Tyrants."

Kent proposed to Zigrosser that they publish a book about the ill-treatment given to Seidenberg and other men of conscience. They could raise money by subscription to publish it inexpensively, "but *so beautifully* . . . that wherever it appears it will be read & preserved & shown." Kent volunteered to "gladly make drawings for it without limit, letter the whole text . . . do the cover, color it—all that I can do. I'd like that to be *my* contribution to the war." And he enthused, "Carl, we could turn out a masterpiece of bookmaking!"

The barbarous mistreatment of his gentle friend was the final blow for Kent. The "people," in whom so much hope had been invested, had betrayed their own bright promise. They had joined willingly, eagerly in the bloodbath, they had become instruments of reaction, they had turned the dogs of war loose on individuals who resisted their way, though in doing so they had become, themselves, "the herd."

Zigrosser shared this disdain. "I was thinking the other day, Rockwell, about the terrible state the world is in, how the brutish greed and hypocrisy of those in power is equalled only by the sheepishness of those who are not."

What, then, should one not a member of the flock do? Was the struggle to bring a better world worth the time and effort? Zigrosser thought so. "If the few original artists and thinkers have nobler and profounder thoughts— and they assuredly do—then it behooves them to make the best plan possible

for their more sheepish brethren." Kent's thoughts went in a different direction. "Maybe we are not so deeply permeated with the culture of today that we could not throw it off." He elaborated to his friend:

> I don't like today ... I don't like our Democracy which appears to me more and more clearly as the last word in brute tyranny. . . . Why *should* one care about a world that if it recognizes him at all sees him as the exception who must be sacrificed for "the greatest good of the greatest number." . . . Why could not a man deliberately isolate himself from his own time if its ideals are annoyingly antagonistic to his own; exclude all news and gossip, fence his domain against intrusion, make of its portal the entranceway from this day in America without to eternity and the Cosmos . . . within.

In his journal, Kent wrote, "The man who wants true freedom must escape from the whole thing. If only such souls could gravitate to a common center and build the new community with inherent law and order as its sole guide!"

Kent, reading widely in his island solitude, found more amenable civilizations through his books. "A few more *Odysseys* to read here in this wild place and one could forget the modern world and return in manners and speech and thought to the heroic age. That would be an adventure worth trying!" An even more attractive world was found in a small book about Albrecht Dürer that he had originally bought for its pictures. "What a splendid civilization that was in the Middle Ages with all its faults. To men with our interests," he wrote Zigrosser, "can anything be more conclusive proof of the superiority of that day to this than the position of the artist and the scholar in the community?"

Though usually not going as far as Kent in their dreams of withdrawal, a large number of people felt the same sense of revulsion toward what they saw as a dying, though still deadly, society. Artists, writers, intellectuals, they felt themselves an elite, but one unrecognized and unappreciated. For inspiration and solace they turned to a philosopher who was himself victim of an uncaring world: Friedrich Nietzsche.

Nietzsche gave them ammunition with which to fight the conventional world:

"Too long have they been admitted to be right, these petty folk."

"Now they teach: 'Good is only what the petty folk approve.'"

And he gave meaning to their rejection of conventional virtue: "Beware of the good and just! They would fain crucify those who invent their own standard of virtue—they hate the lonely one." He assured them that the lonely one "goest the way of the creator."

To those of a religious temperament, who had lost their faith, but who still needed a guiding creed, he showed the value of creating. To artists in a culture that rejected art he gave strength and sustenance. They *were* an elect, they *were* right in pursuing their visions, even if this nation of shop-keepers could not recognize that. Nietzsche's emphasis on striving toward perfection, his support of high aspirations, fitted well with the teachings of their own ambitious, enterprising middle-class parents; but, instead of aspiring to be lawyers, doctors or architects, they fought to create new values, new art. They strove for the stars, and through the act of creation they would become godlike, they would become *Übermensch.*

Thus Spake Zarathustra exalted Kent. There was a gold band on his fountain pen for which he had long sought an inspiring motto. Zarathustra provided one; in German, Kent decided to have engraved, "Write with blood, and thou wilt learn that blood is spirit." The excitement he felt over the volume surged into his art, and he made drawing after drawing of Zarathustra. "I'd love to illustrate the whole book."

If Nietzsche gave sustaining impetus to Kent's creativity, another master helped give it form. In Alaska Kent discovered the poetry, prose and graphic work of William Blake; it had a profound effect on his thinking, and his art. Blake, too, served as an example of heroic persistence, a talent that strove for a personal vision in spite of poverty, neglect, ridicule. Kent later wrote Zigrosser, "Of what little men the world is made, what *blind* men, that having seen Blake could have denied him. Before the compelling grandeur of that work doubt is incredible." He found Blake's "French Revolution" to be "the most stupendous, the most godlike portrayal of human history" that he knew.

Kent also responded to the mystic element in Blake's work. Zigrosser, who had guided Kent to Blake, saw the Englishman as "an example of the mystic way." To Kent he added, "There are two kinds of mysticism, the moonshine and the light-of-day kind. The first is stuff anyone can turn out on moonlight nights, sentimental gush about being in tune with the infinite, silly and vague twaddle. But it is damn hard to bring out one's intuition of the unknown into the light of day, into the brilliant sunshine. To make the essence of the intangible and universal as fixed and definite and tactile as a real object, is to have *real vision.* It is all the difference between copying and creating." There was no doubt in his mind that Rockwell was a creator, and, to the bookish young man in New York the painter seemed a very special sort. "You are the only mystic I know who is also a strong man."

Kent's response was vague. "You speak of mysticism. I have never been quite sure of what it meant [but] I have no contradictory beliefs to hamper the expression of my natural and undirected vision."

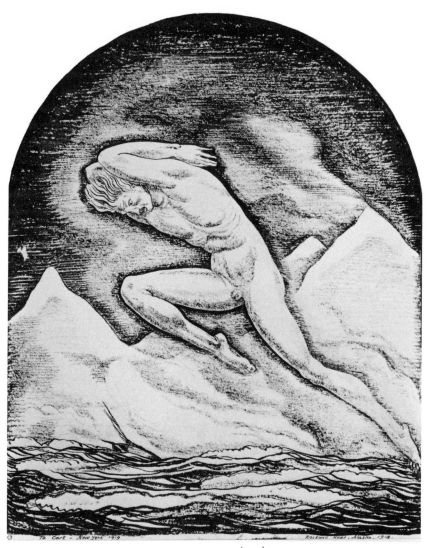

NORTH WIND (INK)

Two of his Alaskan works give particular insight into how his feelings were running. One, inspired by Nietzsche, was named *Superman*. He described this work, while it was still in progress, to Kathleen. "It is of a glorious figure striding with giant steps over the mountaintops, reaching upward to embrace all space. About him are the stars and beautiful, man-colored lights. On the dark mountainous land beneath him men are living as they do today, with slaughter and the burning of homes."

Rockwell loved the northwest wind that blew in, fierce and cold, from the Arctic. Within a month of being settled he was thinking of it as subject for his art. "I must sometime honor the northwest wind in a great picture as the embodiment of clean, strong, exuberant life, the joy of every young thing bearing energy on its wings and the will to triumph." On a map he drew of Resurrection Bay and Fox Island, all the winds were shown held under the control of Poseidon—except for the north wind which flew free and wild. The painting with which he later honored the wind shows a Blakean giant leaping over storm-tossed waves, against a backdrop of snow-covered mountains. Kent saw it as a companion to *Superman*. "It is far and away the finest thing I have done," he wrote Zigrosser.

Blake and Nietzsche filled his imagination that winter, causing his sense of the importance of art, of the artist and of himself to soar like an eagle to godlike heights. "Civilization is not measured by the poverty or the wealth of the few or of the millions, nor by monarchy, republicanism, or even Freedom, nor by whether we work with hands or levers—but by the final fruit of all of these, that imperishable record of the human spirit, Art. The obituary of today in America has surely now been written in the poor workshop of some struggling, unknown man. That is all the future will know of us."

Who the struggling, unknown man happened to be he revealed to Ferdinand Howald, the patron who had given him the financial confidence to go to Alaska. "I begin to be conscious of power—of an absolute power unrelated to anything else in the world. I begin to see a purpose to it all, a direction, and to believe profoundly in my own destiny, but with a kind of wonder *why* it happens to be I who has been chosen to carry on for a while the cloud-hidden ideals of the race." Of the egotism of this he was quite aware, "But I can only be guilty of a breach of the conventions of modest reserve. I confess I see my beliefs written with a feeling of shame—but with no less conviction I *owe* them to you—my 'backer.'"

Kent's opinion of the Alaskans had undergone a dramatic change. At first he had found them crass and boorish. "The inhabitants, aside from the natives, are here only for the money, they're that kind of people that sees no other meaning to life. From several men I've had estimates of other men

purely in terms of income. 'Why I could buy and sell that man. " But as his contact with them increased, he began to notice more positive aspects.

It's a place where people mind their own business . . . I see even gold in a new light. In Alaska it is an ideal. It's the one ideal common men can perceive. It make men live with a purpose, the gold itself, a talisman, a symbol of achievement. These fellows are no greedy city misers who amass fortunes. . . . They find and they spend, spend recklessly, crazily . . . so long as they get rid of it gloriously. Then back to seek for more. It's the adventure of looking for that priceless thing in the hard rocks or the riverbed that gets men here. I have a great symbol for Alaska. It's the *end of the rainbow*. The end of the rainbow can be any glorious place of the imagination—but it has above all the pot of gold.

In many ways Alaska and Fox Island were the end of the rainbow for Kent:

It's a fine life and more and more I realize that for me such isolation as this . . . is the only right life for me. My energy is too unchained to have offered to it the bait for fighting and loving and playing that the city holds out, without its expending itself in absolute profitless and trivial exercises . . . the folly of picking a row with some boor in a subway crowd and yet time and time again I do such things—and each time for hours after I'm sort of unstrung with rage and excitement. And here what a haven of peace!

The haven of peace allowed him to channel his furious energy into work. When the heaviest and most necessary chore of the day, wood cutting, was finished, Kent would paint from nature in order to fix the forms and, above all, the color of the outdoors in his mind. On particularly cold days he would build a fire, jumping back and forth from its warmth to his canvas. "Away from the fire it was too cold to paint in comfort. However I did stick at it. . . ." When the soft glow of daylight grew dim, Kent would retire to the cabin, subdue young Rockwell into absolute silence, then go into a trance of concentration until he would "see a composition, then I make a quick note of it or maybe give an hour's time to perfecting the arrangement on a small scale." After that he was free to fix dinner, help his son with studies or play with him. Sometimes the boy served as model. "I get him to pose for me in some fantastic position and make a note of the anatomy in the pose of my contemplated drawing. . . . Generally I have to feel for the bone or tendon that I want to place correctly."

Rockwell had done all he could to make a warm, secure home for his

son in the Alaskan wilds. The cabin had been repaired, pictures hung, the stove was kept constantly burning the mountains of wood they both cut. The boy took well to the vigorous life; he worked alongside his father, studied hard at his reading and math, drew pictures of the woods and animals. Animals were a great love of his, and he made several unsuccessful attempts to tame wild creatures. Animals entertained his father as well, particularly the otters and whales. They also provided a note of mystery. "This afternoon the whales have been on a rampage . . . there has been the boom of the whales blowing and the report of a great fin-like thing that stands high up in the water and spanks it. . . . It seems to be twenty or thirty feet long and you can imagine the noise it makes."

When weather conditions allowed, the two would occasionally make a trip to Seward. There, after they eagerly read their mail, provisions would be bought, and, while his father played the flute for hours with his friends, young Rockwell would rough-and-tumble with other children. Kent would bathe in the bread pan before these excursions, and shave his beard, but he did decide to keep his moustache. "I must," he wrote Kathleen, "have hair somewhere you know."

Often, in the evenings, Olson would come to call. He was lonely in his old age, having lived for years with only goats and red fox for company. "A story of his life would be—as an old pioneer in Seward told me—a history of Alaska." He was a rough sort of man "who, if his eye troubled him seriously, would stick in his finger and pull the eye out—and then doubtless fill the socket with tobacco juice." In spite of this toughness Kent was able to report to Zigrosser, "Olson illustrates your belief in the intrinsic human qualities. After all his rough life he's like a child."

Though weeks of labor had gone into repairing their cabin, it was still not weather-tight. The moss, so carefully gathered, dried, then tightly driven between the rough logs, shriveled with the cold. Storms forced rain through the chinks; cold breezes roamed the interior, flickering the lantern-flame, rustling the paper as Kent tried to draw, snapping the canvas he had arched as extra protection over the bed. It was there, huddled with his back to the stove, that he would work on particularly bad nights. The stove had to be kept at full roar so that their stores, stacked on shelves about the room, would not freeze.

He loved it all: the rugged demands on his strength, the fierce weather, the isolation, his son, Olson. But still his life lacked wholeness. "Paradise is far, very far from complete. I have terrible moments, hours, days of homesick despondency . . . for my family . . . there are times when if I could I'd have fled from here in any raging storm." Kent missed the other three chil-

dren dearly, but most of his pain came through feelings of guilt toward and longing for his wife, Kathleen. In the solitude of Fox Island he had time to think back over their relationship. "I have decided that with Gretchen it must be over."

Rockwell assured Kathleen that the involvement with Gretchen had not been deep, that, though the German girl had helped him when his spirits had fallen to suicidal depths, she had never really threatened his love for his wife.

Kent, a man who seemed fearless to most of his contemporaries, was prone to horrifying nightmares; nightmares where the fears he repressed while conscious took form to confront him. The possibility of Kathleen seeking revenge became his greatest torment. "I woke up last night in bed shouting . . . a man . . . had taken advantage of my absence to seduce you. . . . And you had yielded. . . . I sprang out of bed with a roar. . . ." This dream, in infinite variation, returned again and again. He warned her, "There are men who will steal a wife and deceive the husband." He begged her to write to him, "and dispell with your promises, carefully and fully made, all fear." The pain reached fever pitch when winter storms kept him from Seward and his mail: he raged, he pleaded, he fell ill—he threatened suicide. "I think for jealousy I could kill a man. No—for jealousy I could kill myself."

In spite of this despair, Kent kept at his work. Even if despondent, or sick, or seeing no purpose in the rest of his life, he had to paint. These domestic agonies did, though, temper the ebullient figures and godlike scale of his creations. He wrote Kathleen of one painting that was a return to his more lugubrious style. It was of a beach with a "view across the water at the mountains, a young day with a shining sea, in the foreground driftwood and the prow of a wrecked dory—and a woman finding it—horror-struck."

He wooed her again; he urged her, "Let's both of us be good except when we're together and then we'll be terribly bad to make up." Since he missed Kathleen so intensely, the solution he saw was for her to leave the children with relatives, then join the two Rockwells in Alaska. "If there's any way you can do it you *must* come. . . . You'd never want to go away from here. It is too beautiful! And free! . . . People have called me a mischief-maker when I have all along known that all I wanted was to be left alone. And Alaska proves that to me."

Kathleen was moved by Rockwell's letters. She, too, wanted a reconciliation, but only if he promised to change, to become less demanding, more supporting, and only if the relationship with Gretchen was truly at an end. Though missing him terribly, she refused to go to Alaska; it would be too hard on the children left behind. He should come home.

That thought had often passed through Kent's mind—but each time, in spite of his agony, he had rejected it. He had come to Alaska to paint, to do his life's real work. He had sought truth, not picturesque scenery; he had found a severe, elemental place and tried to confront it, to feel through its skin the pulsebeat of the Cosmos. Such an attempt was not possible in the tame New England landscape, and could not even be thought of in New York City. Plans had already been made for a summer expedition by dory to Bear Glacier, then up the coast, camping and painting. Returning home now would be like admitting failure. He resisted Kathleen's pleas, but they reached a pitch that frightened him.

Finally, he gave in. "I am returning. . . . It will be somewhat hard to explain this to our friends and I must ask you to let me tell the true cause . . . that you are in so despondent a mood that . . . I must return home." Kent worried that people might think he had weakened in his determination. "I'm very much ashamed of my failure and fear that my supporters will lose confidence in me." Though he missed her, "I also know that my work must be done, and nothing but such things as you have written would bring me back."

To Zigrosser, Kent poured out his frustrations. "I bitterly regret leaving this wonderful free spot—and just as the fairer weather approaches and I begin to see the true wonderland that surrounds this bay. Yesterday for the first time in many months a real calm settled on the water. . . . Oh God, how beautiful these wild mountains are with the virgin sun upon them and the blue fjords and bays!"

Not only was he unhappy over leaving prematurely, there were also the unresolved problems of money and career. "I've no idea what I'll do on reaching New York." Zigrosser, who was still editing *The Modern School*, wrote Kent that the poets Hart Crane and Wallace Stevens had praised some of his artwork that had appeared in the magazine. Stevens had written Zigrosser, "He has a bleak force fitted to express either the dramatic, or satirical or moody." But such compliments, while good for his ego, did not help him support his family. "Just think, I have been, with the most complimentary introductions . . . to every publisher and editor in the city. And from them all not one job came. I don't dare look ahead . . . for I can only see that again." The only publications that had been interested in his work were the frivolous humor magazines. "I already begin to see myself rather a ridiculous figure rushing here and there with my portfolio of ideas that nobody wants, ending finally as a comic artist for *Puck*." He wasn't sure he could face the dreadful ordeal ahead. "I have often thought it over and weighed carefully the choice of . . . quitting life entirely, and I never came to any satisfactory

conclusion. I wonder how the damned business will end."

He thought that perhaps he and Zigrosser could coproduce a children's book. "We could together get up a real book of shipwreck and adventure. My experience has been varied enough, I think, to make me quite resourceful as to incident."

But Kent's bold and creative imagination had also produced an idea that, though as American as the Model-T Ford, had never before been tried by an artist. Why not incorporate?

"I figure that I could retire to the country . . . and live possibly within $1,500 a year. Of that sum I now get from my mother five hundred. The remaining thousand I want to raise. And on paper how simple it seems. I am an indefatigable worker. And by devoting my entire time to doing my own work . . . I would do an immense amount . . . worth . . . five or ten thousand dollars. There I am, then, a valuable productive machine that cannot operate for lack of fuel. But viewing myself thus I should appeal to capital, incorporate if necessary and issue bonds to cover one, two or three years, coupons redeemable yearly with interest added. . . ."

He asked Zigrosser to get in touch with friends in law and business, to have them check out the practical details of the plan.

Kent worked hard his last few weeks on Fox Island, making studies in black and white, rushing canvases to a half-finished state so that they could be more easily completed later, noting down effects of light, the changing colors of the sea and mountains. He tried to cheer up Olson, who was disgusted that Kent was leaving without exploring farther. "You might as well have spent a couple of months back in the mountains of New York for all you've seen of Alaska," the old man told him.

Finally, in mid-March, it was time. They took down the paintings and drawings, packed the books and household goods, dismantled the inside of the little wilderness cabin that had been their home for almost seven months. Everything was carried to their old dory, drawn up on the tree-ringed crescent beach, and loaded. In a spanking spring breeze they left their cove, left Fox Island lying clean, fresh, and green, behind them. Kent had ended his journal the night before: "Ah God—and now the world again."

SUCCESS

I am a colossal egoist. . . . I am not going to do any fool, little thing.
. . . I am . . . reaching to the stars. . . . I don't want petty self-expression; I want the elemental, infinite thing; I want to paint the
rhythm of eternity.
 —ROCKWELL KENT

Rockwell Kent [is] now to undergo the severest test of all—public
success.
 —HENRY MCBRIDE

Nothing, Kent felt, could be further from William Blake's ideal of piping
down the valley wild than the stone canyons of New York City. The noise,
the dirt, the pushing crowds had always grated on him, but now, after
spending months in the quiet beauty of Alaska, these distractions took on an
almost unbearable force.

For the moment there was nothing to be done but endure. The family's
finances were as precarious as ever. Not only had Rockwell returned with
pockets empty, Kathleen had been forced to borrow a thousand dollars. Kent
was sure, though, that the Alaska trip had been a turning point, that the
work done on Fox Island would find its public, and that he would win the
freedom to make his art.

Ferdinand Howald, the collector whose financial backing had made the
Alaska trip possible, added another Kent painting to his collection. That gave
the family some desperately needed cash. Marie Sterner brought the distinguished critic Christian Brinton to view Kent's Alaska drawings. His enthusiasm was such that he offered to sponsor their showing at the Knoedler Gallery.

Knoedler proved eager for the show. Working with his characteristic
dispatch, Kent quickly mounted and framed his pen-and-ink work; the exhibition, dedicated to Carl Zigrosser, opened within a month of his return from
Alaska.

It was an immediate success. Before a week had passed most of the sixty drawings sported the little blue tags indicating that they had been sold. Rockwell, Jr., who had four drawings in the show, enjoyed his own success. All of them were bought by Arthur B. Davies.

The critical reception was highly favorable. Most commentators noticed the influence that Nietzsche and Blake had exerted. One observed, "He has turned over other despairing pages and gone out alone at night to interrogate the heavens." In spite of such profound and serious experiences this critic felt "tragedy has not as yet tinged his style, and it is impossible to be tragic over him or his work. Mr. Kent's life has not been tragic, but, on the contrary, and in spite of his own words, it has been distinctly larkish." The commendable qualities of the drawings were due, he felt, not to their profundity, but to their "pure physical exuberance," their "youthfulness, vivacity and vitality."

Pushing through the admiring crowd on opening night was a young book dealer and magazine publisher named Egmont Arens. To him the drawings seemed "a new kind of statement in art." He found Marie Sterner in the mass of people and had her lead him to Kent. Arens stammered out his enthusiasm for the works and argued that before they were dispersed to their various buyers they should be collected in a book brought out as a deluxe limited edition. He offered both his services and his press.

Kent agreed immediately, and suggested that the book contain some text. "The letters that I wrote to my wife and friends could be printed as a sort of diary."

Since so many of the drawings had already been purchased it was necessary to have the engravings made while the collection was still on exhibit. They were taken down a few at a time, rushed to the engravers, then returned before they could be missed. This work was still in progress when Kent's old friend and fellow practical joker George Putnam heard of it.

He, after years spent in Oregon as a journalist, had just joined the family publishing firm of G. P. Putnam's Sons. Impressed by both the drawings and Kent's prose, he asked Rockwell to reconsider his plans and publish the book not in an elaborate limited format but as a regular trade edition through his company.

Arens, who felt the book merited the wider distribution Putnam could give it, unselfishly stepped aside and allowed Kent to make the new arrangement. It was decided that the book should contain more text, so Kent gathered not only his letters to Kathleen and the children, but also borrowed those he had sent to Carl Zigrosser.

Kent had been so busy, in the weeks since his return from Alaska, that he had not been able to make long-term plans. In the slight pause before he

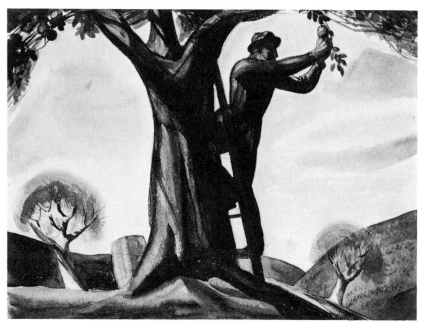

MAN PICKING APPLES (WATERCOLOR)

began assembling his book, Rockwell and Kathleen made a decision. Using money from the Howald sale, the Alaska show and some borrowed from his mother they would leave the city.

A farm in the Green Mountains of Vermont was what they wanted. Not knowing the region well enough to have a particular section in mind, they decided to travel through by train and stop where it seemed loveliest. Looking eagerly from the windows, and making constant reference to topographic maps, they steamed slowly north until they sighted Mount Equinox rising over Arlington.

By good luck they met a couple who gave them great help and encouragement in their search. John Fisher had been in Kent's class at Columbia; his wife, Dorothy Canfield, was a well-known writer. They took Rockwell and Kathleen under their wing, putting them up, giving them advice and driving them along the country roads until, high on the southern spur of Mount Equinox, the perfect place was found.

It was an isolated spot, and the farmhouse was small and decrepit, but it was what they wanted. "It's more beautiful than any place I've ever seen! There are fertile fields, orchards young and old, high hillside pastures, noble groves of maple, hickory and pine. The verdant valley lies like a map below us." There was only one problem; the price of three thousand dollars was one

thousand more than they had. When Kent told the Fishers their reason for not taking it, Dorothy Canfield laughed. "We'll let you have the thousand dollars. Now buy the place."

The purchase took all of Kent's recently earned money and put the family back into debt. By this time they were used to poverty. They spent little on clothes or entertainment, their food was simple. But they needed money now to run Egypt, as the farm was called, and the children were growing and needed more of just about everything. Kent, turning forty, was tired of living on the financial edge.

The seed Kent had planted while in Alaska now bore fruit. Putnam and Zigrosser had actively sought out patrons who would be willing to invest in Rockwell Kent. He was in good health, energetic, talented and quick at his art. The Knoedler show proved that there was a market for what he produced. All he lacked was capital.

Juliana Force, of the Whitney Studio Club, had been approached, but Kent was afraid that personal problems might cause her to refuse. "She compelled me . . . to offend her in a way that we are told a woman never forgives. . . ." Whatever feelings of rejection she may have suffered were overcome, and she became a shareholder in Rockwell Kent Incorporated. The other shares were also easily disposed of. Four thousand dollars in stock was issued, half of which went to Kent, "in return for good will, patents, equipment, etc." Juliana Force held $1,000 worth; Caroline O'Day, suffragette and later congresswoman, invested $500; George Putnam took the remaining shares.

As "general manager" Kent was paid a salary of $2,000 a year in monthly increments of $166.66, plus "necessary expenses for the administration of the manufacturing plant." In return, the proceeds from "artistic products" became the corporation's, and at the end of every fiscal year, if there were profits, a dividend of twenty percent was to be paid. In the event of a net loss the shareholders were privileged to choose "Kent products of market value to balance the account." The artist designed a beautiful stock certificate featuring a heavy-laden apple tree. It very quickly produced a harvest. In January 1920 he sent the corporation, as fruit of his labors, almost $1,500. Within a short time he bought out all the investors.

Once his economic needs were satisfied it took Kent only a few weeks to write the Alaska book. He isolated himself from all distractions, then went through the journal he had kept for his son, supplementing it with material from his letters to Zigrosser. By September he was able to write friends, "My book is in the hands of the publishers." Putnam was pleased with it and required only that he cut, as a sop to the still strong anti-German prejudice, two lines from a German folk song.

The book done, Kent set to work on his two major tasks: making livable his ramshackle farmhouse and preparing his Alaska paintings for a show at Knoedler's in March of 1920.

For the fifth time in fifteen years Kent found himself refashioning a house. "Again I'm jacking up sagged timbers, leveling old floors, laying new ones; ripping out the worn-out, building in the new. . . ." The house was too small for the Kent brood, so he cut down part of a nearby stand of red oak— "that's pretty hard stuff to cut,"—to use in building an addition. An old French-Canadian logger showed him how to use a broadax to form the oak logs. Kent then squared them and cut the mortise and tenon himself. He finished the reconstruction quickly but, with the help of Egmont Arens, Carl Zigrosser and a hired man, labored on the extension over the next year. Arens later wrote, "After a day of back-breaking labor Kent would knock off, cook dinner for us, and after dinner we would sing and tell stories until about eleven. Then Kent would sit down and draw for about two hours. After the most exhausting physical exertion, Kent's hand did not tremble in the slightest degree. Next morning he was up at five as usual; and we kept this up until I for one had to go home and rest. I couldn't stand the pace."

From his local hired man, a combat veteran who had been disillusioned by his European experiences, Kent collected tales of French degeneracy and German heroism. "Often I wonder if with all my one-sided pro-Germanism I've been half pro-German enough," he wrote Zigrosser. He had a hard time containing his self-righteousness. "I'm always wanting to say 'I told you so.' "

Using his large, drafty barn as a studio, Kent also labored at his paintings. They had been taken off their stretchers at Fox Island, rolled carefully and shipped to New York. Somehow the shipping company had misdirected them, and it took several anxiety-filled weeks before they were located. Once they were returned, Rockwell remounted them, repaired damages, retouched and repainted them and completed those that had been left unfinished. He struggled to recapture the clear, sparkling quality of Arctic light. "I'm working all the time now at painting and drawing. Sometimes I'm happy and sometimes depressed. On the whole I think my work is going well— but there's a picture of dawn that I'm desperately concerned about this minute. When a thing is wrong and you don't know why—it's awful." There were, though, times when Kent was excited by his skills. "I've made fine things of North Wind (Energy) and Superman (Will)!"

Rockwell struggled with his brush and paints to communicate that mystical sense of union with nature that he had experienced in Alaska, but he tried to present it through paintings rendered as realistically as possible. "Great art," he wrote Zigrosser, "has always the weight and form of material reality." Weight and form, but also something intangible. He had already

chosen a quotation from Dostoevski to use on the cover of his exhibition catalogue. "Life is sweet, dear! And that it's a mystery makes it only the better; it fills the heart with awe and wonder; and that awe maketh glad the heart. Do not repine, young man; it is even more beautiful because it is a mystery!"

That winter was a happy time at Egypt. Rockwell was absorbed in his work, he and Kathleen were together, the children had their father back. They all loved farm life, though it meant a round-trip walk of three miles to school. The family entertained itself by making music in the evenings, and reading. Loving theater, they also appeared, as a group, in a local patriotic drama about the post–Revolutionary War period in the Green Mountains. "My wife was the heroine and I suppose I was the hero. Little Kathleen . . . looked very pretty and she surprised the audience by turning somersaults all over the stage. Rockwell was an Indian. We've given it in two towns before full houses. It's all Prohibition here but I had a flask full of Irish whiskey in my pocket and drank out of it all through the show. The audience thought it was part of the play and supposed it to be some kind of make-believe drink."

There was an occasional tremor, a moment now and then when Rockwell felt a sense of loss. "I can't think of Fox Island without being a bit homesick," he wrote Olson. But he found that the rolling beauty of Vermont could also renew his spirit. "I really think that every time and forever that I stand on these hilltops I'll love life again as if it were all glorious."

Working around the clock, Kent finished his paintings by the end of February. Braving the heaviest storm of the winter, he managed to get them to New York, where their frames, made by fellow painter Max Kuehne, were waiting. The show was hung the night before it was scheduled to begin.

"The moment the doors were open," Henry McBride wrote in the *New York Sun*, "the gallery was filled with the same old crowd of whispering, awestruck sensation-mongers that one saw there last year when Kent first came back from the frozen north. . . ." Mr. McBride, like many critics, felt that success was dangerous for artists. He warned Kent not to read the reviews, "for all of them will be laudatory." His own review certainly was favorable, but he did perceive "the two very different spirits that are still struggling for the possession of Mr. Kent's soul. . . ." In spite of the mystical nature of some of the paintings, McBride argued, "Mr. Kent is still a Realist. I think he has a brain that stores up facts and that detaches itself from facts with the greatest difficulty. Mr. Kent interprets, but he interprets realistically."

The show was a qualified success; reviews were enthusiastic, the gallery was constantly crowded, but sales were not up to Kent's ambitious hopes. He explained to friends that it was "an unfortunate season—just the time of the

income-tax returns—and no one was spending money." There were positive side effects from the exhibition. Kent's reputation as a wide-ranging artist-adventurer was firmly established, and a proper mood of expectation was set for the appearance of his Alaska book.

Putnam and Sons timed the publication of *Wilderness: A Journal of Quiet Adventure in Alaska* to benefit from the impetus of the Knoedler show. Sales were good from the beginning, and the reviews were appreciative. Robert Benchley in the *New York World* and M. F. Egan in *The New York Times* were particularly enthusiastic. Egan, who felt that Kent's drawings had the "strength of genius," told his readers that "the text is even superior in force and beauty to the drawings themselves." English reviewers, though somewhat disturbed by the heavy Blakean influence, were also impressed. C. Lewis Hind, a well-known critic, described Kent as a combination of Walt Whitman and Winslow Homer. *The New Statesman* wrote, "*Wilderness* is . . . easily the most remarkable book to come out of America since *Leaves of Grass* was published."

It was a remarkable book. With lucid style, and in diary form, Kent recaptured Fox Island. Olson, his son, and Rockwell himself came alive on its pages. The artist's love of Alaska's beauty also shone forth. Only the agony of his loneliness for Kathleen was muted. He had taken the reality and made a work of art.

As soon as he returned to Egypt he built a new studio. The barn, lacking a view, was also too close to the house and the children's noisy games. On a high nearby ridge Rockwell quickly nailed together a flimsy tarpaper shack and equipped it with an old wood-burning stove. The spot overlooked the valley and also gave a clear view of Mount Equinox. From there he painted, among other canvases, *Deer Season*, now at the Art Institute in Chicago, and *The Trapper* and *Shadows of Evening*, both of which found homes in Mrs. Whitney's collection.

A larger building project followed soon after. Kent had kept in touch with Olson, sending him thoughtful presents and trying to help him gain title to his island kingdom. Olson, though, was growing tired of Alaskan solitude. Rockwell urged him to come to Vermont to live with the Kents. When the old man, after suffering a slight stroke, finally agreed, Kent wired passage money and built an elaborate cabin for him. On his arrival he was greeted with great affection and many gifts and messages of welcome that Rockwell had solicited from friends like Carl Zigrosser. A few weeks later, after an angry exchange over the proper weaning of Kent's calf, the proud old sourdough packed up and left for his youthful stamping grounds in North Dakota.

Kent's disenchantment with America, having deepened in Alaska, caused him to continue to brood on the evils of a society he felt to be "a very brutal, very coarse tyranny," as he expressed his feelings in a letter to Ferdinand Howald. "I have the gloomiest forebodings of the future of art in such state as ours." He thought, again, of going to Iceland. "But there's always the serious question of the earning of my living."

Instead of leaving for a foreign state he decided to found one of his own. As he had asked Zigrosser, "Why could not a man deliberately isolate himself from his own time if its ideals are annoyingly antagonistic to his own. . . ." He was particularly concerned that his children might become tainted by a shoddy, middle-class, commercial culture. "In my home there must be the age of chivalry where knightly ideals exist for the growing children." To Kathleen he argued, "Why should we not consider ourselves— with all due humility—as of a caste different from the rest of mankind and bring up our children with ideals as of a special knighthood."

Rockwell and Zigrosser watched carefully the revolutionary struggle going on in Russia, and the attempts made by France, Great Britain and the United States to crush the bolsheviks. Kent saw the armed intervention as "a dastardly betrayal of mankind's hopes" and another blot on his country's conscience. He wrote friends, "The hope of the world lies in the Russian idea of Freedom." There were no doubts in his mind about its eventual triumph.

But this sympathy did not lead him to join a political party or plunge into the struggle. What he wanted was to be left alone, free to paint and create. He had no desire to proselytize or convert others. "The true ideal is to be the thing yourself." During these years he can be seen as more bohemian anarchist than political subversive. "I think that the individual must have such unlimited freedom for spiritual development that even the encouragement of his thoughts impinges on his liberty. Praise will often forge fetters when criticism would only have inspired independence. Really it's rank blasphemy to tamper so much with the soul."

So at Egypt, in the green Vermont countryside, he sought his Eden. His wife, his children, his work were to be his life. All were to develop freely, in their own directions, liberated from the distorted values of a society that placed more importance on machine production and modern plumbing than it did on art or mystery.

The first winter had gone well. All had been happy on the farm. But soon after Rockwell's painting exhibition the experience began to sour.

Kent's energy and ambition were too tempestuous for a placid country life, his desire for experience and adventure too strong. He began to feel restless and confined. It may have been, too, that Kathleen's passive domesticity

made him feel guilty, which increased his unhappiness. And Kent unhappy was not Kent quiet, withdrawn, subdued. He reacted with anger, scorn and slashing blades of criticism that cowed all around him. This was the situation into which Olson had innocently walked.

Kathleen bore Rockwell another son, Gordon, in that fall of 1920. Though he loved children, he expected of them the same energy, determination and drive for perfection he had. When they became frightened by thunder he insisted that they parade around the house banging on pots and pans. He had written Zigrosser of little Rockwell, "Certainly I tell him this or that may do in some other person but not for him of whom I expect better things as a matter of course." When his expectations were disappointed he punished, with cruel words if nothing else. The intensity of his anger could be terrifying, and his scorn could cut like a knife. "Baby elephant," he called an overweight daughter. "Piano legs."

His wife was the target of much of his anger. One daughter's strongest childhood memory is of falling asleep, night after night, as her parents made beautiful music, father on flute and mother at the piano, the playing alternating with the sound of quarreling voices.

Kent's dissatisfactions grew fiercer. Olson's visit, bringing memories of Alaska's wild seas and lonely mountains, made even more obvious the frustrations of Vermont. "Here one is actually thrown back upon that damned thing Imagination. Literally one has to *imagine* that there is loveliness in the world, that all human beings are not physically deformed, slouch-gaited, dull-eyed, dead-souled. . . . I don't like it a bit. New England!"

He began feeling desperate about his painting. Though "working like mad" he found the results unsatisfying. "I wish there were no other people in the world for a time, no horses or cows or mail service or anything more in fact than one finds on a deserted island. Then I COULD work."

Under these pressures it was decided that Kathleen and the children should take advantage of an offer, made because of Rockwell's theories on child raising presented in *Wilderness*, to live at the Edgewood School in Greenwich, Connecticut. After they left he closed the large house and moved into his studio.

There he painted and wrote, attempting a novel and planning a series of monographs on modern artists. And, at a time when his philosophy was so elitist, he began serious work in the most democratic medium of all: printmaking.

Carl Zigrosser, convinced that his friend's liking for clean, sharp lines and precise detail meant he would excel at woodblock prints, had sent the necessary materials to Fox Island. Rockwell had been very unhappy with his

first effort. "It was *terrible!* I was so ashamed." At Egypt he tried again. "I have begun the woodblock! . . . The drawing pleases me very much." It was inspired by the haunting memory of his and his son's near-drowning in Resurrection Bay. "It's a quite ambitious subject—a man in a rough sea in a dory into which is just piling an enormous wave." He soon had it printed to his satisfaction. "Of course there'd be lots I'd like to have done differently—but that shall have to be next time." That he knew there would be many next times is shown by his purchase, for twenty-five dollars, of an old Washington handpress that Zigrosser had found for him. He loved the demands that the difficult art made on his craftsmanship. "You've got to know your mind to work with steel on wood." Wood engraving came to be second only to painting in the arts he pursued.

Marie Sterner, as energetic and ambitious as he, grew increasingly important to his career. She severed her connection with Knoedler's in 1920 and launched her own organization: The Junior Art Patrons of America. Kent's success had made him a valuable property in the art world, and dealers were constantly asking to handle his work; but, though not tied to her by exclusive contract, it was to Sterner that he looked for advice and to whom he gave first rights to what he produced.

Also, and this is perhaps the best indication of the respect with which he regarded her judgment, he accepted her criticism of his work. When she told him that the drawing he had submitted for her to use on a catalogue was "no good, absolutely no good" because it was "slipshod in execution" he bristled but he tried again. "I've sent Mrs. Sterner the *third* drawing for her cover. If she doesn't like this I'll make another & so on until she's pleased."

Kent's charm, talent and propensity for trouble had already made him popular with the press. Mrs. Sterner understood the importance of such publicity, and she did all she could to promote Rockwell as a personality. She also knew that to be successful a dealer had to cultivate a clientele with the means to purchase expensive works. She had the flair and social contacts to attract an exclusive group to her shows.

Rockwell began spending more and more time in New York helping Sterner prepare for her first big exhibition. When he finally produced an acceptable drawing for the catalogue she decided to use it, as well, on two large banners to be hung on 57th Street. Kent and George Bellows worked on them in Bellows's studio, and they proved a traffic-stopping success; so did the show. Kent, who was the featured painter, sold two works, one for $3,500, the other for $2,500.

That would have been enough to lift anyone's spirits, but something had happened in the preceding months that made the sales almost anticlimactic. Kent had again fallen in love.

An associate of Marie Sterner's, intelligent and attractive, Lydia belonged to the rich, cultivated circle of Ralph and Fredericka Pulitzer. She had a streak of devil-may-care rebelliousness that Kent found compelling. One day, just after they had first met, he went walking with her and another man through the wet November woods of a Long Island estate. They teased her. "Only a witch," they said, "could lure two men to walk with her on a day like this. Is this an enchanted wood where you are leading us? What ordeal do we have to face?" She told them that they would have to wait and see.

Soon they reached a large, dark pond that lay between marshy shores. Lydia announced that this was the place. "I'm going to run around the pond. And whichever of you swims across to meet me on the other side, I will be his." Off she went, and without a backward glance. Within seconds Kent had stripped to his underwear and plunged into the rain-pocked water. The ensuing romance led him deep into the world of wealth and luxurious living.

Though Kent enjoyed all the money and fame he had won, he held no illusions about the propinquity of neglect and poverty. He received from Marsden Hartley a strong reminder.

> I want freedom for expression. I'm in the state of being practically unknown outside the artists. You know what that means. Your own gratifying release shows you what is necessary. . . . People subsidize invalides and imbeciles. Why can't a man like myself be put on his feet in a manner he can respect. . . . It needs someone with courage. . . . If there isn't a man it can be a woman. I'm not fussy. I can't go out and play the rotten game now. It's too late. I do not think I could be so surprising a success as yours for I have no such impulse behind me. I need someone to talk about me & for me. . . . Here I am like yourself. One of the real authentic American personalities begging for a foothold. You see how preposterous it all is. . . . Please I beg you use what you can for me. . . . I've got to be projected & quickly.

A hard edge enters Kent's judgments about this time. It is as if success had taken as its price his innocence and naïveté. He was still sincere about his art, but he was also fully aware that to gain and hold an audience one had to "play the rotten game." He wrote Zigrosser, "I've no use for newspaper criticism, one way or the other, except as publicity to sell my pictures." When he found that the collector A. J. Eddy was lying to him about an important matter his first reaction was anger, but he brought himself under control and did not strike back. "That's my policy—and when I can suppress my feelings toward such a man I know I'm doing the right thing. Wagner's autobiography is a lesson in how *not* to act."

Under the press of his new love affair, Rockwell's trips to the city be-

came more frequent and of longer duration. He moved with a sophisticated crowd, spending weekends with the Pulitzers at their Manhasset estate, and bachelor evenings at the Coffee House Club, where "Crownie" Crowninshield held court. He occasionally visited Kathleen and his children in Connecticut, and they spent summers together at Egypt.

The plunge into the Long Island pond had taken him into deeper water than he had expected. Lydia, high-spirited, opinionated and strong-willed, resisted his efforts to dominate the relationship. Their clashes were frequent, and grew increasingly bitter. Kent found himself on an emotional seesaw, elated when things went well, frustrated and angry when they did not. Tensions grew to the limits of the couple's tolerance, then exploded beyond any hope of repair.

As always when faced with such a dilemma, Kent sought physical escape. "If there's a worse place in the world than New York City I will go there." Within an hour of his decision he was shaking the hand of Joe Grace and thanking him for the offer of free passage on a Grace Line steamer to the uttermost part of the earth—Tierra del Fuego and Cape Horn.

The idea had appealed to Kent for years. Barren, wild, known only for its dangers, it now struck him as the perfect place to forget a lost love. With his usual enthusiasm and attention to detail he set about preparations. After a great deal of searching, maps were found. He sought out the rare souls who had been there. George Chappell introduced him to the famous explorer, soldier and painter Charles Wellington Furlong.

Furlong, who could have stepped out of one of the adventure stories Rockwell loved as a boy, had served in the Balkans and as a military aid to President Wilson during World War I. He had led expeditions to Africa, the Middle East and Central America as well as Patagonia and Tierra del Fuego. There he had made life drawings of the almost extinct Ona and Yahgan Indians. He wrote Chappell some warnings to pass on to Kent. "Southern Patagonia has been in the throes of terror the last six months or more because of desperate bands of outlaws burning ranch homes and committing all kinds of depredations among the isolated sheep ranches of the East Coast, so I imagine, if these conditions still prevail, that it would be really unwise if not unsafe to go into that part of the country just now." When Rockwell traveled to Boston to meet with him, the older adventurer was even more direct. "If you meet a stranger and he, let's say, asks you for the time of day, be agreeable: tell him the time—*but have your finger ready at the trigger.*" This advice so impressed Kent that he immediately bought a long-barreled revolver.

Kent worked hard during his last few weeks in New York to earn money for his family. Several paintings were abandoned, even though they were

only a day or two short of completion. He was in need of more immediate cash. Ewing and Chappell provided some, but his major effort was the execution of illustrations for a series of stories that George Chappell had sold to the *New York Tribune*. They split the fee—which came to a whopping $3,900 for the artist.

By late May of 1922 all was ready. Carl Zigrosser and Kathleen accompanied Rockwell to the Grace Line pier in Brooklyn, where he boarded the S.S. *Curaca*. After some time spent meeting the officers and crew, they stood on the dock and waved as the ship steamed slowly into the night. Once again Kent was outward bound.

CHAPTER NINE

VOYAGING TOWARD
CAPE HORN

Whenever I find myself growing grim around the mouth; whenever it is a damp, drizzly November in my soul; whenever I find myself involuntarily pausing before coffin warehouses...then, I account it high time to get to sea as soon as I can.
—HERMAN MELVILLE, *Moby-Dick*

Cape Horn is...the most beautiful page in the history of the sea.
—ALAIN COLAS

Great awkward form upsailing, a red signal flag clutched in each hand, he swings against the cold blue sky as his mates, led by "the Duke," also known as Rockwell Kent, prance below, shouting encouragement and laughing. As a plane passes over, the man excitedly begins to wave his flags and cry out, asking to be plucked from the rigging and flown away. When the airplane disappears from view the figure slumps dejectedly in its harness. Slowly the man is lowered to the deck.

Practical jokes can be used to ridicule pretensions, deflate pomposity, lay low the supercilious. They can also be used to torment the helpless. Kent had refined their execution to an art. His quick wit, his charm, and his dramatic talent allowed him to fox even the wariest game. Some ploys were so brilliant that the victims, once the effects had worn off, were moved to congratulate and even thank him. "I had been warned," wrote one who had visited him in Vermont, "before I left New York, that 'Rockwell Kent is the craziest man at large,' and also that you would rather play a practical joke than eat." The alert had not saved the man. "But you are such a strange mixture of the demonic, the primitive and the true artist that I really couldn't make head or tail of the whole affair.... From beginning to end I was just about as big a fool as possible. And I had it coming to me.... I was fresh, I was conceited, I was all swollen up like a poisoned pup. I thank you (and this is absolutely serious) more than I can say, for a wonderful lesson."

Cherry bombs under the chair and Tabasco sauce in the coffee were not often Kent's style, and he usually picked only worthy targets. On the ship, however, he pulled a series of tricks on such a hapless, pitiful victim that they can only indicate just how full of anger and despair he was.

"Sparks," the *Curaca*'s radio operator, was a tall gangly youth of low intelligence. The ship's crew had detected his gullibility on the very first day of the voyage; it was quickly exploited. Letters began arriving for him from a sweetheart he had not known he had. They were picked up from "mail buoys" and he was encouraged to answer them. A lively correspondence followed—with Kent carrying the "fiancée's" side. Then the radio equipment began to be sabotaged, smoke bombs and firecrackers were thrown into the youth's cabin—"bolshevik pirates" were blamed. Sparks's new friend, the Duke, would go into strange fits at dinner and begin chasing him about the room. The climax came when, after Sparks complained of stomach pains, the ship's medical officer discovered that the young man was pregnant. A plane was sighted, and he was hoisted up by block and tackle in an attempt to flag it down so that he could fly off to marry his fiancée. At the ship's first port of call he was removed to a mental institution.

Though signed on as an assistant freight clerk, Kent did no real work on the ship except to lay a hardwood floor in the captain's cabin. Rockwell did such a good job that Captain Cann had a brass plate bearing Kent's name and the date set into the wood. When not helping the others torment poor Sparks, he lolled in the sun, read or talked with the officers and crew. "Months could slip along like this, with the ship's gentle motion rocking one incessantly ever so tenderly into languorous contentment." Many of his shipmates had already been to Tierra del Fuego or Cape Horn and they assured him that all he had read of their dangers was true.

The *Curaca*'s third mate, Ole Ytterock, nicknamed "Willy," particularly impressed Kent. He had gone to sea when he was fourteen, learning his trade in sailing ships. During the war three vessels had been torpedoed from under him. Though only twenty-six he had lived a rootless, adventuresome life that included time spent as a lieutenant in an Ecuadorian revolutionary army. Though Willy was a bit shorter than Kent, his massive, tattooed arms and chest made him one of the strongest men the artist had ever known. His face, marred by fists, iron pipes, and shrapnel, served as an intimidating advertisement of his past. "He is an adventurer by nature, quite fearless—recklessly so; and with it all—or because of it—romantic, for he writes poems to the girl he loves." Remembering the warnings of Charles Wellington Furlong and the conversation of his shipboard companions, Kent decided to take on a mate. Ytterock jumped at the chance.

The two men quickly came up with a plan. At Punta Arenas, in Chile, they would "buy a 25'or 30' lifeboat, deck her, build in a snug cabin, rig her with a mast and sails, provision her for six months—and set sail." Already sounding in Kent's ears was the siren song of Cape Horn—the most challenging and dangerous passage in the world. For two days the *Curaca* unloaded and reloaded cargo in Punta Arenas; two days of constant partying for her crew. When she left, Captain Cann presented Rockwell and Willy with rope, canvas and a small mountain of supplies from her stores.

Even before the steamer sailed Kent was busy making contacts on shore. Through the captain he had met Jorge Ihnen, head of Braun and Blanchard, the company that controlled Punta Arenas. Young Ihnen, a Chilean of German descent, was charmed by the American Teutonophile. With his help the artist and his mate were lodged on board the *Lonsdale*, an old sailing ship used as a cargo hulk in the harbor. "We're living luxuriously in the captain's cabin. . . . We've a cook, at least seven meals a day, a warm room, nice old sailors for companions when we want them, several steam tugs at our service for errands or to carry us to town and back,—and all free of charge." They had also found their vessel.

She was a battered old lifeboat, bought for twenty-five dollars, off the wrecked steamer *Beacon Grange*. Kent set her up on the deck of the *Lonsdale*, hired two carpenters to help and went to work. "She'll be 3½ tons, 26 ft. waterline, sloop rigged. . . . We're doing everything beautifully. New, strong sails, new masts and spars of Norwegian spruce glistening with varnish; new ropes and anchors and rigging. She'll be a beauty." He had decided to name her the *Kathleen*, and he bragged to Carl Zigrosser that she would be "the smallest boat ever to sail on a voyage round Cape Horn!"

Kent's English and German allowed him to find friends and socialize in the cosmopolitan port. But, as usual, not everyone was enchanted by the vivacious American. The editor of the English-language newspaper invited him to a private club where local Britishers gathered. They were joined there by two other Englishmen. After drinking heavily for several hours, Rockwell made a comment, probably pro-German, that caused one of the men to threaten him. Kent wasted no time in small talk. "I grabbed him suddenly by the neck & threw him head over heels. One heel hit the dining table . . . & upset every glass and bottle of wine on it, and the other hit the editor and knocked him down flat."

On another occasion Willy had to handle an obstreperous drunk who burst into their cabin on the *Lonsdale* proclaiming a violent dislike of Americans. However, the mate was proving a very mixed blessing. He worked as hard as two men and was master of all the old sailor's arts of rigging, sail-

making and carpentry. Unfortunately he also had many of the sailor's vices—particularly drinking, whoring and brawling. Kent had landed with $700 in his pocket—just enough, he figured, to finish and provision the boat. Willy, until Rockwell stopped him, spent what he could get of the sum on his shoreside adventures, then, when all else failed, used Kent's name to obtain credit.

Jorge Ihnen and other friends were of great help, donating supplies, clothes, services. Everyone was impressed by the daring of the two men, while Kent's artistic gifts and sense of mission raised the enterprise from mere daredeviltry to a higher plane. The dangers were often on his mind. "It's a little craft for a big voyage. I guess I'll have rough seas enough this time to last me for the rest of my life." But the beauty of the southern regions, even from the deck of a cargo hulk, promised much. "Today the wind blew hard and the water flew and whole rainbows stood against the clear blue sky!"

After two months of hard, steady work, dawn to dusk, seven days a week, the *Kathleen* stood ready. A great crowd of dignitaries attended the launching. Colorful flags whipped in the wind, elaborate speeches were given in both Spanish and English, Jorge Ihnen's wife broke a champagne bottle across the small craft's bow as it was hoisted from the *Lonsdale*'s deck and onto the water.

Kent had mocked the sea gods with that champagne bottle. Unable to afford the real thing he had refilled one with water, carved a cork stopper from an old life jacket, wired it tightly, then glued over it foil saved from packs of cigarettes. No difference was noticed. Horns tooted, whistles shrieked, the crowd waved and cheered when the adventurers sailed off, singing as a good-bye to their friends some new verses to the old sailing-ship chantey "Rolling Home." They made a brave sight as the wind filled their heavy canvas sails, heeling the boat and putting a bone in her teeth.

They had set their course for Dawson Island. So steady was their speed that they enthusiastically plotted out their itinerary for the next few days. Willy, full of love and good feelings, sang as they clipped along. Kent went below to admire the clean, ordered beauty of their little ship. As he stood in the companionway he noticed a bit of water sloshing about on the cabin sole. Idly, he picked up a cup and bailed it out. More seeped in. Chatting with Willy, he traded the cup for a kettle. Bracing himself he set to work, but still the water flowed. Soon it lapped his knees. Suddenly he realized they were sinking.

The men worked in shifts, one holding the tiller while the other bailed with all his strength. Still the water rose. Soon they were drifting, water-

LIFE IS SO RICH (PEN AND INK)

logged. The mainsail was dropped with great effort; Willy had to climb the rigging and ride down the clattering gaff. Their boat wallowed in the heavy swell. Kent quickly heaved the unwieldy flat-bottomed skiff from the foredeck, jumped in and nailed a canvas cover over it. He had no illusions about its seaworthiness, he had no illusions about their situation. It seemed obvious that they would never make the distant shore.

Willy's lack of imagination proved a boon. He bailed on. To Kent's surprise and admiration the Norwegian seemed to be enjoying their situation. He sang as he worked:

> Smile awhile, I kiss you sad adieu,
> When the clouds roll by then,
> I'll come back to you.
> So wait and pray each night for me,
> Til we meet again.

Since there was nothing else to be done Kent joined in the bailing and singing. For hours the two kept at it, the *Kathleen* rolling sluggishly as seas broke across her deck. Gradually the realization grew that they were holding their own. The water level dropped back to knee height, but it took continuous work to hold it there. As the waves moderated, further progress was made, and in late afternoon they were able to raise the reefed mainsail and make for the windward shore, happy just to be alive.

They spent a wet, uncomfortable night in an exposed anchorage, and the next morning Kent cleaned up the damage as best he could while the mate sailed *Kathleen*. That afternoon the wind rose again, and again they took on water. Another anchorage was quickly found, and their soaked gear was placed out to dry. Tea had just been made and Kent was lecturing Willy on the wonders of wilderness solitude, when suddenly they heard a thump against the side of their boat, followed by heavy footsteps across the deck. As they leaped to the companionway they were met by a party of armed soldiers. "You are," their leader announced in Spanish, "under arrest."

It was a patrol of Chilean *carabiñeros* searching for pirates. Kent showed them his identity papers and protested his innocence. Whether by request or because they still held suspicions of the pair, the soldiers used their launch to tow the *Kathleen* to the only settlement in the archipelago west of Punta Arenas, Port Harris.

At one time it had been the site of a Salesian mission that sought to convert and protect the Ona Indians. Their subsequent extermination had freed the surrounding forests for exploitation, and Port Harris had become a lumber and shipbuilding center. Rockwell, as soon as he was released, made ar-

rangements to have his little craft hauled for inspection. As the *Kathleen* was drawn up and onto the slip she suffered an injury; the cradle made for her was not the right size, her weight came to rest on only a couple of points, her frames were too light for support and her hull buckled. This indicated the earlier problem. She was not strong enough to bear the pressure that wind and sea had exerted; several planks on both sides had sprung. She leaked like an old basket.

A major reconstruction was necessary: braces, rivets, bolts, recaulking and repainting. The manager of the boatyard, feeling responsible for the most recent damage, promised to make her fit for Cape Horn. The artist, in return, offered to paint a portrait of Port Harris's greatest creation, the full-rigged ship *Sara*.

That caused an immediate sensation. The *Sara* had marked the highest peak of local shipbuilding; her subsequent destruction by fire was a blow from which the townspeople still suffered. Kent gathered construction plans, photographs and the reminiscences of the men who had built her. As usual he wanted every detail correct, down to the color of the uniform worn by her captain. He painted the huge vessel running before the wind, all sails set, all flags flying. Into the foreground he painted the *Kathleen*. When, after three weeks, he had finished, so had the local shipwrights.

Again a friendly send-off. The trading schooners dipped their flags, the sawmill whistle sounded, and the *Kathleen* sailed out of harbor, bound for Cape Horn. But the two men were in no hurry. For several days they poked in and out of isolated coves and natural harbors. Occasionally they would leave their boat at anchor and go exploring in the flat-bottomed skiff. Kent always carried his paints and flute on these expeditions, and he sketched constantly. Rumors in Port Harris had located the sole surviving group of Alacaloof Indians somewhere in the twisted channels of Wickham Island. Kent and Willy, tantalized by the Indians' reputation as cannibals, went in search, only to be disappointed by the ragged band of beggars they found. It was the last time that Kent carried his pistol for protection.

After visiting the Indians' hovels they continued down Admiralty Sound, toward the great southern lake, Fognano. A gentle westerly came up and blew them on their way. The run east was beautiful; blue sky marked by long, streaming clouds, snowcapped peaks and sheer rock cliffs rising behind bare golden hills and dark shadowed forests. The farther they sailed into the sound the more abrupt and steep grew the shore. These cliffs funneled the sailors' following wind, strengthening it so that often they were forced to reef.

When the head of the sound was reached they made a temporary an-

chorage, then looked up the solitary tenant farmer, Gomez, whose *padron* in Port Harris had given Kent a letter of introduction. Gomez, to whom Rockwell took an immediate dislike, reluctantly agreed to guide them to the lake. Leaving the mate to find a proper anchorage for *Kathleen*, the two men took off into the mountains of Tierra del Fuego, Gomez riding a horse while Kent ran alongside. The farmer was astounded that the American carried no gun. "Must have gun. Very bad men around here; and wild cattle, very bad." Hours later, as they reached the high, isolated lake, the first sounds they heard were gunshots.

It was a hunting party led by a German settler named Mulach. Big, boisterous, full of *Gemütlichkeit*, he was thrilled to meet a German-speaking artist in the Chilean wilderness. At Mulach's invitation Rockwell separated from Gomez to return with the settler to his isolated ranch, the Estancia Isabel.

Mulach was part of the postwar wave of German immigrants to South America. To Kent he seemed to embody those traits that made the "German residents of Chile the most potent force in the country's development," traits that included prodigious energy and enthusiasm. Mulach dragged the still sea-weary Kent hither and yon about the countryside, hunting the deerlike guanaco and setting brush fires to open up pastureland, until Rockwell took to hiding in the forest to avoid the tiresome excursions. One hunting trip underscored just how different this Latin American adventure was from his trip to Alaska. Hours were spent dragging the bloody carcasses of slain animals to their rowboats, "And as we left the dry meadows we fired them behind us, till the smoke of a huge conflagration hung over everything; so that our retreat with flames and corpses partook the glory of a military progress."

Willy was to have secured the *Kathleen*, then joined his shipmate at the lake. After days of waiting, Rockwell anxiously returned to Admiralty Sound expecting to find his vessel a heap of shivered timbers. Instead, he discovered the boat safely anchored in the Azapardo River, but it had taken all the mate's strength and skill to overcome the current, wind and poor holding ground. Ytterock had finally prevailed by fixing two anchors into the roots of trees and running a stern line to a nearby wooden bridge. With the boat thus secured, the two men returned to Mulach's ranch to find him burning towering heaps of brush as if in welcome.

Another round of bloody sport and wilderness trekking began. Kent had by now regained his land legs and at the first opportunity made a point of walking his energetic host into the ground. But for all this activity, Kent chafed at the condition that kept him at Estancia Isabel: the west wind. Weeks had come and gone since its first gentle stirrings had pushed them

down the inlet. Now it held them prisoner. *Kathleen* was essentially a converted rowboat, unable to point, and slipped away to leeward in a strong blow. She could not beat against a wind funneling down sixty miles of cliff-lined sound.

In their frustration the sailors turned to folk wisdom. The moon was due to change. "That this betokened change of wind all weather bureaus, almanacs, ancient mariners, weather-beaten guides and trappers, all-knowing prophets of the wind and weather are agreed. . . . And we believed it with a faith that was fathered by a deep and ardent desire." They returned to their clumsy yacht and made ready.

The change did not come. Again they jammed their anchors into tree roots, moored their stern to the bridge and huddled in their cramped cabin as the west wind raked the anchorage. Rockwell tried to write in his journal and to compose letters for friends. "God is rocking the boat furiously. I can hardly write. The river current and the tide and the sea swell are waging a fierce battle around our little boat. The wind howls and the rain beats hard and noisily upon us. We can't get out of here." Finally Kent could stand it no longer. He announced to Willie one night, "Tomorrow we sail no matter what happens."

That day dawned gray and calm. Utilizing a light westerly breeze they were an hour beating out of the narrow, island-guarded cove. Soon the wind increased to its usual force, and frequent squalls battered the boat. They finally gained the protection of Three Hummock Island, but not before they were knocked down, almost foundering, because of the mate's reckless contempt for the subtleties of shortening sail. Trained in tall ships on great waters he lacked the sensitivity required of a small-boat sailor. The *Kathleen* was not overfreighted with humility.

After being windbound in their new anchorage for several days they made another attempt to beat up Admiralty Sound. That effort, too, almost ended in disaster when they were caught in a full gale. Under staysail alone they managed to reach the semiprotected anchorage at Bahia Blanca, where a small sawmill was located. The two Chilean lumberjacks who ran it were friendly and provided their restless guests with tobacco and hospitality. Kent repaid them by playing his flute and by giving one "a real North American haircut" that caused the fellow to look like "a huge chrysanthemum on a stalk."

Days slipped by, then weeks. The wind showed no signs of changing. Rockwell passed the time by hiking the hills of Tierra del Fuego and painting the varied landscape. Finally his patience gave way. "We have given up all hope of sailing west and southward, for we could never beat out through

this sound and Gabriel Channel. It is a conclusion that we have found hard to face." But Kent was not willing to give up the idea of Cape Horn. He decided that they would walk south.

The mill hands attempted to dissuade him. It was impossible, no one had ever done it before, the mountains of the Brecknock peninsula formed an impassable barrier. Kent felt he had to try. The only other choice was to vegetate at Bahia Blanca. Early one morning, he and Willy, guided for a short distance by the Chileños, lifted their sixty-pound packs and started up the valley. Not knowing what to expect, they had filled their cumbersome, jury-rigged rucksacks to the limit. But the major burden was their lack of proper footwear. Over the next several days, as they struggled up steep rocky slopes or slogged through swampy low ground, they cursed the poverty that had left them so ill prepared.

Wild beauty surrounded them. Huge condors circled endlessly overhead, guanaco browsed along the hillsides, geese populated the rivers. Kent sketched giant glaciers that overhung the valleys; he marveled at the golden-hued light that bathed these austral highlands. But here, as elsewhere on his southern adventure, a sense of union with nature eluded him. He had been overpowered by that feeling in Alaska, but in this hard land, peopled by hard men, he did not attain the level of openness and trust that would have allowed it to happen.

After two days of difficult hiking, the mate admitted that his right foot, injured earlier, was causing him great pain. Rockwell carved a splint that relieved some of the pressure, but the pain grew worse as they continued their journey.

Another day brought them to signs of settlement, and early on their fourth day of travel they met a very surprised Chilean shepherd. When they told him the route they had taken he was even more astonished. They were the first whites to discover the pass from Admiralty Sound over the Brecknock Peninsula to southern Tierra del Fuego.

After a brief period of recuperation spent with the inhospitable *padron* of their shepherd friend, the two men continued on to the southernmost town in the world, Ushuaia, Argentina. Wanting to make their entrance in style, they stopped on its outskirts, washed, put on their most presentable clothes and swung in singing "John Brown's Body."

Their discovery of the pass made them celebrities in the isolated community, and their desire to "visit" Cape Horn added a note of eccentricity that the locals found irresistible. They became guests of Martin Lawrence, a leading citizen, and this connection established their respectability. Willy, whose foot was causing him excruciating pain, was put to bed, where he re-

mained for a week. As soon as he could, Rockwell headed for the water-front. Cape Horn lies some seventy-five miles to sea from Ushuaia, so they had to find a seaworthy craft if they were to complete their quest. Several vessels lay at anchor in the harbor, but only one looked as if it would be within their means to charter. Kent got in touch with the owner, but when after several days' delay a price of $500 was demanded, he had to look else-where.

Luckily he met a friendly Swedish settler named Lundberg who had a small auxiliary sloop that he was willing to risk. But not just then, for he needed it to work his timber concession. It was decided that Kent and Willy would go with him to his place and wait for the first opportunity to make Cape Horn. As it was, they got out of Ushuaia just in time. Willy, freed at last from his bed, had gone on a wild and drunken debauch that had greatly diminished their local standing.

Kent had assured Lundberg that if the hazardous trip to the Horn re-sulted in the loss of his boat the Swede could have the *Kathleen*. "If we lose mine," Lundberg replied in a solemn voice, "no one of us will ever need an-other." Now, back with his family at their estate, he seemed to regret his hasty promise. Whatever the reason, he found excuse after excuse for post-poning the expedition. The visit, which Rockwell had expected to last a few days, stretched into weeks of rather pleasant monotony broken only by elaborate holiday parties, at one of which the mate again disgraced himself by getting drunk, then making an aggressive pass at another guest's wife, and by the visit of an excursion boat from Buenos Aires. This event allowed the mate at least to partly redeem himself. Dressed up and presented as a dangerous cannibal chief, Willy terrified the day-tripping passengers. While he put on an all-too-real display of angry violence, contorting his battered face and flexing his huge muscles, Rockwell passed a hat through the crowd and collected an impressive amount of cigarettes and change.

Pleasant as he found the area and his hosts, Rockwell had a deadline to meet. Before leaving Punta Arenas he had booked passage home on a steam-er that departed in late January. As that month began to slip away the paint-er became even more impatient to reach Cape Horn, but still Lundberg held back. While Rockwell was considering a truly desperate act—making the at-tempt in an Indian canoe—the unexpected appearance of a local hero solved the problem. Big, calm, slow-moving Ernest Christopherson was a seal and otter hunter who knew the southern waters intimately. He also was familiar with Lundberg's sloop and its unreliable auxiliary. Since he was a trusted friend and compatriot, Lundberg agreed to put the boat under Christopher-son's command for a quick dash to the Cape.

They stopped in Ushuaia for supplies. Willy, to whom Kent had entrusted the task of buying gasoline, so delayed their departure by his bungling that they were caught midway in Beagle Channel by a gale that forced them to find a protected anchorage and sit it out. Twelve hours later they were able to proceed. Christopherson's detailed knowledge of the coves, inlets and bights of these dangerous waters now saved them time and trouble. Hugging the coast as much as possible, he brought them safely to the Wollaston group, just miles from Cape Stiff itself.

The Wollastons are the most exposed islands of the archipelago. The western trade winds, blocked farther north by mountains, sweep through them with unchecked power, making it an uninhabitable place of constant storms and huge, roaring seas. Kent's party was surprised, then, as they poked through Victoria Channel, to see smoke rising from Baily Island.

The smoke proved to be from the camp of Argentine otter hunters poaching on Chilean territory. The adventurers went ashore to visit, taking alone a bottle of very rough whiskey. The hunting party consisted of two couples, an infant and a Yahgan Indian. One of the men, recently released after spending years in prison for murder, proved to be a lover of the arts. "I consider artists, writers and musicians to be the greatest people in the world," he told the astonished Kent. The poacher even graciously agreed to reenact the ax murder he had committed, while his guest took photographs. Everyone gulped freely at the whiskey, and soon the smoky interior of the shanty was filled with drunken shouts and curses. Kent restored order, however, when he discovered that the infant was unbaptized. He organized a ceremony, drew up a baptismal certificate and performed the rite himself, naming the child Kathleen Kent Garcia.

Heavy wind continued through the next day. Squalls of rain swept across the island, but Kent and Ytterock ignored them and climbed to its highest point. There they were caught in a sudden, frightening snowstorm that almost shook them loose from the barren peak. Their reward came when the storm passed, the clouds briefly parted and they sighted far to the south a cloven point of surf-beaten rock—Horn Island!

Lundberg needed his boat back by January 16 to transport lumber. If the bad weather continued they would not even be able to make an attempt at their goal. Eager to find good omens, they took the Yahgan's word that the wind and sea would moderate on the fifteenth. They sailed at dawn.

As soon as they left the islands' lee they were hit by the full force of the southern ocean. Giant, crested seas roared down upon their sluggish, ill-fashioned boat and broke across her deck. Windblown rain and cold punished them. They fought their way into Franklin Sound, Ytterock straining at the

tiller. He and Christopherson studied the mounting gale, talking the conditions over in Swedish. Finally Christopherson turned to Kent. "I tank," he said in his calm voice, "we must turn back." Willy, never taking his eyes off the monstrous waves, nodded his agreement. They turned tail and ran for shelter.

Though the engine quit a few hours later, mocking good luck brought them fair weather on the landward side of the Wollastons. They made it back to Lundberg's that same evening.

Kent quickly made arrangements to leave. The *Kathleen* was sold to a local rancher and Willy was dispatched to make her ready for delivery. Rockwell, after many affectionate farewells to his hosts, set off on the established route across eastern Tierra del Fuego. After he had hiked through the mountains, he chanced on a driver with a Model-T who sped him on his way. Kent reached Punta Arenas in time to arrange a tow for *Kathleen* before he boarded the S.S. *Toluma* for home.

THE GOLD CAMP

Can one be healthful, carefree and a Blake? Is it possible to be a
seer and also to have a perfectly corking time socially?
—HENRY MCBRIDE ABOUT ROCKWELL KENT

I have turned into a machine for money making.
—ROCKWELL KENT

It was an uneventful voyage. Rockwell tried to relax and enjoy it, but his ea-
gerness to see his wife and children made him impatient with the *Toluma's*
slow speed. At the first port of call, Charleston, he disembarked and took a
train to Greenwich, Connecticut, where his family was still occupying the
gatehouse of the Edgewood School.

Everyone was finally together again. Happy and excited, Kathleen and
the children hoped that this time it was for good. Rockwell, after the tumult
died down, went to Brooklyn to meet the *Toluma*. So great had been his
hurry that he had left his paintings and sketches on board. They arrived safe-
ly, but when he tried to take them through customs an unexpected obstacle
arose: bureaucracy. None of the customs agents had ever handled such a situ-
ation before. It seemed to the chief inspector that, since they were to be
eventually sold, the paintings were subject to duty. Kent argued, but could
not convince the official. Customs held onto the half-completed canvases,
while Rockwell headed straight for the phone.

He called his friend Ralph Pulitzer, publisher of the best newspaper of
its day, the *New York World*. Pulitzer send down a reporter, Kent gave him
the story, the *World* gave it serious attention. Within two weeks his work
was in his possession once again, duty-free.

As soon as the children's term at school ended they all returned to their
Vermont farm, where Rockwell set to work on his paintings and wrote a
four-part series on his Tierra del Fuego adventures for the monthly maga-
zine *Century*. These served as the basis for the book he had already prom-

ised George Putnam. Kent later remembered this summer as a happy, golden time, with the children swimming and tumbling naked in the bright sunshine. But at some point during the season he decided another journey had to be made, this time by the family; Kathleen and the children were to go to France.

Rockwell gave as reasons the cultural advantages for the young ones and, because of the postwar strength of the dollar, economy. Kathleen suspected that it was really a device to get them all out of the way of an affair her husband was conducting. She had good reason to be reluctant; once again she was to be thrown on her own with five children, the oldest fourteen, the youngest only three. Walter Overton, the teacher who arranged for the family to stay at Edgewood School, had become a close friend to them all. Rockwell recommended books to him, especially those of Goethe, and the artist encouraged the younger man to take up painting. Overton now was hired as tutor for the Kent children, and sent ahead to Europe to prepare the way. In November of 1923, Kathleen, her children in tow, unenthusiastically embarked for southern France.

Rockwell's friendships with the rich and powerful, Pulitzer among them, worried Carl Zigrosser, who had been relieved when Kent left for South America. "I can't help feeling that when you are in the city you waste your superb energy on unessential things. . . . Of course you know my attitude towards society. . . . Perhaps I have no right to judge without meeting it more than halfway. Nevertheless, I have an intuition of its essential mockery and shallowness. And that is why it hurts me to see you give so much time to it. I am glad that you will soon be breathing the air of the great waste places."

But as soon as the air of "great waste places" had been cleared from his lungs Kent went back to breathing the provocative, though stuffy, atmosphere of Manhattan speakeasies and Long Island dinner parties. The simple vegetarian diet was given up, and he became a heavy smoker. Rockwell moved gracefully with the sophisticated people who were making their careers and fortunes in the frenetically prosperous twenties. Journalists, artists, writers, wits and millionaires formed his circle. He had not become hardened to his earlier sympathies, and still saw himself as a radical, a member of a small elite who, if given a chance, could awaken the world, educate the ignorant and build a healthier civilization. He made no attempt to hide these views from his rich friends, and undoubtedly found it amusing to irritate them with his jibes at the stock market, at big business, at their own comfortable lives.

Though not a member of any organized group he did work to further

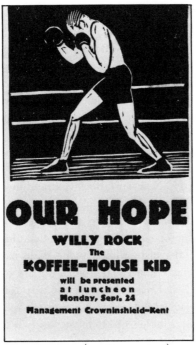

OUR HOPE (LINOLEUM CUT)

radical causes. The recent war, source of his own disenchantment with American society, was still much on his mind. In an article for the magazine *The World Tomorrow,* he argued that only the inability of people to "resist the insidious propaganda of the war makers" allowed such bloody conflicts to take place. Though discriminating intelligence was necessary, he found that "the masses have not that intelligence." They were not inherently stupid, but they lacked education and information. The future would be different, for, "by means of an art and literature that serves the truth, men will in time remote be brought to an understanding of the universal loveliness of life. . . ." The artist therefore bore a heavy responsibility. "It is through art than men become more sensitive." In every great work of art there was a "universal quality" that lifted it above the limitations of its "racial culture and addresses all humanity." Art alone could not prevent wars, there had to be "desperately needed social changes first," but it could point out the idiocy of Caucasian "notions of the essential superiority of the white race," and by showing all peoples their shared values it could "temper the hostility and contempt among the white and colored races, and . . . prevent that terrific clash which seems to be impending in some not-distant future as the last suicidal convulsion of humanity."

Indications that Rockwell now saw himself as writer as well as artist were also in the article. "There is," he stated, "no human power comparable to the printed word." As soon as his family left for Europe he secluded himself at Egypt with a young actress named Maureen, who typed the manuscript of his book about Tierra del Fuego. Postponing plans for a show of his South American paintings, Kent wrote the book quickly, then, working from his rough sketches, completed the illustrations. In early spring of 1924 he delivered the manuscript to G. P. Putnam's Sons.

On one of his trips to New York Rockwell ran into an acquaintance met through the Coffee House Club. F. DeWitt Wells, a former judge of the city's municipal court, was a heavyset, distinguished-looking man of fifty who had recently undergone a major operation that almost cost him his life. Impelled by this reminder of mortality, Judge Wells had decided to fulfill a lifelong dream of sailing a small boat from Denmark to America, following the same course that Leif Ericson had taken in A.D. 1000. A major problem for Wells was that he lacked the experience for such a dangerous voyage into the higher latitudes. His solution was to buy a sturdy boat and fill it with veteran sailors. His first choice was Rockwell Kent.

To the artist the proposal seemed a godsend. He had read the Icelandic sagas so many times that their heroes had been absorbed into his imagination. To sail their waters, see their lands, appealed to him so strongly that he could not refuse. It would also give him a chance to visit his family in southern France while Wells searched for a boat in Denmark.

They left New York in May 1924, sailing on the S.S. *Homeric.* Almost immediately there were personality clashes. Though the judge enjoyed Kent's tales about his peripatetic love life, he resented his active shipboard flirtations. On his side, Rockwell felt that Wells was too pompous and narrow-souled. Interpreting some of Wells's actions as indications of homosexuality, the artist began spending most of his time with a young Swiss governess. Judge Wells wrote a friend about his disappointment in Kent.

> He never reads the newspapers & disregards history. He does not care to see anything in Europe, neither the Louvre, Paris, Pictures, Scenery or Architecture but would like to look at the ceiling of the Sistine Chapel, visit the grave of Goethe & find a friend who used to live in Bremen. Architecture he had studied & pictures are not important as there are only three great artists, Blake and Michael Angelo. History & the development of races are repetitious & only the mountains, the sea, uninhabited regions and icebergs are significant. . . . I began to feel rather old.

On the train from Cherbourg, their point of disembarkation, to Paris, the

judge felt his dignity further ruffled when he found Kent yodeling with the Swiss girl in one of the compartments.

In Paris a parting of the ways seems to have been agreed upon. Rockwell spent the evening with his Swiss friend in Montmartre, then left the next morning to see his family. As far as he was concerned the voyage was off. Wells left for Copenhagen to buy a boat.

In Antibes, Rockwell played happily for the next few weeks. Kathleen and the children were healthy and tan, and they had all picked up the French language easily. Kent lolled in the sun, swam and took part in energetic games of tennis. It was only from a sense of responsibility toward the inexperienced Wells that, in response to a telegram, he agreed to go to Copenhagen and rejoin the expedition. After a few more days of frolicking in the Mediterranean, Kent reluctantly set forth for Denmark.

On the way he made pilgrimages to Goethe's houses in Weimar and Frankfurt, then stopped in Bremen to see a working-class friend whom he had met in Alaska. While in the port city he stayed with an admirer, Ludwig Roselius. Roselius had visited New York the year before, and upon arriving had announced that he was particularly interested in meeting two American geniuses: Henry Ford and Rockwell Kent. E. Weyhe of Weyhe Galleries had introduced the highly cultured businessman to the artist, and an immediate rapport was established. Roselius later arranged for *Wilderness* to be published in Germany, and in Bremen he lavishly entertained the artist. But Kent, still feeling an obligation toward Wells, journeyed on to Copenhagen, where he found the judge in possession of a boat.

The *Shanghai* was a lovely double-ended, Colin Archer–style cutter which had been built in the Orient and sailed to Denmark on a voyage that had won the Cruising Club of America's Blue Water Medal. Wells tried to hire the men that had sailed her from the Far East, but, either because they were tired of hard cruising or because they thought the plan to follow the Viking track suicidal, they begged off.

The expedition was not one to attract the careful or safety-conscious. It was now late June, a bit deep into the summer to be venturing so far north: there was a good chance that on their course to Iceland, Greenland and Newfoundland they would be caught by the hurricane season. Upon the *Shanghai*'s departure, *The New York Times* headlined its story OFF FOR NEW YORK VIA ARCTIC IN KETCH; DANES CALL TRIP OF WELLS AND KENT SUICIDAL. As occasionally happens, the newspaper had some facts wrong: Kent did not go.

Arriving in Copenhagen on June 23, Rockwell discovered that, although the original crew was going to stay with the *Shanghai*, the judge had made

arrangements for other men to join them. Kent, detesting Wells and realizing the lateness of their sailing, decided that this new crew freed him from his own obligations to the voyage. That night, as they all dined and drank in Tivoli Park, he drew aside one of the new men and asked him to tell Wells that he was pulling out.

Returning to Bremen, Kent wrote Zigrosser in elaborate script of his relief. "The flourishes are for my happiness at being free from the nauseating old judge, the sourbellied, grumbling, growling, lascivious old monster, free from him and his project." He spent another two weeks there, being feted by Roselius and meeting Germans of all classes. Rockwell was pleased to find all his expectations fulfilled. "Germany, because of the strong vitality, their normal, wholesome, striving spirit, has built upon its past and is building into the future . . . how wonderful is the youth of Germany!"

Now that he was no longer part of the judge's expedition he had to face the unpleasant economic fact that he had no money for passage home. When a telegram came from his friends Egmont Arens and Rex Stout outlining a crackpot scheme to smuggle in a thousand, twelve-volume sets of Arthur Machen's translation of *The Memoirs of Casanova,* banned from America as pornographic, Kent eagerly agreed to help. When they decided, instead, to issue a "limited" domestic edition, he even more eagerly agreed to illustrate it. As for the problem of getting home, he borrowed money from Carl Zigrosser and returned to the United States in time to read about the fate of his erstwhile shipmates on board the *Shanghai.* Caught in a hurricane, she had struck a rock off White Island and sunk. All aboard were saved, but the lovely boat was a total loss.

The painter's oldest child, Rockwell, followed his father home, having been offered a scholarship that fall to a private school in the Berkshires. Kent came down from Vermont to meet the ship in New York, but when he arrived at the Brooklyn dock he found it empty of passengers. The crew merely shrugged off his frantic inquiries and referred him to the ship's agents. Elwell and Company were just as disinterested. They told him that the ship had docked the day before in New London; the boy might have gotten off there. They suggested he contact Traveller's Aid.

Kent could not imagine why his son would have disembarked in New London, since he had been told to stay on the ship until it docked in New York. Young Rockwell was steady and self-reliant, but who would he think to contact after having lived in Europe for so long? Kent called every likely person, but it was several hours before he found the boy. The story that the youngster related quickly turned his father's anxiety into rage. All other passengers had left the ship in New London. Desiring to clear it completely so

as to be able to begin its refitting, the steward told the trusting youth that he was to disembark there, that a letter from his father explaining the change in plans was waiting for him in the dockside office. Once ashore, penniless and confused, Traveller's Aid had helped him get to New York City.

The angry father stormed back into Elwell and Company's office. At the very least he wanted a full, written apology and some token of their regrets. The shipping agents promised to consider his request that they present the boy a gift of some books. Returning to his farm, the still furious Kent waited exactly one week. When he received no word of their decision, he quickly got a lawyer.

Phillip Lowry was young, energetic and just as unawed by large, powerful corporations as his client. The two men considered all the aspects of the case. True, out-of-pocket expenses had been negligible, but the psychological trauma had been great, and had undoubtedly caused severe strain to the elder Kent's heart; then there was the damage done to a young boy's trusting view of the world and the complexes with which he would be burdened. After consultation with Lowry, Kent realized just how grievously they had been wronged. He decided to demand $50,000 compensation.

If executives of the Fabre Line learned of the decision they probably laughed. They did not know the man. Kent and Lowry had papers made up and processed, then appeared with a marshal at the gangplank of one of the line's capital ships just as its bon voyage party reached full swing. The marshal nailed a notice to the companionway; the ship was attached to ensure that the injured party would get justice. It could not sail.

The music died, the flags stopped waving, the good-bye embraces ended. Lawyers for the Fabre Line appeared, Lowry and Kent disappeared. While the champagne went flat, the ship's agents scurried about trying to raise a $50,000 bond. Newspapers gave the story extensive coverage; the passengers gave everyone hell. It was Kent's first experience in using the law to confound and confuse his enemies. He allowed Lowry, after the case had dragged through the courts for more than a year, to settle for what he could get. The real benefit came from having discovered a valuable new weapon.

Voyaging: Southward from the Strait of Magellan appeared during that fall of 1924. It was an even bigger success, financially and critically, than *Wilderness* had been. Within a month it went into a second edition. The following spring brought the large exhibition of his Tierra del Fuego paintings. Reaction to the work was enthusiastic. It was more than just Kent's skill in portraying the stark and rugged beauty of a desolate land that critics and public appreciated. An America feeling new political and economic power in the wake of the world war desired that its art and literature reflect

that greatness in American terms. In his review of Kent's show, Henry McBride put it succinctly. "Americans sigh in increasing numbers for the racial quality in our output. We'd like to stamp all our art with an unmistakable hallmark certifying its birthplace. We'd like Europeans at the first glimpse of our pictures to say, 'Ah, that's American.'"

Though Kent confused the issue a bit by being such a constant traveler, he was without doubt an American with, aside from occasional symbolism, a no-nonsense approach to that most American subject, landscape. As one critic noted, "Mr. Kent is one of our white hopes." This need for American genius was a dominant theme of the decade and Kent's status as a contender was recognized even by Europeans. When the English artist Maxwell Armfield wrote a book about his travels in the United States, he had to make note, in a chapter titled "The Interpretation of Landscape," that "Rockwell Kent is one of the really typical American painters, for he could have been produced nowhere else."

To many, Kent also had an appeal that reflected the ambiguous position of the American artist and intellectual. In a society that honored the achiever over the dreamer, the practical more than the abstract, and action before thought, Rockwell stood as the symbol of an intellectual masculinity. He was not only a talented artist and writer, but also an adventurer and man of the world. He could sail a boat or build a house, thrash a bully or move comfortably from a rough waterfront dive to a Long Island dinner party. He was a man who responded ecstatically to the beauty of women and of nature, and who seemingly could master both. Like Jack London earlier, or his younger contemporary Ernest Hemingway, Kent validated the manhood and virility of intellectuals in a culture that demanded such proof. A wider public also recognized his democratic ease. After the *American Magazine* wrote a profile of him he received letters from people all over the country asking him, as an oilfield worker put it, to "Come on out here and sling a little paint." Instead he returned to Europe.

The always hectic pace of Kent's personal life had speeded up even more in an America just breaking loose from Victorian restraints. Seduction followed seduction, affair affair, until finally he fell in love with another of the wild and reckless beauties who caught not only his eye but, through stubborn defiance of his will and a refusal to be dominated, also captured his deeper interest. Though their relationship was tempestuous they discussed marriage. Rockwell left for France to arrange a divorce.

Their plans did not survive the separation. She was fickle, and found another. Kent stayed in Europe for the summer, painting and traveling. For a while he found a companion in Waldo Pierce, poet and painter. Marya

Mannes, the lovely young daughter of his friend David Mannes, was in Antibes that season, and Kent tried unsuccessfully to convince her to go off to Paris with him. She was scared, as well as fascinated, by his intensity. Finally, weary of adventuring, he returned to America and found there, at a dinner party on Long Island, the woman for whom he searched.

Frances Lee was a twenty-six-year-old, blue-eyed divorcée who had recently come to New York from her native Virginia. Her sophistication, calm beauty and intelligence captured Kent's heart at first meeting. He proposed; she refused. He persisted, showering her with gifts, including a lifetime supply of stationery printed with a woodcut monogram he specially designed: FLK. She resisted the siege for two weeks, then capitulated. Kent completed arrangements for a divorce from Kathleen, and he and Frances were married on April 5, 1926.

Rockwell was furiously busy, but at tasks he saw as important only for the income they generated. He still contributed drawings to *Vanity Fair* as well as many other magazines, and he occasionally was called in to Ewing and Chappell to help out on particularly important commissions. He also became a sought-after designer of bookplates and trademarks. When two friends, Harold Guinzburg and George Oppenheimer, started their own publishing company, which they planned to call the Half Moon Press, they asked Kent to draw Henry Hudson's ship as their logo. The artist quickly sketched what he considered a proper seagoing craft: a Viking ship. The publishers decided to change their name to the Viking Press. But the major source of Kent's income was an industry that had really just come into its own during the twenties—advertising. Though he disliked the work, he drew ads for automobiles, jewelry, pianos and other products during the decade. He decided to use the occasion of his wedding to get back to his serious work.

The newlyweds spent a few weeks at a friend's farm in the Adirondacks, then left for Ireland. Aided by a monthly stipend of $300 from writer and businessman Rex Stout, who believed strongly in his work, and sales to the wealthy collector Duncan Phillips, he hoped to find an isolated spot, finish the advertising work to which he was already committed, then devote himself to painting.

The place they found was indeed isolated. By train, hired car and on foot they made their way to the west coast of Ireland, until they stood at land's end, a few poor farmers' huts the only dwellings within miles. Kent made arrangements to rent a half-ruined house that was being used as a cow barn. Using his building skills again, he returned it to a habitable state. "But it has taken time to repair this ruin," he wrote Zigrosser, "with the vast labor of carrying every ounce of material on your back these two miles and more

ROLLS-ROYCE ADVERTISEMENT

over the mountain, and I'm only just ready to begin work at my 'Art.'"

There were other responsibilities but he got through those quickly. "Except for the drawings I've made for Ayer & Son, Rolls-Royce and Marcus & Company, I've done nothing but work." He found the place, with its untamed headlands, variable climate, and rough living, ideal for his purposes. "If I can possibly arrange it I'll stay in Ireland until January." Finding the few local inhabitants much to his liking, he spent his free time visiting in their kitchens ("I love even the smell of turf smoke") or sitting around a hidden still drinking poteen.

Some of his friends were unhappy over the trip; among them Egmont Arens, who asked for a speedy return. "I have always a little wish that you would not go to Europe at all to paint . . . I want to keep you for America. I feel that you are at your best here. . . . Leave it to other painters to go and paint those things." Arens need not have worried. Forced by the necessity to provide for all those dependent on him—wife, ex-wife, five children plus Frances's four-year-old stepson—Kent returned from Ireland after only a few months.

Frances preceded him to find an apartment in Greenwich Village, renting an elegant flat at 3 Washington Square North, part of the famous "Old Row." The building served as a focal point for New York's creative energy. Guy Pene du Bois, Waldo Pierce, Edward Hopper and F. W. Stokes painted there; writers like John Dos Passos, Elinor Wylie, e. e. cummings and Frank Harris lived there at one time or another. In addition to their large apart-

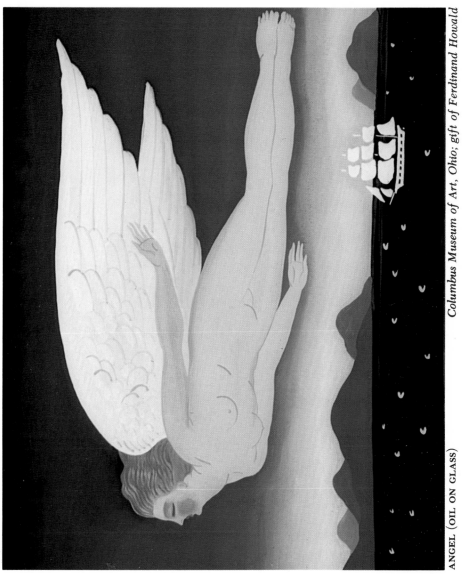

ANGEL (OIL ON GLASS)

Columbus Museum of Art, Ohio; gift of Ferdinand Howald

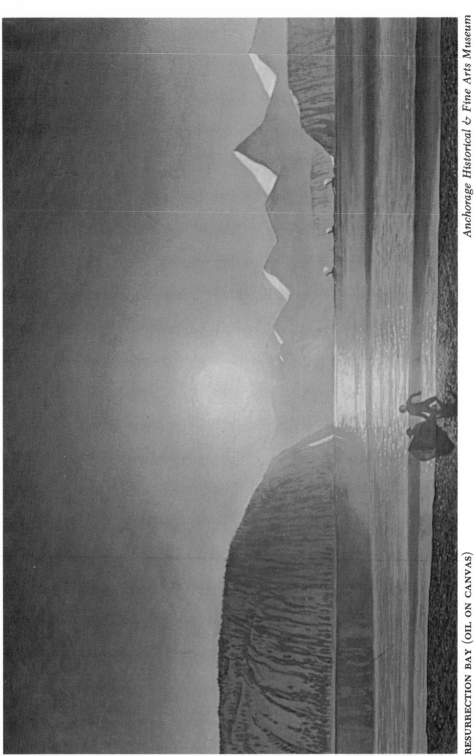

RESURRECTION BAY (OIL ON CANVAS)

Anchorage Historical & Fine Arts Museum

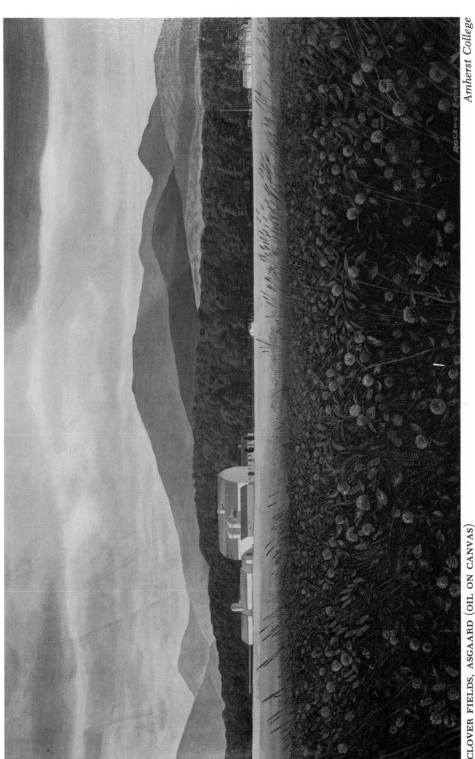

CLOVER FIELDS, ASGAARD (OIL ON CANVAS)

Amherst College

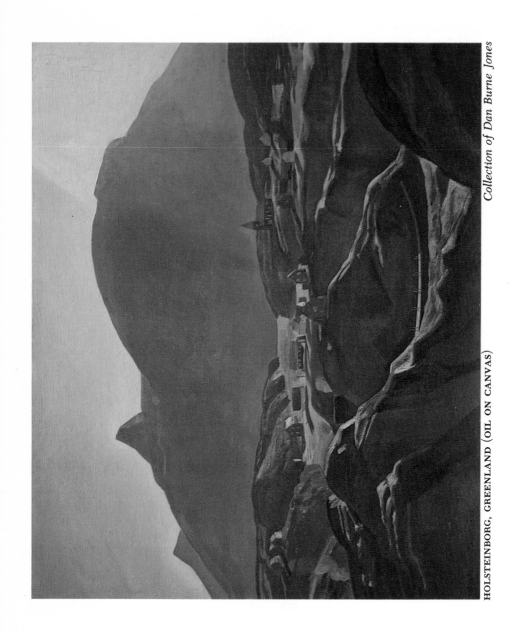

HOLSTEINBORG, GREENLAND (OIL ON CANVAS)

Collection of Dan Burne Jones

COTTAGE IN LANDSCAPE (WATERCOLOR)

ment, Frances also rented a studio on the roof for Rockwell.

He needed it. Though he had always been busy, these final years of the decade saw an unprecedented explosion of activity. Advertising work, book illustration, designs for wallpaper, silverware and watches not only demanded his talent but also great amounts of time for research. For a while he edited the magazine *Creative Art*, and he wrote a movie treatment of the Tristan and Iseult legend at the request of Jesse Lasky of Paramount Pictures. Through it all the couple kept up an exuberant social life, giving parties, going to dances, dinners and boxing matches. When Willy, his shipmate from Tierra del Fuego, visited Kent in America, the artist formed a partnership with Frank Crowninshield to manage the hard-fisted sailor's attempt at a pugilistic career. Unfortunately, Willy, in spite of his awesome physical gifts, proved unwilling to train vigorously. He soon returned to the sea.

Kent jealously saved some time for art. His fame as an artist had reached a height matched by few of his contemporaries. Kathleen, his ex-wife, asked him not to visit the children in Stockbridge, where she had moved after selling Egypt, because he was so famous that it would focus unwanted attention on her. His canvases were selling well and for thousands of dollars each. When the Detroit Institute of the Arts asked him to consider the low offer of $1,800 for a painting because they could not budget more, he,

noting that Edsel Ford and other businessmen served on the museum's art commission, wrote back that they should be able to "appreciate my entire unwillingness to consider an offer of less money for my work than the price. The selling of a work of art is purely a matter of business, and I think an artist can do no better than letting himself be guided there by accepted business ethics." After all, he asked, how would Mr. Ford regard an "offer" for a new automobile.

Kent still took part in the campaign against established art institutions. Early in the decade he had belonged to the organization that Robert Henri and George Bellows had started, The League of New York Artists, which, among other activities, had urged President Harding to appoint a minister of art. The Henri circle, including Kent, were not believers in the techniques of abstraction and extreme distortions of reality that the Armory Show had brought to America from Europe. "I realize," Rockwell wrote Zigrosser, "that I am in many important respects unmodern, and surely in art I do oppose current conceptions."

The struggle, as he saw it, was to establish an indigenous American art. He made speech after speech before art clubs and design societies, arguing that American collectors and museums should give better support to their own nation's artists. "The most important thing we can do is to work together to change the center of artistic production from Europe to America." At one debate, with the critic Walter Pach, emotions ran so high that when the floor was open for questions, Alfred Stieglitz and the sculptor Gaston Lachaise launched a sharp personal attack on Pach. John Sloan, who was presiding, had to call them to order. "When the excavators dig in the ruins of this nation," Kent warned, "they will find a lot of old art and statuary and Grecian mummies. They will not know what our art has been." Private collectors were misled by European-oriented dealers and by that old enemy the National Academy of Design. Museums, he noted, particularly the Metropolitan, bore an even greater responsibility.

The Metropolitan Museum of Art had grown into a powerful force, but, it seemed to the younger artists, a reactionary one. It paid little attention to their work, preferring instead to honor the safe, the established and the dead. An exception had been made for Kent; it was often noted in magazine articles about him that he had been the youngest artist ever to have had a painting purchased by the institution. That did not stop his blasts against its policies. "The post-mortem exhibitions at the Metropolitan . . . in occasional recognition of the work of contemporary American painters are evidence that no power less than the tragedy of a painter's death can move the ponderous minds which direct our museum's activities and spend its money. . . ."

COUPLE (PENCIL AND RED CRAYON)

There was, as Kent and many others saw it, but one solution—to start their own organization. An expensive proposition, but Rockwell thought he had found an "angel," an angel of the sort that has launched many dreams, both artistic and otherwise: an American heiress. A certain Miss Grigsby, called by the newspapers "an anonymous enthusiast," volunteered one million dollars for the project.

Elaborate plans and formulations were drawn up. The National Gallery of Contemporary Art was to be founded as "a suitable and permanent home for the continuous showing of the works . . . of living artists." And only the living were to be represented. Upon his or her death an artist's work was to be sold and all profits given to the heirs. "It is planned thus to provide something in the nature of insurance for the artists' heirs by recognition of the fact that the premium on an artist's work is generally payable only after his death." Newspaper reports and magazine articles generated a great deal of enthusiasm among artists and the public, but, as is often the case, the heiress got bored and turned her attention to some other worthy cause. The project had to be dropped.

The strains of heavy work, lost causes and city living began to have their effect. Kent had agreed to illustrate *Candide* for two friends, Bennett Cerf

and Donald Klopfer, who were going to publish books "at random." He also designed the logo for Random House and their Modern Library series. *Candide* was to be their first production, so they decided to issue, along with a trade edition, an elaborate limited edition, hand-colored and signed by the artist. When Rockwell began to fall behind he called in the young artist Ione Robinson to help, and even went down to the art school located in the basement of 3 Washington Square North to have the young students, awestruck by his presence, execute some of the illustrations.

Remarriage had not stopped Kent's interest in other women. In fact one of the attractions of marriage seems to have been that it set boundaries to be transcended; it also served as a refuge from which he could sally forth to explore new territory. Much to Frances's surprise he continued to conduct affairs with a wide range of beauties. He usually did not try to hide these, but would bring the ladies home, and expect no complaints about it. The temptations and pressures of the "Gold Camp," as he called New York, were proving too distracting. A friend wrote him, "I think of you as we sat and talked one night at Mori's. You were humbler that night than I had ever known you to be. Humbler and more genuine than you had been for a long time. The real Rockwell is a greater man than the swashbuckling actor who parades under his hat so often. And Frances, so lovely, so warm, so gay and so grave—perhaps she will find a way to bring you to peace with yourself." Instead, she left him to travel in Europe. When she returned, Kent, perhaps agreeing with his friend, proposed to her that, for the good of their relationship and his work, they move from the city.

In 1927, Kent inherited almost $50,000 from the Banker estate. He was earning great sums, for an artist, through his combination of commercial and fine art. Though his expenses were high (not only was he the sole source of support for eight people, but others tapped his impulsive generosity), he was sure that they could afford a substantial farm.

After some searching, the perfect place was found. It lay far north in the Adirondack Mountains, just outside the small village of Au Sable Forks. The heart of the farm was an unusually level pasture of just over one hundred acres, with another two hundred acres of pine woods, hills and meadows. The edge of the property dropped steeply to the Au Sable River. Far off to the west stood the rugged form of Whiteface Mountain, while other blue peaks ranged the horizon. The farm buildings were run-down and rat-infested, so Kent quickly drew up plans, had the old structures demolished and within six weeks of buying the farm had contractors building a new house and barn.

CHAPTER ELEVEN

ESKIMOS
AND RAILROADS

Why do men love the wilderness? For its mountains?—there may
be none. For its forests, lakes, and rivers?—it might be a desert;
men would love it still. Desert, the monotonous ocean, the unbro-
ken snowfields of the North, all solitudes, no matter how forlorn,
are the only abiding-place on earth of liberty.
 —ROCKWELL KENT

We saw the huge mountains on shore, an ominous foreboding of the
sternness of the land. The sea ran high and the rocks offered no sol-
ace. They are black and towering, and there is no pity in them.
 —PETER FREUCHEN, DESCRIBING HIS FIRST SIGHT
OF GREENLAND

Rockwell Kent loved nature with a passion shared by few twentieth-century
artists. To find others like him we must go back to the great painter/natural-
ist/explorers of the nineteenth century; men like Frederick Church, John
James Audubon and George Catlin, men who would endure any hardship in
order to discover the unspoiled and exotic, men who found in wild nature
beauty, majesty and godliness—leavened by a strong element of personal
danger.

Paradoxically, Kent enjoyed not only the element of risk but also the
struggle to create a comfortable home in the midst of wildness. The cabin in
Alaska and his little boat in Tierra del Fuego were hand-built refuges,
sources of strength which allowed him to endure the other world outside.

The house Rockwell designed for his farm reflected this need for ref-
uge. "There are those who want indoors to be *unlike* outdoors, who want,
upon entering their houses, to retire from the immensity of the earth and the
heavens, who seek to sense security in their homes and who find in walls an
assurance of it for which their senses are grateful—and in the relative twi-
light of the interior a peace that must somehow be reminiscent of the
womb." No picture windows for Kent, just a solid, sturdy, old-fashioned

CLOSE HAULED (INDIA INK)

house that he hoped would stand for generations. He filled it with his vast library of books, family heirlooms and antiques. The walls were papered with the·charts and maps of his travels, and his favorite paintings were prominently displayed.

A huge barn was built to store hay and to house a herd of Jersey dairy cattle; he wanted a working farm, not just in the hope of recouping costs, but because a farm was meant to produce, meant to defy all the difficulties of weather, poor soil and encroaching forest. Thousands of dollars were put into fertilizers to bring the pastures back to lush productivity. A man was hired to oversee the everyday details.

Ever since his early reading of the Icelandic sagas, the Vikings had symbolized adventure, exploration, fearlessness. They too were farmers and they had conceived of paradise as a giant, glorious farm. In their honor Rockwell named his place Asgaard, "The Farm of the Gods," which he had painted, in letters several feet high, across the face of his barn.

An even closer identification with the Norse heroes became possible soon after. At the elaborate housewarming party that he and Frances threw, a friend, Joe Allen, mentioned that his son was going to sail a small boat to Greenland. Kent was immediately on his feet, "God, can I go with him?" Details were worked out. They were to sail the following summer.

There was much to keep him busy until then. The farm had added tremendously to his already heavy financial responsibilities, so he had to keep at

what he called his "potboiling" labor. But he was also at work on a job that he regarded in a far different light.

The illustrated book, in both limited and trade editions, was an important part of the publishing world during the 1920s. Collectors willingly paid high prices for volumes printed on rare paper in special formats, while a large public appreciated the artwork in less expensive versions. Kent had become one of the best-known artists working in the field, so when R. R. Donnelly, a prestigious Chicago printing company, decided to bring out a series of books that would "contribute something to the improvement of standards in the making of books in America" it was not surprising that they turned to him. The company set a high goal. "It is hoped that in each case a book will result which will stand for all time as the finest edition of the particular text which it preserves." They gave Kent a choice of books; he picked the American novel that most moved him, *Moby-Dick*. They also gave him carte blanche. He was to not only illustrate but design the book. He was to decide on paper, typography, binding, slipcase—every detail that was to go into the production of a first-class limited edition.

It was a project into which Kent could pour his whole heart, and he did. He always researched the background of books he illustrated, but for *Moby-Dick* he pushed his efforts to the limit: whaling books were studied, museums visited, the still-floating whaler *Charles W. Morgan* was minutely examined, old salts and historians were interviewed. As the project progressed it became obvious that there would have to be a multivolume edition. Donnelly not only concurred but voluntarily increased his stipend.

This work, half completed, was put aside for the Greenland voyage. Three men were to go: Kent, Sam Allen, and Lucien Carey, Jr. The boys were only twenty-two years old, less than half Kent's age, but they both were experienced sailors. The proper yacht for the trip had been found by Joe Allen, an adaptation of Colin Archer's famous *redningskoite*, or Norwegian lifeboat design. Thirty-three feet long, double-ended, heavy built, gaff-rigged, she was to prove to have all the virtues and disadvantages of her type. By Allen's choice, and with Kent's strong concurrence, she was to have no radio or engine.

The men marveled at her three-ton keel: "God help the rock she hits!" Kent was less enthusiastic about her name. *Direction* seemed too much a proclamation of man's will in the face of nature's capricious ways. In spite of this hesitation he carved and painted the name boards that decorated her flanks.

Carey sailed the boat to Baddeck, Nova Scotia, with a hired crew. On the way he broke the bowsprit, ate the canned goods and left the perishable

supplies to soak in the bilge. Kent and Allen joined her in Baddeck. Kent was furious at the slovenly disorder he found on board. By the time they sailed, he and "the Mate," as Carey came to be called, were barely speaking.

The voyage itself started well. In late afternoon of June 17, 1929, four days before Rockwell's forty-seventh birthday, they sailed away from Pinaud's boatyard and through the lovely Bras d'Or lakes. With a fresh westerly breeze and a bright warm sun, they stripped, plunged into the blue water and, holding on to a rough manila rope, played at being dolphins in the wake. It was their last bit of good weather.

Greenland lies at the very roof of the world. Icy, bleak and inhospitable, it is the largest island on the globe, and most of its mass lies north of the Arctic Circle. It was a Danish colony, closed to outsiders; permission to visit had been difficult to obtain. Even more difficult was the passage. They were the first yacht ever to attempt it from America.

Gales, head winds, fog and occasional calms. The crew learned *Direction* would not beat to windward, and that she was overrigged; her huge mast and heavy gaff made her heel under even light breezes. In one gale her starboard running light, six feet above the deck, was rolled underwater. The skipper, young Allen, would take refuge in harbors only under the most severe conditions; at least once they came close to losing the boat. Kent admired his courage, but began to doubt his judgment.

They crossed the Cabot Strait and worked their way up the west coast of Newfoundland. Off Greenly Island they encountered the first ice; one large berg came very close to running them down. After clearing the Strait of Belle Isle they spent a couple of days in Battle Harbor visiting the Grenfell Mission. Early on the morning of July 5 they sailed into the open sea bound north by east for Greenland.

Heavy weather swept in, but the Captain was loath to reduce sail. Kent stood his watches, cooked warm nourishing meals and got what rest he could in the fo'c'sle. During one bad blow the port jaw of the gaff broke, but Kent quickly crafted another out of the spare tiller. The hours rolled by, wet, cold, uncomfortable. The cumulative effects of a long, hard voyage began wearing at them: damp clothes, chafed skin, the grainy feeling of never having enough sleep. On their ninth day out from the Strait of Belle Isle the thick fog lifted to give them their first view of the coast of Greenland: it was awesome.

They shook out their reefs, set the spinnaker and made for Godthaab, the largest settlement in the area. But everything was so majestically large on that coast that the distance proved greater than they had thought. After

some heated argument over where, exactly, they were, a decision was made to anchor in a small fjord for the night.

It was a beautiful site, completely surrounded by huge, steep mountains and overhanging glaciers. Streams splashed down the cliffs into the calm waters. It seemed well protected, so an anchor was set and the boat put in good order for their entrance into civilization the next day. Rockwell was excited by the thought of painting such a spectacular landscape.

Early the next morning the williwaw struck. Their secure anchorage proved a trap. The steep mountainsides acted like a funnel for the wind, their anchors could not hold. Within an hour of the first blow *Direction*, after enduring incredible punishment, sank.

Her crew escaped ashore. After staggering about under the lash of wind and rain they found protection beneath an overhanging rock. When the storm abated they began salvaging what they could from the wreck. Kent, who had been exhilarated by the danger, felt let down by the tawdry aftermath: his romantic soul had desired a more complete disaster. Fishing with a stick for bits of waterlogged debris lacked the dramatic elegance he associated with shipwreck. He had not come to Greenland to be a beachcomber.

The three men puzzled over their chart. It seemed likely that the small village of Narsak lay within ten miles of them, but they could not determine if it could be reached by foot on that mountainous and fjord-indented coast. Kent had by far the most experience with wild, rough terrain, so it was he who loaded a pack with supplies and set into the wilderness.

For a day, a night and another day he struggled across storm-swollen rivers, up mountains, through boggy plains. To pass the weary hours he gathered a bouquet of wildflowers for Frances. Occasionally he stopped to rest or brew a cup of tea, but the bitter cold and rain kept him from lingering. He tried to follow the coast, but the steepness drove him farther and farther inland. He began to think of himself as Christian, in *Pilgrim's Progress*, so that when despair began to gnaw at him he muttered, "I will, I will!" Foot by foot, step after step, he passed through the broken countryside until he finally regained the sea.

There, thirty-six hours after beginning his desperate trek, he sighted, far out on the calm ocean, a Greenlander fishing from a kayak. Kent yodeled as loud as he could and frantically began waving. The Eskimo, undoubtedly startled, paddled closer to examine the strange apparition. Soon Rockwell, using all his considerable dramatic skills, was acting out the tale of voyage and shipwreck. Shortly thereafter he was putting on another performance in Narsak for a large, curious crowd of its inhabitants. They quickly sent a par-

THE VOYAGERS (OIL)

ty of kayakers to the wreck; another was dispatched to Godthaab for the governor. When the governor's party arrived in Narsak, Kent joined them and proceeded to the rescue of his shipwrecked companions.

Allen and Carey had been busily salvaging what they could. By the time Kent's group arrived in motorboats they had, working at low tide, cleared away all obstructions below deck. A decision was made to try to save *Direction*. Dozens of empty wooden casks were crammed into her hull, lines were attached to the boats and at high tide she was pulled off her rocky ledge. Much to her crew's surprise she floated, but just barely. Wallowing in the gentle wake of the motorboats, deck awash, she was towed to Godthaab.

Direction was even stronger than they had thought. Though bearing three huge wounds, one measuring six feet by three, her overall condition was still sound; she could be repaired. Allen made arrangements to have the work done there. Planning to return the next summer and sail on to Europe, he and Carey left for Denmark.

Kent stayed to paint. Greenland seemed the place for which he had always searched. The awesome grandeur of the island overwhelmed his senses; not even Tierra del Fuego had offered such a spectacular mix of mountains and sea. The Eskimos, so perfectly suited to their rugged environment, fascinated him. The men were strong, graceful, well-conditioned hunters; the women he found attractive, and generous with their charms. They seemed a happy people—loving to sing, to dance and to spend long hours ambling in the outdoors.

Most of Rockwell's canvas had been lost in the wreck, but he salvaged what he could. This was supplemented with duck and burlap bought at the local store, and he even made a few paintings on bed sheets. A Danish flier who was surveying the southwestern coast for potential landing fields took Kent along on his expedition. The artist also accompanied the area's only doctor on his long crosscountry rounds. A plan to return was already forming. "We may come here to spend a year," he wrote Frances. "It is beautiful." When he left Greenland that fall he had painted almost forty works.

By great good luck the ship he took to Denmark carried the Greenland administrators that would be most helpful in gaining permission for a return visit. It also carried two of the most famous Arctic explorers of the day: Peter Freuchen and Knud Rasmussen.

Freuchen was a gigantic, burly and picturesque figure with a full beard and, as a souvenir of one of his explorations of the Greenland ice cap, a wooden leg. Rasmussen, part Eskimo, was smaller and darker than his bearish companion. He was a born leader of men, possessed an iron constitution and had mastered all the arts of Arctic survival. Kent admired them both, and as the ship made its way down the mountainous coast friendships developed. Freuchen took Kent off at one port of call to view some hidden fjords, and when the ship finally reached Denmark, Rasmussen asked him to stay at his farm, Hundestad.

Frances met him at the dock in Copenhagen, bringing with her the *Moby-Dick* material. The Kents, after a short stay in the city, moved to the Rasmussens'. Rockwell immediately returned to work, and by early November he had finished and sent off to Donnelly and Sons the last 157 drawings. Rasmussen enjoyed the visit and lamented its end. "I miss the inspiration I received by seeing Rock busy and always producing *art,* not only in books and paintings, but even in the smallest things, even when he only was going to make a little dinner-cart. It was simply impossible for him to do any second-class work. It was against his spirit!" The Kents also visited Peter Freuchen's island homestead, Enehøje. There the artist worked on his next illustration job, *Canterbury Tales.* He could not afford to rest.

Kent was determined to return to Greenland. Once back at Asgaard he directed his energies to earning money for the trip, planning, and, through his new, influential Danish friends, receiving permission to revisit.

Days were spent writing and illustrating a book about his recent adventure. At night he would labor at his commercial work while Frances read to him. Soon, however, he found himself absorbed in a struggle that threatened to take all of his time and a good part of his fortune.

He had discovered, on his return from Denmark, that the Delaware and

Hudson had stopped running passenger trains on their line from Plattsburgh to Au Sable Forks. This was an inconvenience. When Kent learned that the company was required to provide service by the terms of its lease of the roadbed, he felt the railroad had betrayed the public trust, and demanded that the public service commission require the D and H restore the passenger train.

Hearings were held in Au Sable Forks, Plattsburgh and Albany. Kent, assisted by his lawyers, James Rosenberg and Phil Lowry, gathered data, interviewed witnesses and rallied the local residents. As always, Kent skillfully used the press; the controversy was given full attention by the New York papers, and several ran favorable editorials. Many people felt inconvenienced by the cessation of the train, and they were angry over the autocratic manner in which it had been done. Kent found one very old man who had contributed his labor free to the construction of the line and who testified that residents throughout the valley had donated money or labor to its completion because they believed it would benefit their communities.

There was some native resistance to Kent's efforts. Members of the county's power structure felt that if the railroad could make more profit on freight than on passengers, then they had a right, in spite of public discommodity, to do so. One of Kent's opponents owned the town's sole industry, a paper mill. He also controlled the local newspaper and credit corporation, and, by coincidence, sat on the board of directors of the Delaware and Hudson. And he was a national committeeman of the Republican party.

It was a tough fight, but after several setbacks, months of effort and thousands of dollars, the battle was won; the passenger line was ordered restored. In an enthusiastic editorial *The New York Times* observed, "It is notice that no railroad . . . may abandon passenger service without first obtaining the consent of the commission." The paper noted that the struggle had essentially been made by one man and congratulated Kent for overcoming "every obstacle which power and legal ability could interpose."

Rockwell was less sanguine. Certain that the railroad would renew its efforts after his departure for Greenland, he tried to organize his supporters to fight on their own. However, many were afraid to persevere. The owners of a local lumber company thanked him for his "courageous" efforts and assured him that every "thinking man and woman in the Au Sable Valley" appreciated what he had done, but they felt that they could no longer help. "The Delaware and Hudson Company have been customers of ours for upward of thirty years. At times their purchases have been as high as $50,000 per year. . . . You can readily see that if we continue to be prominent in this matter there must eventually be a reaction that might be very disastrous to

us." Kent began to suspect that he had won a hollow victory.

There were other distractions to his work. At Moriarity's, a popular New York speakeasy, he met an improvident young man who claimed connection with the royal house of Russia. Prince Michael Dimitri Romanoff had just lost his job. Kent, amused by his elaborate lies, impulsively offered him room and board at Asgaard in return for help with the chores.

Romanoff proved ill suited to agricultural labor. He was lazy, easily bored and prone to overtalking. Kent did not improve his attitude by using him as a foil for practical jokes. On one occasion, assuring Mike that the horse was docile, he got Romanoff on his spirited thoroughbred, Mentora. The ill-matched duo streaked a short distance across the pasture, then, much to the prince's discomfort, parted company. Soon thereafter Romanoff packed his bags and left, taking as souvenirs Kent's driver's license and checkbook.

Within a few weeks the artist began receiving reports that someone claiming to be the famous Rockwell Kent was lavishly entertaining dinner guests, seducing housemaids, and giving expansive critiques on modern art movements to enthralled listeners at a resort in Arizona. The bad checks followed close behind.

Romanoff then moved on to California. "When a gentleman in Hollywood announced recently that he was Rockwell Kent, considerable buzz and excitement spread through the Venetian, Spanish, early Gothic and early De-Mille villas of the cinema folk. The gentleman was pleasant, a social asset and an artist. He accepted all the wining and dining and weekending quite gracefully. He was obliging. He agreed to undertake various commissions." One of the commissions that the prince so graciously accepted was to illustrate and write a foreword for a book called *A Yankee in Patagonia*. The Houghton Mifflin publishing company announced it in their catalogue and in their advertising promoted Kent's participation. Then they discovered the fraud.

An immediate appeal was made to Kent. Could he relieve them of their embarrassment by fulfilling the commission? His agenda was already overloaded, but he agreed. An editor wrote his thanks. "We all appreciate keenly your courtesy and your very sporting attitude in cooperating to unsnarl the tangle in which the imposter had left us."

In spite of all these impositions Kent continued planning for his return to Greenland. His friendship with Rasmussen and Freuchen had deepened through correspondence, and he made the rounds of publishers, trying to arouse interest for American editions of their books. He went so far as to offer to illustrate one of Freuchen's volumes for free, if that was what it took to

have it published. "I have Peter Freuchen's interests so much at heart that I don't want to fail in the least move that can further them."

This willingness to help others was not confined to just the famous or important. Selma Robinson, the young woman in charge of publicity for the Literary Guild book club, met Kent while promoting one of his books. She mentioned that she was a poet. He read her work and said it should be published. Through his friends Donald Klopfer and Bennett Cerf it was, illustrated without charge by Rockwell Kent.

The fruits of all his labor soon became evident. The limited edition of *Moby-Dick*, three volumes in an aluminum slipcase, proved a great success with critics and book collectors. It sold out in spite of its astronomical price of seventy dollars. Random House then published a one-volume trade edition that was selected by the Book-of-the-Month Club. A young writer in Mississippi was so impressed with Kent's interpretation of Melville's classic that he wrote and asked to buy a drawing of Ahab. William Faulkner kept it on the wall of Rowan Oak's library for the rest of his life.

N by E, Kent's book about voyaging to Greenland, was also a great success, and was selected by the Literary Guild. Written in a clear, resonant prose, and illustrated with his prints and drawings, it gave many fireside readers a taste of bluewater adventure. Kent's strong argument for freedom and the great world caused at least one young man, Sterling Hayden, to run away to sea.

Kent bragged in November of 1930, "This promises to be a successful season for me. There are actually seven different editions of books that I have either illustrated or written, or both, being issued between now and December." This plethora did not please everyone. George Putnam wrote him regarding a book based on his forthcoming return to Greenland, "There is only one fly in the ointment we have encountered everywhere. That is . . . you had a hand in too many books. Some of the most important booksellers say in effect 'Isn't it possible to get Kent to give us just one book this season which he will be identified with—his *own* book? That will help it and us so much!' " Kent was doing all he could to prepare for that book. For a while he and Rasmussen talked of a joint expedition, but they could not work out the details. When Kent arrived on the island in July of 1931 he was alone.

Freuchen had recommended a small village on Ubekendt Island as a base. Igdlorssuit is located on the west coast of Greenland, about 225 miles north of the Arctic Circle. Kent had lumber for a small, one-room house shipped from Denmark. His carpentry skills quickly earned him the respect of the villagers, and his charm and openhanded generosity with coffee, cigarettes, cigars and various other items of luxury in the Arctic gained him their

MOBY DICK

OR
THE WHALE

BY HERMAN MELVILLE

VOLUME I

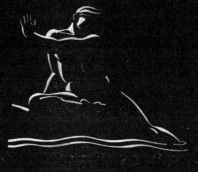

ILLUSTRATED BY ROCKWELL KENT

CHICAGO THE LAKESIDE PRESS 1930

TITLE PAGE FOR MOBY-DICK (CHINESE WHITE ON INK)

affection. He arranged for Salamina, a pretty young widow with three children, to move in as his *kifak*, or housekeeper. "Greenland fashion we all live in one room—me sleeping on the floor. It's intimate, somewhat messy, convivial and, on the whole, grand. It's . . . the closest I can get, a stranger, to a year's life as a Greenlander." The Danish authorities leased him a small motorboat. In what time he had before ice set in, he explored the coast. "This land—mountains, sea, sky—is incredibly beautiful." The more contact he had with the Eskimos, the more he came to respect their ways. "Most wonderful is the gentleness of the Greenlanders. It may prove most of all an experience in human contact—this winter here."

Kent's adjustment to Greenland's customs was not without its rough spots. The people, naturally curious, would gather and stare silently as he attempted one task or another. "I could have screamed . . . from frenzy of annoyance." He found some of their personal habits hard to bear. "Do all Greenland men snore so disgustingly at night?" he asked a friend after a group camping-trip. As a hard-working, self-disciplined product of nineteenth-century America he was often critical of the erratic, easygoing patterns of local life.

But there were other, more dangerous, adaptations to make. He had to learn a whole new set of survival skills. Even eating had its risks. Partaking of boiled seal meat Eskimo fashion, teeth and one hand gripping the flesh while using a knife with the other to slice off a chunk, he cut his nose. Also, until he mastered the arts of driving a dog team and judging ice conditions, he would not be able to stray from the settlement. He set to work.

All the long dark winter season Kent practiced under the tutelage of Eskimo friends until he was self-sufficient in the frozen wilderness. Salamina and he developed a warm, deep relationship, though she was a jealous mistress. They entertained their friends constantly, and were in turn invited out. He met all types of Greenlanders, from the youngest and most "modern" to ancient crones who still remembered and performed the old pagan songs and dances. It was a happy time for him. He even found an appropriate enemy to drive to distraction—the Danish trader, symbol of colonial governmental authority.

When the sun began its return that spring, the artist was able to roam at will, painting where and when he desired. "I would attach a large canvas to the stanchions of my sledge as upon an easel; I'd hang my bag of paints and brushes from the crossbar, lay my palette on the sledge. I'd catch my dogs and harness them. And then, after the mad stampede downhill, and over the shore ice . . . I'd recline upon my reindeer skin. . . . Arrived, I'd halt my dogs, swing the sledge into precisely the position that I wanted it, lay out my

paints and brushes, get to work." It was very cold work, even though he used a down-stuffed, thumbless mitten to keep his brush hand warm. Kent felt that the opportunity to paint such a spectacular landscape was worth any pain. "The beauty of those Northern winter days is more remote and passionless, more nearly absolute, than any other beauty that I know. Blue sky, white world, and the golden light of the sun to tune the whiteness to the sun-illumined blue." His Eskimo friends regarded the work merely as a variation on their own. He went out after sketches, they searched for seal. They would ask, when he returned, "How many sketches you get?" If he reported only one, they would laugh at his poor skill. But when he could say six or seven, they would be delighted and praise him for the "good catch."

Frances arrived on the first steamer able to make its way through the ice. Rockwell drove his dogsled down to southern Greenland to meet her. She was impressed with his skill in handling the team, and the ease with which he made his way in the snowy Arctic. Salamina and her children moved in with a friend. Rockwell and Frances, using the house as a base, took long trips to surrounding villages. Sea-ice conditions in late spring are dangerous, for as warmth returns the surface becomes flooded, and great cracks open to trap the unwary. Coming back from a visit the two found themselves surrounded by water and slush; Rockwell splashed forward with the long pike used to test ice strength. Probing here and there he found what he hoped was a path. The dogs were whipped up and, half swimming, pulled them through to safety.

That summer a German company arrived to make an adventure film. Kent became friends with Ernst Udet, their stunt flier, who had been a famous ace in the world war. Rockwell was less impressed with the rest of the crew. They wasted supplies, drank heavily and had bloody fistfights in front of the gentle Greenlanders. One of the actresses was so ubiquitously promiscuous that the Eskimos named her *Adliskutak*, "the mattress." The troupe included a caged polar bear. When finally released, the great white beast, lord of the ice floes, wandered around a few hours, then returned to the safety and steady meals of captivity. Kent saw a lesson in that.

Frances had brought two items of bad news. One was that the Delaware and Hudson, soon after his departure, had again stopped their Au Sable passenger service. Kent was not surprised. Far worse was word that his entire inheritance, given to an acquaintance to invest, had been wiped out in the growing depression. When the Kents left Greenland that fall, Rockwell promised his friends that he would return, but he was not sure how. The inheritance had not really helped pay many of his expenses, but it had been a reserve, an emergency balance that allowed him the leeway to make such ex-

peditions. Rockwell was forced to turn again to the most consistent way he knew to earn money—advertising.

One of the reasons Kent hated doing such work was its purpose: to sell people things they did not need. But the major reason for his dislike was that one usually was expected to give up creative independence in order to respond to suggestions from copywriters and executive vice-presidents. In his case that often meant anger, arguments, and unpleasantness. There occasionally came, however, an opportunity to do his own work under the sponsorship of a company. Steinway and Sons, famous piano makers, commissioned three paintings from him interpreting classical music compositions. The American Car and Foundry Company gave him a free hand to produce wood engravings that were used both in full-page institutional advertisements and issued as prints.

Printmaking was a field that he pursued intensively in 1933. In the first nine months he made five wood engravings and seven lithographs. The income from their sale was not negligible; Weyhe Galleries, where Carl Zigrosser worked, sold almost $700 worth from May to December during that year.

A fine studio had been built in a grove of young pines just a short walk from the house at Asgaard. There Kent worked hard at finishing the canvases brought back from Greenland. His paintings still sold, but, due to the depression, infrequently. "I have decided to meet the change in conditions ... by reducing all my prices forty percent; it seems the only reasonable thing to do."

The struggle with the railroad was briefly picked up on his return, but he realized that the problems of the Au Sable Valley were far more extensive. He decided that if any progress was to be made, the whole political structure had to be changed. With that end in mind he founded the Jay Taxpayers Association, a group that included local farmers, plus such summer luminaries as "Dr. William Sherman, son of the Civil War General and J. Cheever Cowdin, former member of the American Polo Team."

Local finances were in total disarray, due, Kent was sure, to fraud and corruption. Govenor Herbert Lehman, who had to sign a special bill to aid the county, came close to agreeing. "I am signing this measure with reluctance. Except for gross mismanagement ... this measure would not have been necessary. If county officials and the Board of Supervisors had properly performed their duties and complied with the laws, the county of Essex would not be indebted this $300,000." Under petition by Kent and his group, Lehman opened an official investigation.

When the auditors discovered discrepancies in the county's books the Jay Taxpayers Association was sure that the suspicions of widespread fraud had been substantiated. Since Republicans held office, the group approached the local Democratic party officials, but they proved to be as involved. The JTA decided to run a full opposition ticket in the fall elections. Kent, though not a candidate, led the attack. His friend James Rosenberg felt he was being naïve. "I don't want to see you, my dearly beloved Rockwell, play the role of Don Quixote tilting at windmills and breaking your lance in hopeless endeavors. . . . The one element that you don't . . . reckon with is the inertia, the stupidity, the callous indifference, the utter dullness of most human beings . . . they simply don't care a damn. . . ."

But Kent seems to have recaptured the faith in human beings that he had lost in the Great War. He assured a New York paper, "We're running all the bosses out of office, Democrats, Republicans, both, each and every. . . . We're running all farmers . . . and we're just about sure to win." The Ring, as Kent called the entrenched powers, did not see it that way. It became a bitter campaign. The JTA found it impossible to rent a hall for mass meetings, and Kent's home and barn were threatened. Volunteers stood guard.

The reformers lost the election, but their leader did not despair. "The main reason that the Taxpayers ticket was . . . beaten . . . is because the voters . . . are abysmally ignorant of the facts. . . . If we are ever to get clean government we've got to educate the people." He argued that someone had to found an independent newspaper.

If he was not in despair about politics, he was fast approaching it over his chances of ever returning to Greenland. In spite of his commercial work he was having trouble just holding on to his farm, now grown to four hundred acres. An anthology of his art and writings, *Rockwellkentiana*, sold well, but certainly would not support his family while he was off to the Arctic. He reluctantly accepted a long-standing offer from the lecture manager Colston Leigh to join his stable of personalities.

Kent had always refused to lecture or speak on the radio in support of his books. "I don't think an artist should get involved in that sort of thing." In spite of his strong ego, he did not relish appearing before audiences of strangers. There were two subjects on which Kent agreed to lecture: Greenland and art. In one he presented the people and place as he had come to know them, arguing that Eskimo life, though certainly "primitive," was richer, fuller and happier than the lives led by most people in America. His art lectures were presented as a "defense of liberty of taste against the dogmatism of the critics." There was nothing wrong, he assured his audiences,

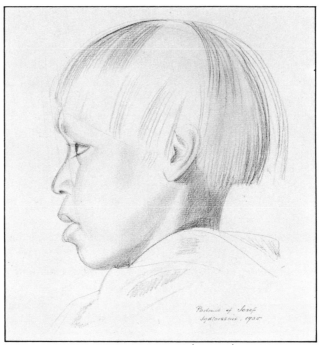

PORTRAIT OF JOSEF (PENCIL)

in trusting their own judgment about what was good and bad in art. Both lectures were illustrated, the first with motion pictures, the second with slides.

For months he bore the grueling schedule of trains, strange hotels and blue-plate specials. He made some friends he valued, like Jake Zeitlin, premier book dealer of Los Angeles, but most of it was drudgery. "Oh, how I want to be home at work." At the end of the season Leigh wrote him, "I can tell you quite honestly that you were one of the most successful lecturers that I have ever had speak for me." He asked Kent to sign up for the next year.

Rockwell, however, had other plans. In fact he had many of them. He was trying every possible avenue toward financing his return to Greenland. "A man of my age," he wrote a friend just after turning fifty-two, "must not permit himself to postpone his enterprises. There isn't too much time left."

The most ambitious proposal was one for making a dramatized documentary on Greenland life. The agent William Morris was interested, but could not find financing because it lacked, *"thrills, sensations* and *Hollywood."* Another scheme involved weekly broadcasts over the Columbia Broadcasting System about life in Igdlorssuit. Along with each talk he was to send, via special radio equipment, a black and white drawing. However, the

necessary equipment would not be ready for a year or two. Pan American Airways did have him do some temperature observations for them, but they did not pay much. He finally was forced to mortgage Asgaard to the Farm Credit Administration in order to finance his trip.

He took along his thirteen-year-old son, Gordon, who, he assured the Danish administrators, was "as free from racial or cultural prejudice as I am myself." Gordon was also physically fit and intelligent enough to learn both the Eskimo way of life and their language.

All the villagers came running when he and his son arrived at Igdlorssuit. "I was made to feel that my return was a real event to my friends." They helped him as he built a small Greenland-style sod house for Gordon; Salamina became once again his *kifak*.

Gordon applied himself to learning how to be an Eskimo hunter, while his father secluded himself and concentrated on writing a book about his previous visit to Greenland. They both did well. "I've emerged from a six-month day-and-night confinement with my book, text and pictures, *done*," Kent wrote Zigrosser the next spring. "Work, work, work—10, 12, 14, 16 hours a day." He bragged about his son. "Gordon's coming here has been a great success . . . he has become a man in self-dependence and resolution. As I write I can see a little speck far out on the sea ice. It is Gordon off with his team to a settlement 22 miles off. The distance is shrouded in fog; in a few minutes Gordon will be lost to sight in it. He has a compass and a map. He'll get there." The boy had caught eight seals in nets of his own making, and he laughed at the Arctic cold. "He has been on journeys and slept out on the coldest nights of this cold year."

It was spring that Kent loved most, when the sun was high, but snow and ice still prevailed. He made long painting expeditions into the white and blue world, and he entered once again into the gay social life of the community. He had told all his friends that this was his last trip to Greenland, that the next year, 1936, he would leave for good. He left much sooner than that.

Frances was due to join him that summer of 1935. She, however, found warm dry climates more to her liking and sent word from Arizona that she was not coming. Kent saw that as a betrayal. "It puts me in a thorough go-to-helling state of mind. . . . It is one of the shortcomings of the modern world that there is almost no wilderness so remote as to be out of communication with the rest." He took Gordon and left for Europe, uncertain what he would do, or where he would go to escape his new frustration.

On the boat to Denmark he received a cable that Frances and his stepson, Dick, had both been badly injured in an automobile accident in Tucson. As quickly as the transportation system of 1935 permitted he rushed to her

side. By the time he arrived she, after having undergone major surgery, was recovering. That was the good news. The bad was that she, pressed by financial worries, had rented out Asgaard.

Kent was furious. His home was "the repository of all my most precious and intimate possessions, of all the memorials of what had been most dear to me in life . . . it is a most real and sacred place." He immediately wrote the tenant, a wealthy woman from Chicago named Blair, and asked her to accept back all of her rent checks, not to send any more, but to regard herself and her family as his guests. Only in that way, he felt, could the stain be removed. Mrs. Blair refused. She would, she insisted, live up to all terms of the lease.

This cold businesslike response made a difficult situation intolerable. He had to find a method to cleanse away this "desecration of a holy place." It was unthinkable to keep the money, but he calculated that, since his insensitive guests were rich, there was one organization to which he could donate it and be sure of offending them. In October Rockwell mailed the full rental amount of $800 to the Communist party of the United States.

FIGHTING
FOR THE CAUSE

The artist, admittedly keenly sensitive to values about him, is deeply hurt and outraged by conditions in the world today. *We* want, with our whole heart and soul, a decent world, a world without poverty, without tyranny, without war; a society of which the watchwords might be Equality and Security.
—ROCKWELL KENT

If the devil himself engages in good work I'll join him. And, let me tell you, I will make no secret of it.
—ROCKWELL KENT

Kent had never lost his faith in socialism, though the forms of his belief had gone through many permutations. Even during the world war, when he concluded that the "masses" in their bloodthirsty stupidity were unworthy of the dream, he still held to it as an ideal. He had greeted the Russian revolution with great hope, and discounted the negative stories about it as being products of a class fearful of losing its hegemony. Even his old mentor Rufus Weeks shared this optimism. When Rockwell ran into him one day in the 1920s, the elderly gentleman's first words were, "Isn't it wonderful what they are doing in Russia!" But only the battle to save Sacco and Vanzetti, the one unifying cause of the left during the twenties, had moved him to direct action. When that fight had been lost, and the two anarchists put to death by the state of Massachusetts, he withdrew a planned exhibition from the commonwealth and promised, with a blast of publicity that brought him much hate-mail, never to allow his work to be shown there again. However, it was not until halfway through the most radical decade América had ever known that he rejoined the political struggle for socialism. His first overt act, appropriately, was in the realm of the arts.

The American Artists' Congress was an attempt to bring out, as Stuart Davis wrote Kent, "the fact that artists as a whole are in a serious condition, economically. . . ." There was also a need to defend themselves against the

growing strength of fascism. "All we ask is that artists who realize the real threat of fascism come together, discuss the situation, and form an organization of artists for their own insurance. The important point is the realization among artists that organization is essential to insure the continued function of the artist as a free individual."

The first public meeting of the American Artists' Congress was held at New York's Town Hall in February 1936. Lewis Mumford, George Biddle, Stuart Davis, David Siqueiros, Margaret Bourke-White and Rockwell Kent, among others, addressed the overflowing crowd. Kent spoke on his old theme of the artist as the great lover of life. It was by virtue of this love that men painted, and it was important therefore that when possible they oppose the enemy of life, war. He talked of the Eskimo and the important lessons he had learned from their simple, peaceful culture.

> Happiness, I find, is not directly related to either wealth or poverty, to standard of living, to education, to climate, or to any specific culture. Its premises appear to me to be security in the earning of a living and equality with one's neighbor in the enjoyment of its fruits. If war presents itself I'll ask myself this question: "Is it a war that will secure to *all* Security and Equality?" And, if it is, I will fight. Does what we call Democracy bring us that? Does Fascism promise it?

The artist found, if not a war, at least a worthy struggle going on in Vermont, just across Lake Champlain from his Adirondack farm. Workers at the Proctor Marble Company had walked off the job in November 1935 and were suffering through a particularly harsh winter. One of the strike organizers wrote Kent about the reasons that the men had left. "The industry has been run in the most ancient paternalistic manner, the children being brought into the world by the Company doctor and the old people being buried by the Company undertaker. The workers live in Company houses and trade at Company stores and, if they are lucky and work fairly steady, they may have a dollar or two left over each month after paying the Company."

Rockwell donated what money he could, personally visited the state's governor, and took part in a commission investigating the workers' living conditions. He was outraged at what he learned. Their situation was so bad that the hard-driving Kent felt their demands for improvement did not go far enough. "I am appalled by the humility, the lack of manly pride, the slavish self-abasement of our working classes in that the most they are fighting for is so little." He designed a poster pleading for aid, which was widely distributed, and he tried to get the New York City newspapers interested in the story. He also contributed ideas on strategy to the strike leaders, ideas

that brought him into conflict with some of his more ideologically disciplined allies. Here, as in later campaigns, these friends would ask to meet with Kent to discuss the proper "approach" to problems.

The workers conducted as militant a strike as they could, but by August 1936 they were beaten, lacking the financial resources to continue the fight. They returned to work, and though the Proctor Marble Company raised their wages from 37½ cents to 40 cents an hour, the larger abuses which had forced them to take action were not rectified.

Kent was disappointed, but he tried to bear in mind that this was just one battle in a much larger conflict. In a recitation of contemporary causes and dangers, he sounded, unconsciously but eerily, like an echo of Robert Pearmain in 1912.

> Southern lynchings; the plight of sharecroppers in the South; the beating . . . of active sympathizers; the . . . arming of civilians in the Southwest against the peaceful lettuce-picker strikers; the Mooney-Billings case; the Herndon case; the Camden strikes; the Scotsboro boys; the Black Legion reign of terror . . . ; the Ku Klux Klan; the teachers' oath; the case of the Jehovah's Witnesses; the mass trial of the miners in Gallup; . . . Coughlin of the air; and Hearst of the poor, nitwitted millions that the great American public school system has made just literate enough to read and swallow.

A case that particularly engaged him involved a personal friend. Joseph Gelders had been an instructor of physics at the University of Alabama before becoming an organizer in the state for the National Committee for the Defense of Political Prisoners. One night, while returning from a visit to a man who had been jailed for possessing Communist literature, he was kidnapped, savagely beaten, then thrown from a speeding automobile.

Kent wrote a bitter letter to John Temple Graves, an Alabama journalist who, while criticizing the beating, had seemed to do so in a mild manner. Graves responded that he had once used a harsher tone in pointing out unpleasant local customs, but the only result had been a trunkful of abusive letters and death threats. "Senator Hugo Black told me over half the people he talked to during his recent months in Birmingham thought the flogging of Gelders a good thing. I know Rhodes Scholars who think so, doctors of medicine who have studied in Paris and Vienna, novelists whose books have sold all over the country." He asked the artist to understand that local conditions required him to use different tactics. "Maybe I'm wrong, but I'm on the scene and you are not, and I know the South and you don't."

Rockwell felt under no such compunction to go slowly. Wanting to fight for the unionization of artists, racial justice, economic equality, he belonged

to almost every activist group on the left, and often served them as an officer or official sponsor. Jokingly, he wrote Stuart Davis after accepting another such position, "It occurs to me that we radicals are getting in the Capitalist class and establishing a fine line of interlocking directorates." When the United States government later issued lists of what it considered to be subversive organizations, he discovered that he had missed some. "I find that since 1935 I'm credited with part in only eighty-five, I am ashamed." But for all of his involvement he did not take the ultimate step. He did not join the Communist party.

Kent believed that the Soviet Union represented at least the beginnings of world socialism. "When the . . . revolution in Russia happened I changed the name of what I believed in to Communism. Communism is coming. Capitalism is an outrageous, silly, cruel farce." He saw the beginnings of an American form of communism/socialism in Roosevelt's New Deal, and he was certain it would be a different product. "We can make the change—the revolution—peacefully; preserving democracy, not as Russia has done." These were not matters for debate with him; they were founded on will and faith. "These are convictions long ago settled in my mind. I don't read any more arguments against Capitalism, and I don't bother doing much arguing for Communism."

Though Rockwell felt that the Communist party in America was a tightly organized, trained cadre that provided valuable aid to causes he cared about, he fully recognized its flaws. Self-disciplined as he was he could not accept the rigid, unthinking obedience demanded by party functionaries. Time after time, while serving on a committee or attending a meeting, he would clash with them over the proper "line" to be taken on a problem. There were members he admired, but many more seemed so lacking in understanding that they were dangerous. "I have always had a strong suspicion that close personal association with Communists, particularly as a member of the Party, would be thoroughly disillusioning to anyone who set a high value on his personal liberty and integrity. . . ."

Art, of course, was always central to his life, but politics began to enter even there. He still painted landscapes, driving into the nearby countryside, setting up several easels overlooking different views, then moving quickly from one to the other trying to do as much as his limited time allowed. But he was happiest when he could combine art with a political message. "I am pretty much of a landscape painter, but when I draw now I find that my art becomes more and more propaganda for the revolution." Some attempts were more effective than others.

The Treasury Department had chosen him to paint a mural for the

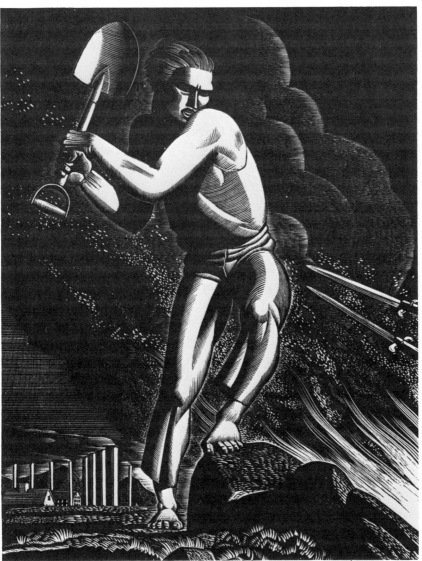
WORKERS OF THE WORLD UNITE! (WOOD ENGRAVING)

Washington, D.C., post office that was to consist of two large panels depicting the wide range of United States mail delivery, from an Arctic scene to a tropical one.

Through the aid of his explorer friend Vilhjalmur Stefansson, who worked for Pan American airline, Rockwell was able to revisit Alaska to gather material for the mural. Though it was a short trip, he managed to "discover" an Eskimo artist named George Ahgupuk, for whom he found a New York dealer, and to become involved with the fate of two Eskimo convicts who were dying of tuberculosis in prison, on whose behalf he met with the governor in a successful effort to get them released. Most of his time was spent in Nome, center of what remained of dogsled mail delivery. The Alaskan technique of harnessing dogs was very different from that used in Greenland, so he studied it carefully. "I got every kind of information as to details and equipment and if, when I finish my picture, there is a single rivet in the dog harness out of place, it won't be my fault."

This need for accuracy drove him to request another favor from Stefansson. "I have been trying hard to fake the Puerto Rican scene, but with so little success that there seems to be nothing left for me but a trip to Puerto Rico." Pan American, coming again to the rescue, flew him to the tropic island.

What he found there shocked him. The stark contrast between widespread poverty and the luxury enjoyed by a few seemed particularly obscene in a land as beautiful and potentially rich as Puerto Rico. He was offended by the paternalistic attitude of most of the American colonial officials he met, but his indignation was really fired by a conversation he overheard at a party given by the governor.

A short time before Kent's arrival the chief of the insular police had been assassinated. Albizu Campos, leader of a liberation group called the Nationalists, had been put on trial, but on the day of the governor's cocktail party the jury, unable to reach a verdict, had been dissolved. Rockwell met the federal prosecutor of the case, and heard him tell a friend that he had already handpicked the next jury. He read off the list, and assured his listeners that this time there would be no chance of acquittal.

Kent, distressed at this blatant manipulation of the judicial system, swore out an affidavit about the conversation and sent it to Campos's lawyer. It did no good; Campos was convicted. Kent's disgust grew even stronger the next year when, on Palm Sunday, March 21, 1937, police fired into a Nationalist demonstration killing eighteen and wounding over a hundred. The Ponce Massacre, as it came to be known, convinced him that the only solution to Puerto Rico's problems was independence.

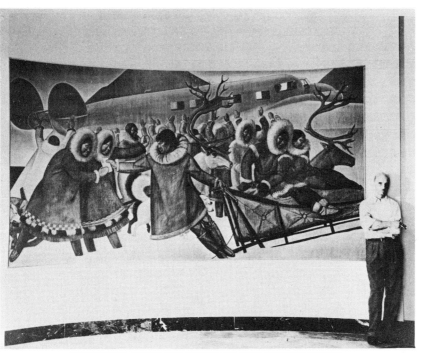

ROCKWELL KENT STANDING BY THE ESKIMO PANEL
OF HIS CONTROVERSIAL POST OFFICE MURAL

His mural was installed in the Washington post office headquarters in early September of 1937. One panel depicted Eskimos with dog and reindeer teams watching the departure of a mail plane. In the other a group of Puerto Rican women was shown receiving a message written in Eskimo script.

Less than a week after the unveiling enraged officials were accusing the artist of having disturbed the peace of the land by fomenting revolution.

With Ruby Black, a one-woman news service, Kent had devised a scheme to give maximum publicity to the Puerto Rican cause. Black issued a story of her painstaking search, begun out of curiosity, for a translation of the mural's Eskimo letter. After supposedly visiting, in vain, language experts all over the District of Columbia she reported that she finally turned to the famous Arctic explorer Vilhjamur Stefansson, who translated it: "To the people of Puerto Rico, our friends, Go ahead, let us change our chiefs; that only will make us equal and free."

The elaborate plant proved a great success, provoking headlines in newspapers across the nation. Things got even better after conservative Puerto Rican politicians entered the fray. They objected not only to the revolutionary message, but also to Kent's having shown the island people as Negroes, or, as Rafael Martinez Nadal, president of the Puerto Rican senate, phrased it, "as a lot of half-naked bushmen." Rockwell laughingly offered to add portraits of these critics to the mural, but, he warned, "painting [them] as their faces look out at me from a two-page, halftone spread, might with good cause give some offense to those Puerto Ricans who are not politicians."

After several weeks of widespread coverage the controversy died down. For a while the Treasury Department threatened to withhold payment for the work; Kent said he would see them in court. A compromise was struck and the troublesome wording of the letter was changed to something more innocuous. The artist felt it had been a successful ploy. "My simple little trick ... has given the Nationalist movement more front-page publicity than was accorded to the Ponce Massacre, or the conviction of Albizu Campos. So much for the newspapers."

At least there had been the pleasure of the fight. His fee of $2,500 barely covered expenses. As usual he was forced to rely on his commercial work to make ends meet. "I support myself by turning my hand to the production of almost every low-down job that commerce, the great prostituting patron of the arts, demands. I can do many things; I have perhaps the gift, but I certainly through necessity had to cultivate it." There were occasional commissions to illustrate such books as *Leaves of Grass* or a one-volume edition of Shakespeare. His Greenland book, *Salamina*, had appeared in 1935 and sold well. At times of great need he would reluctantly return to the hated lecture

circuit. He even considered, briefly, running an art school at Asgaard, and one summer he and Frances did play nursemaids to a group of neurotics and misfits sent them by the Boston psychiatrist and poet Merrill Moore.

It was with reluctance, now, that Rockwell would agree to leave his farm. He resisted for months pleas from the Communist party and one of its front groups that he help investigate political conditions in Brazil under the reactionary regime of Getulio Vargas. Reports had reached the United States of arrests, torture and murder of Brazilian leftists. The radical press in America was charging that Brazil had all but officially joined the Fascist camp.

Though the artist willingly led a delegation to meet with Oswaldo Aranha, Brazilian ambassador to the United States, he hoped that someone other than he could be found for the actual trip to South America. But in the end only Kent and Jerome Davis, president of the American Federation of Teachers, went. After a quick stop in Puerto Rico to appear on behalf of political prisoners there, Kent made the tiring, four-day flight to Brazil.

After their arrival the two exhausted men went to their separate rooms and fell into bed. A few hours later Kent was awakened by loud banging on his door. "Get the hell out of here and leave me alone!" he shouted. The pounding continued. Kent phoned the desk and shouted again. Finally he was made to understand; it was the police, paying a midnight call.

Rockwell immediately let them in. The three plainclothesmen ransacked his room, gathered up every scrap of paper, then demanded that he dress and accompany them to headquarters. Kent knew that police in Brazil were under no constitutional restraints. "My one thought from the start was to make them friendly." He had been a tenderfoot in enough bad corners of the world to know the proper attitude, so he played the good-hearted clown, skimming his passport across the room and into his half-opened briefcase, then strutting in self-mocking pride at his feat, offering cigarettes and smiles.

They took him to central police headquarters, the same building, then up to the same floor, from which a young American Communist, Victor Barron, had mysteriously plunged to his death a few months before. There a lieutenant told him that they were keeping his papers "to protect them." Over the Atlantic Kent had disposed of most of the documents that might cause him trouble, but the police did ask some angry questions about a list of political prisoners he had retained. Rockwell, continuing to play the fool, demanded back only the address of a good tailor who had been recommended to him. When the arresting officers drove him back to his hotel he insisted on buying them drinks.

After that episode Kent and Davis were allowed to pursue their investigations in peace. They worked independently in order to make the most use

of their limited time, a fact that pleased the artist, for he had found that Davis "doesn't tip waiters, and sponges all his cigarettes and drinks." By the time of their departure the two had interviewed, through interpreters, dozens of writers, journalists, artists and workers. They went home feeling full of accomplishment.

Trouble began as soon as Kent made his preliminary report. He had decided that, though the Vargas regime was without doubt a dictatorship, and a brutal one, it could not be called Fascist. "He is no more a Fascist than Roosevelt is a Communist." This was not what the sponsoring groups wanted to hear. On their own they revised his report. Kent, who would not tolerate even professional editing of his writing, exploded. The "revisions" were dropped. "You know," he wrote a friend, "I am getting sort of fed up with the cheap jingoism of a whole lot of radicals. They are as unprincipled in branding things and people Fascist as Ham Fish is in calling his opponents red."

In spite of a growing sense of disenchantment with many of his leftist colleagues, Kent continued to support the general program of the Communist party. It was, to him, the road to socialism. "You don't forsake the religion you believe in because of the kind of people you find in church." The party at least was doing something.

The Spanish Civil War and its horrors called particularly for the utmost efforts. Among Kent's many contributions were poster designs, speeches and the donation of prize money from art exhibitions. He wanted all artists to contribute such funds since they were "in the nature of gifts from God." When the National Academy of Design awarded him $600 it was all given, for medical aid, to the Spanish republic.

Rockwell still dreamed of changing society through art. But while he felt that people could be transformed by exposure to an environment filled with beauty, he also expected some help from the people themselves. "Now they are talking," he told an interviewer, "of putting the modern workman in filing cases—small model houses, all in a row. But the workman when he finds himself living in one will revolt."

Working-class homes in Denmark had been filled with art, paintings and sculpture often obtained through the exchange of goods or services. Kent believed that the federal art projects had fostered "the first one hundred percent American art," and he hoped this would awaken the people to its importance. One reason for establishing artists' unions was to push for continued government support, though Kent argued that more care had to be taken in selecting participants. "I think that there is no doubt that with the inauguration of WPA innumerable unqualified people became enrolled as artists."

Kent believed that, as leaders in the movement for true democracy, unions, in conjunction with government, should also take up patronage of the arts. Rockwell used his personal friendships with union officials, such as Joe Curran of the National Maritime Union, in efforts to get commissions for members of the Artists Union—Willem de Kooning, among others—to decorate meeting halls, headquarters buildings or to design and illustrate their journals and pamphlets.

From as early as 1909 Kent had objected to the poor typographic qualities of Socialist publications. Finding no improvement over the years he tried to educate his comrades in the importance of fine printing. "The only eloquent design is good design." He often refused to use the Typographical Union symbol because of its ugliness. "It defaces every page that it appears on. It really is a scab label, because the Typographical Union employed, not an artist, but a scab to design it."

Kent continued to play as hard as he worked, but socializing was held to weekends. Guests, to their surprise, would often find themselves handed a rake or shovel and, led by their ever-active host, put to some farm chore. Their labor would be rewarded by the evening's elaborate feast as well as the innumerable toasts that Rockwell would offer as he stood in front of his six-foot-high fireplace or his well-stocked bar. He had discovered aquavit through Knud Rasmussen, and he could appreciate the fine points of other species of strong drink. "It frequently seems to clear the road for straight, clear and sometimes highly imaginative thinking. Such an effect is decidedly worthwhile—though I don't value it as applied to my work."

Guests, in spite of chores and their host's penchant for waking them at 5 A.M. with a recording of Wagner's "Ride of the Valkyries," were never in short supply. The ever-flowing stream included people like Louis Untermeyer, Peter Freuchen, John Dos Passos, Isabel Soule, Donald Ogden Stewart, O. Byron Brewster and the man Kent regarded as the greatest of his contemporaries, Paul Robeson.

For all his vitality and charm, Rockwell was, even at the best of times, difficult. Hard-driving, impatient, critical and domineering, he felt a need to always be considered right. He, and those around him, suffered from his inability to tolerate opposition, and friendships of long duration would be broken over seemingly trivial disagreements or imagined snubs.

Frances, whose health and inclinations could not bear cold weather, began spending winters in Arizona. Neither her absences nor her inability to write letters pleased Rockwell, and their relationship became increasingly attenuated and painful for him.

In 1940 he met Sally Johnstone, an attractive twenty-six-year-old who

NASH AUTOMOBILE ADVERTISEMENT

had been born in England and educated in Canada. Kent found her good humor, grace and gentle disposition enchanting. Frances divorced him in the same year. After a challenging courtship the fifty-eight-year-old artist re-married again.

It was one note of happiness in a world that seemed hell-bent on de-struction. An autobiography covering his years at Asgaard and his political activities appeared in 1940. Containing a strong plea for peace, *This Is My Own* was both paean to, and a criticism of, his country.

The Hitler-Stalin nonaggression pact, which split the American radical movement, did not seem a betrayal to Kent. It would be naïve, he felt, to ex-pect otherwise of a great power; after all, England and France had tried to appease the Nazi beast in their own self-interest. What irritated him was the complete turnaround that the party executed after the German surprise at-tack on Russia. "Frankly the 'line' in regard to all-out aid . . . makes me a bit sick," he wrote the *New Masses*, organ of the radical left. "The new position which the attack on Soviet Russia has forced upon those of us who had been opposed to . . . an imperialist war can be stated honestly and truthfully, and in terms that will command more respect than the sudden outbursts of devo-tion to England and, as though incidentally, to the USSR."

Since Kent hated war, he hoped that the United States could stay out of this one. But he was sure it would not. "We can get together and weep," he wrote a friend, "for we are living in a time foretold . . . long over a thousand years ago and called 'the twilight of the Gods.' In that twilight 'the Wolf Skolls swallows the sun, and Hati swallows the moon so that heaven and earth are sprayed with blood.' "

But when the war did come, against an enemy that desired the destruction of everything that Kent believed in, he tried to enlist his most potent weapon: art. A few posters were designed for the Office of War Information, an exhibition of his paintings, titled "Know and Defend America," toured the country, he designed blackout shades, and he executed a large mural for the House Committee on Interstate and Foreign Commerce on the theme of Peace and Progress; but all his requests for heavier tasks were ignored.

Letters from service friends like Manny Greenwald, Arto Monaco, Bill Calhoun and his son Gordon, serving in Greenland, kept him informed of military life and gave him a personal view of the course of the war. To his surprise he learned that his old Arctic drinking and flying companion Ernst Udet had become a high-ranking member of the Nazi war machine. "It's curious [since] he is personally a genial, lovable, kind-hearted fellow."

One thing he could do to help the war effort was to expand his dairy operation. The herd of quality Jerseys was doubled, the barn enlarged and a bottling operation set up so that he could sell directly to the public. He became both a feed and a farm machinery dealer to cut his own costs.

Since the Soviet Union seemed to be bearing the brunt of the fighting Kent supported Russian War Relief with what money he could spare. He began an extensive correspondence with several Soviet artists, and invited a group of Russian students who were studying at Columbia to Asgaard for Christmas. They won Rockwell's respect with their sincerity and good-hearted simplicity. He also followed closely the progress of the Red Army. Their victories seemed to belie the reactionary statements made over the years that Russian modernization had been a sham, that the people would revolt at the first opportunity, that socialism could not work. "If the Russians had not turned them back at Stalingrad, I would just have thought, 'Well, they haven't got socialism working right over there.' They did. And my conclusion is that it is working."

But now evidence was all around him that it was not going to get a chance to work in the United States. The radical groups into which he had put so much effort were all dissolving, often leaving debts that he felt obliged to pay. He and Lynd Ward made an effort to carry on the dream of an effective artist's union, but finally that too disappeared.

Even more ominous were the signs of growing political oppression.

Radical bookshops were raided and their owners jailed; enlisted men, including his son Gordon, were denied commissions because either they or a family member had been, as the government put it, "premature anti-Fascists"; and a national smear campaign seemed to have been launched against every public figure with the slightest connection to the left. After the Russian students had visited Asgaard, the Blooms, a couple newly arrived in Au Sable Forks, began hosting a discussion group on life in the Soviet Union. They found themselves denounced from the pulpit of the local Catholic church and subjected to anti-Semitic slurs. Shortly thereafter the state police began questioning townspeople who had attended the meetings. The discussion group dissolved.

If these things could happen while the United States was in alliance with the Soviet Union, what harsher steps would follow Nazi defeat? A friend wrote Kent of his prediction. "As things are moving, we will find ourselves in the position—when the military victory has come—of being outcasts, isolated and despised while the fat-headed and the reactionary elements grab the flag and proceed to create a 'new' America which will be exactly the sort of America we fought to prevent it becoming."

This sense of impending disaster grew stronger after President Roosevelt's death. Kent had seen him as a good-hearted statesman whose compassion and humanity had led him to adopt leftist programs and whose tolerance had at least kept the federal government from leading the campaign against political "deviates." He had no such faith in Harry Truman. The dropping of the atomic bombs horrified Kent; truly it seemed, as the Icelandic saga had predicted, that the world was sprayed with blood. What was to be done?

Perhaps it was time for a third political party, broadly based, but unashamedly leftist. Peter Freuchen, after having been a hero of the Resistance in Denmark, had returned to New York to work as a journalist, and he now challenged his friend to answer some pointed questions. Kent responded quickly. "You ask me why in hell we don't have a labor party in America and tell me how the Communists of Denmark scared the Social Democrats into putting forward a decent program. The trouble is that the Communists in America are so weak that they can't really scare anyone into doing anything. It appears at times that they serve no ostensible purpose but that of a bugaboo for the use of the reactionaries in scaring labor into being conservative." What was needed was a party that would clearly and forcefully present a socialist-labor program. It was still the unions that Kent looked to for social change. When his friend Lewis Merrill, head of the United Office and Professional Workers, came under criticism from Communists for publicly

disagreeing with the party, Kent leaped to his defense. "I think he is dead right. . . . In the present crisis, and perhaps always, the solidarity of labor is more important than Communist discipline or, for that matter, than the Communist Party."

In 1948, Kent found what he hoped was a solution to the manifold problems of the left in the third-party presidential candidacy of Henry A. Wallace, former vice-president and cabinet official. Rockwell organized a district branch of the American Labor party and distributed leaflets to the citizens of Au Sable Forks.

The citizens soon responded.

Kent's effort to bottle and sell his dairy's own milk during the war had been expensive and time-consuming, but he was proud of the high quality, the efficiency and the success of his operation. He was only mildly irritated when he received a letter from a customer stopping delivery because of Kent's politics. He wrote a polite response defending his views and expressing his understanding of her motives. "I believe your action was the result of principle and deserves great respect." The next day ten more quit, then thirty, then seventy. Within a week over a hundred customers had joined the boycott. "We don't want Russian milk," said one.

Kent searched for an organizer behind the drive, and found that the local Catholic priest had visited one of his employees, telling him to quit and asking about the politics of the other workers. "Are they Communists?" Under such pressure two employees did quit, and customers continued to drop away. Even friends were affected. One wrote that because he had a family to support he was, in spite of all the favors Kent had done him, in "no position . . . to get involved in any controversies."

There was only one thing to do. Rockwell called in the two loyal workers who had stuck with him and gave them the whole business—pasteurizer, cooler, washer, bottles, boiler and two new trucks. "Take the whole thing," he said. "Change the name and move it off this place just as quick as you can. Spread the news and spread it quick!"

The news spread even farther than the Au Sable Valley. The wire services picked up the story and ran it coast to coast. Kent tried to see the bright side. In response to a letter of appreciation from Senator Glen Taylor, Wallace's running mate, he wrote that though the boycott had cost him almost $15,000 it had yielded many times that in good Wallace/Taylor publicity. "It has been a good investment for peace."

As a further contribution to peace the former dairy operator decided to run for Congress on the American Labor party ticket. He attended the party's national convention where, with the help of the photographer Paul

Strand, he was able to get a plank added to the platform promising a Department of Culture. As soon as he returned home he began his campaign.

A farm wagon, decorated with patriotic bunting and equipped with loudspeakers, toured every city and hamlet in the district, blaring his campaign song, "Hallelujah, Kent for Congress." The candidate himself often rode along, giving speeches and glad-handing voters. The American Legion gazed on this one-wagon parade with a baleful eye, but were restrained from more forceful criticism by Kent's age, sixty-six, and his gentlemanly demeanor.

He also traveled outside the district in support of the ticket. A fund-raiser had been scheduled in Albany with Kent and the playwright Lillian Hellman as featured speakers. She entered, to Rockwell's intense annoyance, in the middle of his address, walked noisily to the platform, and clattered up the steps and pulled a chair out of the wings. When he volunteered to sing his campaign song for a donation of $100, the caustic Ms. Hellman asked, "How much not to sing?"

Kent replied, "A hundred and twenty-five."

"I'll pay it," the lady said.

Rockwell waited until she began her speech, then pushed his chair back, clattered down the steps and noisily exited.

Personality clashes occurred even in the small ALP group in Clinton and Essex counties. Kent fought with a local college teacher over which of the two truly represented the party. The fight split the already thin ranks, and Kent wrote a vitriolic letter to party headquarters. "Some strongly suspect him of being an FBI agent. From Patterson I learned that he consorts with Social Democrats. Long ago we had come to the conclusion that if he were . . . a Trotskyite intent on disrupting the movement up here, he couldn't be doing a better job."

As if there were not enough barriers to victory, a "culture caravan" was sent to aid the campaign. This consisted of several fervent young entertainers who were expected to rally the masses through songs and skits. Kent made his appearance with them in Plattsburgh, speaking from his wagon before a large crowd, addressing them on farm issues, the need for more housing, and inflation. When he left the platform the caravan went into action.

> Now, the people of this region are about 80% Catholic. They are more Catholic than they are Republicans or Democrats. They have been taught that Franco is the defender of the faith and that the Loyalists were Communists directed from Moscow. They have been taught this on the nearest authority to God himself, their priests; and there is . . . nothing to be done about it but leave that issue strictly alone. So the

Caravan began with skits against Franco and extolling the virtues of the International Brigade. From this they switched to songs in Yiddish and skits bringing in all the foreign languages. . . . Those who didn't recognize the songs as Yiddish—and that was bad enough—took them to be Russian. By the time they got to "United Nations on the March" the place was a bedlam of cat-calls, tooting horns and shouts of "Go back to Moscow."

As Rockwell and Sally walked away in disgust the first tomato arched out of the crowd toward the singers. In spite of Kent's pleas the caravaners were not recalled. They made other appearances in the district on their own. Each occasion, as word spread, got ruder and rougher, until they were finally assaulted by some American Legionnaires.

The outcome of the election was a foregone conclusion. "As a speaker I won lots of praise; as a debater I annihilated my opponents; and as a vote-getter I was only less of a washout than Wallace," Kent reported.

During the milk boycott, threats had been made against his home. "Someday they'll be up to burn him out," one harridan had warned. Later, a death threat was sent. Whenever Rockwell and Sally left their farm, a friend named Billy Burgess stayed behind, armed with two guns. The siege was on.

HARD YEARS

And then the Knave begins to snarl
And the Hypocrite to howl
And all his good Friends shew their private ends
And the Eagle is known from the Owl.
 —WILLIAM BLAKE

Thus, stubborn I became; stubborn—like a mule or jackass if you like—I remained. May I now, in these hard years . . . stay stubborn!
 —ROCKWELL KENT

America had known repression at other times during Kent's life. Immediately after the First World War there had been a wave of anti-Red hysteria that resulted in lynchings, prison terms and mass deportation for its victims. Kent, isolated from the radical movements by living on his remote Vermont farm, had missed most of its impact. That was not to be the case this time.

Freelance work by its very nature is uncertain. Kent had experienced both lean and fat periods during his commercial career, but he had never doubted his ability to find some task to which he could apply one of his talents. There would always be a book to illustrate, an advertisement to draw, an industrial pamphlet to design or some article of everyday use, like dinnerware, to decorate.

Rockwell's personality, as well as his talent, had played a role in winning these commissions. Art directors, often frustrated artists themselves, admired his paintings, his success, his hard-drinking charm, and his glamorous adventures. While he had been on this third trip to Greenland, his friends in the General Electric Company's management had arranged broadcasts to Admiral Richard Byrd in Antarctica and their favorite artist in Igdlorssuit, "carrying messages to the representatives of the white race who are nearest the South Pole and the North Pole," as the press agent put it. Sending the

messages from the Silver Grill of the Hotel Lexington in New York were some of the most famous writers and artists of the day, backed up by Al Kavelin's orchestra, "Al having given much thought to the kind of music an Eskimo would like." Unfortunately, Kent's radio malfunctioned so neither he nor his native friends heard it. General Electric later commissioned him to execute a huge mural for the 1939 World's Fair on the theme of Electricity and Progress.

Kent's politics had concerned his patrons very little, but, as the chill of the cold war swept across America, groups of right-wing vigilantes formed to apply pressure on companies that hired anyone with the slightest reputation for radicalism. Kent certainly felt the pressure, but that merely caused him to increase his activities. When union organizers at the Lakeside Press pleaded with him to send a letter of support to be distributed among the workers, Kent agreed, in spite of his reliance on the press for some of his commercial jobs. The organizers later sent word that his letter had greatly aided their campaign. Management indirectly sent their own opinion—his work would never be accepted there again.

When General Electric was struck, the workers invited Kent to join their picket line; he accepted. The previous year he had provided a painting for the company's calendar, and had been asked for a second one. After his appearance on the line, General Electric informed him that they were no longer interested. Kent retained a lawyer to make it clear that there had been a verbal contract. After some maneuvering the company agreed, but they insisted that he change the New England scene he submitted by removing a picket fence. The art director wrote him, "Anything reminding them of pickets down here drives them crazy." It was his last work for General Electric.

Very little more came his way from any source. Vanguard records did have him decorate some album covers, another company commissioned some fabric designs, but aside from such small-scale work his career in commercial art was over, and the major source of his income was gone.

When Rockwell's mother died in 1947, her estate yielded each of her children $30,000. Kent put his money in the extremely capable hands of Bob Rosenberg, son of his old friend James, who quickly doubled, then tripled the capital. By being frugal, and raising, canning and freezing their own food the Kents were able to endure. Others were not so lucky.

Friends lost their jobs, were blacklisted, then were harassed by FBI agents who would follow them wherever they went, interrogate neighbors about their activities and visit potential employers the day after they had ap-

ALBUM COVER

plied for a position. Some left the country; others survived by taking jobs as janitors, waiters or gardeners. Rockwell gave what funds he could, and he offered his house and farm as a refuge.

Some of Kent's most active radical friends were immigrants who were arrested by the federal government for deportation, once the crackdown came. Norman Tallentire, a poetry-loving member of the Communist party, was imprisoned under harsh conditions on Ellis Island while the bureaucratic machinery moved toward his expulsion. A native of England, he had gone to work in the mines at the age of thirteen, and his whole life had been dedicated to fighting for "the workers." Kent admired him enormously, and that respect was reciprocated. "I don't know," Tallentire wrote Rockwell, "whether you fully appreciate what it means to a person of my origins and upbringing, an uneducated cub from a back-country coal-mining village . . . brought up in poverty and penury, to be able to meet and have for friends people who have made their mark in the literary and artistic world."

Though Tallentire had resided in the United States for thirty-three years, and suffered from a severe heart condition, the government would make no allowances for him. It seemed, in fact, as if the immigration service especially sought out the old and long-established radicals for harassment; al-

most one-third of those arrested for expulsion on political grounds were over sixty years old and had lived in America for more than forty years. Tallentire spent his time on Ellis Island trying to organize the other prisoners. He died of a heart attack while fighting the deportation order.

Kent resisted the domestic repression as best he could, but his major effort for the rest of his life was made for international peace. Atomic bombs, he was sure, meant an end to civilization; they had to be renounced. In 1949 he attended the World Congress for Peace, which was held in Paris. The following year he returned to France with a delegation that addressed the French Chamber of Deputies to ask that they ban nuclear weapons. He was then invited to continue on to Moscow, where he was part of a group that spoke before a special session of the Supreme Soviet for the same cause.

The trip to Moscow was immediately followed by one to Sweden and a conference attended by leftists from all over the world. Kent served on the committee that wrote the Stockholm Appeal, a call for the complete banning of atomic weapons, then returned to the United States with a feeling of accomplishment—but minus a passport. The State Department informed him that by crossing into Eastern Europe without a proper visa he had violated government regulations. He could no longer journey abroad.

Whatever longings he had for travel were fulfilled by crossing and recrossing the country speaking on behalf of peace and the Stockholm Appeal. Sally and Rockwell were accompanied to one address, in Los Angeles, by his second wife, Frances, who had moved to southern California. As Rockwell introduced his lovely young wife from the platform, a woman sitting next to Frances in the audience turned to her and said, "Why the old *goat!*" However, after Rockwell had given his talk, full of his usual verve and sparkling energy, the woman turned back to Frances, "Now I understand what she sees in him."

It may have been on this trip that he visited the Hollywood restaurant owned by his old impersonator, Michael Romanoff. Friends had asked him to be their guest at Romanoff's, one of the best, and most expensive, dining spots in the area. After they had eaten, Rockwell, to his hosts' great surprise, asked to be allowed to take care of the bill. He wrote, with a flourish, across the face of the check, "Michael Romanoff." After the waiter had quickly consulted with the proprietor it was honored.

No matter how enjoyable the trip or how worthy the cause for which it had been taken, Rockwell was always happiest when he could drive the Au Sable river road, then turn up the hill toward his farm. On one such return he was horrified to smell smoke and see the red glow of flames through the

pine woods. He sped onto the property fearing that he would find his trea-sure-filled house burning. To his relief it was only a brush fire, but it gave him a shock he never forgot.

Kent had gotten along with friends of most political persuasions throughout his long life. He had also fought with them, but usually on per-sonal grounds, not because they were Republicans, Democrats, Socialists or Communists. "I think I only draw the line at racial intolerance, for that ap-pears to me to result from a combination of stupidity and inhumanity that is utterly unendurable." Just how inhuman it was he found out at first hand.

Harry Moore was Florida state director of the National Association for the Advancement of Colored People. A sheriff had shot two handcuffed Ne-gro prisoners, killing one, and Moore was leading the local people in a de-mand for an investigation. On Christmas night, 1951, a tunnel was dug un-der the bedroom of his house and a charge of dynamite set off. Moore was killed immediately, his wife, horribly maimed, lingered for two weeks before succumbing. Kent, with a racially mixed group from the north, attended her funeral.

He had never been in a completely segregated culture before. Separate waiting rooms at the airport, separate toilets, drinking fountains, restaurants and hotels. They had been warned that it would be dangerous for a mixed group to ride together, so they took separate taxis. When they arrived at the cemetery they found that even it was segregated.

The delegation, angry because the murderers had not been arrested, was granted an interview with the governor, who explained that under his state's constitution local authorities had jurisdiction; there was little he could do. The sixty-nine-year-old Kent responded, "My constitution imposes certain limitations on me too; I am no longer a young man. But I have traveled here because I know that at a time like this I must exceed these limitations. I urge that you exceed yours." The governor assured them that he would do every-thing he could to see justice done, then gave them a motorcycle escort back to the airport.

They found that their plane would be delayed for several hours. When Albert Kahn, one of the leaders of the delegation, asked if the airport restau-rant would serve Negroes, he was told that they would be given food to eat outside. The northerners decided to sit together inside and demand to be served. Several hard-faced men entered, saw the racially mixed dinner party and rushed to the telephone. Soon knots of men were gathering around the terminal. One group stood just outside the restaurant window and stared in at the would-be diners.

The manager called the police, who arrived angry and belligerent; but

when it was explained that Kahn and his friends had just come from seeing the governor they, reluctantly, became protectors. Food was quickly served. Later, as the delegation was on its way to the plane, one of its members, a young Negro man, leaned to take a drink from a fountain designated for whites. An airport official struck him on the back and motioned him away. Rockwell caught up to his friend and told him that the fountain had just been white water, that in his pocket he had a flask of good strong brown water that they would share once on board.

Of all the organizations to which Kent belonged his favorite was the International Workers Order, a fraternal group that specialized in low-cost insurance to both Negro and white members. It was also, in economic terms, the most successful Communist-front organization in the United States. It was less effective in its efforts to raise a militant class consciousness among its members.

Though Kent served as its president for many years, he played mainly a titular role. Made up of various ethnic lodges, the order tried to promote racial and cultural understanding among its members, but there were incidents of prejudice, particularly in some of the Slavic lodges in western Pennsylvania. Rockwell joined the Harlem lodge to symbolize his own feelings.

At its peak, in 1946, the order had 185,000 members whose various insurance policies were worth $122 million. It was one of the most prosperous and efficiently run insurance organizations in the country, until the government launched an overwhelming attack against it.

The IWO was the first organization to be put on Attorney General Tom Clark's list of subversive organizations. To Kent it seemed as though that action had lit a powder train; members were ejected from federally financed housing projects, those working for the government were fired, foreign-born members were arrested for deportation and the FBI investigated the order's officers. But the ultimate detonation was the attempt by New York State to liquidate the order as a "hazard." The superintendent of insurance, while admitting that the order was financially sound, asked that its lucrative policies be turned over to a private company. The ensuing court battle was fought using all the weapons at the government's disposal.

The prosecutor set the tone by stating, "You know, your honor, we are at war with Russia." To prove that the IWO was on the wrong side of that conflict he brought out several reformed Communists, including one named Louis Budenz, former managing editor of the party's organ, *The Daily Worker*. In 1945 Budenz had rediscovered the Catholic Church and had broken from the Communists, becoming a professor of economics at Fordham University, as well as an imaginative and well-paid professional informer.

Among his contributions to the IWO case was his statement, under oath, that the organization's president, Rockwell Kent, was personally known to him as a member of the Communist party. "He stated so to me himself," Budenz declared, "and he was introduced as Comrade Kent at meetings which only Communists were permitted to attend." Budenz made the mistake of mentioning dates.

Kent was furious. He told newspaper reporters that the testimony was a lie, and therefore perjury. "Lying Louis Budenz" became the phrase by which Kent would refer to him in public, hoping for a libel case. The artist had kept almost every scrap of paper he had ever been sent, plus carbon copies of all his letters. He could tell to the day where he had been and what he had been doing. A "closed" party meeting, for which Budenz had supplied the date, turned out to have been a much-advertised public discussion of postwar problems in America. Kent submitted proof of this, and testified at the trial. He asked, to no avail, that Budenz be indicted for perjury.

Actually, the whole defense had been to no avail. Judge Henry Clay Greenberg upheld the dissolution. The International Workers Order, as historian David Caute wrote, "thoroughly holed and pirated, finally sank much to the detriment of its policyholders, with the artist Rockwell Kent gallantly manning the bridge as the last president."

To Kent it seemed as if there were no refuge from the madness. In 1947 he repurchased the little Monhegan house that he had built decades before. In spring and late fall, after the flocks of tourists had left the island, he and Sally visited for a few weeks so that he could paint once again the headlands, forests and sea.

Even on that remote chunk of rock fear was apparent. On their very first visit the fisherman who ran the ferryboat assured them that fires then raging through Maine's forests had been set by the Communists. Rockwell's politics were well known to the islanders, but it was not until two FBI men paid him a visit there that they reacted. Sally remembers, "How sad we were as suspicions grew on the part of our close friends. . . . We recognized the symptoms promptly: avoidance on the footpaths, hurried departures from the store when we appeared, a little less warmth and willingness in helping out when need arose." In 1953, Kent again sold his house, and left Monhegan forever.

More shocking to him than the fact that irrationality had spread even to isolated corners of America was the realization that liberals were doing little to fight it. They seemed to have collapsed under the weight of the attack. "Bah!—the whole thing makes me sick!" he wrote his friend, the artist and radical cartoonist Bill Gropper. He tried to encourage resistance by quoting

what Harry Bridges, leader of the West Coast longshoremen, had told him, "It is too late to be afraid!" But as the repression continued it became obvious who had won. "I think it is a hell of a time to have lived into. It is disillusioning and dreadful what these times have done to people—or, rather, to have become aware of people's vulnerability to fear."

It was a poignant time for Kent, a time of pain and reassessment. He began work on an autobiography and found to his surprise that several publishers were interested. He chose Dodd, Mead because of Ed Dodd's enthusiasm for the book. Through his usual fierce concentration he was able to write and illustrate the 200,000-word epic in a year. He titled it, from a Negro spiritual, *It's Me O Lord.*

Unfortunately, the publisher's enthusiasm began to wane after receiving a blast from the reactionary sheet *Counter-Attack;* they ran only three advertisements for the book. Legitimate reviews were mixed. The reader for the *Chicago Sun-Times* regarded it as a classic, others felt it was too long and rambling. Sales were moderate. A five-thousand-copy first printing was sufficient to cover the demand.

Painting was still the most important activity in Kent's life, but as Abstract Expressionism came to dominate the art world his work was less and less valued. "Realism is not the vogue at the moment, and I have never been the least bit interested in adapting myself to the production of current fashions." His youthful belief in art as communication, and as a guide to an appreciation of life, had not changed. He had always distrusted art that took too great a liberty with the weight and form of reality. "The sappy New York critics keep yapping that it is the duty of the artist to be Modern, that Modernism is New York today, and that art should be a paean to steel, noise, jazz and its vulgarities. Of course art can be that. But it seems to me that if the artist has any real historical function it is to preserve the consciousness of the deeper and more enduring values of life against such threats of disintegration as our rampant city Modernism holds."

Through the pages of the *New Masses*, Rockwell had engaged in a controversy over whether Picasso's claim to be a Communist could be accepted. Kent felt that the Spaniard's art, obscure and difficult to understand, disqualified his statement. He had great respect for Picasso's genius as an experimenter, but felt that his followers had completely lost track of their purpose. "Abstraction is the cultural counterpart of the atom bomb."

"I have gotten quite accustomed to painting pictures without the least expectation of their being seen except by Sally," he wrote a friend. But in 1953, returning home to Au Sable Forks from Monhegan Island, he stopped at the Farnsworth Museum in Rockland, Maine, to talk to its director about

mounting an exhibition of his paintings. Wendell Hadlock enthusiastically agreed. Kent then made a further proposal. He had long been worried about what he would do with the large collection of his own work that he had kept. There were almost a hundred paintings that covered every stage of his career, plus almost a thousand drawings and prints, his journals, photographs and books. The record of a long, productive life.

All of this was offered to the Farnsworth Museum. Hadlock eagerly responded that he would talk to the trustees about building a new wing to house the collection. Rockwell was just as excited, and he returned to Asgaard to prepare his paintings for their first exhibition since the war.

It was inevitable that a man as prominent and politically active as Kent would sooner or later confront the figure that more than any other symbolized the nation's climate of fear and hatred. In late June of 1953 there arrived at Kent's door a subpoena demanding that he appear, within forty-eight hours, before Senator Joseph McCarthy's Permanent Subcommittee on Investigations.

The ostensible reason for this particular hearing was to investigate authors whose books had been purchased for American overseas libraries. Some books, by authors whose politics were suspect, had already been burned by the State Department, and others were scheduled for destruction. Since *Wilderness* and *N by E* had been discovered on the shelves of these institutions, Kent was called to answer questions about his political beliefs. He was accompanied by Sally and two good friends, Angus Cameron and Albert Kahn.

McCarthy wanted to know why he had donated $800 to the Communist party in 1935. Kent explained that he had wanted to offend the rich people who had paid that amount, against his will, as rent for his home. The senator then shifted to what had come to be called "the sixty-four-dollar question." Had he ever belonged to the party? Kent replied that it was no one's business what political groups he belonged to, and he took protection in the Fifth Amendment. After several more fruitless attempts, McCarthy said that such answers proved to him that the artist was a Communist. Kent smiled.

Rockwell asked if he could give a statement for the record, but McCarthy curtly rejected the request: "I'm not going to listen to a lecture from you." Kent snapped back, "You're not going to get one. I get paid for my lectures." As he was dismissed Rockwell said, "I'm sorry. I had serious charges to bring here of a conspiracy to overthrow the government by force and violence."

To the reporters outside the hearing room he passed out copies of his statement charging that McCarthy was the leader of a conspiracy to overthrow "our Democracy in favor of a Fascist, totalitarian government." He

also, laughingly, told the newsmen that he had never been a member of the Communist party, but that he would never answer the question before an inquisitional proceeding because such cooperation speeded the already rapid erosion of American liberties.

An enterprising reporter discovered the mural Kent had painted for the House of Representatives in 1943, and he asked various conservative politicians what they thought of the government owning the work of such a man. One representative wanted to know how it had gotten there, since Kent's politics had been common knowledge when it was painted. Rockwell, sure that it would not be destroyed, found the situation amusing. "Showing four angels symbolizing the Four Freedoms flying over a prosperous America and bearing the caption, 'On Earth Peace,' it will be a tough one for them to do anything about. We are wondering if somebody will recognize the angels as Mrs. Marx, Mrs. Lenin, Mrs. Stalin and Mrs. Malenkov."

His response to a letter he found waiting for him when he returned home was less lighthearted; the Farnsworth Museum had decided that it did not want a Kent show, nor the Kent collection. He learned later that the head of the Boston bank that administered the museum's trust had jumped up screaming when Hadlock had presented the proposals to the board of trustees: "Kent! Rockwell Kent! The man who was being investigated in Congress! Never! Not in this museum!"

That attitude was shared by the news organs of the art world, the journals, newsletters and magazines that had once found Kent so worthy of notice. A friend asked him if he subscribed to *American Artist*. "I may have seen *American Artist* but have never subscribed to it, having received the impression throughout many years that a virtual boycott of my work was in progress, and being even somewhat amused at the thought that whole volumes on American art were being compiled as though for the sole purpose of leaving my name out." Years later, when it finally published an article about him, the magazine admitted Kent's intuitions had been correct.

It was as if these years were the declining arc that matched his rise forty years earlier. Through sacrifice and hard work he had achieved fame as a painter and printmaker, respect as a writer, admiration for his daring adventures, and fortune through his skill as a commercial artist. Now, old but still strong, the rewards of effort and talent were stripped from him, his very name a hindrance. "I have played with the idea of starting out again as an artist under a different name. . . . The main trouble is they would get under my skin by calling me an imitator of Rockwell Kent and being an imitator, even of one's self, is thoroughly despicable."

Since the late 1920s there had been a confusion in many people's minds

TRANSPORTATION MURAL

between Kent and Norman Rockwell. So often had each been mistaken for, and effusively complimented on the work of, the other that they had written lighthearted articles on the problem for a magazine. Kent took a slightly malicious pleasure in forwarding to his fellow artist the angry letters he occasionally received that demanded to know how the person who painted such sincere celebrations of the American way of life for the cover of the *Saturday Evening Post* could harbor the subversive sentiments that had been attributed to him by that morning's newspaper. Less enjoyable were the several times, as his own reputation diminished, that he was confused, in both print and on the airwaves, with George Lincoln Rockwell, head of the American Nazi party.

But it was through the very vicissitudes the artist was suffering that he met the most generous, and strangest, patron he had ever known.

J. J. Ryan had long admired Rockwell's work. He also resented the growing attacks on American freedoms. After the right-wing newspaperman Westbrook Pegler wrote a column slurring Kent, Ryan flew to Asgaard to offer his help. He flew in the giant B-17 bomber that he had converted into his private plane.

J. J., the grandson of one of the most successful of the nineteenth-century robber barons, Thomas Fortune Ryan, was enormously wealthy—and irrepressibly eccentric. On this first visit he promised Kent that if the political situation in America became intolerable, or outright fascistic, he would personally fly the artist, his friends and his family to a neutral country. Of greater interest to Rockwell was his purchase of six paintings. Over the next several years Ryan was to buy dozens more, some of them the finest works the painter had ever done, and he commissioned others, sending Kent to various sites to record their beauty.

One of the weapons the government used in its war against the left was restriction of travel. Passports and visas were denied by the State Department on the most capricious grounds, or often on no grounds at all. There would be merely a reference to anonymous sources and secret information. This placed an extra burden on those citizens, blacklisted in America, who had hoped to find work abroad. Kent's good friend Paul Robeson seems to have been singled out for special harassment. Scholar, athlete, lawyer, actor and singer, Robeson was one of the most gifted men of his time. Because he was black, it had taken a tremendous struggle to develop his talents; because he was a radical, he was not to be allowed to use them. Blacklisted from theaters, films and concert halls in the United States, he came to rely on overseas engagements to earn his living—then the State Department refused him permission to leave the country.

Kent found the restrictions on his own movement galling. "We are interned in America." He believed that a passport was nothing more than proof of citizenship; therefore the government should issue one on request, without political tests, political questions or political investigations. The secretary of state did not agree. When Rockwell asked for a passport so that he could return to Ireland and paint, he was informed, "This Department will not grant you a passport to travel anywhere for any purpose." He was told that if he consented to sign an affidavit swearing he had never belonged to the Communist party, his request might be reconsidered.

Not willing to accept such a condition, Rockwell decided to fight the restrictions in court. Clark Foreman offered the resources of the Emergency Civil Liberties Union and its brilliant counsel Leonard Boudin. Corliss Lamont, good friend and strong civil libertarian, offered his support. J. J. Ryan flew his four-engine bomber up and bought another batch of paintings so that the artist had the funds to start. Kent was prepared to take the case to the Supreme Court if that proved necessary.

It did. The struggle lasted from 1955 until 1958. At times money fell so low that the ECLU presented art shows to fill the coffer, at one of which a painting by Rockwell Kent was the door prize. Another fundraising event became the scene of a near-riot when a policeman told the assembly that politics could not be discussed, only art. The journalist I. F. Stone was hero of that encounter. "Izzy Stone . . . challenged him, like a little bantam fighting cock, demanding by what right he was there and by what right he gave such orders." To share costs, Kent's case was joined with that of a Los Angeles psychiatrist, Walter Briehl.

During this long battle Kent found new admirers, a whole country of them. Albert Kahn had sent photographs of his friend's work to artists he knew in the Soviet Union. They sent back an enthusiastic appreciation, and the Soviet cultural attaché in Washington later requested that Rockwell assemble an exhibition for his country.

The Russians decided to make that show a celebration of the artist's seventy-fifth year. He was invited to attend, but, because the passport litigation was still unresolved, he could not. At the same time, Pablo Picasso, who had been denied a visa to enter the United States because of his political beliefs, was unable to attend the exhibition mounted by the Museum of Modern Art in honor of his seventy-fifth birthday. So the government which was leader of the "free world" and self-styled defender of individual liberties found itself in the embarrassing position of interning one eminent artist while excluding another. The two consoled each other with telegrams.

Even more comforting than friendly words from Picasso was his victory

over John Foster Dulles. Kent's case had started badly. Both the federal district court and the federal court of appeals found against him, but the Supreme Court, in a five-to-four decision, agreed with Kent that the secretary of state did not have the right to withhold passports because of the "beliefs and associations" of applicants. It was a landmark case, one that Leonard Boudin regards as the most important he ever argued. It freed thousands of people, including Paul Robeson, to travel.

For a while it looked as though it would not free Kent. Though he had won a passport, the battle had so strained his financial resources that he could not afford to go anywhere. Soon, however, the invitation to visit the Soviet Union, expenses paid, was renewed. After stopping in Ireland for a tearful reunion with old friends, he and Sally journeyed on to the country in which he had placed so much hope.

That the Union of Soviet Socialist Republics represented a great and noble experiment he had no doubt. That there were flaws still to be worked out he also knew. "They have Socialism but they have not got Democracy," he freely admitted to American reporters. He just as freely told the Russians.

Andrew Wolfe, an American newspaper editor and publisher, was dining in his hotel in Kiev when he noticed an American couple and a Russian couple sitting, with a young female interpreter, at a nearby table. "The American was a man of about 60, slender, well dressed, and quite obviously at his ease. His wife was a beautifully groomed woman, some years younger than he, dark-haired and very attractive." As the dinner went on Wolfe noticed that the conversation at the table was becoming heated. As the men's voices grew louder he could hear them arguing the merits of the democratic and Communist systems.

The American's neck became red as he said, "I'm a Socialist. I've been a Socialist ever since I was 20 years old, but good lord, man, the important thing we believe in is individual freedom. Now I have great respect for you Communists, but you don't give quite enough consideration to the individual." Neither man was willing to retreat, and the argument grew hotter before they let their wives move them to friendlier ground. Wolfe, who had assumed the American to be a retired businessman, was astonished to learn that he was Rockwell Kent, noted artist and fellow traveler.

In spite of his criticisms, Kent still supported the Socialist experiment. "And I can only justify the suppression of civil liberties that has been in force in the Soviet Union . . . as an unavoidable measure of self-defense. . . . I believe that if the Cold War had not supplanted the friendly coexistence which FDR anticipated and worked for, socialism would by now, by its dividends in well-being, security, happiness and peace, have become an example of

high achievement to all the world." As things were, he felt, it was the hope of the world.

For Rockwell it filled the need that had earlier been met by Christian Socialism, the example of pre-1914 German socialism and the American radical movement. It was a faith as profound as any revealed religion—a better world was coming. "I believe socialism to be the eventual and only solution to our increasing problems. I believe that out of the unquestioned repressions and cruelties of the Bolshevik Revolution a greater civilization may emerge than we have ever known, and that—if it is allowed an opportunity to develop in peace—may in many respects serve as a pattern for America of the future." His faith was unshakable; he held to it in spite of the exposure of Stalin's misdeeds and the suppressions in Hungary, Poland and Czechoslovakia.

Soon after Kent's visit in 1958 the Soviet government asked to buy some of his paintings. The traveling exhibition celebrating his seventy-fifth birthday had been an enormous success; thousands of people jammed the Pushkin and Hermitage museums, bought the catalogue and wrote him enthusiastic appraisals of his art.

The problem of what to do with his enormous collection of his own work still weighed on him. In the years since the Farnsworth debacle no other museum had asked about acquiring it, in spite of his having discussed the situation in his autobiography and in the press. He was worried that a resurgence of McCarthyism might lead to their going the same way as some of the State Department's books had—up in smoke. In 1960 he decided to give the collection to the people who seemed to appreciate his work most. Over 80 paintings, 800 drawings, and copies of his prints were presented to the Soviet Union that year. That generous gift was followed a few years later by the handwritten, illustrated manuscripts of his books and journals. "It meant a great deal to me to get my work into a country where it would be safe."

Editions of his own books and many of the classics he had illustrated were published in Russia with great success. "I have the honor of having introduced Melville to the Soviet people." He became a well-known figure to those people, his paintings exhibited in their finest museums, his written works printed in great numbers and the man himself paying frequent visits to their country.

Kent's lifelong horror of war, as well as his appreciation of Russia, moved him to accept the presidency of the National Committee of Soviet-American Friendship, and to devote his efforts to encouraging mutual understanding. When he was challenged to explain why he, an artist and writer, involved himself in such causes he used an analogy that, living on an

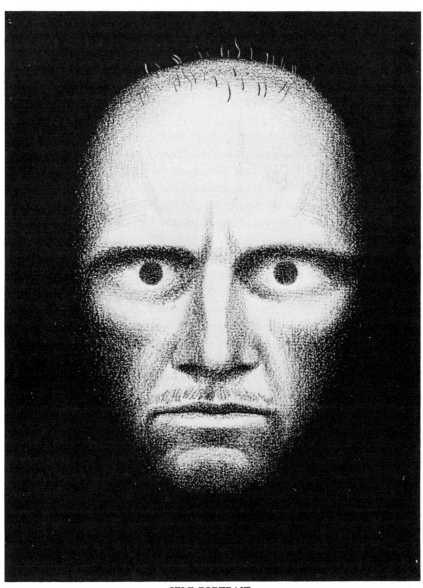

SELF-PORTRAIT

isolated farm, was terrifyingly real to him: "I have answered that if the Adirondack woods are on fire it is only a question of how close to my studio and home the fire gets before I stop painting and become a fire fighter. We must all, I believe, become fire fighters now." But his political efforts were increasingly frustrated during these years as his strong body began to feel the effects of advancing age.

He enjoyed good health during his seventies, marred only by such ailments as kidney stones and gallstones. Strangers often thought, as the newspaperman Wolfe in Kiev had, that he was ten or fifteen years younger than his actual age. Angus Cameron remembers seeing him dive off the board at Asgaard's pond looking as strong and supple as a man of thirty. As he neared eighty, however, the energy and strength that had been the envy of his friends began to fade.

In 1962, as he was painting in his studio, he was suddenly struck by a fainting spell so acute that he was barely able to reach a nearby couch before he collapsed. It was a cerebral stroke severe enough to paralyze the left side of his body. Doctors prescribed rest and a set of muscle exercises that Kent found infuriatingly stupid. Carl Zigrosser had once observed of his friend, "I have never seen a man whose powers were so completely under control and at the service of the will." Rockwell now needed all that strength of will, and Sally's devoted help, as he struggled toward recovery. "I certainly won't whine . . . I am steadily improving and, though I am inclined to quaver in my talk, gradually regaining use of my left hand and arm and my ability to walk steadily."

No sooner had the effects of the stroke been overcome than he began to suffer from a debilitatingly low heartbeat, and subsequent loss of energy. An electric pacemaker was implanted in 1965. "These heart gadgets are truly wonderful, and after a couple of years of enduring a heartbeat of nearly thirty it now is ticking 72 as steadily as the Seth Thomas clock on our mantel that, given my mother as a wedding present, is older than I am."

Though his heartbeat was strengthened he never did fully regain his famous vitality. These physical problems increased his irritability, and brought a return—if they had ever really left—of the nightmares that had plagued his early years, nightmares that he had tried to suppress through sheer willpower. Both loved ones and strangers suffered from his anger and sharp tongue. His insurance agent sued him after he sent an intemperate letter to the company accusing the man of fraud. The artist, on advice of counsel, settled the case out of court.

While his ability to be of active help in political matters was limited by his health, he did try to support what he felt was "the most hopeful movement of my whole lifetime in America—the participation at long last of our

young people in political affairs." He particularly loved and admired the daughter of his close friend and lawyer, Leonard Boudin.

Kathy Boudin spent a year studying in Russia under Rockwell's sponsorship, then returned to Bryn Mawr to take her degree. Though she considered attending law school, she chose instead to join the radical Students for a Democratic Society. Kent had come to know and respect her through her visits to Asgaard. "She is a beautiful and thoroughly remarkable young woman, high in her ideals, keen in her observation of life, and wise in her judgments."

She joined the SDS project in the slums of Cleveland. The sense of mission and comradeship she shared with her friends was satisfying, but in the face of such overwhelming misery it was hard to gauge the group's effectiveness. "Organizing is a slow difficult process. I don't know how to evaluate our results."

Rockwell worried when she was arrested during the demonstrations at the Democratic convention in Chicago in 1968, and he came quickly to her defense when she was attacked by some members of the old left for writing an article discussing the dissatisfactions of Russian youth with the Soviet system. "What a courageous girl you are in all that you are doing here in America," he later wrote.

As the war in Vietnam grew fiercer, Boudin came to play a leading role in the efforts to end it. She moved to New York City, which she found grittier, more fragmented and more frustrating than Cleveland. To Sally and Rockwell she wrote, "I think of you both often, clinging to memories of you and the time that I have spent in Au Sable Forks. . . . Clinging because it all seems so distant in the world in which I now live full of politics and cities and America. I harbor a hope that soon I will take a rest from it. . . ." Within the year she was a fugitive, fleeing underground in the wake of an explosion that blew a New York town house apart. The police claimed it had been a bomb factory and that she had been seen running from its wreckage. To Rockwell it was as shattering a blow as the death of Robert Pearmain had been sixty years before.

The war in Vietnam seemed to Kent to be a nightmare come true. "I think it is the most shameful thing that has occurred in our country's history. It is absolutely and completely inexcusable." He was horrified by the terror-bombing of cities, the napalming of women and children, the destruction of a land because its people dared defy the American will. He raged at the ill health and weakened body that kept him from being more active in the struggle against the war. But in 1967 he was able to strike a blow against his country's war policy.

In April 1967, Rockwell Kent was awarded the Lenin Peace Prize,

founded as a Soviet-bloc counterpart to the Nobel Prize. Accompanying the award was a cash prize of 25,000 rubles, which was the equivalent of approximately $28,000. Since Kent had always felt that prize money was something to be shared, just as he had donated such funds to help the victims of the Spanish Civil War, he now gave $10,000 of the money for medical supplies for "the suffering women and children of the South Vietnamese Liberation Front. . . ."

There was a quick surge of anger in his homeland. Newspaper columnists condemned him, the local congressman called him a traitor and the government threatened to prosecute him for trading with the enemy. The usual load of hate-mail arrived demanding that he "go back" where he came from, but there was also a heartening number of letters supporting his stand. To reporters Kent explained, "I have great pity for those poor people who are suffering from what we are doing to them. . . . My God, it is up to us, the American people, to indemnify them for that. It would take billions to do the right thing."

The storm soon died down, and Kent returned to relative obscurity. But he was not totally forgotten. Strangers often wrote to tell him of their love of his paintings and books. One reported from Alaska that the spot where his cabin had stood on Fox Island had subsided below sea level during the great earthquake of 1964. Another wrote that while visiting Greenland he had met a charming young child who was Salamina's granddaughter. The greatest surprise of all came when Joseph Smallwood, premier of Newfoundland, wrote to say that he had discovered, while going through some old official papers, the story of Kent's explusion as a German spy fifty years before. The artist was offered an official apology and was invited to return as a guest of the government. Sally and Rockwell eagerly accepted. "It was a remarkable experience—remarkable as an act of atonement and by the warmth of the welcome we received from everyone."

Scholars entered his life asking impertinent questions about old associates like Robert Henri, Abbott Thayer and George Bellows. His own prodigious body of creative work was being painstakingly catalogued by his good friend Dan Burne Jones. "He is continually surprising me with information about things I have done. Thank God he isn't cataloguing my private life!"

Some of his old friends got in touch after decades of long silences. Bennett Cerf reminisced, "I'll never forget my weekends with you up at Au Sable—and all the beautiful creatures who flitted in and out of our lives in the glorious times we had together." Charles Wellington Furlong, his advisor on Tierra del Fuego, wrote at the age of ninety-four to congratulate him again on having been the first white man to find a pass over the Brecknock Penin-

sula. Carl Sprinchorn, fellow student of Henri's, wrote, and together they lamented modern art and their lost youth. Lying in Kent's old clipping notebook was a disintegrating review of a 1903 or 1904 show. "Here one may see the work of the men who glory in the appellation of 'the outcasts'—Kent, Sprinchorn and the rest." The reviewer wondered if it was not all a practical joke. "One cannot deny that it is interesting and provocative of thought . . . but is it *Art?* . . . It is too brutally masculine, too crudely straightforward; too uncompromisingly commonplace . . . to be acceptable as art."

No matter how tired his body or poor his health, Kent would not stop painting and writing. When he felt strong enough he would load his 1952 Chevy station wagon with easel, canvas and paints, take his old dog Gunnar, named for the hero of his favorite saga *Burnt Nyal,* and drive off into the Adirondacks. At other times he painted in the studio that he kept as immaculate and ordered as a craftsman's shop. Several exhibitions were held in his last years, with critics stressing the continuing vitality of his work.

In 1962 his *Greenland Journal,* unedited, was published as a record of his second trip to the Arctic island. It was followed by two small, privately printed booklets on his contemporary travels. Angus Cameron, editor at Alfred A. Knopf publishers, asked him to consider making an anthology from his earlier works. Kent reread them with great pleasure. "But I have come to the definite conclusion that each of the books is too definitively of one piece to be cut up into samples."

The greatest pleasure of all came from Asgaard, his "most real and sacred place." "Unfailingly we cry out to each other, as we look at our green meadowland and the distant Adirondacks, 'This is the most beautiful place in the world.' " The house itself, walls papered with charts of his voyages, filled with family heirlooms, thousands of books, and rarities collected on his travels, was a constant source of comfort and reminiscence. Friends in the Soviet Union had given him a huge walrus tusk on which Chukotka craftsmen had engraved scenes of the Far North. He would sit and gaze at it for hours, reminded of his own Arctic adventures.

If there were nightmares and goblins of terror nibbling at his heart they were not the result of a sense of failure, or second thoughts about paths taken or ignored. He had done what he had wanted to do. When asked by an interviewer what he had wanted out of life he immediately shot back, "What did I want? Why, I wanted it *all!*"

CODA

Lightning struck on a cool spring night in 1969.

The bolt hit a power transformer, then traveled, a huge blue ball visible for miles, along the line to the house, where it exploded high against the living-room wall.

Sally, awakened by the tremendous crack of the bolt, lay still for a moment. Her first thought was that there had been a nuclear explosion at the nearby bomber base, then she realized that it must have been lightning hitting a tree. Rockwell, who had taken a sleeping pill, stirred briefly awake then lapsed again into unconsciousness. Suddenly the smell of smoke filled the room.

Shaking Rockwell awake, Sally told him that they must immediately leave the house. He was quick to rise, but stumbled and lost his way in the large dark bedroom. His wife, after a few anxious moments, found his hand and together they made their way through the choking smoke to the front door. As they emerged into the night air, Rockwell looked up at the sky, "At least napalm isn't being rained upon us."

Naked, shivering, but now fully awake, Kent told his wife that she must drive to the telephone office to put in the alarm while he roused their farmer, Tink Emerson.

Sally returned from town to find him, dressed in outsized clothes from the Emersons', sitting in his old Chevy station wagon watching the volunteer fire company fight the blaze. The firemen had not realized that a pond lay near the house, so their pumper truck had not been brought; a vital half hour was lost as men went to get it.

Kent, optimistic as always, said several times that he was sure the fire was under control. At one point, when it briefly became safe to enter the house without a smoke mask, the eighty-six-year-old artist determinedly made his way into the bar and pried a favorite Greenland painting from the wall. Then the couple just sat in the Chevy, heater on against the cold, feeble headlights glowing in an effort to help the caped, masked and helmeted men who fought to save their home.

The fire rose higher, a flaming mountain of treasures and memories. Books, paintings, drawings; polar-bear skull, narwhal tusk, walrus tooth engraved with Arctic scenes; precious carvings, handmade boxes, homemade furniture; Hogarth mirrors, Navajo rugs, mother's Seth Thomas clock; father's flute, father's tools, Steinway concert grand; map-covered walls, photographs of friends, files of letters and notes—all joined in a roaring Viking blaze.

Finally even Rockwell's optimism had to recognize the impossible, the dreadful, truth. He asked Sally to drive behind the barn so that they would not have to watch the end. "A wonderful house, wasn't it," one of them said. Within hours a shroud of snow fell on the blackened, still-smoking corpse.

Early the next day, Rockwell began drawing plans for a new house. "One can't start life again at eighty-seven," he wrote a friend after his birthday, "and hope to have much time for rest." The couple moved into a two-room cottage attached to their barn and began the painful chore of picking through the charred and waterlogged salvage.

Both sons came to help. Dan and Jacquie Burne Jones, Charles Colvin, George Spector and other friends sent money and encouragement. His eight-year-old grandson, David, offered him all his savings. The National Institute of Arts and Letters, which had earlier honored him with membership, sent a gift of a thousand dollars. The Soviet Artists' Union invited Sally and Rockwell to recuperate in one of their rest homes. Corliss Lamont, who had immediately driven up from New York City, began a fund for his friend. But Kent did not want charity. "It happened," he explained, "that at the time of our disaster we were reading together Harrison Salisbury's splendid book, *The 900 Days: The Siege of Leningrad.* His telling of the suffering endured by Leningraders... was in our minds a factor in our rejection of 'relief.'" He felt that worthier recipients were the people of Vietnam and flood victims in the Dakotas.

The fire consumed some of his most beloved paintings, but others had been spared because they had already been sent to Bowdoin College to be part of a retrospective exhibit honoring his early work. Rockwell attended the opening that August of 1969. "I'm not trying to make people love my art," he told the guests. "Through my art, I'm trying to make people love nature. That's all." Public response to the show was gratifying; it had the highest attendance of any in the college museum's history.

By late summer the new house, smaller and less elaborately outfitted than its predecessor, was ready. Rockwell took up as best he could the broken rhythm of his life. He labored on a continuation of his autobiography, dictating for several hours a day to his wife; and, working from a color slide, he

tried to recreate the most precious of his lost paintings, *Sally and the Sea*. Political activity was limited to writing a few letters and signing petitions. "It makes me damn mad," he wrote Carl Zigrosser, his friend of almost sixty years, "to have to sit on the sidelines in these trying days in America."

Bronchitis struck him that fall. After ravaging his body for several months it receded, but it never really left. In early 1970 a new cardiac pacemaker was implanted, but did not improve his condition or return his energy. Slowly he began to slip away.

Nightmares and a dreadful sleeplessness. In the mornings an exhaustion that would force him to ask, "Is it all right if I stay in bed a little longer?" When he could finally rise, he would make his slow, faltering way down the dark corridor, hand on the wall for guidance and support, to sit in the living room by the fireplace. "Why am I always so tired?" he would ask, as if surprised that it could be happening to him. His eyesight dimmed; his hearing, damaged years before by a hammer blow too close to his ear, faded; he lost his interest in the world.

Sally, suffering herself from the crippling effects of scleroderma, tried to bring him back. She read to him, brought him pictures and bright flowers. But, though he could not bear to be alone, she knew that in his mind he was elsewhere—painting in the cold of Alaska, singing as his boat sank in the Strait of Magellan or picking his way through the rugged mountains of Greenland.

One evening in March of 1971, as he was sitting in his favorite chair by the fire, he said with a special note of wonderment in his voice, "I am very tired." He refused to go to bed, so Sally built up the flames and brought her dinner in to eat with him. Suddenly, mumbling words she could not understand, he leaned down and tried to pluck the flowers woven into the carpet, then fell back into his chair, unconscious.

Sally rushed to the phone, sure it was the end. An ambulance came, he was given oxygen, then taken to the hospital. A doctor told her that he would probably not last the night. But, though he never regained consciousness, his body kept up the struggle for eleven more nights and days. When, on March 13, he finally died, Sally felt there was no peace on his face, only a pale exhaustion.

Rockwell was buried at his beloved Asgaard. A large block of Vermont granite was placed over the grave bearing the line from Walter Scott that he had used to title his book on America: "This Is My Own."

ACKNOWLEDGMENTS

Over the years it took to complete this biography, I had cause to call on the help of many people.

Garnett McCoy, of the Archives of American Art, was not only a guide to the collections under his control but he was also a constant source of advice and friendly encouragement. Sally and John Gorton opened the resources of the Rockwell Kent Legacies to me. Lois Fink, of the National Collection of Fine Arts, helped develop my understanding of American art. Dan and Jacquie Burne Jones were always ready to assist me in my research, and their generous provision of items from their vast Kent collection saved me much trouble. George and Gladys Spector's *The Rockwell Kent Collector* is a valuable source of information on the artist. Bill Spangler gave me expert advice on Kent's advertising art. Richard West, who is working on a catalogue *raisonné* of Rockwell's paintings, provided help, as did Carl Vilas. Many people willingly submitted to interviews. I would especially like to thank Kathleen Kent and Frances Gay for their cooperation, and Olivia Kahn for her sharp eyes.

Friends and faculty at the University of California at Santa Cruz were of great aid during the early part of this study. John Dizikes, Richard Cooley, George Baer, Jon Beecher, James Borchert, Terry Burke, Richard Olson, Jasper Rose and Laurence Veysey were always available to both direct my efforts and to encourage them. The U.C.S.C. Graduate Council provided me with fellowships at crucial times, and the Smithsonian Institution gave me a postdoctoral fellowship that allowed me to finish my research. The Council for the International Exchange of Scholars awarded me a Fulbright lectureship in France that not only left sufficient free time to complete this book but also allowed me to spend a year in the beautiful Franche-Comté.

Heartfelt thanks must also go to the following friends and family who provided moral and often financial support. Without their active belief in this project it would have taken years longer to complete: Evelyn Traxel, Amalie Rainey, and Elsie Crouse; Beth Bellamy, Michael Dally, Ben and Jan Dunn, Jeff Dunn, Eduardo Escobedo, Gail Grant, David Kimball and Anne

Taylor, Michael and René Marlin, Constance McGraw, Hannah Olson, Mary Paterno, J. Richard and Anne Scott Ranck, Michael and Mary Sarratt, Thorne and Marban Sparkman, Karen Williams and Ron Yerxa. Avi Wortiz gave me expert publishing advice.

The saga of this book, though not as long as Kent's, extended over quite a bit of time and space, and included far too many storms, reefs, icebergs and contrary winds. For aid in navigating, I would like to thank my agent, Julie Fallowfield. If she had been on board from the beginning we would have gotten to port much sooner and with less trouble. Joan Kahn, Buddy Skydell, Bill Reynolds and Michael Louden of Harper & Row also stood watch and helped keep us on our course.

Edward, Samuel and Joshua McIlvain were of good cheer through all the voyaging, and even learned a sea chantey or two. Rosemary Ranck was, and is, my mate, my Polaris, and my anchor to windward.

Though all of these people contributed to the making of this book, I am, of course, solely responsible for any errors of fact or interpretation.

Page

12 "I became": RK to Egmont Arens, 31 May 1923.

12 "enlarged the horizon": *IMOL*, p. 50.

12 "From as early": Ibid., p. 51.

13 "The organ and the voices": Ibid., p. 40.

13 "My mother shared": Ibid., p. 59.

14 "the heroes were": Ibid., p. 62.

14 The inconvenience grew: Several years later, after Kent had proven himself at Columbia and had received some recognition as a painter, Virgil Pettyman, the principal of Horace Mann, wrote to him, admitting that the school had done him an injustice. Pettyman asked to be allowed to set matters straight by awarding him a diploma. Kent refused. Pettyman to RK, 23 and 29 March 1911.

15 "May I also": There are two letters from Hamlin to RK on this theme, 25 July and 10 October 1902.

15 "Look at me": *IMOL*, pp. 77–80.

16 "The Hudson River": Ibid., p. 75.

16 Chase recognized: See Chase to RK, 22 November 1901. Aside from mentioning the prize Kent won, Chase also writes, "I shall hope soon to have you down for a sitting on the portrait sketch." An oil portrait was eventually painted.

16 "Hell," he thought: *IMOL*, p. 73.

TWO: APPRENTICESHIP

17 Art is draughtmanship: Quoted in Homer and Organ, *Robert Henri and His Circle*, p. 133.

17 It is not: Quoted in Read, *Robert Henri*, p. 10.

17 No man may: *IMOL*, p. 57.

17 "more of an approach": Homer and Organ, p. 2.

17 "The Classic Spirit": Cox, *The Classic Point of View*, p. 22. Cox gave the Scammon Lectures at the Art Institute of Chicago in 1911. They were published the same year, and later republished.

 Once, while serving on a jury for the National Academy of Design's annual show, Cox became enraged when George Luk's *Man with Dyed Mustachios* was placed on the viewing easel and shouted, "To hell with it!" Perlman, *The Immortal Eight*, p. 158.

18 Ralph Waldo Emerson, and Walt Whitman: For a discussion of Henri's intellectual debt to these men see Kwiat, "Robert Henri and the Emerson-Whitman Tradition," *Publications of the Modern Language Association* 71, pt. 1, (September 1956), pp. 617–636.

18–19 "It is a very interesting": Henri, "What about Art in America?," *Arts and Decoration* 24 (November 1925), p. 35.

19 "Sometimes he would": Quoted in Perlman, p. 117.

19 "Work with great": Ibid., p. 115. Chase shared Henri's belief that time should not be wasted while painting.

19 "When Henri spoke": Stuart Davis, quoted in McCoy, p. 70.

19 "Be a man": Quoted in Perlman, p. 18.

NOTES

Unless otherwise noted, all material quoted is located in the Kent Col
Archives of American Art, Smithsonian Institution, Washington, D.C.
 The abbreviations used in these notes are:

cz Carl Zigrosser

czp Carl Zigrosser Papers

imol *It's Me O Lord* (Kent's autobiography)

kw Kathleen Whiting

kwk Kathleen Whiting Kent

mh Marsden Hartley

rk Rockwell Kent

w *Wilderness: A Journal of Quiet Adventure in Alaska* (by Kent)
 Full author and title references appear in the bibliography.

EPIGRAPH
Rockwell Kent to Loman Bassett, 13 May 1937.

PROLOGUE
Everything in this prologue is documented. See Allen, Jr., "A Summn
Greenland," *Yachting* (April and May 1930); Kent, *N by E*, pp. 129–15९
and interviews with the two crew members in *New York Times*, 11 Sep
New York Herald, 15 December 1929; and two unidentified clippings in
grosser Papers, Van Pelt Rare Book Room, University of Pennsylvania.

ONE: THE EARLY YEARS
Page

5 I am not: Kent Collection, Columbia University Rare Book Roo
6–7 The courting episode is based on *IMOL*, pp. 15–18, and an in
 Dorothy Kent.
7 Almost seventy years: William Perl, "Psycho-Graphologist," to I
 1951.
9 "Why, when Dorothy": Interviews with Sally Kent Gorton
 Kent.
10 "It got to be": *IMOL*, p. 39.
11 "one of whom had": Ibid., p. 45.
12 "tantamount to": Ibid., p. 36.

Page

20 "Henri's point of view": Read, *Robert Henri and Five of His Pupils*, un-paged. This is an exhibition catalogue. Kent was one of the pupils.

20 "were men and women": *IMOL*, p. 17.

20 "exerted a strong influence": Homer and Organ, p. 228.

20 "At an early age": Ibid., p. 17.

20 "I find nature": Henri, *The Art Spirit*, p. 184.

20 "Bright red": *IMOL*, p. 86.

20 "some of us": Ibid., pp. 85–86.

21 "It was like": Ibid., p. 99.

21 "In painting it": Ibid.

21 "But," he asked: dialogue from *IMOL*, p. 100.

22 "Mr. Thayer says": Mrs. Thayer to Sara Kent, 23 June 1903. The painting is of the golden head of a rattler among fall leaves and it is reproduced in Thayer's *Concealing Coloration in the Animal Kingdom*. In 1910, Gerald Thayer wrote to RK that he was sending him a copy of the book, "with your copperhead, whom you loved so dearly. . . . Our excuse for giving our book is that you made the snake for us. And, indeed, it is no kind of payment for the great help you gave." Gerald Thayer to RK, 28 January 1910.

22 all the particulars: A typed carbon copy is in Box B.

23 "That cry was": *IMOL*, p. 104.

23 To his surprise: In the days of weak interior lighting, the closer to eye level a painting was hung the better chance it had of being noticed, appreciated and sold. The worst fate was to be "skyed," i.e., placed high on the wall.

24 "As Chase had taught us": *IMOL*, p. 83.

26 "And suddenly": Ibid., p. 91.

26 He was also a Socialist: See Shannon, *The Socialist Party of America*, pp. 58–59.

26 "they served only": *IMOL*, p. 96.

26 "millionaire socialist": He is mentioned as such in Shannon, p. 58. Weeks bankrolled the *Masses* for a year and a half.

27 "were inclined to be": Young, *Art Young: His Life and Times*, p. 274.

27 "A Backward Glance": A copy of this address is in the Kent Collection.

28 "I love to talk": RK to KW, 6 September 1908.

28 "Tell them I'm": *IMOL*, p. 98. There is some irony in this, for Art Young reports that Kent described to him Rufus Weeks's manner of going to the polls. "The family carriage would be driven to the polling place by his Negro coachman, who was also a Socialist. Together Weeks and the coachman would go in and cast their ballots for the straight Socialist ticket." Young, p. 274. The coachman also attended the Socialist party meetings with his boss.

29 "of such cliffs": *IMOL*, p. 116.

THREE: MONHEGAN AND FREEDOM

30 He is a hard-liver: Entry for 24 October 1910 in Bruce St. John, ed., *John Sloan's New York Scene*, p. 469 (hereafter cited as Sloan).

30 I discovered sex: Said in conversation to Sally Kent. Interview with Sally Kent Gorton.

Page

31 "I envied their strength": *IMOL*, p. 122.

31 The team of Cazallis and Kent: The incident is related in Kent's *N by E*, pp. 61–62.

32 "I now felt": *IMOL*, p. 126.

33 I spent the weekend: CZ to "Kinglet" (his wife), 24 March 1920, CZP.

33 "Altogether": *IMOL*, p. 129.

33 "Would you like": Interview with Dorothy Kent.

33 It was, perhaps: *IMOL*, p. 118.

33 He also volunteered: See playbill, 24 February 1906.

34 "The rough floor": *IMOL*, p. 129.

34 The arrival of William Moody: See Kent, "William Moody on Monhegan Island," *American Book Collector* 14, no. 10 (Summer 1964).

35 "and instead one must": Manuscript, 13 September 1906.

35 "The fact is": *IMOL*, p. 137.

36 If you long: James Huneker, *New York Sun*, 2 April 1907.

36 "At last we have": Guy Pene du Bois, *New York American*, 3 April 1907.

36 "in less than no time": Unfinished letter, RK to Barry Faulkner, 13 February 1908.

36 George Bellows: See Morgan, *George Bellows: Painter of America*, p. 68.

36 "These pictures": Sloan, p. 121.

37 "And now I have": Unfinished letter, RK to Barry Faulkner, 13 February 1908.

37 "At daylight": *IMOL*, p. 152.

37 As the summer progressed: Description from penciled notes by CZ, CZP.

37 Such a prig: Ibid.

37 "a night of": *IMOL*, p. 118.

38 "The mighty bulwarks": Unfinished letter, RK to Barry Faulkner, 13 February 1908.

39 tell his mother: Kathleen always felt that Rockwell's mother did not like her, "but she was always fair and square with me because . . . I was the wife of her favorite son." KWK to the author, 20 May 1974.

39 On the island: Kent forgets this in *IMOL*, and says the houses were finished the summer before.

39 "Often, that year": *IMOL*, p. 176.

39 "It's too bad": RK to KW, 20 May 1908.

39–40 "I went over": KW to RK, 9 June 1908.

40 "There is something": KW to RK, 20 May 1908.

40 Only this you must do: RK to KW, 21 May 1908.

40 "We can say": RK to KW, 31 May 1908. It is interesting to compare this with the entry in John Sloan's diary for the next year's Decoration Day: "May 31, 1909—Memorial or Decoration Day is observed today. There were great wagonloads of children being driven to a day's outing in the park. Reminded me of loads of cattle going to slaughterhouses. Very beautiful they were in light colored dresses, packed together . . . like flower beds of youth and beauty . . . but, ultimately, for the slaughter." Sloan, p. 315.

40 "Don't you dare": RK to KW, 31 August 1908.

Page

40 "Yesterday afternoon": RK to KW, 1 June 1908.

41 "She has been trying": RK to KW, 7 July 1908.

41 "A wreck is": RK to KW, 20 July 1908.

41 "the work was": RK to KW, 27 August 1908.

41 "When I feel": RK to KW, 6 September 1908.

41 "He wants me": RK to KW, 15 September 1908.

43 "My darling, darling little Comrade": RK to KW, 1 November 1908. The speaker was probably J. Stitt Wilson, a Protestant minister who was later elected mayor of Berkeley, California. See Shannon, *Socialist Party of America*, p. 40.

43 "However I am": RK to KW, 1 November 1908.

43 "It is splendid": RK to KW, 13 November 1908.

44 "I have met": RK to KW, 4 November 1908.

44 "He did it": RK to KW, 14 November 1908.

44 "we in all": RK to KW, 15 November 1908.

44 "if it ever comes": Ibid.

44 "It is $4,000": RK to KW, 19 December 1908.

44 "Cast not thy pearls": RK to KW, 8 September 1908.

44 I have just been reading: RK to KW, 28 December 1908.

45 "Pittsfield being": *IMOL*, p. 118.

46 "The type of mind": RK to KW, 14 November 1908.

46 Marriage was his: *IMOL*, pp. 199–200.

47 "Oh, Kathleen": RK to KW, 3 October 1908.

47 Traubel and Rockwell: Sloan was particularly excited about meeting Traubel. "April 25, 1910—At Petitpas' for dinner where Kent brought Horace Traubel, Whitman's great friend and staunch supporter who has by his own writings done much to make Walt better known. He proved a fine likable man, short, thickset, white bushy hair, heavy eyelids and though a bit slow in thawing out, he was fine when he got started. . . . " Sloan, p. 414. Less impressed was Carl Zigrosser, who found John Burroughs a more engaging link to Whitman than "Horace Traubel, who in his old age was ill and irascible, snarling at everybody, and especially at John Burroughs." Zigrosser, *My Own Shall Come to Me*, p. 55.

47 For Kathleen: Interview with KWK.

47 Jack London: Jack London to RK, 18 December 1909.

48 "The three large floors": Sloan, p. 405.

48 "He is interested": Henri, "The New York Exhibition of Independent Artists," *Craftsman* 18, no. 2 (1910), p. 162.

48 "A fine energetic character": Sloan, p. 408. There are many references to Kent in the April entries.

48 "Mrs. Kent played": Sloan, p. 414. "Yeats" is John Butler Yeats, father of the Irish poet, and himself a gifted painter. He had a special relationship with the Sloans, and lived his final years in New York in order to be close to them.

49 His written evaluation: A rough draft survives in the Kent Collection.

49 It seems like: John Cournos, "Rockwell Kent's Democratic Ideas on Life and Art," *Philadelphia Record*, 23 October 1910.

Page

50 Bayard Boyesen: For portraits of Boyesen see Zigrosser, pp. 64–66, and Hapgood, *A Victorian in the Modern World*, pp. 281–282, 550–557.

50 "He even offered": RK to KWK, 20 June 1910.

50 Stunned and forlorn: Kent in *IMOL* claims to have told her all, but *when* is unclear since the sexual relationship with Janet began in the summer of 1909, and Kathleen did not leave him until June 1910.

51 "As I write": RK to KWK, 11 June 1910.

51 "Well, Kathleen": RK to KWK, 21 June 1910.

51 "Oh, darling": RK to KWK, 3 July 1910.

51 "I can't bear": KWK to RK, 20 June 1910.

51 "I'm cross": RK to KWK, 30 June 1910.

51 "[Their letters were]": RK to KWK, 2 July 1910.

52 "My response": Zigrosser, p. 37.

52 "Mr. Kent sprayed": Quoted in ibid.

FOUR: REBELLION

53 It is important: *IMOL*, p. 75.

53 I will be good: RK to KWK, 7 November 1910.

53 "I had served": *IMOL*, p. 205.

54 He called on the young woman: This information is given in a letter from RK to KWK, 15 October 1910.

54 His resolve washed away: Based on penciled notes by CZ, CZP, and on a letter from RK to KWK, 17 October 1910.

54 "dramatically ominous": RK to KWK, 17 October 1910.

54 "That trip into the mine": RK to KWK, 20 October 1910.

55 "You should have heard": Sloan, p. 467.

55 "I have planned": RK to KWK, 20 October 1910.

55 "Oh, you never": RK to KWK, 21 October 1910.

55 "to be a first-rate fellow": RK to KWK, 24 October 1910.

55 "[We] have been": RK to KWK, 24 October 1910.

56 "if you really": KWK to RK, 3 November 1910.

56 "I will be good": RK to KWK, 7 November 1910.

57 "[Kent] is greatly joyed": Sloan, p. 478.

57 "R. Kent is": Ibid., p. 480.

57 "spoke clearly": RK to KWK, 5 December 1910. He reprints the letter in *IMOL*, pp. 219–223.

59 "Do you remember?": RK to KWK, 14 December 1910.

59 "it flaked off": RK to KWK, 7 December 1910.

59 "I am not happy": KWK to RK, 3 November 1910.

59 "I feel": KWK to RK, 14 December 1910.

59 Kent had probably: Based on notes by CZ, CZP.

60 "And so, Kathleen": *IMOL*, p. 225.

60 "What the dickens": Sloan, p. 505.

60 They decided to ask: Kent has the sequence of some of these events confused in *IMOL*, and says that he went directly from Henri to Davies. This was impossible, since Davies was on his way back from Italy at the time, and he was not brought into the project for another week or so.

Page

60 The wad proved: *IMOL*, p. 228.

61 "The reporters are bound": Sloan, p. 399.

61 "[Henri] is perhaps": Ibid.

61 organizational skills: The quiet Davies was later to pull off an even bigger coup by almost singlehandedly organizing the Armory Show in 1913.

61 "Henri is right": Sloan, p. 506.

61 "Went to see Henri": Ibid., p. 412.

61 Kent talked of: Ibid., p. 506.

61 "I have no thought": Quoted in Homer and Organ, p. 283.

62 "an unusually uniform": *Vogue*, April 1911.

62 Illustrative of the problems: Sources on the Columbus show are *IMOL*, pp. 223–224, and Morgan, pp. 128–129.

64–65 "Julius has not": RK to KWK, 21 June 1911.

65 Kathleen's shy innocence: Interview with Dorothy Kent.

65 "I just can't": Ibid.

65 Kent felt: Ibid.

65 "A dozen times": RK to Janet, 23 July 1911.

65 Spokane: In *IMOL*, Kent says Seattle, but in a letter to KWK, 11 October 1911, he says Spokane.

FIVE: WINONA

66 I cannot live: MH to RK, 22 September 1912.

66 if I am killed off: Robert Pearmain to RK, 12 May 1912.

66 He decided to experiment: Based on handwritten notes by CZ, CZP. Kent in *IMOL*, pp. 242–244, gives a somewhat different version of this episode. He also wrote Kathleen what I believe to be an edited version of these events in two letters, 9 and 10 October 1911.

67 "It was the only": RK to KWK, 9 October 1911.

67 "one who by": *IMOL*, p. 250.

68 "[It is] a revolutionary": Quoted in Fitzgerald, *Art & Politics*.

68 Kent, too, submitted: See letter from Nancy Pearmain to RK, 11 August 1912, wherein she mentions a cartoon he submitted to the *Masses*.

68 "A man who": Fitzgerald, p. 194.

69 so small: Interview with Mrs. Frances Lucas, daughter of the Prentisses.

70 "After having more": Robert Pearmain to RK, 4 October 1911. Seeger, who was later killed while serving in the French Foreign Legion, is best known for his poem that begins, "I have a rendezvous with death. . . ."

70 "I found that": Robert Pearmain to RK, 24 April 1912.

70–71 "Things are very interesting": Robert Pearmain to RK, 12 May 1912.

71 "a most unusual": Alexander Berkman to "Mrs. Permain" *(sic)*, 23 October 1912. Pearmain Papers, Archives of American Art, Smithsonian Institution, Washington, D.C.

71 "I think it takes": Margaret Sanger to RK, 11 October 1914. She does concede, "few agree with me on this view, but my experience everyday strengthens my belief."

71 "There were about": Robert Pearmain to RK, 12 May 1912.

72 "Nancy and I": Ibid.

Page

72 "damning to the goddamnedest": Ibid.

72 "Mr. Brush": Ibid.

72 "to justify myself": Ibid.

72 "intellect, glory and romance": Pearmain refers to this advice in a response to RK, 25 June 1912.

74 Hartley had become: Interview with KWK.

74 "Kathleen and the sweet babies": MH to RK, 2 April 1912.

74 "[Kathleen] is purely": MH to RK, undated letter, probably written in early 1913.

74 "You at least": MH to RK, 22 September 1912.

74 "I shall make": MH to RK, 12 August 1911.

74 "What is fine": MH to RK, 22 September 1912.

74 "I go to the Trocadero": Ibid.

75 "the Frenchmen—alas": MH to RK, 22 August 1912.

75 I was at Gertrude Stein's: MH to RK, 22 September 1912.

75 "I had intended": Ibid.

75 Kent was wont: See, for example, the response of the famous musician and teacher David Mannes to RK in his letter dated 13 May 1912. Kent had asked him why he was not a "consistent revolutionist."

75 "I personally can allow": MH to RK, 22 September 1912.

75 "I am making": MH to RK, undated letter, probably written in early 1913.

76 "I have an audience": Ibid.

76 His strength seemed: This information is in the letter to Pearmain's parents from William Trautman, 4 January 1913. Pearmain Papers, Archives of American Art, Smithsonian Institution, Washington, D.C.

76 "The place is just seething": Robert Pearmain to RK, 21 August 1912.

76 After several weeks: The details of his last days are from a letter, 29 September 1912, Nancy Pearmain to the Kents, and from a letter from Margaret Sanger to RK, 11 October 1914. There are letters of condolence to Pearmain's family from Alexander Berkman, William Trautman and other IWW leaders praising Pearmain's character and work. These are located in the Pearmain Papers, Archives of American Art.

76–77 And you told me: MH to RK, Christmas Eve, 1912.

77 "He was your friend": Nancy Pearmain to RK, 29 September 1912.

77 Physical threats: Interview with KWK.

77 "Nothing but German": RK to KWK, 12 April 1913.

78 "They're so different": RK to KWK, 14 April 1913.

78 "I always remembered": MH to RK, undated letter, probably written in early 1913.

78 "I am . . . determined": RK to KWK, 11 April 1913.

78 "It's really good fun": RK to KWK, 1 May 1913.

78 "He was the first guy": *Winona* (Minn.) *Daily Record*, 23 May 1971.

78 "Just think": RK to KWK, 7 May 1913.

78 Prentiss was more tolerant: Interview with Frances Lucas.

78 PAINTER OF FAME: There is a clipping of this article with the letter from RK to KWK, 31 May 1913.

78 "You are a great painter": *IMOL*, p. 269.

Page

78 "I was astounded": Kenneth Hayes Miller to RK, 23 March 1913.

78–79 "It was like": Ibid.

79 "During the day": RK to KWK, 12 April 1913.

79 Frances Lucas: Interview with Frances Lucas.

SIX: FRUSTRATION AND ESCAPE

80 In all fields: Part of the text of the speech "A Backward Glance," 1914. A copy is in the Kent Collection.

80 I assure you: RK to James S. Benedict, 14 September 1914.

80 Some of his contributions: Dr. Seitz to RK, 27 March 1915. See also Kenneth Hayes Miller's letter to RK, 9 May 1915. "It seems to me the passages in the text of the Conn. College prospectus show plainly that Ewing has come to realize the value of your ideas in architecture. . . ."

81 "While he is not": RK to KWK, 8 October 1913.

82 "Last night for me": RK to KWK, 19 December 1913.

82 "pleasantly intoxicated": Ibid.

82 "ploughed through fields of ice": RK to KWK, 26 February 1914.

82 "the country there": RK to KWK 1914.

83 "So instead of living": RK to KWK, 8 March 1914.

84 "That's a bad moon": Kent, *N by E*, p. 68.

84 "It's a hard chance": Ibid., p. 72.

85 "Nothing is so vital": Rufus Weeks to RK, 21 May 1914.

85 "You could do": Ibid.

86 "Your poem will find": Kenneth Hayes Miller to RK, 30 November 1914.

86 "I can't accomplish": Quoted in Rothschild, *To Keep Art Alive*, p. 30.

86 "And nature here": Ibid., p. 26.

86 "In the East": Ibid., p. 31.

86 "All that space": Kenneth Hayes Miller to RK, 26 May 1912.

86 "an extension of consciousness": Kenneth Hayes Miller to RK, 10 November 1912.

86 "Poor Ryder": Kenneth Hayes Miller to RK, 19 May 1915.

87 they met Hearn: See *IMOL*, pp. 291–296 and the official documents in the Kent Collection.

88 "The proper strategy": The statement haunted Kent for decades. He quotes it in a letter to Elmer Adler, 28 May 1940.

88 "Oh, well": Quoted in *New York Tribune*, 29 October 1916.

88 "What will the censor say": Quoted in *New York Sun*, 27 October 1915.

88–89 "I'll show you": Ibid.

89 *Portrait of a Child*: The story is told in an interview with *New York Tribune*, 29 October 1916.

89 "The mental subservience": Rufus Weeks to RK, 8 November 1914.

89 "I *do* claim": RK to James S. Benedict, 30 November 1914.

90 "Because of the depression": Charles Daniel to RK, 4 June 1914.

90 "I believe the worst": Charles Daniel to RK, 27 January 1915.

90 "The Ass'n of American": Charles Daniel to RK, 4 June 1914.

90 "It would not surprise me": Charles Daniel to RK, 27 January 1915.

91 "I'm without anchorage": RK to KWK, 28 June 1915.

Page

91 "I can't bear": RK to KWK, 21 June 1915.

91 "I wonder whether": *The New Republic,* 22 May 1915, p. 71.

92 "I have been advised": James S. Benedict to RK, 26 July 1915.

92 "I have found one": RK to KWK, 21 September 1915.

93 "a continuous wail": *IMOL,* p. 289.

94 "Virtue is a sin!" See his letter to KWK, 23 August 1915, describing an evening spent with a Protestant clergyman.

94 "needed to experience": Interview with KWK.

95 "You are so beautiful": *IMOL,* p. 319.

95 "I took work": RK to KWK, 7 June 1917.

95 "I'm earning not one cent": RK to KWK, 16 June 1917.

95 "Nothing important": RK to KWK, 14 June 1917.

95 "I am seriously": RK to KWK, 26 June 1917.

95 "An Oshkosh (Wis.) sheet": RK to KWK, 18 June 1917.

95 "I'm making money!": RK to KWK, 26 July 1917.

95 "Here I am again": RK to KWK, 16 August 1917.

96 "This last 'affair' ": KWK to RK, 26 July 1917.

96 "It is, I promise you": RK to KWK, 30 July 1917.

96 "make him a decoration": RK to KWK, 6 September 1917.

96 "In a few days": RK to KWK, 18 September 1917.

97 "It's strange": RK to CZ, 15 October 1918, CZP.

97 "I can't face": RK to KWK, 9 July 1918.

97 "I know all": RK to KWK, dated only "Monday" (1918).

99 "I get terribly lonely": KWK to RK, 12 July 1918.

SEVEN: ALASKAN WILDERNESS

100 "like stokers": RK to KWK, 1 August 1918.

100 "This prairie": RK to CZ, 2 August 1918, CZP.

100 "tall, splendid-looking man": *IMOL,* p. 327.

100 "It's quite beyond": RK to CZ, dated only "Monday, August ? 1918," CZP.

101 He wrote Carl: Ibid.

101 "It is, I believe": RK to KWK, 7 August 1918.

101 "huge and hairy": RK to KWK, 15 August 1918.

101 "And there are wolves": ibid.

101 "I knew at once": Handwritten paper titled "Introduction," dated "May 1920." Evidently it was never used.

102 "In the midst": Ibid.

102 "Come with me": Quoted in Kent's *Wilderness: A Journal of Quiet Adventure in Alaska.* All quotes are from the Ward Ritchie Press edition (Los Angeles, 1970) (hereafter cited as *W*), p. 4.

103 "Our cabin is": RK to KWK, 4 September 1918.

104 "I sharpen my axe": RK to CZ, dated only "September ? 1918," CZP.

104 "I wonder if": Ibid.

104 "Well, it rains": Ibid.

104 "Olson says": RK to KWK, 7 September 1918.

105 "i am noting": L. M. Olson to RK, 26 September 1919.

Page

105 "I have never": RK to CZ, 13 December 1918, CZP.

105 "He laughs": RK to KWK, 5 September 1918.

105 "Well, I'll believe": RK to CZ, dated "September ? 1918," CZP.

105 "You know, I want": W, p. 21.

106 "I never dreamed": RK to CZ, 3 October 1918, CZP.

106 "I cut more wood": W, p. 40.

106 "Here I have stopped": RK to CZ, 13 December 1918, CZP. 107

107 "fury at a world": W, p. 162.

107 "has, after ever-increasing": RK to Ferdinand Howald, 19 February 1919, Special Collections of the public library of Cincinnati.

107 "But about Seidenberg!": RK to CZ, 17 February 1919, CZP.

107 "It is only by": RK to Roderick Seidenberg, 17 February 1919, CZP.

107 "but *so beautifully*": RK to CZ, 17 February 1919, CZP.

107 "I was thinking": CZ to RK, 24 March 1919.

107–108 "If the few original": CZ to RK, undated letter, ca. March 1919.

108 "Maybe we are not": W, p. 138.

108 I don't like: RK to CZ, 6 March 1919, CZP.

108 "The man who wants": W, p. 175.

108 "A few more": W, p. 138.

108 "What a splendid": RK to CZ, 6 January 1919, CZP.

109 "I'd love to": RK to CZ, 24 January 1919, CZP.

109 "Of what little": RK to CZ, 26 December 1919, CZP.

109 "the most stupendous": RK to CZ, 6 January 1919, CZP.

109 "an example of": CZ to RK, 10 August 1918, CZP.

109 "You speak of": RK to CZ, 3 December 1918, CZP.

111 "It is of a glorious": RK to KWK, 8 December 1918.

111 "I must sometime honor": W, p. 43.

111 "It is far": RK to CZ, 13 December 1918, CZP.

111 "Civilization is not": W, p. 100.

111 "I begin to be": RK to Ferdinand Howald, 27 November 1918, Special Collections of the public library of Cincinnati.

111 "The inhabitants": RK to KWK, 27 August 1918.

112 It's a place: RK to CZ, 26 December 1918, CZP. Kent later used a rainbow on the dust jacket of the first edition of *Wilderness*.

112 It's a fine: RK to CZ, 13 December 1918, CZP.

112 "Away from the fire": RK to Sara Kent, 9 March 1919.

112 "see a composition": RK to CZ, 24 January 1919, CZP.

112 "I get him": Ibid.

113 "This afternoon": RK to KWK, 5 September 1918.

113 "I must," he wrote: RK to KWK, 4 September 1918.

113 "A story of his life": RK to CZ, 12 December 1918, CZP.

113 "who, if his eye": RK to CZ, dated only "September, Nineteen Eighteen," CZP.

113 "Olson illustrates": RK to CZ, 17 February 1919, CZP.

113 "Paradise is far": RK to CZ, 13 December 1918, CZP.

114 "I have decided": RK to KWK, 1 December 1918.

Page

114 "I woke up last night": RK to KWK, 3 December 1918.

114 "There are men": Ibid.

114 "I think for jealousy": RK to KWK, 8 December 1918.

114 "view across the water": Ibid.

114 "Let's both of us": RK to KWK, 7 December 1918.

114 "If there's any": RK to KWK, 18 December 1918.

115 "I am returning": RK to KWK, 16 February 1919.

115 "I'm very much": RK to KWK, 19 February 1919.

115 "I bitterly regret": RK to CZ, 8 March 1919, CZP.

115 "I've no idea": RK to Sara Kent, 9 March 1919.

115 "He has a bleak": Quoted in CZ to RK, 27 January 1919.

115 "Just think": RK to CZ, 24 January 1919, CZP.

115 "I already begin": RK to CZ, 23 November 1918, CZP.

115–116 "I have often thought": RK to CZ, 24 January 1919, CZP.

116 "We could together": RK to CZ, 8 March 1919, CZP.

116 "I figure that I": RK to CZ, 23 November 1919, CZP.

116 "You might as well": RK to KWK, 15 February 1919.

116 "Ah God": W, p. 193.

EIGHT: SUCCESS

117 I am a colossal egoist: Quoted in Hind, "Rockwell Kent in Alaska and Elsewhere, *International Studio* 67, no. 268 (June 1919).

117 Rockwell Kent: *New York Sun,* 11 May 1919.

118 "He has turned over": Ibid.

118 "a new kind of statement": Arens, "Rockwell Kent—Illustrator," *The Book Collectors Packet,* 1, no. 9 (December 1932).

118 "The letters": Ibid.

119 "It's more beautiful": RK to CZ, 20 June 1919.

120 "We'll let you": *IMOL,* p. 343.

120 "She compelled me": RK to CZ, 8 March 1919.

120 "in return for": Undated memo, ca. June 1919.

120 As "general manager": Ibid.

120 In January 1920: See note dated 29 January 1920; $1,350 came from sales made at the Painters, Sculptors and Gravers show.

120 "My book": RK to L. M. Olson, 2 September 1919.

121 "Again I'm jacking up": *IMOL,* p. 343.

121 "that's pretty hard": RK to L. M. Olson, 2 September 1919.

121 "After a day": Arens.

121 "Often I wonder": RK to CZ, 2 September 1919.

121 "I'm working all the time": RK to CZ, 27 October 1919, CZP.

121 "I've made fine things": RK to CZ, 30 November 1919, CZP.

121 "Great art": RK to CZ, 6 December 1919, CZP.

122 "My wife was the heroine": RK to L. M. Olson, 2 September 1919.

122 "I can't think": Ibid.

122 "I really think": RK to CZ, 22 June 1919.

Page

122 "The moment the doors": *New York Sun*, 7 March 1920.

122–123 "an unfortunate season": RK to L. M. Olson, 6 April 1920.

123 "strength of genius": *New York Times*, 20 April 1920.

123 "*Wilderness* is": *The New Statesman*, 31 April 1920.

124 "a very brutal": RK to Ferdinand Howald, 19 February 1919, Special Collections of the public library of Cincinnati.

124 "Why could not": RK to CZ, 6 March 1919, CZP.

124 "In my home": RK to CZ, 3 December 1918, CZP.

124 "Why should we not": RK to KWK, 8 December 1918.

124 "a dastardly betrayal": RK to CZ, 27 October 1919, CZP.

124 "The hope of the world": RK to L. M. Olson, 2 September 1919.

124 "The true ideal": Both quotes in this paragraph are from a letter from RK to CZ, 7 January 1919, CZP.

125 "Certainly I tell him": RK to CZ, 3 December 1918, CZP.

125 "Baby elephant": Interview with KWK.

125 One daughter's: Interview with Kathleen Kent Finney.

125 "Here one is": RK to Gerome Blume, dated only "August Something."

125 "working like mad": RK to CZ, dated only "August thirteenth," CZP.

126 "It was *terrible!*": RK to CZ, 26 December 1918, CZP.

126 "I have begun the woodblock!": RK to CZ, 27 October 1919, CZP.

126 "Of course": RK to CZ, 6 December 1919, CZP.

126 "You've got to know": *IMOL*, p. 354.

126 "no good, absolutely no good": Quoted in letter from RK to CZ, 15 February 1921, CZP.

126 "I've sent Mrs. Sterner": RK to CZ, 7 March 1921, CZP.

127 "Only a witch": *IMOL*, p. 356.

127 "I'm going to run": Ibid.

127 I want freedom: MH to RK, undated letter but obvious from contents to be from the early 1920s.

127 "I've no use": RK to CZ, dated only "June 1920," CZP.

127 "That's my policy": RK to CZ, 9 January 1921, CZP.

128 "If there's a worse place": *IMOL*, p. 357.

128 "Southern Patagonia": C. W. Furlong to George Chappell, 30 April 1922.

128 "If you meet a stranger": *IMOL*, p. 358.

NINE: VOYAGING TOWARD CAPE HORN

130 Cape Horn is: Quoted in Johnson, "A Legend Lost at Sea," *Sports Illustrated*, 8 January 1979.

130 "I had been warned": John V. A. Weaver to RK, 29 August 1921. Weaver may have been able to maintain his equanimity through having the last laugh. "With your wonderful sense of humor, I know you will appreciate correctly the write-up of you and your work that will appear in my column next Saturday."

131 "Sparks": There are several documents in the Kent Collection, including a written report by the radio operator himself, that relate to this episode.

Page

131 "Months could slip along": RK to CZ, 26 June 1922, CZP.

131 "He is an adventurer": Ibid.

132 "buy a 25′ or 30′ lifeboat": Ibid.

132 "We're living luxuriously": RK to KWK, 24 July 1922.

132 "She'll be 3½ tons": RK to CZ, 2 August 1922.

132 "the smallest boat": Ibid.

132 "I grabbed him": RK to KWK, 24 July 1922.

133 "It's a little craft": RK to CZ, 10 August 1922, CZP.

133 "Today the wind blew": RK to CZ, 2 August 1922, CZP.

135 "Smile awhile": Quoted in interview with RK, *Boston Sunday Post*, 15 April 1923. The rest of this chapter is based on that interview and Kent's book *Voyaging: Southward from the Strait of Magellan*.

138 "God is rocking the boat": RK to CZ, 30 October 1922, CZP.

138 "We have given up": This is a journal entry, quoted in *Voyaging*, p. 102.

141 The poacher even graciously agreed: In *Voyaging* Kent says that a knife was used, but photographs in *Boston Sunday Post* show the murderer wielding an ax.

TEN: THE GOLD CAMP

143 Can one be healthful: Henry McBride, *New York Sun*, 7 March 1920.

143 I have turned: RK to Frances Kent, 19 March 1928.

144 Kathleen suspected: Interview with KWK.

144 "I can't help feeling": CZ to RK, 1 June 1922.

145 "resist the insidious propaganda": All quotes in this and the next paragraph are from "The Artist and World Friendship," *World Tomorrow*, February 1924, pp. 47–48.

146 Postponing plans for a show: This chronology is at odds with *IMOL*, where Kent remembers the show taking place in 1924. However, an advertisement in *New York Times* in 1925 announced that year's show as the first one with Tierra del Fuego paintings.

146 He never reads: F. DeWitt Wells to "Morgan," 23 May 1924. Carl Vilas supplied this and other valuable material.

147 OFF FOR NEW YORK: *New York Times*, 12 July 1924.

148 That night, as they all dined: Letter from the crew member "Chanler" to "Olivia," 22 July 1924. Copy provided the author by Carl Vilas.

148 "The flourishes are for": RK to CZ, 20 June 1924, CZP.

148 "Germany, because of": RK to CZ, 10 July 1924, CZP.

150 "Americans sigh": Henry McBride, *New York Sun*, 18 April 1925.

150 "Mr. Kent is": Clipping, 21 May 1925.

150 "Rockwell Kent is": Armfield, *An Artist in America*, p. 110.

150 After the *American*: *American Magazine*, March 1925.

150 "Come on out here": Letter to RK, 26 February 1925.

151 She was scared: Interview with Marya Mannes.

151–152 "But it has taken time": RK to CZ, 17 June 1926, CZP.

152 "Except for the drawings": RK to CZ, 26 July 1926, CZP.

Page

152 "I have always": Egmont Arens to RK, 23 July 1926.

153 Jesse Lasky: Lasky wrote from Hollywood that he had the treatment read "by some of our best minds here" and they had decided that "the real masses" would not be interested. Jesse Lasky to George Putnam, 7 February 1927.

154 "appreciate my entire unwillingness": RK to Clyde Burroughs, 27 September 1926.

154 The League of New York Artists: See *New York Times*, 4 April 1921.

154 "I realize": RK to CZ, 7 January 1919, CZP.

154 "The most important thing": *New York Times*, 12 February 1926.

154 At one debate: *New York Times*, 15 March 1926.

154 "When the excavators dig": Ibid.

154 "The post-mortem exhibitions": Letter published in *New York World*, 17 January 1926.

155 National Gallery of Contemporary Art: See the undated typescript describing Kent's plans, plus various newspaper clippings.

156 When Rockwell began: Dorothy Dehner to the author, 28 December 1976. She and her husband, the sculptor David Smith, had great respect for Kent's success, though they felt he was too conservative in technique.

156 Remarriage had not stopped: This paragraph is based on an interview with Frances Gay.

156 "I think of you": Egmont Arens to RK, 23 July 1926.

ELEVEN: ESKIMOS AND RAILROADS

157 Why do men love: Kent, *Salamina*, p. 22.

157 We saw the huge mountains: Freuchen, *Arctic Adventure*, p. 36.

157 "There are those": Kent, *This Is My Own*, p. 62.

158 "God, can I go": *IMOL*, p. 439.

159 "contribute something": W. A. Kittrege to RK, 16 September 1926.

159 "It is hoped": Ibid.

159 "God help the rock": Kent, *N by E*, p. 8.

161 "I will, I will!": Ibid., p. 159.

162 Allen made arrangements: Just a few days after arriving home Allen was killed by a speeding automobile. *Direction* was repaired and brought back to the United States. She is presently owned by Carl Vilas. For the full story of the boat and its adventures see his book, *Saga of Direction*.

163 paintings on bed sheets: Mentioned in interview, *New York Herald*, 15 December 1929.

163 "We may come": RK to Frances Kent, 24 July 1929.

163 "I miss the inspiration": Knud Rasmussen to Frances Kent, 1 January 1930.

164 "It is notice that": *New York Times*, 27 October 1930. For details of the struggle see Kent's *This Is My Own* and documents in the Kent Collection. There are also many newspaper accounts. See *New York Telegram*, 10 April 1930.

164 "thinking man and woman": W. H. Mason to RK, 10 December 1930.

Page
165 Prince Michael Dimitri Romanoff: Romanoff's real name was Harry F. Gerguson.

165 Within a few weeks: Interview with Frances Gay. Also, Malachy Hynes to RK, 14 April 1931.

165 "When a gentleman": *New York Evening Post*, 8 April 1931. Jake Zeitlin supplied this information about both Romanoff and Rockwell Kent in Hollywood.

165 "We all appreciate": Ira Rich Kent to RK, 29 April 1931.

166 "I have Peter Freuchen's": RK to Thomas Smith of Horace Liveright Publishers, 18 December 1930.

166 William Faulkner: Mentioned in a letter from Joseph Blotner, Faulkner's biographer, to RK, 17 December 1965.

166 Sterling Hayden: See Hayden's autobiography, *Wanderer*. The book is dedicated to Kent and Warwick Thompkins, another radical and sailor.

166 "This promises to be": RK to Knud Oldenov, 10 November 1930.

166 "There is only one": George Putnam to RK, 7 March 1932.

168 "Greenland fashion": RK to CZ, 1 September 1931, CZP.

168 "This land—mountains": Ibid.

168 "I could have screamed": *Salamina*, p. 43.

168 "Do all Greenland men": Ibid., p. 62.

168–169 "I would attach": Ibid., p. 197.

169 "The beauty of those": Ibid., p. 197.

169 "How many sketches": Interview, *New York Times*, 25 December 1932.

169 One of the actresses: Interview with Frances Gay.

170 The income from: See report of sales, 17 January 1934.

170 "I have decided": RK to Macbeth Galleries, 14 January 1933.

170 "Dr. William Sherman": *Plattsburgh Daily Press*, 16 May 1933.

170 "I am signing this": *Adirondack Record*, 11 April 1933.

170 "I don't want to see": James Rosenberg to RK, 6 March 1934.

170 "We're running": *New York Herald Tribune*, undated clipping, CZP.

171 "The main reason": Open letter from RK to the Jay Taxpayers Association, 1 May 1934.

171 "I don't think": RK to Selma Robinson, 10 May 1933.

171 There were two subjects: See the lecture outline sent to Colston Leigh, 12 January 1933.

172 "Oh, how I want": RK to CZ, 15 February 1934, CZP.

172 "I can tell you": Colston Leigh to RK, 8 March 1934.

172 "A man of my age": RK to Daugard-Jensen, 26 June 1934.

172 "*thrills, sensations* and *Hollywood*": William Morris to RK, 30 April 1934.

173 "as free from": RK to Daugard-Jensen, 26 June 1934.

173 "I was made to feel": RK to CZ, 22 September 1934, CZP.

173 "I've emerged": RK to CZ, 13 March 1935, CZP.

173 "It puts me": RK to CZ, 1 May 1935, CZP.

174 "the repository of all": Rough draft of a letter from RK to Mrs. Blair, 28 July 1935.

174 "desecration of a holy": Ibid.

Page

175 The artist: Typewritten outline of a radio talk sent to Margaret Bourke-White, 31 January 1936. Copy in Kent Collection.

175 If the devil: RK to D. Keppel, 10 February 1942.

175 "Isn't it wonderful": RK to "Dear young comrade," 13 January 1942.

175 never to allow his work: He later did agree to design decorative murals for the Cape Cod Cinema, but they were painted by Jo Mielziner. Kent scrupulously avoided receiving any financial return for the designs.

175 "the fact that artists": Stuart Davis to RK, 29 January 1936.

176 Happiness, I find: Typewritten address for the American Artists Congress, 14 February 1936.

176 "The industry has been run": Ralph Wood to RK, 28 January 1936.

176 "I am appalled": Letter from RK published in *New Masses*, 31 January 1936.

177 Here, as in later campaigns: See, for example, Norman Tallentire to RK, 16 June 1936.

177 Southern lynchings: RK to Sydney Lowenthal, 30 September 1936.

177 "Senator Hugo Black": John Temple Graves to RK, 3 February 1937.

178 "It occurs to me": RK to Stuart Davis, 27 January 1936.

178 "I find that": *IMOL*, p. 493.

178 "When the . . . revolution": RK to Stuart Davis, 27 January 1936.

178 "We can make the change": Interview, *Washington* (D.C.) *Daily News*, 1 November 1937.

178 "These are convictions": RK to Stuart Davis, 27 January 1936.

178 "I have always had": RK to "Hans," 11 April 1950.

178 "I am pretty much": Interview, *Washington* (D.C.) *Daily News*, 1 November 1937.

180 "I got every kind": RK to Vilhjalmur Stefansson, 25 October 1935.

180 "I have been trying": RK to Vilhjalmur Stefansson, 6 July 1936.

182 "To the people": Signed, undated letter from Stefansson.

182 "as a lot of": San Juan, Puerto Rico, newspaper *La Democracia*, 17 September 1937.

182 "painting [them]": *New York Times*, 22 September 1937.

182 "My simple little trick": RK to Reggie Orcutt, 22 September 1937. My version differs from the one that Kent gave in both *IMOL* and *This Is My Own* in that he kept the secret of Ruby Black's involvement. Their cooperation is obvious from the correspondence. Kent wrote to Cap Pearce, his son-in-law: "Between ourselves, it was, of course, a plant, and we're quite proud here about how we manipulated the thing." RK to Cap Pearce, 18 September 1937.

182 "I support myself": RK to Margaret Bourke-White, 31 January 1936.

183 "Get the hell out": Undated manuscript letter to an unnamed friend.

183 "My one thought": Ibid.

184 "doesn't tip": Ibid.

184 "He is no more": Ibid.

184 "You know": Ibid.

Page

184 "You don't forsake": RK to Bayard Boyesen, 2 January 1940.

184 "in the nature of gifts": RK to Evelyn Ahrend, 10 April 1937.

184 "Now they are talking": Interview, *Rochester* (N.Y.), *Evening Journal*, 19 December 1933.

184 "the first one hundred percent": Typewritten transcript of a bookshop address given by RK, 29 November 1940.

184 "I think that": RK to Chet LaMore, 9 September 1937.

185 Rockwell used his personal friendships: See RK to Joe Curran, 28 July 1941.

185 "The only eloquent design": RK to "Bill," 16 October 1941.

185 "It defaces every page": RK to Marina Lopes, 25 January 1938.

185 "It frequently seems": RK to W. J. Dornuf, 4 September 1946.

186 "Frankly the 'line' ": RK to *New Masses*, 2 August 1941.

187 "We can get together": RK to "Lewis," 17 October 1941.

187 "It's curious": RK to "Mr. Mallery," 12 February 1941.

187 "If the Russians": RK to Vincent Fagan, 10 December 1945.

188 The discussion group dissolved: See Kent's letter of complaint to Father Kelley, 15 February 1943.

188 "As things are moving": Duke Roe to RK, 16 May 1943.

188 "You ask me": RK to Peter Freuchen, 6 January 1947.

189 "I think he is": RK to Gordon Kent, 19 February 1947.

189 "I believe your action": RK to "Mrs. Votraw," 1 March 1948.

189 "We don't want": Quoted in a typewritten report of the boycott.

189 "Are they Communists?": Ibid.

189 "no position . . . to get": Tim Kelley to RK, 24 March 1948.

189 "Take the whole thing": Typewritten report.

189 "It has been": RK to Glen Taylor, 3 April 1948.

190 A fundraiser had been: RK to "Bill," 20 October 1948.

190 "Some strongly suspect": RK to Arthur Schutzer, 23 August 1948.

190 "Now, the people": RK to Archie Wright, 25 September 1948.

191 "As a speaker": RK to "Charles," 6 November 1948.

191 "Someday they'll be up": Typewritten report.

191 Whenever Rockwell and Sally: RK to Gordon Kent, 10 April 1948.

THIRTEEN: HARD YEARS

192 Thus, stubborn: *IMOL*, p. 75.

192 "carrying messages": Both quotes in this paragraph are from an undated press release.

193 "Anything reminding them": RK to "Milo," 1 March 1948. The picket fence was allowed to remain after being thinned down and covered with snow.

194 "I don't know": Norman Tallentire to RK, 28 March 1953.

194–195 almost one-third of those: See Caute, *The Great Fear: The Anti-Communist Purge under Truman and Eisenhower*, p. 243.

195 "Why the old *goat*": Interview with Frances Gay.

195 He wrote, with a flourish: Interview with Frances Gay. See also Zigrosser, *A World of Art and Museums*, p. 137.

Page

196 "I think I only draw": RK to "Luther," 29 January 1957.

196 "My constitution": Quoted in a copy of the group's report.

197 Rockwell caught up: See RK to Loyal Compton, 12 January 1952.

197 "You know, your honor": Quoted in several documents.

198 "He stated so to me": Carried on the Associated Press wire, 1 March 1951.

198 "thoroughly holed and pirated": Caute, p. 174.

198 On their very first: RK to Sam Milgrom, 28 October 1947.

198 "How sad we were": Sally Kent Gorton in *The Kent Collector*, Winter 1977.

198 "Bah!—the whole thing": RK to Bill Gropper, 15 July 1953.

199 "It is too late": RK to "Norman," 19 November 1952.

199 "I think it is": RK to "Norman," 19 December 1955.

199 "Realism is not": RK to Tom Danaher, 16 September 1950.

199 "The sappy New York": RK to Bayard Boyesen, 7 January 1936.

199 Kent felt: See letter to *New Masses*, 19 March 1945.

199 "Abstraction is": RK to editor of *New York Times Magazine*, 30 December 1952.

199 "I have gotten": RK to Molly Tallentire, 5 March 1953.

200 "I'm sorry": The Associated Press wire carried full details. See also a clipping of Fred Othman's column.

200 "our Democracy in favor": From carbon copy of statement in the Kent Collection.

201 One representative wanted: *New York Times*, 5 July 1953.

201 "Showing four angels": RK to Bob Heller, 7 July 1953. The mural has recently been restored after having been covered for many years. See *New York Times*, 19 November 1978.

201 "Kent! Rockwell Kent": See letter to Kent dated 16 December 1953. The writer should remain anonymous.

201 "I may have seen": RK to "Mr. Pierce," 15 July 1970.

201 Years later: See Preiss, "Rockwell Kent," *American Artist* 36, no. 364 (November 1972).

201 "I have played": RK to "Gene," 10 February 1950.

203 So often had each: See Rockwell, "Rockwell—Before or After?" *Colophon* 1, no. 4 (June 1936).

204 "We are interned": RK to "Nance," 7 November 1950.

204 "This Department": Quoted in a letter from RK to "Mr. Groden," 7 January 1952.

204 "Izzy Stone": RK to "David," 8 February 1956.

204 So the government: The situation received much publicity. See *New York Times*, 9 June 1957.

205 It was a landmark case: Interview with Leonard Boudin.

205 "They have Socialism": See, for example, transcript of interview with John Wingate on the "Night Beat" television program, 12 September 1957, Kent Collection.

205 "The American was": This story appeared in his column in the *East Rochester* (N.Y.) *Herald*, 9 January 1959.

205–206 "And I can only": RK to "Luther," 29 January 1957.

Page

206 "I believe socialism": RK to "Hans," 11 April 1950.

206 "It meant a great deal": RK to "Linda," 19 September 1968.

206 "I have the honor": RK to "Morris," 28 July 1952.

208 "I have answered that if": RK to Lewis Mumford, 15 November 1961.

208 Angus Cameron remembers: Interview with Angus Cameron.

208 "I have never seen": Zigrosser, *The Artist in America*, p. 46.

208 "I certainly won't whine": RK to "Andrei," 27 November 1962.

208 "These heart gadgets": RK to "Thea," 29 April 1965.

208–209 "the most hopeful": RK to "Paul," 23 April 1965.

209 "She is a beautiful": RK to Corliss Lamont, 9 October 1965.

209 "Organizing is": Kathy Boudin to RK, 4 January 1965.

209 "What a courageous": RK to Kathy Boudin, 20 March 1969.

209 "I think of you": Kathy Boudin to RK, undated letter, ca. March 1969.

209 "I think it is": Interview, *Beekman Street*, 26 January 1968, a student association publication of the State University of New York, Plattsburgh.

210 "the suffering women": RK to Frances Gay, 3 January 1968. See also *New York Times*, 7 July 1967.

210 "I have great pity": See, for example, interview, *Beekman Street*.

210 "It was a remarkable experience": RK to David Wesley, 10 August 1968.

210 "He is continually": RK to Arthur Price, 13 April 1954.

210 "I'll never forget": Bennett Cerf to RK, 12 March 1969.

210 Charles Wellington Furlong: C. W. Furlong to RK, 3 January 1966.

211 Carl Sprinchorn: See, among others, his letter to RK, 5 February 1970.

211 "Here one may see": Clipping from *New York Evening Post*, dated only "April."

211 "But I have come": RK to J. J. Ryan, 23 March 1966.

211 "Unfailingly we cry out": RK to Horatio Colony, 24 March 1965.

211 "What did I want?": See undated transcript of interview with a Chicago broadcaster. For a slight variation of the answer see interview with John Wingate.

CODA

212 "At least napalm": Mentioned in several letters to friends, and quoted in Sally Kent Gorton's account of the fire published in *The Kent Collector* (Summer 1977).

213 "A wonderful house": Ibid.

213 "One can't start": RK to Vladimir Kemenov, 18 July 1969.

213 "It happened": Ibid.

213 "I'm not trying": *Bath-Brunswick* (Me.) *Times-Herald*, 15 August 1969.

214 "It makes me damn mad": RK to CZ, 18 June 1970, CZP.

214 "Is it all right": Interview with Sally Kent Gorton and the typescript reminiscence of Rockwell's final days that she showed the author.

214 "Why am I": Ibid.

214 "I am very tired": Ibid.

SELECTED
BIBLIOGRAPHY

WORKS BY ROCKWELL KENT

"Adam and Eve and Art." *The Forward* 11, no. 5 (March 1924).

After Long Years. Au Sable Forks, N.Y., 1968.

"Alaska Drawings." *Arts and Decoration*, June 1919.

"Alias Kent, by Hogarth, Jr." *Colophon*, Spring 1930.

"And That's the Story of My Life." *Fraternal Outlook* 2, no. 7 (August 1940).

"Apple-Jack." *Creative Art*, April 1931.

"Art and the People." *Christian Register Unitarian* 122, no. 11 (November 1943).

"Art and the Understanding Between Peoples." *New World Review* 26, no. 25 (May 1958).

"Art Differs from Literature in This." *Advertising and Selling*, 8 January 1930.

"Art with a Little *a*." *Craft Horizons* 2, no. 2 (May 1943).

"The Artist and World Friendship." *The World Tomorrow*, February 1924.

"Artist of the Common Man." *New Masses*, 1 February 1944.

"Artists: Unite!" *New Masses*, 23 August 1938.

A Birthday Book, New York, 1931.

"The Blonde Eskimo." *Esquire*, September 1934.

The Bookplates and Marks of Rockwell Kent. New York, 1929.

"Brazil and Vargas." *Life and Letters Today* 78, no. 12 (Summer 1938).

"Brothers of the Northland." *Rotarian* 46, no. 5 (May 1935).

"Cinderella in Greenland." *Esquire*, July 1934.

Editorial. *Creative Art* 2, no. 4 (April 1928).

Foreword to *American Pioneer Arts and Artists*, by Carl Dreppard. Springfield, Mass., 1942.

Forty Drawings to Illustrate the Works of William Shakespeare. Garden City, N.Y., 1936.

"Free Art in an Iron Age." *World Tomorrow*, June 1938.

"From This Day Forward, Forever More." *Labor Defender* 11, no. 8 (September 1937).

"George W. Bellows: His Lithography." *Bookman*, February 1928.

The Golden Chain: A Fairy Story. New York, 1922.

"Greenland: An Obligation." *American Scandinavian Review*, September 1940.

Greenland Journal. New York, 1962. Russian ed., 1969.

The Home Decorator and Color Guide. Sherwin-Williams Paint Company. Cleveland, 1939.

How I Make a Woodcut. Pasadena, Calif., 1934.

"If I Had My Teens to Live Over." *Scholastic*, 13 December 1931.

"In the Name of the Great Jehovah." *New Masses*, 31 March 1936.

Introduction to *Fifty Prints, 1927*. New York, 1928.

Introduction to *Portinari: His Life and Art*, by Candido Portinari. Chicago, 1940.

Introduction to *Rockwell Kent: The Early Years*, edited by Richard West. Brunswick, Me., 1969.

Introduction to *Silk Screen Stenciling as a Fine Art*, by J. I. Biegeleisen and Max Arthur Cohn. New York and London, 1942.

Introduction to *Southern Cross*, by Lawrence Hyde. Los Angeles, 1951.

Introduction to *White Collar*, by Giacomo Patri. San Francisco, 1940.

Introduction to *World Famous Paintings*, edited by Rockwell Kent. New York, 1939.

It's Me O Lord: The Autobiography of Rockwell Kent. New York, 1955.

Know and Defend America. New York, 1942.

Later Bookplates and Marks of Rockwell Kent. New York, 1937.

Letter. In *Writers Take Sides: Letters about the War in Spain from 418 American Authors*. New York, 1938.

"Man the Creator." *New World Review* 33, no. 5 (May 1965).

"My Gift to the Soviet People." *Mainstream* 14, no. 4 (April 1961).

N by E. New York, 1930. Many subsequent editions, including Russian (1965) and Estonian (1964).

"New Influences in Art." In *Recent Gains in American Civilization*, by Kirby Page. Chautauqua, N.Y., 1928.

Of Men and Mountains. Au Sable Forks, N.Y., 1959.

"On Being Famous." *Colophon* n.s., 1, no. 4 (June 1936).

On Earth Peace: A Christmas Story. New York, 1942.

"Peace and Happiness to All Children." *New World Review* 32, no. 5 (May 1964).

A Portfolio of Drawings by Rockwell Kent. Bloomfield, N.J., 1938.

Rockwell Kent. New York, 1945.

"Rockwell Kent (by himself)." *Creative Art* 22, no. 5 (May 1928).

"Rockwell Kent Sees USSR's Future." *New World Review* 22, no. 11 (November 1954).

Rockwellkentiana: Few Words and Many Pictures, with Carl Zigrosser. New York, 1933.

Salamina. New York, 1935. Many subsequent editions, including Danish (1936), Icelandic (1943), Russian (1962) and Estonian (1966).

"A Short Autobiography." *Democourier* 6, no. 10 (October 1937).

"Skaal Salamina!" *Esquire*, August 1934.

"Smoke the Calumet Together." *World Marxist Review* 5, no. 9 (September 1962).

Statement. In *We Hold These Truths: Statements on Anti-Semitism by 54 Leading American Writers, Statesmen, Educators, Clergymen, and Trade-Unionists*. New York, 1939.

"Sticks and Stones." *World Tomorrow*, March 1925.

"There's No Such Thing as Commercial Art." *Professional Art Quarterly* 11, no. 4 (June 1936).

This Is My Own. New York, 1940.

Voyaging: Southward from the Strait of Magellan. New York and London, 1924. Many subsequent editions, including Russian (1967).

What Is an American? Los Angeles, 1936.

"What Is Worth Fighting For?" In *First American Artists Congress.* New York, 1936.

Wilderness: A Journal of Quiet Adventure in Alaska. Los Angeles, 1970. (Many previous editions, including Russian [1965].)

"William Moody on Monhegan Island." *American Book Collector* 14, no. 10 (Summer 1964).

GENERAL SOURCES

Adams, Frederick Baldwin. *Elmer Adler: Apostle of Good Taste.* New York, 1942.

Adler, Elmer. *Breaking into Print.* New York, 1937.

Allen, Arthur S., Jr. "A Summer Cruise to Greenland." *Yachting,* April and May 1930.

Alsop, Joseph. "The Strange Case of Louis Budenz." *The Atlantic Monthly,* April 1952.

Arendt, Hannah. "The Ex-Communists." *Commonweal,* 20 March 1953.

Arens, Egmont. "Rockwell Kent—Illustrator." *The Book Collectors Packet* 1, no. 9 (December 1932).

Armfield, Maxwell. *An Artist in America.* London, 1925.

Armitage, Merle. *Rockwell Kent.* New York, 1932.

The Artist in America. Compiled by the editors of *Art in America,* 1967.

Aymar, Gordon. "A Gauntlet to American Illustration." *Advertising Arts,* July 1932.

Barr, Alfred E., ed. *Paintings by Nineteen Living Americans.* New York, 1929.

Baur, John I. H. *Revolution and Tradition in Modern American Art.* Cambridge, Mass., 1959.

Beebe, Lucius. "Artist Adventurer: The Saga of Rockwell Kent." *Forum* 87, no. 2 (February 1932).

Belfage, Cedric. *The American Inquisition, 1945–1960.* Indianapolis, 1973.

Bennett, Ian. *A History of American Painting.* New York and London, 1973.

Bennett, Paul A., ed. *Elmer Adler in the World of Books.* New York, 1964.

Bentley, Eric, ed. *Thirty Years of Treason: Excerpts from Hearings Before the House Committee on Un-American Activities, 1938–1968.* New York, 1971.

Bessie, Alvah. "The Artist as a Fighter for Man's Rights." *New World Review* 23, no. 1 (December 1955).

Blesh, Rudi. *Modern Art, USA: Men, Rebellion, Conquest, 1900–1956.* New York, 1956.

Bottomore, T. B. *Critics of Society: Radical Thought in North America.* New York, 1968.

Braider, Donald. *George Bellows and the Ashcan School of Painting.* Garden City, N.Y., 1972.

Brinton, Christian. *Alaska Drawings of Rockwell Kent.* New York, 1919.

Brooks, Van Wyck. *John Sloan: A Painter's Life.* New York, 1955.

Brown, Milton W. *American Painting from the Armory Show to the Depression.* Princeton, N.J., 1955.

Bruce, J. Campbell. *The Golden Door—The Irony of Immigration Policy.* New York, 1954.

Budenz, Louis F. *The Techniques of Communism.* Chicago, 1954.

Byrne, Peggy. "A Glance Back with the Artist." *Adirondack Life* 1, no. 2 (Spring 1970).

Cary, Elizabeth L. "Modern American Prints." *International Studio,* December 1924.

Caute, David. *The Great Fear: The Anti-Communist Purge under Truman and Eisenhower.* New York, 1968.

Chase, Harold W. *Security and Liberty: The Problem of Native Communists, 1947–1955.* Garden City, N.Y., 1955.

Chegodaev, Andre. *Art Fighting.* Leningrad, 1970.

———. *Rockwell Kent.* Bucharest, 1963.

———. *Rockwell Kent.* Moscow, 1964.

Cook, Fred J. *The Nightmare Decade: The Life and Times of Senator Joe McCarthy.* New York, 1971.

Cox, Kenyon. *The Classic Point of View.* Freeport, N.Y., 1968.

Crowninshield, Frank. "Rockwell Kent." *Creative Art* 2, no. 5 (May 1928).

Cummings, Paul A. "An Interview with Rockwell Kent." *Archives of American Art Journal* 12, no. 1 (January 1972).

Dies, Martin. *The Trojan Horse in America.* New York, 1940.

Diggins, John P. *The American Left in the Twentieth Century.* New York, 1973.

Draper, Theodore. *American Communism and Soviet Russia.* New York, 1960.

Du Bois, W. E. B. "Comments on Rockwell Kent Gift." *Mainstream* 14, no. 4 (April 1961).

Duggar, Ben. "Rockwell Kent: The Artist, the Man." *Professional Arts Quarterly* 2, no. 4 (Summer 1937).

Eastman, Max. "Open Letter to Rockwell Kent." *Plain Talk* 4, no. 7 (April 1950).

Editors. "Interview with Rockwell Kent." *Beekman Street,* 26 January 1968.

Ekirch, Arthur A., Jr. *Man and Nature in America.* New York, 1963.

Fitzgerald, Richard. *Art & Politics.* Westport, Conn., 1973.

Freuchen, Peter. *Arctic Adventure.* New York, 1959.

———. *Vagrant Viking: My Life and Adventures,* translated by Johan Hambro. New York, 1953.

Fried, Albert. *Socialism in America.* Garden City, N.Y., 1970.

Goldman, Eric. *The Crucial Decade—and After: America 1945–60:* New York, 1960.

Goodman, Walter. *The Committee: The Extraordinary Career of the House Committee on Un-American Activities.* New York, 1969.

Gorton, John F. H. "Rockwell Kent's Adirondack Years." *Conservationist* 29, no. 3 (December–January 1974–75).

Gorton, Sally Kent. Article in *The Kent Collector,* Summer 1977.

———. Article in *The Kent Collector,* Winter 1977.

Gussow, Alan. *A Sense of Place: The Artist and the American Land.* New York, 1972.

Halstead, Thomas. "Artist Superman." *Spur,* 15 February 1929.

Hapgood, Hutchins. *A Victorian in the Modern World.* New York, 1939.

Hayden, Sterling. *Wanderer.* New York, 1963.

Henri, Robert. *The Art Spirit.* New York, 1923.

———. "The New York Exhibition of Independent Artists." *Craftsman* 18, no. 2 (1910).

————. "What about Art in America?" *Arts and Decoration* 24 (November 1925).

Hind, C. Lewis. "Rockwell Kent in Alaska and Elsewhere." *International Studio* 67, no. 268 (June 1919).

Hodgson, Godfrey. *America in Our Time: From World War II to Nixon*. New York, 1976.

Homer, William Innes, and Organ, Violet. *Robert Henri and His Circle*. Ithaca, N.Y., 1970.

Hourwich, Rebecca. "An Artist Builds a House." *Country Life*, July 1929.

Howe, Irving, and Coser, Lewis. *The American Communist Party: A Critical History*. New York, 1962.

Huth, Hans. *Nature and the American*. Berkeley, Calif., 1957.

Johnson, W. O. "A Legend Lost at Sea." *Sports Illustrated*, 8 January 1979.

Jones, Dan Burne. "Books Illustrated by Rockwell Kent." *American Book Collector* 14, no. 10 (Summer 1964).

————. "A Descriptive Checklist of the Written and Illustrated Work of Rockwell Kent." *American Book Collector* 14, no. 10 (Summer 1964).

————. *The Prints of Rockwell Kent*. Chicago, 1975.

————. "Rockwellkentiana." *Antiquarian Bookman* 11, no. 1 (1953).

Kahn, Albert E. "Citizen Rockwell Kent." *American Book Collector* 14, no. 10 (Summer 1964).

————. *High Treason: The Plot Against the People*. New York, 1950.

————. *The People's Case*. New York, 1951.

————. "A Toast to Rockwell Kent." *New World Review* 35, no. 6 (1967).

————. "A True American." *Culture and Life*, no. 2 (1961).

Kemenov, Vladimir. *Rockwell Kent: Painter, Writer, and Fighter*. Moscow, 1970.

Kent, Sally. "America Fetes Soviet Students." *Fraternal Outlook* 5, no. 2 (February–March 1943).

————. "Big and Kind." *New World Review* 26, no. 11 (December 1958).

————. "Rockwell Kent: His Engagement with Life." *American Dialog*, Autumn 1971.

————. "The Young Are Always Beautiful." *New World Review* 27, no. 8 (September 1959).

Kuznetsova, I. "Rockwell Kent Exhibition in Moscow." *Culture and Life*, no. 2 (1958).

Kwiat, Joseph J. "Robert Henri and the Emerson-Whitman Tradition," *Publications of the Modern Language Association* 71, pt. 1 (September 1956).

Lamont, Corliss. "The Great Kent Collection at Columbia!" *Kent Collector*, December 1974.

————. "A Life to Celebrate." *Rights* 18, no. 1 (June 1971).

————. *The Right to Travel*. New York, 1957.

————. "The Rockwell Kents: A Tribute to Courage." *New World Review*, second quarter 1969.

Lamparski, Richard. *Whatever Became Of?* New York, 1967.

Larkin, Oliver W. *Art and Life in America*. New York, 1949.

Lasch, Christopher. *The Agony of the American Left*. New York, 1970.

————. *The New Radicalism in America, 1889–1963*. New York, 1965.

Lawson, John C. *Strike of Vermont Marble Workers: Verbatim Report of Public Hearing, Town Hall, West Rutland, Vermont*. Barre, Vt., 1936.

Lewis, John N. *The Twentieth-Century Book: Its Illustration and Design.* New York, 1967.

McCausland, Elizabeth, ed. *Work for Artists: A Symposium.* New York, 1947.

McCoy, Garnett. "Reaction and Revolution, 1900–1930." *Art in America* 53, no. 4 (August–September 1965).

McKinzie, Richard D. *The New Deal for Artists.* Princeton, N.J., 1973.

Mangravite, Peppino. "Aesthetic Freedom and the Artists' Congress." *The American Magazine of Art* 29, no. 4 (April 1936).

Mather, Frank Jewett, Jr. *The American Spirit in Art.* New Haven, Conn., 1973.

Mellquist, Jerome. *The Emergence of American Art.* New York, 1942.

Mitchell, Broadus. *Depression Decade.* New York, 1947.

Morgan, Charles A. *George Bellows: Painter of America.* New York, 1965.

Murray, Robert K. *Red Scare: A Study in National Hysteria, 1919–1920.* Minneapolis, Minn., 1955.

Myers, Jerome. *Artist in Manhattan.* New York, 1940.

Narodny, Ivan. *American Artists.* Freeport, N.Y., 1969.

Novak, Barbara. "The Persuasive Eloquence of Rockwell Kent." *Columbia Library Columns*, February 1972.

O'Connor, Francis V., ed. *The New Deal Art Projects: An Anthology of Memoirs.* Washington, D.C., 1972.

Pearson, Ralph M. *Experiencing American Pictures.* New York, 1943.

Perlman, Bennard B. *The Immortal Eight.* New York, 1962.

Phillips, Duncan. *The Artist Sees Differently.* New York, 1951.

———. *A Collection in the Making.* New York, 1926.

Powell, Lawrence Clark. *Books in My Baggage.* Cleveland and New York, 1960.

Preiss, David. "Rockwell Kent." *American Artist* 36, no. 364 (November 1972).

Price, F. Newlin. "Rockwell Kent, Voyager." *International Studio* 79, no. 326 (July 1924).

Putnam, George Palmer. *Wide Margins: A Publisher's Autobiography.* New York, 1942.

———. "World's First Incorporated Artist." *Collier's*, 5 June 1920.

Read, Helen Appleton. *Robert Henri.* New York, 1931.

———. *Robert Henri and Five of His Pupils.* New York, 1946.

Reed, Walter. *The Illustrator in America, 1900–1960s.* New York, 1966.

Richmond, Al. *A Long View from the Left.* Boston, 1973.

Ripley, A. C. *Profile of Rockwell Kent in Twenty-Two Letters.* London, 1946.

Robeson, Paul. *Here I Stand.* London, 1958.

Robinson, Ione. *A Wall to Paint On.* New York, 1946.

Robinson, Selma. "Rockwell Kent, the Writer of the Moment." *Charm*, January 1931.

Rockwell, Norman. "Rockwell—Before or After?" *Colophon* 1, no. 4 (June 1936).

Rosenberg, James N. "Ghosts: The Exhibition of the New Society." *International Studio* 72 (December 1920).

Rothschild, Lincoln. *To Keep Art Alive.* Philadelphia, 1974.

Rovere, Richard H. *Senator Joe McCarthy.* New York, 1959.

St. Gaudens, Homer. *The American Artist and His Times.* New York, 1941.

St. John, Bruce, ed. *John Sloan's New York Scene.* New York, 1965.

Salaman, Malcolm C. *The New Woodcut.* London, 1930.

Saunders, J. M. "An Artist Who Works at the End of the World." *American Magazine* 99 (March 1925).

Shannon, David A. *The Decline of American Communism: A History of the Communist Party of the United States Since 1945*. New York, 1959.

———. *The Socialist Party of America*. New York, 1955.

Simon, Howard. *500 Years of Art in Illustration: From Albrecht Dürer to Rockwell Kent*. New York, 1942.

"Spiritual Adventures of an American Artist in Newfoundland." *Current Opinion* 62, no. 4 (April 1917).

Squires, Frederick. *Architectonics: or Tales of Tom Thumbtack*. New York, 1914.

Stewart, Donald Ogden. "A Neighbor Looks at Rockwell Kent." *Democourier* 6, no. 10 (October 1937).

Strawn, Arthur. "Rockwell Kent, Incorporated." *Outlook*, 9 July 1930.

Thayer, Abbott. *Concealing Coloration in the Animal Kingdom*. New York, 1909.

Trumbo, Dalton. *The Time of the Toad: A Study of Inquisition in America*. New York, 1972.

Untermeyer, Louis. *From Another World*. New York, 1939.

———. "Kent: The Writer." *Democourier* 6, no. 10 (Summer 1964).

Vilas, Carl. *Saga of Direction*. New York, 1978.

Vogue magazine. April 1911.

Watson, Forbes. *American Painting Today*. Washington, D.C., 1939.

———. "Rockwell Kent, Incorporated." *Arts and Decoration*, March 1920.

West, Richard. "Rockwell Kent Reconsidered." *American Art Review*, December 1977.

———. *The Rockwell Kent Collection*. Brunswick, Me., 1972.

———. ed. *Rockwell Kent: The Early Years*. Brunswick, Me., 1969.

Young, Art. *Art Young: His Life and Times*. New York, 1939.

Young, Stark. "The World of Rockwell Kent." *The New Republic*, 4 May 1927.

Zigrosser, Carl. *The Artist in America*. New York, 1942.

———. *My Own Shall Come to Me*. Philadelphia, 1971.

———. "Rockwell Kent." *Print Collector's Quarterly*, 25 April 1938.

———. "Rockwell Kent: Painter, Lithographer, and Book Illustrator," *London Studio* 13, no. 73 (April 1937).

———. *A World of Art and Museums*. Philadelphia, 1976.

INDEX

Abbott, Leonard, 47
abstract art, 154, 199
Ahgupuk, George, 180
Alaska, 96, 97, 99, 100–116, 117–118, 120–121, 122, 139, 210, 214
Alger, Horatio, 14
Allen, Sam, 158–162, 231
American Artist, 201
American Artists' Congress, 175–176
American Car and Foundry Company, 170
American Labor party, 188–191
American Legion, 190–191
American Magazine, 150
Anshutz, Thomas, 18
Aranha, Oswaldo, 183
Arens, Egmont, 118, 121, 148, 152
Armfield, Maxwell, 150
Armory Show, 78–79
Art Students League, 19
Asgaard Dairy, 187, 189–191
Asgaard Farm, 156, 157–158, 163–165, 173–174, 185, 189–191, 195–196, 208, 211, 212–214
Atomic bomb, 195, 212

Banker, James, 6–8, 156
Banker, Josie, 6–9, 24, 156
Barron, Victor, 183
Becker, Maurice, 68
Bellows, George, 19, 36, 48, 62–64, 68, 126, 154, 210
Berkman, Alexander, 71, 224
Biddle, George, 176
Black, Hugo, 177
Black, Ruby, 182, 233
Blake, William, 5, 100, 109–111, 116, 117, 143, 146, 192
Book of the Month Club, 166
Boss, Homer, 61
Boudin, Kathy, 209
Boudin, Leonard, 204–205, 209
Bourke-White, Margaret, 176
Bowdoin College, 213
Boyesen, Bayard, 50, 52, 56, 97, 222

Brazil, 183–184
Brecknock Peninsula, 139, 210–211
Brewster, O. Byron, 185
Bridges, Harry, 199
Briehl, Walter, 204
Brinton, Christian, 117
Brown, John, 6, 69, 139
Brush, George de Forest, 38, 69, 72
Budenz, Louis, 197–198
Burnt Nyal, 23, 211
Burroughs, John, 221

Calhoun, Bill, 187
Cameron, Angus, 200, 208, 211
Campos, Albizo, 180, 182
Cape Cod Cinema, 233
Cape Horn, 128, 130, 131, 132, 136, 139–142
Carey, Lucien, Jr., 158–162
Caute, David, 198
Cerf, Bennett, 155–156, 166, 210
Chappell, George, 24, 60, 92, 96, 128–129
Chase, William Merritt, 15–17, 20, 24
Christopherson, Ernest, 140–142
Clark, Tom, 197
Coleman, Glenn O., 19, 61, 68
Columbia Broadcasting System, 172–173
Columbia University, 6, 14–16, 19, 50, 52, 81, 119, 187
Colvin, Charles, 213
Communist party (of the USA), 174, 177–178, 183–185, 188, 194–195, 197–198, 200, 201, 204
Connecticut College for Women, 80, 225
Cox, Kenyon, 17, 24, 218
Crane, Hart, 115
Crowninshield, Frank, 92, 128, 153
Culture Caravan, 190–191
cummings, e. e., 152
Curran, Joe, 185

Daniel, Charles, 80–82, 89–90, 92, 93, 94
Darwin, Charles, 26, 27
Davey, Randall, 19
David, Jerome, 183–184

David, Stuart, 68, 175–176, 178
Davies, Arthur B., 60–64, 78, 90, 118, 222, 223
Dehner, Dorothy, 231
de Kooning, Willem, 185
Delaware and Hudson Railroad, 163–165, 169
Detroit Institute of the Arts, 153–154
Direction, 1–3, 159–162, 231
Dodd, Mead (publishers), 199
Dodge, Mable, 81–82
Dos Passos, John, 152, 185
Dostoevski, Fyodor Mikhailovich, 45, 121–122
du Bois, Guy Pene, 19, 61, 90, 152
Du Bois, W. E. B., 47
Duchamp, Marcel, 94
Dulles, John Foster, 204–205
Dürer, Albrecht, 108

Eakins, Thomas, 18
Eddy, A. J., 90, 127
Edison, Thomas, 6
Egypt Farm, 119–126, 128, 143–144, 153
Emergency Civil Liberties Union, 204
Emerson, Ralph Waldo, 18, 23, 44, 49
Episcopal Academy, 10, 12
Exhibition of Independent Artists, 48, 61

Farnsworth Museum, Maine, 199–201, 206
Faulkner, Barry, 66, 71
Faulkner, William, 166
Federal Bureau of Investigation, 193–194, 197
Ferrer Association, 97
Fisher, Dorothy Canfield, 119–120
Force, Juliana, 94, 120
Ford, Edsel, 154
Foreman, Clark, 204
Freuchen, Peter, 157, 163, 165–166, 185, 188
Frick, Henry Clay, 71, 97
Furlong, Charles Wellington, 128, 131, 210–211

Geckler, Alex, 77–79, 88
Gelders, Joseph, 177
General Electric Company, 192–193, 234
Glackens, William, 19, 81
Goethe, Johann Wolfgang von, 65, 91, 144, 146–147
Goldman, Emma, 50, 71, 82
Golz, Julius, 19, 49, 61, 64–65
Graves, John Temple, 177
Greenland, 1–3, 157, 158–163, 164, 166–169, 170, 171, 172–173, 180, 187, 192–193, 210, 211, 214
Greenwald, Manny, 187

Gretchen, 94–99, 101, 114
Gropper, Bill, 198

Haeckel, Ernst, 34
Haggard, H. Rider, 22
Harris, Frank, 152
Hartley, Marsden, 66, 68, 69, 74–78, 93, 127
Hayden, Sterling, 166, 232
Haywood, "Big Bill," 76
Hellman, Lillian, 190
Hemingway, Ernest, 150
Henri, Robert, 17–20, 24–26, 29, 31, 48, 49, 60–64, 68, 74, 86, 90, 94, 154, 210, 211, 222
Henty, George Alfred, 14, 22
Hind, C. Lewis, 123
Hitler-Stalin nonaggression pact, 186
Hogarth, Jr., 93
Holgate, Jo (Aunt), 9–14, 19, 21, 36
Hopper, Edward, 19, 152
Horace Mann School, 12, 14, 218
Houghton Mifflin (publishers), 165
Howald, Ferdinand, 97, 111, 117, 124
Huneker, James, 36

Iceland, 96, 124, 146
Icelandic Sagas, 23, 96, 146, 158, 211
Ihnen, Jorge, 132–133
Independent Exhibition of 1917, 94
Industrial Workers of the World, 71–72, 76, 77
International Workers Order, 197–198
Ireland, 151–152, 204

Janet, 36–37, 40–41, 46–47, 50–51, 53–54, 56, 59–60, 65, 91, 222
Jay Taxpayers Association, 170–171
Jones, Dan Burne, 210, 213
Jones, Mary "Mother," 47

Kahn, Albert, 196–197, 200
Kent, Dorothy (sister), 8–9, 33, 65
Kent, Frances Lee (second wife), 151–153, 156, 163, 169, 173–174, 185–186, 195
Kent, George Lewis, 6
Kent, Gordon (son), 125, 173, 187, 188, 213
Kent, Kathleen Whiting (first wife), 39–52, 54, 55, 56, 57–60, 64–65, 74, 81–84, 90–92, 94–99, 103, 106, 114–115, 117–120, 123, 124–125, 128–129, 143–144, 147, 151, 153, 220
Kent, Ohio, 5–6
Kent, Rockwell
 BIOGRAPHY
 adultery, 46–47, 50–51, 53–54, 59–60, 65, 66–67, 94–99, 126–128, 144, 146, 150–151, 156, 222

Kent, Rockwell (cont'd)
BIOGRAPHY (cont'd)
advertising art, 95, 151–152, 182
alcohol, 185
architectural studies, 14–16, 19
art studies, 12–13, 15–16, 19–26, 29, 47–48, 68
birth, 7
childhood and youth, 7–14
childhood reading, 8, 14, 22
children, 47, 59, 64–65, 80, 91, 94, 97–116, 125, 128, 143–144, 148–149, 153, 173, 187, 188, 213
Congressional campaign, 189–191
Creative Art magazine, 153
death, 214
education, 9–16, 19–29
expulsion as German spy, 87–92
family history, 5–6
family snobbishness, 8, 13–14
gift to South Vietnamese Liberation Front, 210
gift to USSR, 206
Hogarth, Jr. (pseudonym), 93
illegitimate son, 59–60, 65, 91
illnesses, 91, 208, 211, 214
incorporation, 116, 120
lecturing, 171–172, 182–183
Lenin Peace Prize, 209–210
marriages, see Kent, Frances Lee; Kent, Kathleen Whiting; Kent, Sally Johnstone
nightmares, 8, 114, 211
passport case, 195, 203–205
political repression, 187–191, 192–210
practical jokes, 23, 38, 130–131, 165
romances, see Janet; Lydia
IDEAS AND OPINIONS
abstract art, 154, 199
advertising, 95, 170, 182
architectural drafting and rendering, 67–68
art criticism, 127, 171–172, 199
artists' unions, 184–185
Christianity, 13, 35
communism, 178, 187, 205–206
Communist party (of the USA), 178, 184, 186, 188–189
Eskimos, 162, 168, 171, 176
federal art projects, 184
German culture, 45, 77–78, 88, 97, 121, 137, 148, 169
Hitler-Stalin pact, 186
mysticism, 109, 121–122
need for American art, 154–155, 184
purpose of art, 16, 35, 49–50, 51, 111, 145–146, 178, 184, 199, 213

Kent, Rockwell (cont'd)
IDEAS AND OPINIONS (cont'd)
racial intolerance, 145, 196–197
Russia, Russian revolution, 124, 175, 178, 186, 187, 205–206, 213
sexual virtue, 37, 46–47, 65, 66–67, 94, 156
socialism, 28, 41–45, 57–58, 79, 175–176, 178, 184, 187, 205–206
unions, 176–177, 185, 188–189
wilderness, 104, 115, 157–158, 169, 213
working class, 25, 31, 43–44, 57–58, 72, 77–78, 105, 176–177, 184
World War I, 88–89, 97, 100, 145, 171
World War II, 176, 186–187
WORKS
Architectonics: or Tales of Tom Thumbtack (book illus.), 81
Burial of a Young Man (painting), 41, 64
Candide (book illus.), 155–156
Canterbury Tales (book illus.), 163
Come to Bohemia (scenery for play), 81
Deer Season (painting), 123
Down to the Sea (painting), 64
Dublin Pond (painting), 20, 23
Fisherman's Farewell (painting), 59
Greenland Journal (book), 211
House of Dread (painting), 89
House of Representatives (mural), 187, 201, 235
It's Me O Lord (book), 199
"Kent's Tent" (Independent Exhibition), 60–62
Leaves of Grass (book illus.), 182
Man the Abyss (painting), 89
The Memoirs of Casanova (book illus.), 148
Men and Mountains (painting), 62
Moby-Dick (book illus.), 159, 163
Monadnock (painting), 23
N by E (book), 166, 200
Newfoundland Dirge (painting), 89
North Wind (painting), 121
painting on glass, 96
Picklock Holmes (scenery for play), 33
Portrait of a Child (painting), 89
Post Office (mural), 178–182, 233
printmaking, 125–126, 170
Road Roller (painting), 38
Rockwellkentiana (book), 171
Ruin and Eternity (painting), 89
Salamina (book), 182
Sally and the Sea (painting), 214
The Seiners (painting), 97
Shadows of Evening (painting), 123
Superman (painting), 111, 121

Kent, Rockwell (cont'd)
 WORKS (cont'd)
 This Is My Own (book), 186
 Toilers of the Sea (painting), 37, 64
 The Trapper (painting), 123
 Voyager Beyond Life (painting), 89
 Voyaging: Southward from the Strait of
 Magellan (book), 143–144, 149
 Wilderness: A Journal of Quiet Adven-
 ture in Alaska (book), 118, 120–121,
 123, 125, 147, 149, 200, 227
 Winter (painting), 37, 94
 Winter (Berkshire) (painting), 20
 A Yankee in Patagonia (book illus.), 165
Kent, Rockwell, Jr. (son), 47, 94, 97–116, 118,
 125, 148, 213
Kent, Rockwell, Sr. (father), 6–8, 83
Kent, Sally Johnstone (third wife), 185–186,
 191, 195, 198–200, 205, 208–210, 212–
 214
Kent, Sara Holgate (mother), 6–8, 12–15, 19,
 24–25, 33, 37, 39, 41, 44, 49, 82, 116,
 193, 208, 220
Kent, Zenas, 5–6
Klopfer, Donald, 155–156, 166
Knoedler Gallery, 117, 120, 121, 122–123, 126
Kropotkin, Prince, 82
Kuehne, Max, 122
Kuhn, Walt, 61, 90

La Chaise, Gaston, 154
Lakeside Press, 159, 163, 193
Lamont, Corliss, 204, 213
Lasky, Jesse, 153, 231
Lawrence, Martin, 139–140
League of New York Artists, The, 154
Lehman, Herbert, 170
Leigh, Colston, 171–172
Lenin Peace Prize, 209–210
Literary Guild, 166
London, Jack, 22, 47, 49, 150
Lowry, Phillip, 149, 164
Luks, George, B., 19, 62, 90, 218
Lydia, 127–128

Macbeth, William, 64
McBride, Henry, 117, 122, 143, 150
McCarthy, Joseph, 200–201
McPherson, John, 61–62
Mannes, David, 150, 224
Mannes, Marya, 150–151
Marin, John, 61
Masses, 26, 68
Maurer, Alfred, 61
Merrill, Lewis, 188–189
Metropolitan Museum of Art, 37, 94, 96, 154
Mielziner, Jo, 233

Miller, Kenneth Hayes, 24, 68, 78–79, 86, 89,
 93, 225
Moby-Dick, 130, 159, 163, 166, 206
Modern School, The, 97, 115
Monaco, Arto, 187
Monhegan Island, Maine, 30–41, 45–47, 58–
 59, 95, 99, 198
Moore, Harry, 196–197
Moore, Merrill, 183
Morris, William, 172
Mumford, Lewis, 176

National Academy of Design, 15, 17, 19, 23,
 48, 60–62, 74, 154, 184, 218
National Association for the Advancement of
 Colored People, 196–197
National Committee for the Defense of Po-
 litical Prisoners, 177
National Committee of Soviet-American
 Friendship, 206–207
National Gallery of Contemporary Art, The,
 155
National Institute of Arts and Letters, 213
New Deal, 178
Newfoundland, 51, 52, 53–57, 81–94, 160, 210
New Masses, 186, 199
New Republic, The, 91
New York School of Art, 16, 19–20, 24
New York Times, The, 123, 147, 164
New York World, The, 96, 123, 143
Nietzsche, Friedrich, 100, 108–111

O'Day, Caroline, 120
Odyssey, 108
Olson, L. M., 102–116, 122, 123, 125
Overton, Walter, 144

Pach, Walter, 19, 90, 154
Painters, Sculptors, and Gravers Show, 228
Pan American Airways, 173, 180
Pastor, Rose (Stokes), 45, 47
Pearmain, Robert, 66, 68, 69–72, 76–78, 177,
 209, 224
Pegler, Westbrook, 203
Pennsylvania Academy of the Fine Arts, 16, 18
Phi Delta Gamma, 15
Philadelphia Record, 49–50
Phillips, Duncan, 38, 64, 151
Picasso, Pablo, 75, 199, 204–205
Pierce, Waldo, 150, 152
Ponce Massacre, 180, 182
Prendergast, Maurice, 61
Preston, James, 19
Proctor Marble Company, 176–177
Puerto Rico, 180–182, 183
Pulitzer, Ralph, 127, 128, 143–144
Putnam, George Palmer, 38, 118, 120, 144,
 146, 166

Random House (publishers), 155–156, 166
Rasmussen, Knud, 163, 165–166, 185
Robeson, Paul, 185, 204–205
Robinson, Ione, 156
Robinson, Selma, 166
Rockwell, George Lincoln, 203
Rockwell, Matilda, 6
Rockwell, Norman, 203
Romanoff, Prince Michael Dimitri, 165, 195, 232
Roosevelt, Franklin D., 178, 184, 188, 205
Roselius, Ludwig, 147–148
Rosenberg, Bob, 193
Rosenberg, James, 164, 171, 193
R. R. Donnelly & Sons, 159, 163, 193
Ruggles, Carl, 78
Ruskin, John, 34
Russia, 124, 175, 178, 186–188, 204–206, 213
Russian War Relief, 187
Ryan, J. J., 203–204
Ryder, Albert Pinkham, 86

Sacco and Vanzetti, 175
Salisbury, Harrison, 213
Sanger, Margaret, 71, 223
Schopenhauer, Arthur, 34
Scott, LeRoy, 47
Seeger, Alan, 70, 76, 223
Seidenberg, Roderick, 107
Shanghai, 147–148
Sheridan, Philip, 87–88
Shinn, Everett, 19
Siqueiros, David, 176
Sloan, John, 19, 30, 36, 48, 54, 57, 60–62, 68, 74, 90, 154, 220, 221
Smallwood, Joseph, 210
Smith, David, 231
Socialist party, 28, 33, 41–47, 58, 71, 85
Society of American Artists, 15
Soule, Isabel, 185
Soviet Artists' Union, 213
Spanish Civil War, 184, 210
Spencer, Herbert, 34, 82
Sprinchorn, Carl, 19, 211
Squires, Fred, 81
State Department, U.S., 89, 195, 203–205
Stefansson, Vilhjalmur, 180–182
Stein, Gertrude, 75
Steinway and Sons, 170
Sterner, Marie, 94, 96, 97, 117, 118, 126–127
Stevens, Wallace, 115
Stewart, Donald Ogden, 185
Stieglitz, Alfred, 74, 89, 154
Stockholm Appeal, 195
Stoddard, James, 10
Stokes, F. W., 152
Stokes, J. G. Phelps, 45, 47, 60

Stone, I. F., 204
Stout, Rex, 148, 151
Strand, Paul, 189–190
Strunsky, Rose, 47
Students for a Democratic Society, 209

Tallentire, Norman, 194–195
Taylor, Glen, 189
Thayer, Abbott, 20–23, 38, 51, 69, 210, 219
Thayer, Gerald, 22–23, 37–39, 51, 219
Thoreau, Henry David, 23, 49
Thwaites, John E., 101–102
Tierra del Fuego, 50, 128, 131–142, 143, 146, 149, 153, 162, 210–211
Tolstoy, Leo, 26, 28, 34, 49, 50, 82
Traubel, Horace, 47, 53, 221
Trautman, William, 71, 76, 224
Truman, Harry, 188
Turgeniev, Ivan, 34, 44

Udet, Ernst, 169. 187
Untermeyer, Louis, 68, 185

Vanguard records, 193
Vanity Fair, 92, 95
Vargas, Getulio, 183–184
Vermont Marble Workers strike, 176–177
Vietnam, 209–210, 213
Viking Press (publishers), 151

Wagner, Richard, 45, 65, 127, 185
Wagner, Theodore, 97
Wallace, Henry A., 189, 191
Walling, William English, 47
Ward, Lynd, 187
Weeks, Rufus W., 17, 26–28, 31, 34, 41, 68, 70, 80, 85, 89, 176, 219
Wells, F. De Witt, 146–148
Weyhe Galleries, 147, 170
Whitman, Walt, 18, 47, 123, 221
Whitney, Gertrude Vanderbilt, 94
Winona, Minnesota, 68–79
Wolfe, Andrew, 205, 208
World Congress for Peace, 195
World Tomorrow, The, 145–146
Wylie, Elinor, 152

Yeats, John Butler, 221
Young, Art, 26, 68, 219
Ytterock, Ole "Willie," 131–142, 153

Zigrosser, Carl, 52, 97–98, 101, 107–109, 113, 115–116, 117, 118, 120, 124–126, 127, 129, 132, 144, 151–152, 154, 170, 173, 208, 214, 221
Zeitlin, Jake, 172